LASTING IMPRESSIONS

LITERATURE NOW

LITERATURE NOW

Matthew Hart, David James, and Rebecca L. Walkowitz, Series Editors

Literature Now offers a distinct vision of late-twentieth- and early-twenty-first-century literary culture. Addressing contemporary literature and the ways we understand its meaning, the series includes books that are comparative and transnational in scope as well as those that focus on national and regional literary cultures.

Caren Irr, *Toward the Geopolitical Novel: U.S. Fiction in the Twenty-First Century*

Heather Houser, *Ecosickness in Contemporary U.S. Fiction: Environment and Affect*

Mrinalini Chakravorty, *In Stereotype: South Asia in the Global Literary Imaginary*

Héctor Hoyos, *Beyond Bolaño: The Global Latin American Novel*

Rebecca L. Walkowitz, *Born Translated: The Contemporary Novel in an Age of World Literature*

Carol Jacobs, *Sebald's Vision*

Sarah Phillips Casteel, *Calypso Jews: Jewishness in the Caribbean Literary Imagination*

Jeremy Rosen, *Minor Characters Have Their Day:
Genre and the Contemporary Literary Marketplace*

LASTING
IMPRESSIONS

THE LEGACIES
of
IMPRESSIONISM
in
CONTEMPORARY
CULTURE

JESSE MATZ

Columbia University Press
New York

Columbia University Press
Publishers Since 1893
New York Chichester, West Sussex
cup.columbia.edu
Copyright © 2016 Columbia University Press
All rights reserved

Library of Congress Cataloging-in-Publication Data

Names: Matz, Jesse, author.
Title: Lasting impressions : the legacies of impressionism in comtemporary culture /
Jesse Matz.
Description: New York : Columbia University Press, 2016. | Series: Literature now |
Includes bibliographical references and index.
Identifiers: LCCN 2016018775 (print) | LCCN 2016034377 (ebook) |
ISBN 9780231164061 (cloth : alk. paper) | ISBN 9780231543057 (electronic)
Subjects: LCSH: Impressionism in literature. | Art and literature. |
Impressionism (Art)
Classification: LCC PN56.I5 M38 2016 (print) | LCC PN56.I5 (ebook) |
DDC 700/.411—dc23
LC record available at https://lccn.loc.gov/2016018775

Cover design: Jordan Wannemacher
Cover image: © Musee Marmottan Monet, Paris, France/Bridgeman Images

CONTENTS

ACKNOWLEDGMENTS

I would not have written this book without the encouragement of editors who have been such a great help to so many of us. Douglas Mao and Rebecca Walkowitz invited me to contribute an essay to their book *Bad Modernisms*, and thanks to their wonderful editorial stewardship, that essay, which became this book's chapter 2, also became the basis for the project as a whole. Another chapter went from a conference paper to an essay for David James's collection, *The Legacies of Modernism*, and that led, in turn, to his invitation to publish the larger project in this series at Columbia. David James and his series co-editors Matthew Hart and (again) Rebecca Walkowitz enabled the development of the project at every stage. I recall gratefully and fondly many moments when their support and guidance were decisive, and of course their own work inspiringly set a high bar for achievement in this field. When Philip Leventhal took the reins as editor, the book gained in intellectual and professional distinction, and I am also grateful to Miriam Grossman and Leslie Kriesel for their work bringing the book to completion. My superb research assistant Aaron Stone also gave me invaluable help in locating rights holders and also some of the book's key examples.

Five friends, all far better scholars than I, read parts or all of five chapters and gave me crucial advice about them. James Carson's eagle eye and sharp mind transformed the introduction. Kate Elkins's theoretical expertise helped me clarify the invited talk that became chapter 2. Jed Esty's

intellectual and personal generosity were crucial in many ways, and Nico Israel, also incredibly generous and so helpfully brilliant, gave me excellent advice. Sophia Padnos offered marvelous editorial guidance.

James Carson's advice came as part of a seminar session (devoted to discussion of this book's introduction) that also included Piers Brown, Jennifer Clarvoe, Deborah Laycock, Tessie Prakas, Patsy Vigderman, and Nobuko Yamasaki. A prior session of the same seminar that helped me with chapter 7 also included Laurie Finke, Sarah Heidt, and Kim Mc-Mullen. Also invaluable has been the support of the group of modernist scholars that has met monthly for more than ten years at the lovely home of Stephen Kern, including Murray Beja, Kate Elkins, Ellen Jones, Brian McHale, James Phelan, Bill Palmer, Jessica Prinz, and others. Scott Klein and Michael Moses asked me to write an essay on Jean Renoir, and research for that project greatly enhanced this book's work on French impressionist cinema. Similarly, an essay prompted by Michael D'Arcy and Matthias Nilges helped me develop thoughts about impressionism after film, as a context for this book's account of the fiction of David Mitchell.

Friends and colleagues who gave me vital help on particular points include Eliza Ablovatski, Reed Baldwin, Ian Baucom, Fred Baumann, Gary Bowman, Jessica Burstein, Robert Caserio, Sarah Cole, Thomas Davis, Matthew Eatough, Philip Fisher, Laura Frost, Andrzej Gasiorek, Cécile Guédon, Marcell Hackbardt, Lewis Hyde, Grant Johnson, Pericles Lewis, Janet Lyon, Natalie Marsh, Wendy Moffat, Don Monson, Mona Nacey, Ilona Sármány-Parsons, Christopher Reed, Max Saunders, Jené Schoenfeld, Urmila Seshagiri, Jonah Siegel, Joy Sperling, Anna Sun, Helen Vendler, and Stephen Volz. (If I have forgotten to name others, it is only because this book has been too long in the making.) I am deeply grateful to Réka Mihálka, whose fine translations enabled me to read material on Béla Kontuly, and my cousin Lili Márk, who helped me communicate with Hungarian museums and galleries. In the final stages, people including Kay Peterson at the Smithsonian and Tracey Panek at Levi Strauss & Co. Archives were graciously helpful with images and permissions. Much earlier, my critical insight into impressionism developed under the instruction of my dissertation advisors, Paul Fry and Mark Wollaeger, and I remain indebted to them for everything.

Kenyon College gave me support through Faculty Development Grants and, most importantly, the Newton Chun Award. My mother, the

painter Susan Matz, graciously gave me permission to use her Kontulys—including one of my sister, Patty Matz, upon whom I always depend and who gave me such loving care while I was trying to write this book. Support and inspiration also came from the rest of my family, Melvyn Matz, Alayne Baxter, Morty Peritz, Chris Brozyna, Gordon Matz, Guy Matz, Jennie Matz, Sadie Matz, August Matz, and Skyler Brozyna. And then there is Jeffrey Bowman, who needs no acknowledgment but still.

Material in this book appeared in substantially different form in the three essays mentioned above: "Cultures of Impression," *Bad Modernisms*, ed. Douglas Mao and Rebecca L. Walkowitz (Durham: Duke University Press, 2006), 298–330; "Pseudo-Impressionism?" *The Legacies of Modernism: Historicising Postwar and Contemporary Fiction*, ed. David James (Cambridge University Press, 2012), 114–132; and "Impressionism After Film," *The Contemporaneity of Modernism*, ed. Michael D'Arcy and Mathias Nilges (London: Routledge, 2015), 91–104.

LASTING IMPRESSIONS

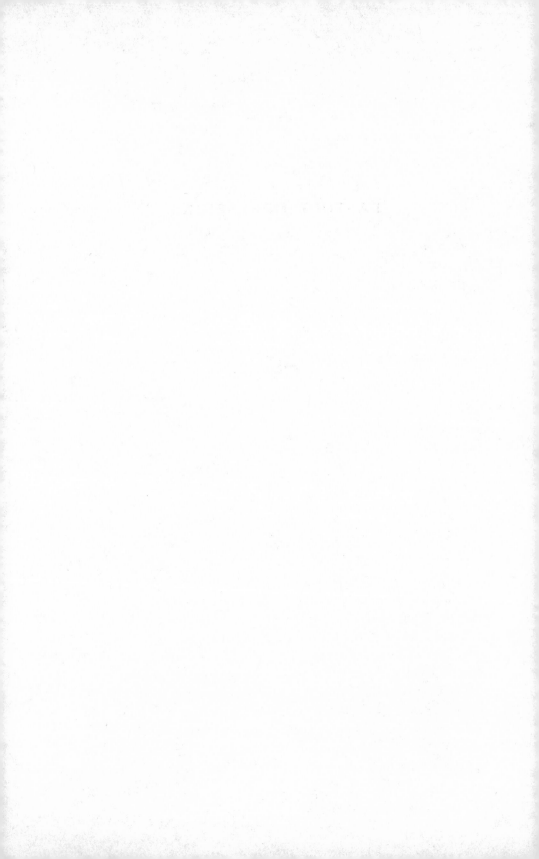

INTRODUCTION

BÉLA KONTULY, PSEUDO-IMPRESSIONIST

Two still-life pictures hung in my childhood home (fig. I.1, fig. I.2). Had you seen them, you might have called them impressionistic, judging by the brushstrokes, the sketchy rendering, and the relatively loose and open composition (fig. I.3). Then again, their dates—1962, 1963—would have distinguished them from actual impressionist pictures, as would the dark palette, dissimilar to the impressionists' higher tones. But had you asked me, I would have said only that they were pictures of fruit and flowers and that they were art. I had no sense of their style or significance and certainly no way to judge their value. Really, I hardly saw them. They were simply natural features of our domestic environment. My innocence, however, lasted only until I was fifteen, when someone made me see these pictures all too clearly.

I had a friend who knew a lot about art. Her parents were serious collectors with wonderful taste. Her aesthetic environment had always been significant, and in this respect, our worlds were very different. But the difference escaped me until the day she happened to coin a term to describe my family's still lifes: "pseudo-impressionism." She spoke it politely enough, but the term was an eye-opener. Instantly I saw the truth. Our pictures were cheap knock-offs, and I perceived them for what they were—for their false artistry, their fake luxury. I knew little about

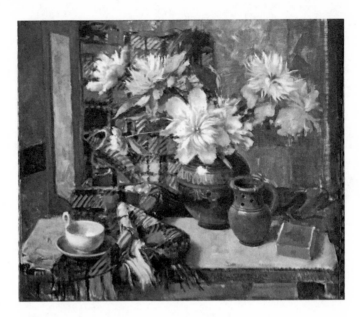

1.1 Béla Kontuly, *Still Life*, 1962, oil on canvas, 60 x 70 cm., private collection

1.2 Béla Kontuly, *Still Life*, 1963, oil on canvas, 77 x 98 cm., private collection

I.3 *Still Life*, 1963, detail

impressionism, but I could tell what was wrong with these pictures. With their failed insouciance and obvious commercialism, they were poor pretenders, and certainly not art. And I too was defined by the difference, brought to self-awareness (like so many before me) by an aesthetic distinction.

How I wish I could say I knew better than to care. But this experience did have a lasting effect. I developed a strong interest in impressionism, pursuing college coursework on the subject and writing a dissertation on impressionism in literature. Although I would not say the shame of "pseudo-impressionism" really motivated me, it did sharpen my insight, making me sensitive to the cultural politics of impressionist aesthetics. Not just the works themselves but their part in the social life of modernity captured my interest. I saw the point of the revisionist sociology pursued by Robert Herbert, who taught my undergraduate survey, and my dissertation depended heavily on Fredric Jameson's account of impressionism's political unconscious. Both were rejoinders to "pseudo-impressionism"— Herbert with his analysis of the bourgeois social life implicit in the pictures, Jameson with his sense of the "romance and reification" in impressionist aesthetics.[1]

The dissertation became a book about the social politics of impressionism in literature. *Literary Impressionism and Modernist Aesthetics* (2001) argues that social difference helped shape the way modernist writers saw how "impressions" make their way from life to art. As many critics have noted, impressions blend forms of perception. Sensations and ideas, feelings and judgments, belief and speculation: these opposites are combined by what "impression" connotes. What is more, fiction writers dedicated to rendering impressions (Joseph Conrad, Marcel Proust, Virginia Woolf, and others) tend to conceive of these combinations as fraught collaboration between different social types. That is, when these writers explain themselves, they imply that impressionism demands joining powers of perception typically attributed to different kinds of people. Rich and poor, male and female, young and old: these social opposites are also conjoined, precariously, by what the impression connotes, and so impressionism strangely thrives on social difference, in works of fiction lush with perceptual immediacy but fraught with thematic conflict, plots in which struggles between different kinds of people both enable and jeopardize the kinds of subjective revelation so important to modern fiction.

Centering on this social crisis in impressionist representation, my book built upon other studies of impressionism's social politics, but it was also a legacy of pseudo-impressionism. It made something of my own early brush with social difference.

But impressionism has long been known to create conflict over the nature and function of art. In its day, it seemed at once to heighten aesthetic value and to lower aesthetic standards. It was politically radical—*intransigeant*—but also socially insouciant, exacting in its eye for cultural detail but apparently reckless in its way of trading time-honored procedures for the flighty whims of the *premier coup*. Impressionism reduced better judgment to superficial sensations—unless it actually grounded judgment in truer realities. Or both: the problem with impressionism was that it undid the difference. This was so even after impressionism came to an end. Postimpressionism was one result but by no means a final one, for much of the subsequent history of Western art follows from the problem whereby impressions entailed conflicting paradigms for aesthetic experience and cultural value. What I came to know as the problem of the impression has persisted more generally, not only in the history of art but also in many areas of cultural and social life. Especially where we think

we encounter pseudo-impressionism, we actually see latter-day versions of the perplexity through which impressionism originally troubled art's status and uses. My trouble over it, then, was part of what helped make impressionism powerfully transformative, not just in its day, but beyond.

Lasting Impressions looks to this beyond to show how telling confusion over the status of the impression—its perceptual role, its cultural effects, its social implications—continues to generate meaning. When impressions shape our judgments, structure information, and define aesthetic experiences, they persist in the thematic dynamism that originally made them a basis for a revolution in art. Such persistences vary in their effects in literature, film, the art world, popular psychology, and other areas of culture. I begin with "pseudo-impressionism" because it poses the question of persistence with special variability. Perhaps it fakes the impression's perceptual dynamic; perhaps it is a belated pretense, true to the impression but too late to count as authentic. Perhaps it aims at some material advantage contrary to the spirit of the original impressionist revolution. Any of these motives would define pseudo-impressionism as *kitsch*, and indeed there is plentiful evidence that kitsch is what characterizes impressionism's persistence today. But of course kitsch raises questions about aesthetic authenticity and its social fallacies. No longer what it once was, kitsch suggests another way to define pseudo-impressionism, for if that term names a mass-market commodity that threatens to destroy aesthetic experience, it actually does carry forward the special perplexity of the original impression. In other ways too, impressionism continues to work new variations on its original dynamic. This book explores some of these lasting impressions—the important and often unlikely significance of many forms in which impressionism has survived its historical moment.

But I begin with pseudo-impressionism for another reason as well. There is more to the story of my family's still lifes. Recently I thought to find out more about them. And what I found was a complex history of impressionism and its legacies across the twentieth century.

For twenty-five years I presumed that the pictures were mass-market hack work. Painted in a clichéd style by no one in particular, they seemed to embody the worst of what impressionism had become: commercial art, avant-garde improvisation dead-ending into dashed-off kitsch. That, anyway, was my anxious view of them. But they had a more telling provenance, and a more compelling history. My mother bought them for a total

of $300 in 1964 from a Hungarian painter who had traveled to the United States to sell more of his work. He found us through our family doctor, who had been his boyhood friend. If this ordinary acquisition had always confirmed the insignificance of the pictures, I began to wonder if a Hungarian artist in the United States in the 1960s might not have had a different story to tell. What I found, when I went in search of him, was a major artist. His name was Béla Kontuly, and he had been a figure in Hungary in the years leading up to World War Two—a significant innovator, a leading portraitist, and an exquisite muralist whose works still appear in cultural sites across the country. A 2003 retrospective exhibition of Kontuly's work at the Ernst Museum in Budapest confirmed my discovery of an artist to be proud of after all.

But the truly surprising discovery was not that Kontuly's style of impressionism had a respectable extraction. It was that he had been no impressionist at all. The pictures we bought from him in 1964 looked nothing like the work that had made his name before the war. Kontuly had developed his signature style in the late 1920s and 1930s as a member of the School of Rome, the neoclassical movement first established in proto-fascist Italy and then active across Europe. Kontuly held a prestigious scholarship at the Hungarian Academy of Rome and dedicated himself to that school's *novecento* forms and ethos: a constructivist abstraction and its avant-garde modernity, the planar, hard-edged style so forceful for its aesthetic, dehumanized, often ironic detachment from human interests. *Girl in a Striped Shirt* (fig. I.4) captures the spirit of the style as Kontuly practiced it. Here a purified realism is the better part of modern sophistication; the girl's doll seems more human than the girl herself, and the contrast joins with pure color and closed fields to stress the more inhuman beauty of abstract forms. Another picture, *Orphans* (fig. I.5), makes explicit the aesthetic ethos at work in Kontuly's modernist classicism. Dispossession, alienation, and impersonality abet the liberation of purer forms, in the spirit of the antisubjectivism that defined this moment in the history of European painting. The 2003 exhibition catalog sums up this style and its claims to timely participation in the "neo-classical, Neue Sachlichkeit, precisionist and objectivist realist trends . . . in Europe and American in the 1920s and 1930s."[2]

Abstraction, objectivity, and their uses—to cutting-edge aesthetics, to prewar cultural politics—are a world away from the bland likeability

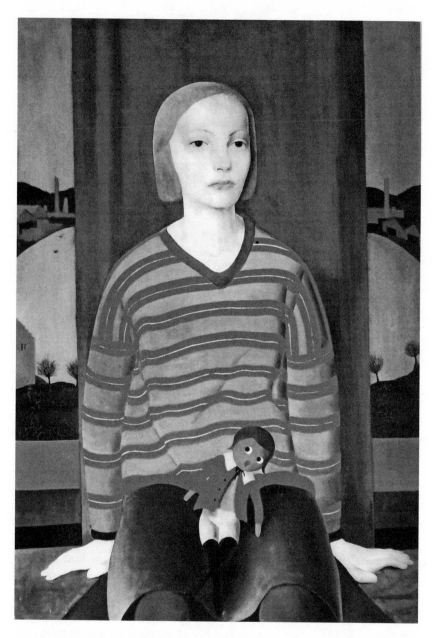

I.4 Béla Kontuly, *Girl in a Striped Shirt*, 1930, oil on canvas, 99 x 69 cm., Tamás Kieselbach collection

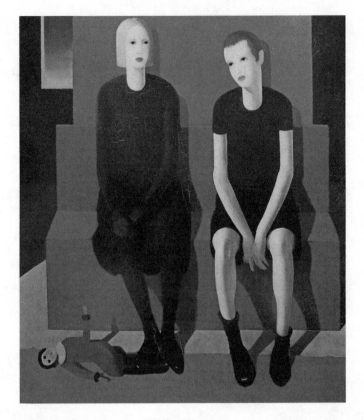

I.5 Béla Kontuly, *Orphans*, 1931–1932, oil on canvas, 90 x 80 cm., JPM MMK, Pécs

of the later still lifes. And the difference is a matter of record. Although the later work ended up in anybody's domestic spaces, the early work triumphed at big exhibitions, in 1936–37, for example, when Kontuly won the Arnold Ipolyi Award and the Klebelsberg Memorial Award, appeared in the Hungarian exhibition at the Venice Biennale, and won gold and silver medals at the 1937 World Exhibition in Paris.

What a gratifying discovery, Kontuly's true importance. It redeemed us both: here was a true artist with avant-garde credentials, and even if my family's pictures were not the major ones, they had an indirect claim to value. A serious collector (and his daughter) might take real interest

in Kontuly's work from the 1920s and 1930s, and, by extension, a polite interest in his later paintings. Had I known, I might have answered the charge of "pseudo-impressionism" with some significant remarks of my own. But what exactly would I have said? Kontuly's important work only makes the question of pseudo-impressionism more perplexing. What made him revert to it? How could he have painted *Orphans* in 1931 and then, thirty years later, our pictures, which look like they should have been painted sixty years before? Compare two other pictures, one an example of Kontuly's signature 1920s portraiture and the other a portrait of my sister, painted from a photograph in 1964. How could he first paint the ultramodern portrait of Magduska Pacher (fig. I.6) and then much later the impressionistic Patty Matz (fig. I.7) as if she were at Argenteuil rather than Astoria? How did bold, forward-looking abstraction revert to

I.6 Béla Kontuly, *Portrait of Magduska Pacher*, 1937, oil on canvas, 80 x 81 cm., collection of Károly Lászlo

1.7 Béla Kontuly, *Portrait of Patty Matz*, 1964, oil on canvas, 50 x 30 cm., private collection

Permission: Susan Matz

yesterday's dappling? My gratification at discovering Kontuly's historic art made me only more curious about the style of our paintings, not only for personal reasons, but because an explanation could say something about impressionism more generally. What does Kontuly's pseudo-impressionist reversal tell us about the afterlife of impressionism?

Of course, Kontuly might have chosen to simulate impressionism in order to sell pictures. In the years following World War Two, public taste in Hungary rejected contemporary artistic developments in favor of more comforting, serviceable forms of realism—domestic or pastoral imagery rendered in familiar, inviting ways. The choice of impressionist realism specifically would have been a smart one for an artist trying to maximize profits in a depressed economy simply because it could be achieved more quickly, with less risk. Even if the original impressionist *non fini* took painstaking labor, later knock-offs could be finished fast, to no small advantage for the artist. Evidence does show mass production of imitation Hungarian impressionism after the war as well as a market overseas for it.[3] Kontuly himself took advantage of the ARTEX distribution system to find buyers in Japan and the United States.[4] If this was opportunism, a tactical strategy, Kontuly's pseudo-impressionism might exemplify one primary way impressionism survived its moment: through co-optation or "selling out." Kontuly's late style might be symptomatic of the way impressionism easily becomes a commercial aesthetic, when its popularity, expediency, and gestural energy make it so handily available to vigorous mass production and circulation. We discover something uniquely self-destructive about the impressionist aesthetic in its readiness for reproduction in forms that compromise its aesthetic and cultural ideals.

But the relationship between aesthetic ideals and commercial realities is not so simple. There are many reasons to complicate it—weren't the impressionists themselves always commercial, and hasn't public taste always shaped modern art?—and there are specific reasons to rethink "selling out" in Kontuly's case. In the years leading up to the war, the School of Rome moved toward closer alignment with fascist goals—"dropped the modernist touch" and "shifted more toward Nazi artistic ideals."[5] Reactionary trends encouraged an antimodernist rejection of the school's avant-gardism; a "conservative megalomanic monumentalism" became the benchmark for achievement.[6] Kontuly took part in the production of fascist art, for example with his *Hungarian Industry* (1936–37), the work that won a gold medal at the 1937 Paris World Exhibition, a mural Ivan Berend cites as an example of the Hungarian School of Rome's political shift. But at the moment in which full fascist takeover in Hungary failed and Hungarian art managed to avoid the complicity that took hold elsewhere in Europe, Kontuly's mural work took on a more benign

religious iconography. Avowedly apolitical, Kontuly shied away from fascist iconography, and his particular Neue Sachlichkeit style transitioned nicely into a kind of neutral realism. After the war, however, even his relatively neutral style read as School of Rome, and, as the 2003 exhibition catalog notes, "he was not very warmly received; neither did he get any awards, which was mostly due to the fact that the Roman grantees were politically 'compromised.'"[7] Now adrift in a world without patronage or a viable public market—without the state, elite buyers, or the masses, all of whom now favored traditional realism—Kontuly had to shift again, to "a pictorial world created with light strokes, attenuated and empty surfaces . . . looser handling of the brush and enrichment of the color scheme of the pictures."[8] He turned to pseudo-impressionism, but the shift looks different in the context of the available options. There is a subtle but significant difference between the forms of realism demanded by official art policy and public taste at this moment and Kontuly's impressionistic style, which has aspects of both a generic neoclassical realism and impressionist modernity. This pseudo-impressionism could well have been a gentle but notable way to nudge art away from instrumental forms of realist representation toward something more aesthetically free. Indeed, the conditions of art's survival often determine choices that disallow any valid distinction between art and pseudo-art, and in this case, Soviet-era impressionism may even reverse the relationship between authenticity and what might seem to be regressive co-optation.

Moreover, if Kontuly had only been trying to sell pictures, he might not have committed himself aesthetically to the project. But at least one picture indicates that he did. In 1961, Kontuly produced an impressionistic self-portrait (fig. I.8). Compared to an earlier self-portrait, painted in 1932 (fig. I.9), this picture seems to be more evidence of a regressive tendency, more evidence that impressionism's survival is aesthetically backward. Here again, the vanguard style is a thing of the past, strangely supplanted by a nineteenth-century optic. But because the later picture is a self-portrait, it would not have been intended for public sale; Kontuly probably painted it for his own sake, and it probably expressed his own interests. Moreover, elements of the picture indicate a telling affinity between Kontuly's 1930s aesthetic and his 1960s work: the two pictures frame their subjects at the same level, in the same position, with analogous objects assigned to similar parts of the picture plane. Figural artworks appear in

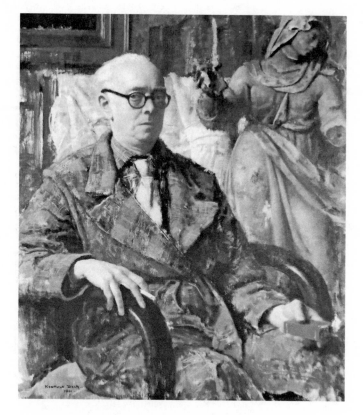

I.8 Béla Kontuly, *Self-Portrait,* 1961, oil on canvas, 80 x 70 cm.

© 2015 Artists Rights Society (ARS), New York/Hungary, Budapest

the upper-right corner, framed items in the upper left, and both pictures show Kontuly holding something of allegorical significance in the fingers of his right hand: in the older picture, a paintbrush; in the later one, a cigarette. This altered motif might solve the mystery of Kontuly's stylistic reversal. Although it is tempting to read the cigarette as a sign of protest against what art has become—a sign of late-career "bitterness," a tragic loss of what the paintbrush figured in 1932—it has a certain aesthetic modernity of its own.[9] On one hand, the cigarette might suggest that Kontuly had no choice but to adopt a style not really his, and the self-portrait as a whole does seem to say so: Kontuly has rendered his face in fine detail but surrounded it with a swarm of sketchy impressions, as if to indicate that

I.9 Béla Kontuly, *Self-Portrait*, 1932, oil on canvas, 80 x 80 cm., JPM MMK, Pécs

he himself has been consumed by an impressionistic prerogative. On the other hand, the cigarette might just indicate a different and not necessarily lesser prerogative, an aesthetic more amenable to ordinary pleasure, in the same way a Soviet-era impressionism might nudge a compromise between instrumental realism and a freer form of art.

There is more evidence that impressionism might have had this weak but important aesthetic significance for such an artist at such a moment. In Hungary, impressionism began to develop much the way it did elsewhere. Parallel to the Barbizon School—France's earlier plein air set—was Hungary's Nagybánya Group, who similarly went out into the open air for impressions of the moment. But whereas Barbizon had been a mid-century phenomenon, Nagybánya was founded in 1896. Impressionism

in Hungary got a later start, and then never really took hold, because Na-gybánya never really embraced the fundamentals: spontaneity, apparent formlessness, and aleatory effects.[10] Instead, it went directly for something more like an art nouveau aesthetic, and from there to postimpressionist forms. In Hungary, impressionism itself was a non-event, and if it did matter, it was mainly as an object of opposition for artists and critics who had, by 1910, taken a more direct route to modernist neoclassicism and ab-straction.[11] The Group of Eight, championed by Georg Lukács, set an anti-impressionist agenda, favoring "disciplined, intellectual 'investigative art' of structure, solidity, and order," equating impressionism with "unbridled and selfish individualism in a society lacking in any solid substance and valid, powerful ideas."[12] Lukács influentially attacked the way impression-ism "turned everything into decorative surface" and promoted an "archi-tectonic" art that could "destroy all anarchy of sensation and mood," even to the point of what he called a "declaration of war on all impressionism."[13] Impressionism lost that war, but it did become a force in the marketplace, as dealers alert to its mass-market potential promoted commercial pro-duction of new canvases and post-hoc reclassification of old ones. Miklós Rózsa's *Impressionist Painting* of 1913, for example, now appears to have been a tactical effort to drum up business rather than an accurate account of a true movement in Hungarian art.[14] In one sector of culture, anyway, calling art "impressionist" was a way to confer status upon it. But this was precisely why Lukács and others opposed it: the status in question was that of a cosmopolitan aesthetic, and the Hungarian avant-garde wanted to assert a uniquely national modernity. Impressionist modernity seemed to disallow the kind of local aesthetic through which Hungary's future might be a renewal of its ethnic past. And it was mainly Hungary's Jewish bourgeoisie that drove the market for impressionist pictures in the years before World War One because those pictures enabled "Jewish art con-noisseurs to articulate their identification with their homeland but also to demonstrate that they were *au jour* with the modern Parisian taste."[15] Add to this complex context the fact that its critics were largely Jewish intellec-tuals, and Hungarian impressionism takes on a special character—a cer-tain cultural significance quite possibly behind Kontuly's peculiar version of it. The anti-impressionist Jewish intelligentsia felt the need for stable society governed by rules that could treat them fairly—nothing like the anarchy of impressions.[16] Hungarian impressionism was defined, then,

through a kind of infighting between cosmopolitan taste and national-
ist realism. For an artist like Kontuly, fifty years later, this mixed history
would have made impressionism a very meaningful point of reference:
a nation once resistant to the impressionist aesthetic now could use it,
insofar as that aesthetic could restart a Hungarian modernity in defense
against Soviet imperialism. In other words, the non-event of an impres-
sionism once lost to commerce and nationalism could now be repurposed
as a form of free-market cosmopolitanism, its imagery signifying a kind
of worldly insouciance. In small measure, of course, and weakly, but that
weakness is significant too. For it would have amounted to no small apol-
ogy for Kontuly's participation in the strong art of fascism. Although he
always spoke against any political use for art, he did win that gold medal
at the 1937 Paris World Exhibition, which was, as Karen Fiss has shown,
a playground for fascist collaboration.[17] Pseudo-impressionism was, ulti-
mately, a mode of wishful expiation.

Another way to make this case would be to contrast pseudo-impres-
sionism with the apparently more authentic movement dominant around
1960. If abstract expressionism was America's way of asserting its fully
energetic dominance of the art world, a belated impressionism could have
helped a migrant Hungarian artist to assert an alternative that questioned
the validity of any dominance at all. In a sense, to make this claim is to
return to the worst implications of pseudo-impressionism, but to redeem
them. The worst thing to say about Kontuly's pictures of the 1960s—what
was implied by my friend's dismissal of them—is that they are merely
opportunistic simulations, sadly artless versions of an art form that had
been important a century before. They are pseudo-art both for failing at
aesthetic contemporaneity and for failing even to achieve true impres-
sionist excellence. Even worse than just "selling out," Kontuly is guilty of
the deficiency attributed to this sort of thing more generally—amateur
art, mass-market landscapes, pictures meant for decoration, which out-
strip the problem of their commercialism with their essential failure as
art. If, however, the heedless pleasure involved in such cases has some le-
gitimate use as a corrective, in moments in which art's pseudo-conceptual
power has become all too dominant, pseudo-impressionism becomes
harder to dismiss. Amid mid-century sociopolitical repression, the weak
aestheticism of a belated, mitigated impressionism has a certain power;
in a different context, in a different fashion, Kontuly's late work finds the

right time for the impressionist effort to perform its uncertain combination of truth to life and good-for-nothing, and might be appreciated for its originality in this regard, especially if impressionism in Hungary had never really had a chance to assert the incipient challenges of its historical forms.

Pseudo-impressionism may well be little more than a mistake, a naïve production separate from progress or contemporaneity in the arts, only a sign of impressionism's irrelevance. Or worse, it may be opportunistic, a deliberate refusal of aesthetic, cultural, or social relevance chosen in order to profit by the public's easy preference for impressionistic imagery, and therefore a sign not just of inauthenticity but of impressionism's own unfortunate collusion with today's merely popular taste. Both of these negative views, however, raise further questions, with a force we might attribute to impressionism itself. Perhaps impressionism has its own kind of timeliness, essential to its version of the aesthetic. Perhaps the legacy of impressionism is to allow for a kind of co-optation that makes us question the nature and purpose of art itself. This legacy makes us attentive to the ways aesthetic relevance depends upon context—impressionism's antirealism has meant different things in different times and places—but it also suggests that the problem of impressionism has a special transhistorical effect, confusing categories that keep changing, giving it ever new opportunities.

One last thing must be said about Béla Kontuly, something about the irony of Hungarian pseudo-impressionism circa 1963. The year Kontuly painted our second still life was also the year that saw a general amnesty for political prisoners, and, in the same spirit, a start to a relaxation of official art policy in favor of renewed avant-gardism. The mitigated aesthetic progressivism we have attributed to his late work may not have been so timely after all. It could have become something more ambitious, perhaps, and this irony contributes yet another quality to Kontuly's impressionistic style of painting. If I had regarded it first with shame and then with something like pride in its peculiar claim to cultural significance, I have finally come to value its *pathos*—to feel for its layered traces of lost chances, which are not unlike those of my own family history. In some ways this pathos is like kitsch as pseudo-impressionism redefines it. Both are small consolation. But it is also an aesthetic feeling—a misplaced longing very much symptomatic of what impressionism itself has become.

LASTING IMPRESSIONS

Impressionism is everywhere. Its original imagery dominates blockbuster exhibitions as museums ceaselessly "crank out shows of impressionism as a form of fancy art sausage for the masses."[18] It also prevails among the new mass-market pictures and posters that decorate so many public and private spaces, with its "unique wide appeal and non-offensive nature," as well as the amateur painting leagues that constitute so much public art practice.[19] Because impressionism historically ramified across the arts into literature, film, and music, these arts also continue its legacy. It is still a dominant style of mainstream literary fiction, and much cinematic style is indistinguishable from its first impressionist innovations, despite technological change. Indeed, technology has only made life more impressionistic: much of what defines perception and information in new media environments—fleeting and fragmentary distractions, superficial and immediate quality—make impressionism more pervasive than ever. Impressionism is the folk art of modernity itself.

And yet impressionism is nowhere. Few major artists today would lay claim to it. Unlike other historical styles or movements that have been revived and reinvented, impressionism itself, despite its great influence and general dominance as a mode of perception and information, has no contemporary art world avatars. Those who invoke it do so at their peril. Peter Doig, for example, whose early work bore traces of the impressionist project and was explicitly indebted to the likes of Monet and Bonnard, has been successful only to the extent that he has been able to transcend, ironize, or brazen out this debt. If Doig credits Monet as a source for the pinkish snow of *Bob's House* (fig. I.10), he makes it clear that Monet is but a memory trace refracted through a set of transformative reconceptions.[20] By contrast, there is Thomas Kinkade, who has made an industry out of unreconstructed impressionism, characterized by sentimentalized color and light effects and touristic plein air improvisations. If Kinkade's *An Evening Out* (fig. I.11) also owes a debt to Monet's pinkish snow, honoring that debt with such fidelity means destroying the picture's status as art. The more directly Kinkade cites Monet, the more he sells, but the more he becomes a nonart problem. Of course, he also owes that status to unrestrained mass marketing, a factor that only sharpens the strange contrast between impressionism's ubiquity and its effective nonexistence.

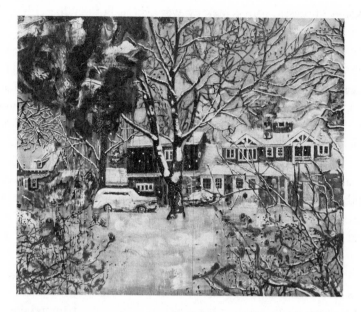

I.10 Peter Doig, *Bob's House*, 1992, oil on wood, 72 x 90 in.

I.11 Thomas Kinkade, *An Evening Out*, print, 21 x 26 in.

Kinkade's impressionism is literally everywhere, but that has only further guaranteed impressionism's art world erasure.

Kinkade's ubiquity suggests that impressionism survives as a kitsch aesthetic, even as it also survives in debates still animating art history, aesthetics, and art criticism. Impressions may have ended up highlighting paintings of snowy cottages in suburban American living rooms, but they have also made their way into the visual diversities of digital technology, the dispersions of edgy mediated imagery, and the circulatory dynamics of new image formats. In other words, impressions are now both nostalgically decorative and technologically radical. This combination corresponds to a set of related reversals all across contemporary culture. It animates a sense that first impressions at are times our best chance at insight and at other times "merely impressionistic." It confuses our feeling about the validity of "subjective" memoirs, the pleasures of glossy consumerism, the value of gut feelings. Impressionism's mixed legacy also characterizes works of contemporary literature still dedicated to its styles and themes, texts at once retrograde for their old-style modernist impressions but contemporary for impressionism's new relevance. Given this complexity and the way it undermines the very questions we would ask about it, how do we account for the afterlife of impressionism?

In its day, impressionism revolutionized the arts. Abandoned to the transient moment, immersed in the vivid appearance of life in process, impressionist vision changed aesthetic visuality, and along with it, perception itself. The immediate transitory glimpse—confirmed by vivacity, true for its subjectivity—became essential to human understanding in new ways. In pursuit of the impression, painting dissolved realism into a flux of glancing effects, transforming reality itself into whatever was true to the life of the moment. In literature, this new verisimilitude likewise traded narratorial fact for experiential feeling, objective reality for the consciousness of it, founding modern fiction on shifting, fragmentary, uncertain appearances and intuitions. Radical in its implications, indelible in its imagery, and magnetic in style, impressionism could only cast a long shadow; its willful rapidity, glamorous brio, and sheer modernity ensured a lasting influence. Although it was very much the art of its day and therefore quickly disclaimed, its avant-gardist charisma and restless mobility carried it forward into a perpetual series of reactions and rejoinders—very different movements unified in their debt to

what impressionism had begun. With postimpressionism and new social realisms, art and literature moved on, but impressions came along, still setting the terms of aesthetic engagement even as these movements gave way to cubist, filmic, and postmodern successors.

But such a far-reaching, diverse posterity can only be elusive. If the indomitable brio of the impression has ensured it a future in everything from analytic cubism to filmic mobility and mass-market decoration, from the sacred space of the museum blockbuster to the lawless exchange of instant information, its afterlives may hardly be distinct from contemporary life itself. And they become only more indistinctly ubiquitous if they are legacies of both the impression and impressionism—the form of perception and the art-historical movement. Surely a picture by Thomas Kinkade would seem to have little to do with contemporary theories of cognition, for example, in which the impression (rather than impressionism) exerts influence. But impressionism's most fundamental legacy is precisely this conflation of a perceptual category and an art movement. Impressionism depended upon the rhetoric of impressions to solidify into a historical phenomenon; impressions were in turn transformed by impressionism, their rhetoric forever after shaped by the cultural associations of the new painting, its imagery, and its ethos. The total result was not just a style or a movement or a theory but a new *mode*. Understood as structured by the rhetoric of impressions and most decisively instantiated by the watershed movement in painting, impressionism becomes a singular field of practice that includes such diverse variants as a picture by Thomas Kinkade and a crux in cognitive psychology.

Impressionism winnowed the basis of human understanding to its most minimal sources, not only staking art and knowledge upon mere impressions but also making the most valid judgments a function of the least origination. As the immediacy, fragility, or slightness of primary perception became the measure of truth, and as the haphazard contingency of life itself became definitive of it, impressionism entailed a transformative set of reversals. What had been true enough for empiricists and Romantics became a new cultural ethos as well as a new regime of sensibility in which appearances were reality, sensations were ideas, art was life, and the result was not just an exciting new way to paint or write. It was a provocation to envision—in all senses of that word—the *emergence* of human value from primary perception. For the impression implied that

the most minimal perception could emerge into meaning, value, or feeling precisely because of its minimality, which, in modernity, would strike up dynamic developments no fuller thing could muster. Had impressions merely been primary perceptions, they might have inspired only a limited kind of empirical craft or Romantic reaction. As forms of *emergence*, they provoked more lasting engagement and emerged into new generic configurations.

To paint or to write an impression, to see or read one, was to wonder at the eventual plenitude of something at first so partial—to wonder what, if anything, could make so simple a perception or presentation yield fuller forms of recognition. Such wonderment was pressing at impressionism's original historical moment, which famously saw the decline of systems of belief that could link the small to the great. Without backing in religious faith and the traditional social collective, perceptual emergence lost some momentum, and that drew further attention to its processes. The threat of no emergence at all—the isolation of physical experience from higher thinking, often seen to be the hallmark of modernity in the age of science, capitalism, and total war—compelled yet more attention to the possibility that impressions could be at once sudden perceptual events and fuller, lasting recognitions. In this historical moment, the brushstrokes that first declared the impressionist revolution stood out on the canvas. Even as they vividly reproduced immediate perceptual determinants, they could look like empty gestures; things composing a scene could look like heedless output. Viewers naturally puzzled over these marks, much the way they wondered whether the impressionist picture was meant to convey a personal view (the artist's idiosyncratic personal impression) or an objectively scientific trace of scenic data. These uncertainties were essential to the meaning of the pictures produced in the 1870s because they took part in narratives about changing relationships between individual freedom and state power. In the aftermath of the Franco-Prussian War and the Paris Commune, conflicts among radical, bourgeois, and aristocratic claims to authority proposed different possible stories about the meaning of the free subjective gesture. As we will see, impressions were a political crux, and how to read them was a fraught question. Likewise in literature, Joseph Conrad's impressions had a questionable breadth. In his essays, he claims that a writer's personal sensations can be the basis for sympathetic public fellowship. We all share the same core of responsive feelings, Con-

rad says, and impressionistic writing can provoke them, thereby creating human sympathy. But his fiction tells the rest of the story, showing what happens when responsive feelings conflict—when impressionist fellow feeling breaks down and yields skepticism instead of sympathy, when racial difference makes impressions all too personal and all too much a factor in racist inhumanity.

The promise of instantaneously total perception provoked faith and doubt, experiential conviction along with aversion to perception's basis in unaccountable, primal, merely sensory experience. Not new to public discourse, this ambivalence became a new kind of subtext within the impressionist artwork. In many cases, it produced thematic content, in images or stories of dynamic or agonistic relations among basic and elevated forms of cultural experience. In other cases, it became an engine for narrative not just within but around the artwork, most famously in postimpressionism's way of making the problem of the impression apparent reason to reject it. These enlargements of scope are definitive. Strictly speaking, impressionism was a late-nineteenth-century period style of art dedicated to capturing the fleeting effects of subjective perceptual experience, the look and feel of everyday modern life as it struck the openly observing eye. Essentially, it is at work when quick, vivid, fragmentary perception achieves verisimilitude—and compels belief—by matching representation to subjective process. For this reason we define it as a bridge from representational to aesthetic regimes of art, historically located by the way Parisian modernity was also such a bridge between governmental and idiosyncratic realities. As a mode, however, impressionism develops when its basic phenomenological dynamic takes on thematic resonance, in everything from unstable pictorialism (where vivid, fragmentary brushstrokes half stray from verisimilitude) to narrative and historical elaborations within and beyond the work of art. At times, conviction that impressions should compel belief lends dramatic resonance to the oneness of primordial perception and strong, robust thoughts and feelings: pictures and texts alike at times feature optimistic composition of this essentially aesthetic totality. But regretful efforts to distinguish true ideas from basic perceptions, to guard belief from hasty conviction and distinguish true aesthetic unity from serendipitous pleasure, might frame a far less optimistic thematic. Or they might motivate the history of art to reconfigure the terms of unity proposed and defeated by the problem of

the impression. Or all of this at once: broadly conceived, impressionism pluralizes its perceptual, thematic, and historical forms of self-reflection. What consistently asserts itself, however, is the problem of emergence. The impressionist mode asserts that aesthetic and cultural value emerges most forcefully from the least likely sources, and so the whole possibility of emergence—of the further development of primary perception— becomes its central obsession.

Its plurality must always undermine any effort to explain impressionism philosophically, or in terms of the aesthetic and cultural explanations it might seem to invite. If it seems to center around a post-Kantian or Hegelian aestheticism, its internal indecision prompts very variable dialectics. If its variations are all in Humean empiricism alone, it can involve an idealist disposition compatible with that of Hume's successors, or an entirely different sense of the role of affect in the feeling of verisimilitude. Culturally, impressionism is a variety of late-nineteenth-century aestheticism but also a naturalist phenomenon, describable in terms of these different ways of staging the relationship between art and life. Even within its aestheticism there is ambivalence; self-doubts would seem to compel conflicting theorizations—at times, something like Jacques Rancière's version of *aisthesis* (and its sense of the relationship between the sensible and the political), and at other times, something more like Peter Osborne's very different sense of art's minimal dependence upon its sensible substrate. These conflicting possibilities for explanatory context suggest that theoretical conflict is itself the right context: impressionism as a mode performs in praxis theoretical uncertainty about the scandal of aesthetic perception. Impressionism's variants may be helpfully explained through reference to Rancière or Osborne as well as Georg Lukács, Claude Lévi-Strauss, Gilles Deleuze, Jonathan Crary, Max Saunders, and others, but no single framework encompasses them all, not because impressionism is no coherent object of inquiry, but because it varies in practice much the way theorists differ within aesthetic discourse. This is a problem, certainly, and perpetually a reason impressionism gets the better of critical inquiry. But it is also what makes impressionism a living mode and a very contemporary concern.

For nothing could be more contemporary. Ambivalent commitment to primary, immediate information and its thematic elaboration are everywhere. The effects of new media on human attention, the costs and ben-

efits of technologically abbreviated cognition, the status of new forms of pleasurable immersion, the questionable efficiency of digitized condensation: these things are new contexts for the mode of aesthetic engagement innovated around the impression. This book traces that mode from historical impressionism to the forms of discourse and visuality that embody our contemporary version of it. The premise is that to identify contemporary forms of impressionism is to bring to bear upon them insight developed through long-term engagement with the fraught possibility of perceptual emergence. At the same time, however, it is to discover what has become of impressionism as it has persisted as a cultural mode. Our dizzied images and snap judgments look different in the context of a historical project that found so much meaning, value, pleasure, and danger in its impressions. But today's impressions transform that history, for impressionism's persistence has brought it to fuller realization; more than "lasting," it has come into its own, perhaps, well beyond its historical moment. This book has a double objective. It seeks to explain what really makes contemporary culture impressionistic, but it also seeks to redefine impressionism in terms of its fuller life as a transhistorical mode.

That fuller life is full indeed: so much might compose it. What are the best examples? A twenty-first-century painting that looks like a Monet is surely not very true to it, since to paint like Monet today may be to avoid rather than to confront the problem of what the impression has become. An homage to Virginia Woolf may amount to an inadvertent parody of her style, if it applies that style to settled matters of cultural privilege rather than open questions of being. That is, her proper legacy may be found less in nicely stylized interiority than in edgy new media "moments of being"—epiphanic recognitions achieved through forms of engagement Woolf herself never anticipated. Sometimes impressionism persists through the continued influence of its signature forms of painting, writing, and film. Sometimes its persistence depends upon transmedial migration and a remediation of its original perceptual habits. And neither is necessarily most valuable: just as much as any authentically contemporary impressionism, an inadvertent parody of Virginia Woolf or a kitsch painting by Thomas Kinkade is very much a meaningful phenomenon in this context. In fact, the best examples, finally, are the unlikely ones—or, rather, those that perform strange variations while still claiming some debt to impressionism itself. A straightforward influence

study or reception history would have to neglect impressionism's living posterity. But many of its living legacies lack the sort of explicit linkages necessary to valid genealogy. And so this book accounts for impressionism in terms of explicit variations that are also telling departures, strange outcomes that are also recognizable offspring, in the hope that they will be the best basis for explaining how and why impressions have had such lasting power.

IMPRESSIONISM NOW

Only in mainstream literary fiction does impressionism persist with cultural authority in more or less the same forms used by the original practitioners. Contemporary writers still write much the way Proust, Conrad, and Woolf did, despite the differences history and context have made to the projects they pursue. Moreover, the literary establishment constituted by prestige publishers and other institutional arbiters still defines successful representation in terms set by the historical impressionists. Of course, any number of subsequent developments did transform fiction—social realism, existentialism, postmodernism, and postcolonial projects broke with modernist subjectivity in many ways—but modernist subjectivity as defined specifically by impressionism has survived those trends to occupy a secure place at the technical and thematic core of literary fiction.

For that reason, contemporary fiction is a symptomatic register of impressionism's persistence, not just in general, but in all its variety. Literary impressionism today is a belated recurrence as well as a living force; impressions in literature are at once a vestigial element and a timely dynamic—a kitsch throwback and a medium of contemporaneity itself. This introduction will now turn to two examples of this persistence, two high-profile works of literary fiction that raise a host of fundamental questions: David Mitchell's *The Thousand Autumns of Jacob de Zoet* (2010) and Zadie Smith's *NW* (2012).

Mitchell's *Thousand Autumns* is set in 1799 in Dejima, a man-made island in Nagasaki Harbor. The island is the site for trade with the West; away from the mainland, it keeps foreigners at a distance from Japan itself. The novel's protagonist, Jacob, has come to work for the Dutch East

India Company, and he is an honest man caught up in the complexities of contact between ambitious imperial powers. Rules of decorum, systems of privilege, and ultimately extreme corruption make Jacob's story one of endless cultural, ethical, and narratorial intricacy. But despite these complexities, the novel begins with no narratorial context. No historical explanation offers any framework for the first scene, in which the midwife Orito saves the life of a magistrate's child. The scene is implicitly determined by elaborate histories and power relationships that go unexplained. Everything in the opening is focalized from the midwife's point of view, which channels momentary observations and fragmentary consciousness of current demands, remembered wisdom, and personal anxiety. This choice raises a question: Why would a novel located in such singular territory risk such a minimally informative, momentary, haphazard beginning?

Why, in other words, would this sort of contemporary novel take the risk of impressionism? The answer is in the reality effect achieved by the radically subjective, incomplete, dynamic impressions offered in the place of objective narratorial facts. Mitchell has instantly created an immersive, affectively rich register that gives his story vivacity and verisimilitude. The facts, when they come, will have far greater meaning for having been grounded in such a keen sense of their practical context. The facts of life on Dejima are hardly straightforward, so Orito's impressions are true to a situation in which everything is subject to momentary definition. Their immediacy is supremely valid, and it justifies what many critics have praised in the vivid, vital, vibrant style Mitchell has chosen.[21] Even so, the question still stands, because Mitchell has made use of techniques that presume a certain everyday universality of experience. To give only impressions of a scene is to imply that we all might infer its significance from them. But can conventional inference bring late eighteenth-century Japan to a twenty-first-century Western reader? If not, is the consequent bewilderment a thematic advantage to Mitchell's novel? Bewilderment could be the desired effect of a skeptical impressionism, through which Orito's subjective confusion matches the problem of understanding her world. But Orito knows quite well what is going on. It is only her current impressions that exclude fuller knowledge. Do they do so for good reasons? Is Mitchell's impressionism thematically necessary, or is it possibly a default, routine style, a merely conventional survival of impressionist rendering into a

scene where it does more harm than good? Does impressionism serve the purposes of this novel in its contemporaneity, or is it here perhaps a kind of pastiche, patched in for its traditional association with literary distinction, its standard implication of aesthetic value?

These questions match larger ones about impressionism today. If it is a holdover that sanctions flimsy attention in a cultural moment already given to distraction and heedlessness, it may be a problem, and an ideological one, given the sort of cultural blindness it aestheticizes in this instance. And here we arrive at a major reason to be suspicious: whereas impressionism originally freed up a culture bound to academic, authoritative, steady ways of seeing, today it might only dignify a culture that has exceeded such freedoms to a reckless degree. But if by contrast it enables a provocative, exciting enactment of cross-cultural negotiation, it has enhanced historical impressionism in such a way as to make it a resource for a very contemporary project—the tracing of the global networks that structure the circulation of culture.

Subsequent descriptions in *The Thousand Autumns* multiply such questions about impressionism's contemporary validity. When Mitchell sets a scene, he gives short, evocative glimpses of landscapes, interiors, and social life. He has a tendency toward single-sentence-paragraph scenery; one minimal element of the spatial environment stands for the whole. "In the after-dinner half-dark, swallows stream along Seawall Lane, and Jacob finds Ogawa Uzaemon at his side": this sort of brief, marginal, but highly motivated descriptive style conjures an instant image, making the force of instantaneity a force for vivacity.[22] Similarly, another initial description channels its impressions' energy into narratorial verve: "The three bronze booms of the bell of the first cause reverberate over the roofs, dislodge pigeons, chase echoes around the cloisters, sluice under the door of the newest sister's cell, and find Orito."[23] Here, sensory impressions initiate the action precisely because they are so actively intense, and they perform what would seem to be a redoubled and renewed form of impressionist alacrity. But once again impressionism's legacy is doubtful. Do these economical impressions compress description into more highly effective, efficient enactments of what it takes to imagine a landscape, or do they trade true worlds for merely charming fragments, only standing in for the fuller descriptions necessary to give context to character and culture? Perfectly poised and artfully evocative, Mitchell's impressions can seem

like decorative embellishments, and at times they read like the scene settings indicated in a screenplay, economical not for heightened effect but because they only defer to the work of cinematography. Do Mitchell's impressionistic descriptions take part in his scenes or only barely indicate imaginative work they should do more fully? Are they rote grace notes, or even a sign that fiction now defers its work to our filmic collective consciousness—and therefore a confession of impressionism's obsolescence?

If Mitchell has brought impressionism to new heights—applying it to global projects, intensifying its descriptive power—then *The Thousand Autumns* exemplifies the contemporary renaissance of this mode. It might guide recognition of the comparable impressions at work in new media, transnational environments. Their thematic resonance and motivated contingency might model new links between mere impressions and wider worlds of inquiry and transparency. If Mitchell's impressionism is instead a vestigial, convenient, conventional shorthand for immersion and immediacy, demonstrating a belated aesthetic or a very late style, it may only reflect what undermines cross-cultural insight and rich phenomenal engagement in the world today. Literally reductive, his impressions would then be a continuance of something more simply impressionistic, and an example of the way impressionism has tapered off into the most minimal version of itself. Which could, of course, have virtues of its own, its immersions and immediacy only more highly effective registers of identification and pleasure—all the more so for being mere impressions. Mitchell's various possible impressionisms reflect a range of legacies subject to multiple possible forms of evaluation.

So fully does Zadie Smith's *NW* recall the styles and thematic interests of impressionist fiction that it might seem to be a throwback.[24] Its highly focalized inchoate responses to a world dangerously in flux could be those of many a high-modernist psychological novel. What accounts for this apparently derivative performance? Any answer to this question must consider the relative originality of the novel's central section, "host," a 100-page compendium of numbered and titled sections documenting, in fragmentary fashion, significant moments in the lives of the novel's two protagonists. Leah and Natalie have grown up together in Northwest London, and the doubtful condition of the lives they have wrestled out of the neighborhood's social confusion gets represented in peculiar ways as the novel shifts from a familiar impressionist register (that of a fluid narrated

monologue) to that of the central section. Here, memories take shape into chunks of labeled, minimal, and momentary recall, each summed up not only in its title but also in a suggestive sense of its significance. Numbered and categorized, these moments seem too systematic to be impressions, until it becomes clear that their coherence is less a product of authorial objectivity than an effect of the information environment now shaping our minds and lives. Smith's characters have become vulnerable to mediated forms of self-fashioning, and therefore the novel's central section makes their impressions methodical, formatted, and mediatized. Such hybrid representations—ephemeral recollections organized into progressive units of information—are consistent with those that originally enabled modernist writers to register the perceptual process of the day. Those too had borrowed their structure from context, albeit an urban, wartime, or colonial one. Updating impressionism for the digital age, Smith actually refits it for our moment; advancing the impression into new territory restores its power while realizing it in new ways. If this is so, what does *NW* tell us about impressionism—and what does it suggest about the contemporary mediated mind? Is the novel satirical, written in the spirit of the skeptical impressionism that once regretted the bad effect of modernity on mental life, or is it a positive enactment of mental remediation? Is Smith warning against the impressionistic habits of mind shaped by information media, or does she demonstrate just how much those habits structure rich insight?

Raising these questions, *NW* asserts impressionism's contemporaneity. Indicating how its heritage might help frame questions about our cultural present, Smith's novel exemplifies the evolving critical purchase of the lasting impression. At the same time, it suggests that impressions hardly had a chance to realize their critical and cultural potential in their first historical moment as part of an aesthetic mode—that "lasting" has meant awaiting fuller cultural fulfillment, in the manner of the Hungarian impressionism innovated by Béla Kontuly.

NW represents a possibility we will now follow from its first historical instance through its evolution to today. From the dynamic "dual nature" of the original impressionist brushstroke, we will move to the rapid-fire distractions of advertising and the ambiguities of filmic *photogénie*. We will study the form in which impressionism survives the challenges of social realism, and how its fraudulence by any realist measure has actu-

ally been a valid invention in performance art, high finance, and memoir. When we arrive back at contemporary fiction and painting, we will have defined a mode in which impressionistic styles, thematics, traditions, and theoretical implications compose different possible registers for aesthetic experience today. In some of these cases, what is *merely* impressionistic reflects faults in the mode and the culture alike. But mere impressionism can also be a good thing, and what is apparently better can sometimes be a merely vestigial impressionism not at all indicative of a contemporary project. For that is the goal: to discover how impressions continue to be the focus for aesthetic experience that is also a forum for speculation about the emergence of what we value from what we momentarily and incompletely perceive.

We begin with a return to the original scene of impressionism, to rethink its fundamental "dual nature." From the start and to the present moment of critical inquiry into the nature of impressionist painting, impressions have been seen to have a core duality, elaborated, practiced, and theorized in many different ways. Chapter 1 proposes that we understand this duality pragmatically as a narrative function, and, in turn, a principal feature of the impressionist mode. Duality allows this mode to include the relationship between impressionism and postimpressionism, making the storied conflict between them an internal motivation, which then characterizes critical developments that continue in literature, film, and music up to the present day. This chapter also discusses the variant that begins at Giverny: from the leisured arts colony that grew up around Monet to the tourist site of his house and gardens, impressionism has also been a decorative pleasure, just as present to us as any more critical function. Chapter 2 takes a more skeptical view of this reversal to wonder whether impressionism has given us modern advertising. In the quick-cut, rapid-fire imagery of the advertisement, impressions are perhaps at their most superficial, their deceptive worst. Classic critiques of the culture industry attribute advertising's pernicious effects to something very much like the form of distraction characteristic of the impression. But those critiques also suggest how to consider the impression's distraction in relation to real attention, and chapter 2 argues that advertising involves yet another variation on the impression's dual nature: a dynamic relationship between distraction and attention, which, in this context, indicates surprising ways to rethink culture-industry perceptual management. The

film advertisements of Len Lye are the focus of the chapter's argument, but film becomes a different focus for chapter 3. Whereas impressionism is a force for fragmentation in the distractions of advertising, it unifies the film image in the magic of *photogénie*. Chapter 3 explains why theorists and practitioners of French impressionist cinema needed *photogénie* to accomplish the emergence of film art from camera mechanics—and why that emergence was, for better and for worse, an avatar of the impression.

Chapter 4 wonders what impressionism could persist in African fiction following Chinua Achebe's epochal denunciation of Joseph Conrad. Decrying Conrad's racism, Achebe also rejected the impressionist form that allowed it to flourish unacknowledged. That form subsequently became invalid for writers who shared Achebe's project—those involved in his fraction of African letters and those with postcolonial objectives more generally. But it was institutional backing in the colonial university that set impressionism against the postcolonial. Other writers not subject to its curriculum maintained impressionism despite Achebe, and in the work of the contemporary novelist Chimamanda Ngozi Adichie we see one result: a postcolonial impressionism. In chapter 5, Achebe's problem becomes something even more fundamental: the possibility that the impression's ambiguities are a function of an essential trickster tendency that throws everything into doubt. Three versions of impressionist fraud come under scrutiny: the "happenings" of the artist Yves Klein, which were styled as latter-day elaborations of impressionist sensibility; the financial malfeasance of Ryoei Saito, who was one of the Japanese businessmen responsible for the Japanese impressionism bubble of the late 1980s; and the lies of James Frey, the writer whose notoriously "subjective" memoir, *A Million Little Pieces* (2003), has given impressionistic truth such a bad name. These three tricksters seem to exemplify fundamental illegitimacy in the aesthetics they exploit, but they may also justify it, and chapter 5 explores the possibility that fraud is but the leading edge of something more essential to cultural vitality.

Chapter 6 contrasts the two very different painters we have briefly compared: Peter Doig, the celebrated contemporary artist, and Thomas Kinkade, the commercial "painter of light." Both have impressionist backgrounds and styles, and the great difference between them becomes an opportunity to speculate about that which must always haunt impressionism's contemporaneity: the problem of kitsch. Kinkade would seem

to represent what is wrong with keeping impressionism alive—pseudo-impressionism—but inquiry into his kitsch aesthetic actually leads back to Doig, and to greater insight into what pseudo-impressionism might mean both for the kind of postconceptual aesthetic he represents and for kitsch, which now emerges as a valuable minimalist aesthetic. A similar reversal is important to chapter 7. Here, we come to the problem of pseudo-impressionism in literature, and the possibility that contemporary writers who deliberately place themselves in this tradition achieve only a belated or failed version of their precursors' achievement. W. G. Sebald, Michael Cunningham, and Colm Tóibín have all written novels dedicated to projects first pursued respectively by Marcel Proust, Virginia Woolf, and Henry James. To the extent that they simply repeat their predecessors, they too seem to risk a kitsch aesthetic, perhaps only to claim a prestige lost with the end of modernism. But the postconceptual impressionism innovated by Doig is at work here as well, in a form of contemporary engagement that demonstrates how epistemological ambiguities reassert a minor value after postmodernism. That reassertion, however, is not the last word about contemporary impressionist fiction, because chapter 8 discovers it at work in another field: that of "popular cognition," the version of pop psychology that has captured public attention in recent years. Malcolm Gladwell, Daniel Kahneman, Jonah Lehrer, and others have developed a new form of self-help advice on profitable thinking—a genre of business book—out of what is really an impressionist fiction about the relationship between instant recognition and better judgment. A rhetorical reading of their work identifies what may be the most pervasive way impressions have lasted into contemporary culture.

This book's conclusion returns to Mitchell and Smith to see how impressionism in film, advertising, and popular cognition, its kitsch fraudulence as well as its postconceptual, very contemporary relevance, explain what impressions mean to culture today. The hope is that broad exploration of impressionism's legacies will have identified a way to explain why, and with what effect, impressionism gets written today, and more generally, how that prevalence in literature relates to contemporary cultures in which the incipient modernity of the impression yet has its role to play in persistent projects still determined by modernity as impressionism defined it. The continuities that motivate Mitchell and Smith in these projects are a telling feature of the persistent claim of modernity upon

aesthetic and cultural impulses and values, which has lately been prompting many of us to rethink the longer history of the developments that have shaped our age. If impressionism does and does not survive, in original and in modified forms, it does what modernity itself has been seen to do in current debates about its larger project. Lasting impressions, then, will prove to have real currency, whatever their value, all the more for their mere modernity alone.

1

FIRST AND LASTING

Histories for the *Tache*

FROM FIRST TO LASTING: THE DUAL IMPRESSION

At first, painting *impressions* seemed absurd, but soon it taught the world that trick of the eye, so pleasing forever since, by which haphazard spots of paint launch matchless verisimilitude. At the First Impressionist Exhibition in 1874, Claude Monet's *Impression, soleil levant* (fig. 1.1) famously provoked satire from Louis Leroy, who coined the term "Impressionniste" to attack the apparent incompetence of Monet's depictions. But soon enough, the public saw reality there.[1] Leroy may have described Camille Pissarro's *Gelée blanche* as nothing but palette scrapings on a dirty canvas—a "funny impression" overall—but Ernest Chesneau could argue that when seen at a distance, the "indecipherable chaos of palette scrapings" of Manet became "the elusive, fugitive instantaneity of movement . . . captured and fixed in its tremendous fluidity."[2] The title of Paul Cézanne's *Étude: Paysage à Auvers* (fig. 1.2)—another picture shown at the first exhibition—indicates the project supporters would soon promote: whereas *études* had once been preparatory work only, here they became central to the project of showing life itself in process.[3] Even pictures with sentimental content could be valued for their new realism: Berthe Morisot's *Cache-cache* depicts mother and child at play, but also, as one contemporary noted of her work more generally, the "observed and living reality" of this domestic ideal.[4] Impressionism "recreated nature touch by

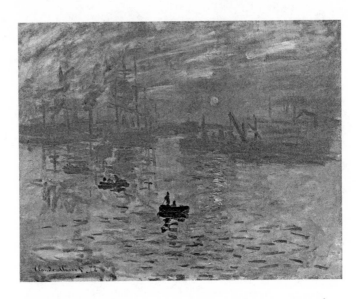

1.1 Claude Monet (1840–1926), *Impression, soleil levant,* 1872, oil on canvas, 48 x 63 cm., *Impression: Sunrise,* 1872 (oil on canvas), Monet, Claude (1840–1926)

Musée Marmottan Monet, Paris, France/Bridgeman Images

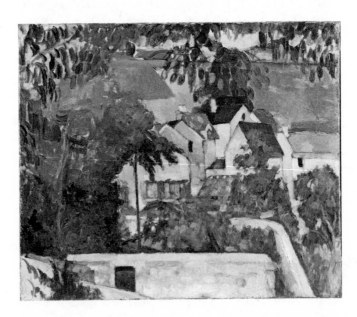

1.2 Paul Cézanne (1839–1906), *Étude: Paysage à Auvers; Quartier Four, Auvers-sur-Oise* [*Landscape, Auvers*], c. 1873, oil on canvas, 18¼ x 21¾ in. (46.3 x 55.2 cm.), The Samuel S. White 3rd and Vera White Collection, 1967, Philadelphia Museum of Art

Photo: The Philadelphia Museum of Art/Art Resource, NY

touch"; Mallarmé's assessment would become a common view of the way impressions enabled fresh and true observation of natural reality, their spontaneous brushstrokes equal to the very impulse by which natural light reaches the innocent eye.[5]

To look again, however, was to see something else entirely. As much as that brushstroke—the impressionist touch or *tache*; the spot, the smudge—could simulate something real, it also expressed the artist's individual personality. Whereas Monet's *soleil levant* was the color and light of an actual sunrise, it somehow also embodied the subjective self with which Monet depicted it. Cézanne's vision of Auvers in process was obviously uniquely his, whoever he was—squared off in signature style with his special *passage*. Morisot actually "had no illusions of recording some immutable 'reality' available to the eye," as Anne Higonnet notes, and her images clearly "reflected her individual perceptions and their stylistic translation."[6] What looked so real became valuable also for the way it could embody an artist's own sensibility.

Such was the "dual nature" of impressionism, which, as Stephen Eisenman, Richard Shiff, Richard Brettell, Norma Broude, and others now remind us, divided definitions from the very start.[7] Thus Théodore Duret could say of Manet, "he brings back from the vision he casts on things an impression truly his own," identifying in prepositional convolution what were really distinct activities.[8] When Mallarmé credits the impression with "an original and exact perception," he calls the impressionist work at once a product of the innocent eye and "a new creation of the mind," recognizing its double venture of natural exactitude and artistic originality, of sensation and creation.[9] Edmond Duranty too saw "acuity of observation, as well as the most delicate and intense feeling" at work in the impressionist brushstroke.[10] Despite the standard view, first offered most notably by Félix Fénéon and often still dominant, "impression" did not intend only objective sight but subjectivity, a duality of real seeing and personal vision. Related dualities followed, as impressionism could seem to deliver appearance or reality; to require innocence or sophistication; to favor life or art, the natural or the aesthetic.

Even if such dualities are essential to aesthetic perception, and even if they are always at work in the practice of representation, impressionism gave them new focus and a modern project, raising questions no consensus has answered: How could Monet and Pissarro really seem at once to

favor the results of natural objectivity and personal, subjective, idiosyncratic self-expression? How could these artists be seen, understood, and valued both ways at once?

These familiar questions arise compulsively all across the arts of impressionism. The English writer and critic Walter Pater, wondering about impressions of his own around 1874, also defined them as at once an empirical index and a venture of sensibility, properties of the object "pressing upon us with a sharp and importunate reality" but transformed by consciousness into "its own dream of a world."[11] A forerunner of impressionism in literature, Pater helped to define it as a highly personal mode with new claims to larger validity. Ford Madox Ford's essays on literary impressionism make the duality even more explicit. Ford claims that the impression entails an escape from personality for the writer wishing to render real-world truths. But Ford also admits that his mode of writing must be a "frank expression of personality," since its yielding of individual selfhood happens only according to the sensitivity of the individual temperament.[12] As we have seen, Joseph Conrad likewise located impressionism in a writer's "secret spring of responsive emotions" but contended that these were universal in such a way as to make a writer's individual self-expression a matter of public consensus.[13] What begins as individual subjective response proves to be something everyone can share, and, by sharing it, achieve public solidarity. Something surprisingly similar creates confusion about the nature of impressionist music. If Debussy, for example, was an impressionist—the designation has always been controversial—it was because he "tries to create an impression analogous to the one produced by a nonmusical phenomenon or by any phenomenon of the senses" and because of his music's own suggestive emotion.[14] Something referential remains even as Debussy dissolves conventional forms into elusive expression. In film, impressionist *photogénie* is that magical juncture of the real and the ideal—of the profilmic object and its cinematic transformation—so important to the justification of early cinema in the 1910s and 1920s.

What was similar across the arts, however, has defined impressionism in very different ways. Impressionist duality has taken many forms. As we will see, sometimes the duality is but a *sequence* of steps in the process by which art gets made, easy enough to resolve in practice. Natural impressions strike the artist, then inspired to respond with equal power;

receptivity enables expressivity. If not a sequence, duality can become a *contradiction* important to impressionism's response to the crisis of modernity, its self-division matching that of the modern subject. When the contradiction is resolved through art, impressionism presents a *paradox* important to a kind of utopian aesthetic, for better and for worse. When the contradiction cannot be resolved, it produces *irony*, and impressionism devolves into alienation. But it might become sequential in a new way and strike the compromise of *dialectic*, in which opposites alternate to energize a text, a picture, or the history of art. At its most effective, that dialectic becomes *performative*, simulating its transformations for public use.

By 1927, Virginia Woolf could write an impressionist novel in which a philosopher's problem with "subject and object and the nature of reality" is all too familiar: *To the Lighthouse* is aware that it might founder upon an old contradiction in the nature of things, and the belated paradox that results is essential to the novel's aesthetic modernity.[15] Jules Laforgue had thought as early as 1883 that impressionism occurred in these paradoxical "flashes of identity between subject and object," and in Richard Shiff's gloss on this view, impressions are "the moment at which subject and object are one."[16] For Richard Brettell, "The work is at once objective and subjective, as if it is an impression not on the eye, but on the mind of the artist"; for James Henry Rubin, the impressionist brushstroke "combines both the external world and the artist's individual vision of it—the objective and the subjective simultaneously."[17] "Subjective objectivity" is the term H. Peter Stowell has coined to explain this impressionist synthesis in literature, and other critics have likened it to the unifying acts of *aesthesis* puzzled over for centuries by thinkers from Baumgarten to Rancière.[18]

The most celebratory version of this synthesis endows it with utopian potential to undo the alienating effects of modernity. Less celebratory versions establish different legacies. Some stress the historical circumstances necessary to make it seem possible—how, for example, the 1870s credited the artist with an "authenticity" or "sincerity" that undid any difference between personal expression and public truth.[19] And other accounts stress the ruse involved in any such fantasy: for Georg Lukács and Fredric Jameson, such a synthesis was a specious distraction, a seductive inverse of what Lukács called the "concrete typicality" art ought to entail, or (for Jameson) a questionable "compensation" for capitalist reification.[20]

The reality was more ironic, and indeed impressions often seem to raise hopes only to dash them, confirming alienation, solipsism, and irremediable difference—for example, in much impressionist fiction, when the truth behind appearances comes out. Insofar as the outcome is instructive, however, the irony can have its own kind of truth, as it does for T. J. Clark. In his account of the "painting of modernity," Clark finds that impressionism only embodies ironies essential to modernity itself, offering critical purchase upon them as it "enforces distinctions and disparities."[21] And irony has a similar function in accounts of impressionism as a kind of proto-deconstructionist, pre-postmodern project: John Carlos Rowe, for example, argues that Henry James's impressions never register the world immediately but instead stress the priority of language, so that their failed synthesis registers another truth. Similarly, Daniel Hannah stresses the "marginal detachment" James learned from the impressionist painters and their "ambivalent play with the spectacular logic of the Parisian scene."[22] Not full, immediate insight but ironic mediation becomes impressionism's means of longer survival.[23]

The impression's binarisms, then, may seem to fuse or to part. If they do both at once, they enter into a dialectical relationship. In Stephen Eisenman's account, it was productive conflict between realist and idealist motives that originally energized the impressionist project. At first, in the 1860s and 1870s, the painters were two things at the same time: "intransigents" for their radical politics and the searching realism it entailed and "impressionists" because they were "affirmative and individualistic," given to a subjective aestheticism that could transcend politics.[24] For a time, both identities flourished in relation to each other. "The essence of the new art was its insistent indeterminacy," which was "a signal instance of Modernist dialectics."[25] This dialectic was short-lived. The "burial of the Intransigent and the birth of the Impressionist" put an end to this version of the duality that had been so productive. But it might have lasted longer than Eisenman allows, insofar as it was a kind of performance built into the pictures themselves. This insistent indeterminacy was, in some accounts, enacted in the facture of the impressionists' very artwork. Richard Brettell argues that the "performative verve" essential to "painting quickly" is a perpetual dialectic: we "seem to be in the presence of an artist who is improvising the picture as he paints, who derives stimulus from nature, but who clearly communicates the results of that stimulus in

a direct, gesturally positive way."[26] Nature and artist are together an improvisatory presence, performing their relationship. James Henry Rubin sees something more specific in this performance: a reassuring simulation of human labor. Impressionism "combines both the external world and the artist's individual vision of it" in a "doubly indexical" impression, but by performing the work of this combination: impressions "acted out the instrumentality in modernity's imposition of change upon its environment," but counteractively, as if it were a human development, the constructive labor of the artist. To see impressions doubly was to witness human agency—perhaps the most affirmative thing this duality could signify.[27]

It signified in these many patterns of sequence, contradiction, and paradox; of irony, dialectic, and performance. All of these dynamics have characterized the impression's dual nature, making it extravagantly meaningful, and sometimes working together to develop elaborate structures of engagement. Taken together, they compose what has made impressionism so significant and such a persistent phenomenon: its abundant *antinarrativity*. The many versions of its duality make the impression a dynamic engine of explication, so dynamic that it provokes different, often competing stories at once. To determine the relations in its oppositions is to try and try again to grasp the narrative that would relate them, with results we might understand in terms of antinarrative composition. But they might not have developed such compelling antinarrativity had they not been given such a mixed visual identity—had they not been embodied, figurally and literally, in the notorious impressionist brushstroke. It was certainly not the main thing about impressionism—not its critical contribution to art, to modernity, or any individual career—but the *tache* localized the dual impression in such a way as to secure it a lasting place in the cultural imagination.

HISTORIES FOR THE *TACHE*

After decades of vital contextual work, scholars who have recently redirected attention to the substance of the paintings have shown that the impressionist *tache* itself signified in complex ways.[28] Most striking was

the provocative combination of its own objecthood and its claim to iden-
tity with the object world: the thickly visible brushstroke had a surprising
correspondence to something seen. In other words, impressionist duality
is figured here, with charismatic provocation, and, as we will see, the sheer
visibility necessary to lasting influence. Brettell notes that this combina-
tion of the "calligraphic and representational" enabled the *tache* to make
"technical virtuosity" referential; its very "rapidity of execution" signified
at once a willful aesthetic and life itself, in the double meaning of the
painterly gesture.[29] And such combinations redoubled as the *tache* took
up different positions in the further sequence of events by which painting
at once asserted correspondence and coherence. House notes that the first
impressionist exhibitions saw the fuller advent of this combination as the
tache made a shift "from a relatively impersonal representational short-
hand to distinctively personalized—and sometimes virtuoso—'signature
styles.'"[30] The difference itself was emphasized and made apparent by the
way the pictures were displayed. Monet's *Impression, soleil levant*, for
example, was originally juxtaposed with another, more finished view of
Le Havre, and "this dichotomy was presented as part of the impression-
ist programme from the start."[31] Showing process—also in the *esquisses*
and *pochades* representing other stages of completion—these paintings
stressed the aesthetic variability of the *tache*, its differential virtuosities.
Once the differences emerged, what had first looked like a piece of nature
could look like art's very signature, or nothing at all, and the *tache* could
summarize a wide array of possibilities: radically material unity with the
object world; such unity, but enabled dualistically by the gesture, to dif-
ferent degrees of virtuoso self-expression; self-expression matching the
object world only for energy, or acting on its own terms to transform
the world—naturally, or with enough of an aesthetic departure to leave
the object world entirely. In the *tache*, then, the "dual nature" of impres-
sionism becomes an abundant source of significance.

Of course, art historians have long provided terms for this kind of di-
versity—or, to borrow a term from Gestalt psychology, "multistability"—
in the experience of the marked surface of a picture. In E. H. Gombrich's
foundational account, a picture is seen for both its surface markings and
its representational content. Gombrich argues for a duality: we cannot
see both ways at once, and a representational illusion develops as we split
the difference. We engage in "seeing-as," and seeing one thing for another

develops the mimetic effect.[32] By contrast, Richard Wollheim argues that this "twofoldness" is necessarily a single experience. The "strange duality" at work in "seeing the marked surface, and of seeing something in the surface" actually involves "two aspects of a single experience . . . distinguishable but also inseparable."[33] Whereas Gombrich attributes representational illusion to perceptual events we might have separately, Wollheim argues that "they are neither two separate simultaneous experiences, which I somehow hold in the mind at once, nor two separate alternating experiences, between which I oscillate."[34] Instead of "seeing-as," there is a more unified act of "seeing-in." But what if there were both? And what if one seems to entail the other, multiplying the effect? This is what the *tache* achieves, provoking "oscillation" between what these two theorists describe and making the reciprocity reflexive. To wonder what if anything the *tache* signifies as it seems to go from an illusion of something seen to virtuoso marking and back again is to get from the *tache* itself different possible stories about art.

And this is to say that the *tache* is eminently but excessively narratable. Its kinetic dualities, at once provoking alternative ways of seeing, have in abundance the kind of generative uncertainty that elicits but confounds narrative construction. It is not just that the *tache* has ambiguities that invite but elude explanation, but that the proliferating dualities in question here involve mixed narrative relations of sequence, causality, and eventfulness. They are, first of all, the sort of "trigger" that provokes narrative explanation, because they compel the effort to account for the relationship between two moments in aesthetic production.[35] But if narrativehood might be defined, as Gerald Prince argues, as "the logically consistent representation of at least two asynchronous events that do not presuppose or imply each other," the *tache* invites interpretation at once very strong and very weak in narrativity: variable "consistency" puts the aspects of its dual nature into cause-and-effect relations all the more compelling for their variety.[36] David Herman notes that "the greater the number (and diversity) of the repertoires set into play during the processing of a narrative sequence, the more narrativity will the processor ascribe to that sequence."[37] Diversely narrative to the point of excess, the *tache* provokes more ascription than narrative can handle, perpetually reprocessing the attention it seems to repay. Another way to make the same point would be to say that the *tache* entails ceaseless narratability as D. A. Miller

defines it: the "disequilibrium, suspense, and general insufficiency" that provides the "incitements" and the "implex" for narrative action.[38] Narratable without ever achieving closure, the *tache* undermines stories we would tell about it, but to its own advantage, since this antinarrative force has kept its aesthetic dynamic alive.

What motivates this antinarrativity, however, is not just the *tache* itself but its extrapictorial contexts. The point here is not to attribute impressionism's lasting power to some formal dynamic and, in so doing, revert to a formalist account of its essential nature. No amount of intrapictorial antinarrativity could have made the impression a special or a lasting provocation, had it not been for the way the stories generated by the *tache* correlated to those of the historical moment. The dualities competing over the *tache* circa 1874 became so lastingly compelling because of the ways they could engage cultural and political histories and, in turn, the longer history of art. The great moment for this convergence was the 1870s—the moment in which the *tache* and its coincident histories together generated such cultural energy. What explains this intensity is, first, something about the *tache* itself at this time. In 1874, it had a certain maximum duality, because there was yet a visible correspondence to it. Although some impressionists had begun to develop brushstrokes that would decisively shift the balance toward compositional unity, at this moment the brushstroke's two tendencies could seem almost simultaneous. "There was, in principle at least, a correspondence between the unit of vision and the unit of paint," and it was still possible "to view the coloured touches in the paintings as standing for some distinct element in the scene."[39] But it became increasingly less possible to do so as "the unit of paint in both Monet's and Pissarro's work became smaller than the unit of vision and often quite separate from any such unit," "no longer [to] be directly identified with any distinct visual experience."[40] If the *tache* could seem perplexingly to conflate natural reality and artistic will, it was perhaps most perplexing at this pivotal moment for its narrative "implex." A special convergence linked impressionism generally to this effect, making the impression a kind of summative cultural synecdoche. Impressionism concretized into its twofold *tache*, which became a dominant cultural signature.

When House describes this passing but powerful formation, he recognizes its essential antinarrativity. In his reading of Pissarro's work of the

late 1870s, House recognizes the crux of what gave these pictures their explanatory power:

> The textures in these paintings may still be seen as a response to the visual stimulus—the *sensation*—of the scene itself; the marks may readily be viewed as standing for the textures of the grasses and foliage. Yet, when these small dashes and flecks of colour are carried over into the sky and onto the walls of cottages . . . it becomes clear that they have transcended any 'natural' starting point, and have become an organizing principle whose prime point of reference is the effect of the finished picture.[41]

Here House describes a visual metaphor for impressionism's departure from its natural basis, but he also gives a good account of the effect of the pictures that, temporarily, maintained it: their failing balance of scenic and organizational effects provokes a story, which is, in this case, minimal, but becomes compellingly but diversely allegorical. For what reasons does the *tache* transcend nature in this narrative, and with what effects? The narrative implications of this organization might be many. And because House's revisionist account of impressionism embeds its politics in the material substance of the paintings, the story by which organizing principles transcend nature as an effect of the picture becomes larger stories as well, which resonate with the social and political concerns of the day.

The brushstroke of the mid-1870s achieved its powerful balance of correspondence and configuration at a historical moment in which parallel properties raised pressing political questions. These were questions of national sentiment in the years following France's humiliation in the Franco-Prussian War and the Commune, the chaos that brought down the Second Republic and led to communard violence and Versaillais reprisal, and in turn, the establishment of severe cultural restriction under the Third Republic. The war had provoked efforts to restore national pride—in the arts, to reenergize uniquely French claims to cultural excellence. But the 1870s also saw the establishment of a repressive, conservative regime with negative effects on prospects for aesthetic innovation. MacMahon's "moral order" government sought to root out the decadence perceived to have led to France's military defeat and revolutionary turmoil, and that

effort entailed official demand for artworks similarly conservative in their dedication to traditional imagery and techniques.[42] This sociopolitical context has long been recognized as one of the first prompts to a properly avant-garde aesthetic fraction: the intransigence critical to impressionism's status as an oppositional and progressive art of crisis was resistance to conservative efforts to curtail freedoms associated with individual creative liberty. The intransigent artist innovated new artistic techniques for the sake of liberty and equality, his or her refusal of traditional style also a refusal of an opportunistic bid to make France's troubles justification for political tyranny. To do justice to the world's sensible profusion was to undermine hierarchical values beyond the picture plane as well; sincere seeing corresponded to what remained of the anarchic radicalism so many political historians have ascribed uniquely to the Commune and its revolutionary sociability. And the impressionists accomplished all this at once in other social worlds as well, to the extent that their ventures into momentary acts of leisured indulgence upset hierarchical class values. In this cultural history, we begin to see the cultural correlate to the duality of the *tache*: its combination of sincere seeing and stylistic departure could seem to assert a certain crucial political story of aesthetic production.

But impressionist technique could communicate many different political stories. As much as its brushstrokes were leveling, democratizing truths, they were incipient forms of containment. Also a retreat into the personal, they could seem to transition intransigent objectivity into an individualist aesthetic, a modernist autonomy. The impression had no simple fealty to any singularly radical response to an entirely repressive governmental regime. It entertained a much less totalized history. The dual impression got its foundational antinarrativity from the sheer variety of political narratives available at this moment, ranging from different versions of radicalism to counterinsurgent reactions—and from myths of art world insurgency to plots of aesthetic complicity.

"Intransigence" could go either way. Even the radical story, the proletarian theme itself, could generate an alternative: public complicity. Albert Boime argues that the impressionists in the early 1870s were complicit in the Third Republic effort to rebuild and restore Paris and to erase the traces of the destruction caused by war, siege, and commune. Denying that they sought a true record of the historical moment, Boime argues that our sense of them as radicals inimical to state interests is wrong, since

they pursued the forgetfully reconstructive mission of the state itself. Actually "moderate republicans" rather than intransigents, they "descended into the public sphere to reclaim symbolically its sullied turf for the new bourgeoisie," beautifying landscapes actually still scarred by violence, using their signature style to empty, smooth, and brighten the landscape back into good shape.[43] But Boime's account includes other ways to make such a link, noting that Third Republic officials themselves did not see these pictures that way, since elements including "antihierarchical content and technique" made them seem dangerous to "conservative spectators still influenced and threatened by the bitter memories and the outrageous actions of the Commune."[44] They did not simply smooth away destruction or democracy. Here again we have an excessively narratable conjunction of paint and politics, conflicting stories that undo each other around the impression's perpetual recoding.

This is to say that the impression in 1874 was a symptomatic duality at a dramatic historical moment, prompting narrative profusion. It is to recognize the epochal, charismatic result—the special status and definitive significance necessarily achieved by the impression. For the complexity of the historical moment was singular. House and Boime encourage us to see that the usual number of players and positions had multiplied into a dizzying matrix of political possibilities, not just for the impressionists but for the public that received them. Communards, bourgeoisie, and royalists may correspond to perennial interests, but now they entered into relationships so fluid that they forced critical relationships among interpretation, identity, and action. Perhaps the impressionists generally aligned with the Commune; perhaps their radical politics did justify their provisional characterization as intransigent. But in large part their intransigence was a reaction against poor treatment by the cultural establishment prior to the war; it had set them against the future bourgeoisie that would dominate the Republic, rather than the royalists, who played no part in the assertion of middlebrow taste they so resented. So their intransigence was sociopolitically ambiguous at best, even if they were not "moderate Republicans," and even if self-interest did not dictate commitment to the emerging art world marketplace.[45] Complexity on this order had special narratability, corresponding to something special in the impression, which, at this moment, had taken up a similarly unstable set of reciprocities, corresponding to the brushstroke itself and its provocation

to wonder how we configure what we see. The impression and its history together prompted stories that could answer essential questions: What should individual liberty mean for public life? How might individual creativity reshape the social whole without asserting simply subjective interests? How do individuals take shape into a collective body, if not in a commune, without loss of their distinctive human outlines? Political historians have long made this point in history a focus for such questions. Impressions gave the questions historic form.

And just as the impression could narrate very different political histories, it could position itself mercurially among conflicts between commerce and avant-garde aesthetics at this incipient moment in their fraught fellowship. As documented in many accounts of impressionism's debt to the work of private dealers, commercial enterprise was crucial to the very invention of the modern individual artist. Most notably, Paul Durand-Ruel staged the first individual painter exhibitions in an effort to develop marketable artist brands, and other forms of private enterprise similarly helped determine what would become autonomous aesthetic categories.[46] Nicholas Green has shown that the "individualizing schema" formed at this moment was one in which "the relation between the painter and that which was rendered into paint was constructed as transparent."[47] This "transparency of the artist/nature couplet" was an invitation to read the nature depicted as a product of the artist, even as it had its figural status, and this version of twofoldness locates the impression's narrative crux amid the marketplace as well as painting's other histories. Art market ventures were also meaningful context to explanations of the dualities encoded in the pictures themselves. The subjective designs through which impressionist painters declared their autonomous individuality could well be read as brand insignia; *that* narrative could explain the shift from correspondence to "organization." But this explanation for the shift within the impressionist brushstroke did not only tell a story of commodification. 1874 had not yet seen the distinction between high-art painting and mass-market commodity, so no narrative could simply identify co-optation; no category of aesthetic autonomy would have required painterly subjectivity to distinguish itself from a commodified instrumentality. At the same time, however, implications of commercial self-interest would have given a different "aspect" to the impression's subjective side, raising a set of narrative questions: If objectivity yields in the impression to subjective individuality, will that shift reinforce the brand singularity

of the aesthetic gesture, preparing for its marketization? If inversely, the artist brand embodied in the individualized brushstroke yields to democratized perception—if it can be seen to be the cause of it, rather than its outcome—has art made an attempt to encourage a larger cultural sacrifice of personal interest? In other words, the signature *tache* was also a force for antinarrativity here, given the historic ambiguity in the marketing of impressionist art. Once again, impressions gave historic form to pressing questions.

As they did to such historical effect in Monet's *Impression, soleil levant*. As we have seen, this picture was an impression among other more finished products. Together with other views of Le Havre, it told the story of painting's progress from immediate perception to a more finished aesthetic, featuring a dynamic relationship between natural presence and the artist's process in such a way as to provoke different explanations for the brushstrokes that composed it. Such explanations, however, were historically motivated; context drives their narrative urge, given the picture's location. It has become customary to note that Monet's impression of Le Havre takes a politically optimistic view of a place recently ravaged by war.[48] To derealize Le Havre into a haze of impressions, to render that effect as a sunrise, is to propose that a war-torn landscape may be redeemed by a new day's aesthetic vision. But to the extent that Monet's picture set up a "transparent" relationship between that proposition and his own artistic agency, individualizing the design of its natural figuration, he drew attention away from public futures toward heroic artistry—perhaps even attributing the former to the latter. Such an attribution would mean one thing if artistry were work (a version of commonly shared public endeavor) but something else if it were a branded interest (a function of art world marketing). And if the utopian vision were shadowed by ironic possibility—if sunrise could seem to be a merely natural, sensory phenomenon tragically heedless of modernity's own dawning—the story centered here upon the impressionist brushstroke could take yet further forms. All this suggests that Monet's inaugural impression gave not just a name but a real vocation to the movement. It founded not only a style and a movement but also a form of antinarrative engagement that has had a long life as an impressionist mode.

As a living mode, impressionism does not persist timelessly, since it adheres so memorably to its original movement's motivations, styles, and historical determinations. But the persistence is a living thing because

impressionism never originally settled upon its meaning to its moment. So it proceeds across time and space, across history and other media, maintaining open relations around its core feature: its dual nature's antinarrative thematics, associated (in the way of genres) with its charismatic main instance, the impressionists' original imagery and history, their indelibly resplendent modernity.

ARTS OF IMPRESSION

The antinarrative mode of impressionism makes history in literature too, where it is often dedicated to subjective consciousness, tending toward the stylistic immediacy, flux, and indeterminacy typically associated with the "merely" personal impression. But that impression was like the *tache*, generating prodigious dualities and their antinarrative thematics. Henry James, Ford Madox Ford, Virginia Woolf, and others all argued that fiction ought to represent impressions. The result, however, was no simple matter of phenomenological realism. James responded to claims made by Walter Besant in *The Art of Fiction* (1881) that fiction must be true to experience: he agreed, but countered that "a novel is in its broadest definition a personal, direct impression of life," that "impressions *are* experience."[49] Whereas Besant had argued for something directly empirical, James argued for the way the impression enables the imagination to transform reality. But how it did so entailed more speculation, which became, in turn, a thematic subject for James's fiction, which devolved the impression's experiential unity into plots of social conflict. Ford explicitly professed impressionism and wrote extensively on its requirements—mainly, the need to bracket the truth in order to make a true impression on the reader. As he wrote in *Joseph Conrad: A Personal Remembrance* (1924), "we wished to produce on you an effect of life," which required that we "not narrate but render . . . impressions," even if there developed a conflict between appearance and reality.[50] Ford's essay "On Impressionism" (1913) explains what is lost and gained by this shift, and his fiction dramatizes worst-case scenarios in which appearances at once captivate and mislead. And Woolf famously defines modern fiction in terms of the flux of impressions that compose the experience of reality at any moment as well as the powerfully singular impression that

must form the basis of any account of human character.[51] In flux and yet a fixation, the impression gives Woolf's fiction different motives, an oscillation between experiential plenitude and abstract nothingness.

For these writers, then, impressionism was a theory of perception and a matter of style, but also a dualistic outlook and thus a thematic concern—and a problem for plot. Like their counterparts in the visual arts, the literary impressionists really made a difference by dramatizing the dualities essential to any art of subjective impressions, similarly enjoying their opportunities for drama at every level. Here, dualities transposed the painters' dialectics of nature and art, recognition and configuration, into others having to do with the concerns of novelistic fiction: the relationship between innocence and experience, for example, or fact and value, or feeling and reason. And these relationships entered into narratorial elaboration in similar but different ways as well, conjoining to politics, commerce, and aesthetic culture with stress upon the writer's relationship to the larger stories that might emerge on the basis of small, inchoate perceptions. How to get from subjective perception to fictional construction, to artful knowledge, to social authenticity and political insight or even commercial success: these were the problems for authors using impressionism in literature, which made allegories of the styles of seeing, feeling, and thinking they employed to represent the fictional world.

These antinarrative allegories characterize the impressionist fiction of writers including Marcel Proust, Anton Chekhov, Thomas Hardy, Stephen Crane, Joseph Conrad, and Dorothy Richardson; critical work by Ian Watt, Michael Levenson, H. Peter Stowell, Paul Armstrong, Tamar Katz, John Peters, Adam Parkes, Max Saunders, and others has shown that these writers stake the art of fiction and its sociopolitical significance on the impression's perceptual thematic.[52] Poets too pattern out this thematic, especially those closely associated with the painters and their milieu—Charles Baudelaire, Stéphane Mallarmé, Arthur Rimbaud, and Paul Verlaine—although the tendency to call these poets "symbolists" puts their work into a different, longer history.[53]

To elaborate upon the most common example: Conrad is a "painter of modernity" in T. J. Clark's sense in that he tends to stress a preemptive discrepancy between the subjective sense of things and any actual reality. Appearances belie reality; sensory experience is savagery or solipsism. Ian Watt recognized this tendency in a foundational account of Conrad's

impressionism, locating it primarily in Conrad's style of "delayed decoding."[54] When his characters have a vivid perception and only later come to know the name for it, his fiction stresses a gap between perceptual experience and its meaning. And yet, as we have seen, Conrad took another view of inchoate sensuous perception, valuing its significance to felt solidarity among human beings, hoping it could emerge into meaningful consensus through literary form. Conrad's fuller attitude toward impressions develops a complex aesthetic, described in fuller generic terms by critics for whom his impressionism is a major form of aesthetic and historical engagement. John Peters has shown how Conrad's impressions took part in a broader field of scientific, political, and personal affairs, developing important complexity in the diversity of their cultural engagements. Adam Parkes has defined literary impressionism in part in terms of Conrad's effort to discover an alternative to journalistic forms of information, especially as they relate to the construction of political reality.[55] Just as the impression's duality gave a picture by Monet or Pissarro a core differential that could become a crux for diverse stories of aesthetic, cultural, and historical engagement, it becomes the energetic crux of Conrad's primary imagination. When, for example, characters in *Heart of Darkness* (1889) misinterpret signs of colonial resistance, mistaking arrows for "little sticks," this famous example of "delayed decoding" sets up a chain of differential correspondences.[56] The wrong impression has implications beyond any ironic gap between appearance and reality. "Little sticks" recognizes the limited potency of colonial resistance at this moment, and "arrows" recognizes the different failure of a standard reference to capture the reality of this specific colonial situation. The truth, as it were, is somewhere in between sticks and arrows. And as the novel elaborates upon it, we move from an ironic duality to one that redoubles into fuller narrativity, enabling the larger anticolonial recognitions of *Heart of Darkness*. In other words, impressions that seem to be immediate perceptions actually have a duality that generates a plot of its own, and thrives upon it; impressionist fictions may seem to dedicate themselves to immediate perceptions distinct from cultural or political contexts, but the nature of those perceptions—if they are impressions—is to match historical conflict. *Heart of Darkness* resembles its painterly equivalent, or, rather, shares its generic profile and history, by making the dual impression a critical interchange among perceptual, thematic, and historical

registers. That interchange would become a lasting tendency in texts that dwell upon the consequences of perception defined against itself.

This legacy takes part in foundational constructions of the filmic image. The French impressionist filmmakers of the 1910s and 1920s occupied an important middle ground between the nascent Hollywood film industry and the avant-garde. Between the instrumentalized imagery of Hollywood and the incipient abstraction of avant-garde purity, the impressionists worked out an approach to the filmic image that attempted to assert its reality but also to give it a uniquely cinematic aesthetic, to make it at once a real-world presentation and a magical phenomenon. The result—for the image itself, but also for the film theory that became thematically important to impressionist productions—was what came to be called *photogénie*, that elusive quality that characterized the photographic image imbued with significance. At a foundational moment in its history, film became an impressionist genre by making *photogénie* a thematic as well as a technical concern, and, more than that, involving it in the early negotiation of film's cultural status. As the impressionists struggled to define film as an art of its own, distinct from theater, literature, and other visual arts, they called upon the magic of *photogénie* to elevate it above American commercial dominance. But *photogénie* was at once a sublimation and a ruse, never any sure blend of the mystical and the real, a source of obsessive thematic speculation about the mystifications it might entail. Chapter 4 reads its effects upon Abel Gance's *La roue* (1922), the masterpiece of French impressionist cinema. Gance's film, which became an influential repository of aesthetic technique, demonstrates how *photogénie* goes from technical property to thematic crux and historical negotiation as it works upon the image of modernity.

Impressionism would continue to assert itself where the duality of representations taken for immediate, minimal perceptions gets thematized and narrated, correlated to sociohistorical plots that return attention to the problem of perception. The mode that moves forward in history has a lasting commitment to the emergence of the mere impression and consequently a dual sense of its nature; that duality, so diverse in its operations, becomes a thematic concern narrated together with any number of historical ones, but always colored by the spirit of impressionist modernity. Diversity enables this mode to instantiate itself in many forms—not only an array of art forms but also very different cultural projects with a range

of social values. Not only vanguard and highbrow aesthetic practices but also apparently inartistic and artless ones could result, and these legacies cut across cultural fields, finding common cause among seemingly divergent developments, nowhere more so than when impressionist painting developed into first legacies that split the arts of the subsequent century: cubism, in which the dualities of the *tache* achieve an avant-garde apotheosis, and decorative impressionism, in which they seem to energize sentimental adornment.

THE CUBIST IMPRESSION REVISITED

Although we typically say impressionism gave way to postimpressionism when later painters reacted against the impressionists' formless objectivity, we might actually see this opposition as yet another product of impressionism's dual nature. The history that goes from one movement to the next is yet another narrative generated by the impression itself, and, seen as such, it contains both movements within the problem of the original *tache*. In response against pictures lacking active compositional or formal initiative, the story goes, painters including Cézanne and Seurat went from impressions to formal, proto-abstract design scenes and more fully scientific determinations, ushering in an essentially different aesthetic objective that marks the real beginning of modern art as such. Only then did painting move decisively away from naïve visuality toward the truly aesthetic priorities of modernism, the purer forms and autonomous vision that would constitute the true response to modernity itself. Such was the story told by the painters, their advocates, and the art historical schemas that could then array painting's progress in genealogies showing the further advent and development of this modernist aesthetic. Cézanne declared a wish for something more solid; Félix Fénéon celebrated Seurat's rejection of aleatory intuition in favor of scientific structure; and Roger Fry, with the most influential long-term effects, defined postimpressionism in these terms. "The Post-Impressionists consider the Impressionists too naturalistic," Fry wrote in his catalog for the 1910 postimpressionist exhibition, and "their attitude towards nature was far more independent."[57] Whereas impressionism had "hindered artists from exploring and expressing that emotional significance which lies in things, and is the

most important subject matter of art," its successor movement became free to construct significant forms, abstract harmonies better suited to aesthetic expressivity.[58]

But such accounts often confess that the difference between these movements was available in the first. When, for example, Arnold Hauser concurs that modern art begins with the renunciation of "all illusion of reality," he adds that "impressionism itself prepares the ground for this development in so far as it does not aspire to an integrating description of reality, to a confrontation of the subject with the objective world as a whole, but marks rather the beginning of that process which has been called the 'annexation' of reality by art."[59] We might add that the "process" in question is one in which art history recapitulates impressionism itself. That is, if the annexation of reality by art is a process that happens as impressionism gives way to postimpressionism and what follows, and if that process begins with impressionism, it also begins in it—in the impression's version of this duality. This does not mean that late work by Cézanne is not to be distinguished from early work by Monet, but rather that they are limit-case versions of alternatives made available by the visual rhetoric of the impression. For the purposes of the present argument, then, postimpressionism is not a legacy of impressionism but rather an initial variant (as indeed the "post" might be taken to imply). Legacies would come later in the "process"—most famously with the advent of cubism.

With cubism, impressions became abstractions: this is the surprising development that perhaps best dramatizes the impression's movement into posterity. It is well known that cubism arrived, as Ortega y Gassett put it, when "Cézanne, in the midst of his impressionist tradition, discovers volume," and that Cézanne was the pivotal figure after whom "painting only paints ideas."[60] Yves-Alain Bois has noted that "cubist semiology allowed one to turn the Cézannesque cave-in to the profit of form (no longer a matter of figures or perspectival space, but of structure)," and that "Modernism owes much to this brilliant conjuring trick."[61] It is easy to see this trick in action. In Monet's *Impression, soleil levant*, impressions are formed through little volumes of opticality, and in Cézanne's contemporaneous *Étude: Paysage à Auvers* (see fig. 1.2), we already see what could come next in the process, as those components begin to form irrespective of perceptual configuration, already squaring off into shapes fit for compositions unrelated to those of optical science. These self-shaped impressions then begin to plot the structure of the cubist grid.

Cézanne's impressions are the mediator here because, as Clement Green-berg put it, they compel effort both of "abstraction and of eyesight."[62] The twofoldness important in 1874 further extends itself, becoming a kind of transhistorical effect, "a pictorial tension the like of which has not been seen in the West since late Roman Mosaic," a "sculptural impression" or "vibration" that subsequently shook the impressionist canvas into cubist disarray.[63] D. H. Lawrence called it a "mysterious shiftiness," and we see it do its work across pictures representative of the cubist revolution: in those of George Braque, for example, where the *tache* evolves from its role in perceiving real rooftops to its shifting construction of the objecthood of the female body (fig. 1.3), Monet's brushstrokes have gone abstract, and impressionist dispersion has enabled cubist analysis.[64]

Even the cubist grid, then, was no departure from the impression, but something that can be seen to follow from it. Despite what Cézanne and Bois may have said, it was no real "trick" at all to find "volume" avail-able in impressionism itself, in the way the *tache* worked both on and off the canvas. On the canvas it had already begun that annexation of reality by art, articulating nonrepresentational space, even if at first in pursuit of naturalistic effects. Off the canvas it had been spurring theoretical re-versals. What emerged after Cézanne is less the trick of some discovery than a self-realization on the part of the impression itself, a performance of its duality, if not the dialectical fulfillment of its destiny. In analytic cubism—that first stage, visible in Braque, before cubism left impression-ism behind to pursue the different aesthetics of collage and abstraction— we see not yet a departure from the impression, but the graphic image of its attentional logic. Where we see surfaces hurtling quickly together, yet also taking shape into things that are shapes of their own; where we are provoked to recognize an image reconfigured into its parts, or made to feel as if our bodies were moving about an image in fact fixed and still, then we see a graphic literalization of the narrative that impressions gen-erate. Not that Braque was an impressionist: this is in no way to argue for a longer period-style that subsumes the cubist revolution, conflating stylistic practices that really differ in any number of ways. It is rather to observe that if the relationship between impressionism and postimpres-sionism is less a matter of reaction and rejection and more a playing out of the dynamic inherent to the mode, its narrative conducted at the level of art history, then the cubist conclusion shows just how meaningful the

1.3 Georges Braque (1882–1963), *Female Figure*, 1910–1911, oil on canvas, private collection

mode can become. It can make sense of developments that verge on radical abstraction and its cultural implications. It moves into collage, and montage. It foresees the total irrelevance of figuration, for example, in its last moments; it even has a kind of postwar epilogue. And if the relationship between impressionism and postimpressionism demonstrates that the dynamic inherent to the mode becomes art historical, dictating terms for the process of the story of modern art, the cubist conclusion shows just how influential the genre has been. To the extent that the heroic narrative of modern art derives its narratability from the uncertain aesthetics of the relationships among impressionism, postimpressionism, and cubism, it is itself an impressionist genre, for a long time caught up in the dialectics and performances that originally made the impression such a useful aesthetic signature. We might say that the dualities of the *tache* are still working themselves out, in aesthetic engagements still caught up in wondering what represented visualities really perform.

But what happens when impressionism seems to persist as such—not in vanguard dynamics wrested from its kinetic duality, but in the same old visuals, and some single commitment to them? For that is how impressionism has most visibly come down to us. Often the *tache* has simply persisted, telling old stories about aesthetic engagement. It began to do so nearly immediately. Just when the postimpressionists were transposing the impression's duality into the heroic narrative of modern art, other artist were framing it more lightly. But if the ultimate result has been of lesser value, if it means less to us today, that too is part of the story.

THE DECORATIVE IMPRESSIONIST

The year that Roger Fry brought postimpressionism to England was also the year of another turning point for impressionism. In December 1910 at the Madison Gallery in New York, *The Giverny Luminists* showed the American impressionists Frederick Carl Frieseke, Richard Miller, Lawton Parker, and Guy Rose, prompting renewed admiration for the sort of work Fry's event would consign to the past. "These men are impressionists of the very best sort" was the opinion of the *New York Morning Telegraph*.[65] Others agreed that the Giverny Luminists had improved upon impressionism without resorting to more disturbing methods. *The New*

York Globe and Commercial Advertiser noted that in the work of these artists "efforts have been made in a sane and intelligent direction, which is a relief in these days of new departures."[66] The Giverny Group painted what has come to be known as decorative impressionism, which favored those colors, patterns, and subjects most likely to produce a pleasant effect. It mainly depicted women in domestic spaces or enclosed gardens, wrapped and surrounded in textiles and flora rich in jewel-like coloration. William Gerdts calls it a "genteel aestheticism," and it was certainly gentler and more aestheticist than anything produced by the original impressionists, let alone their successors.[67] To produce decorative impressionism was to try for a "pleasant optical sensation," as Miller suggested, rather than the sort that provoked controversy among the "new departures" on display at the Grafton Galleries that same year.[68] Whereas fauves and cubists affronted viewers with unpleasantness, denying the easy opticality of art, the Giverny Group perfected pleasures familiar to the public eye. And whereas those avant-garde movements determined radical art for years to come, the Giverny Group led to something else: a decorative aesthetic that is as much a way of life as a form of art, that impressionist ethos of natural enrichment still so enticing to the public imagination.

Decorative impressionism was an apt outcome for the American artists' colony at Giverny. The first pilgrims to that Mecca—Americans who began frequenting Giverny not long after Monet moved there in 1883—were not simple acolytes. They did not abandon themselves to impressionist technique, however much they may have respected Monet for it. Because they had come to France to study in academic workshops and because they had been trained in an American realist tradition, the first Giverny colonists tended to stop short of the bold colorism and provocative modeling distinctive to Monet himself.[69] And they certainly refused the subject matter of his contemporaries: urban scenes suggesting social class problems and people from the lower social orders never featured in their works, which were dedicated to the serene rural landscape and scenes of upper-class domesticity. No *anomie* undermined the optimism of American Giverny painters, who tended to persist in the basic principles they had when they arrived: realist ones, or those of the tonalist aesthetic derived from Barbizon, which had been highly popular in America—similar to impressionism but for its uniform palette centered on a particular tone and its more spiritually elevated thematic. All this

guaranteed a more refined impressionism, in the work of great American impressionists including Theodore Robinson, Philip Leslie Hale, Lilla Cabot Perry, and others. It explains why the work of the Giverny artists developed a less radical, less provocative look as it emerged toward the 1910 exhibition at the Madison Gallery. The Giverny Luminists did learn much from the Monet of the 1870s and then, in the decades that followed, from other influences including Whistler, the Nabis, and even pictorial photography, but they remained faithful to an aesthetic ethos of graceful pleasure, perhaps indebted less to any artists than to the pleasant spirit of Giverny itself.

From the start, Americans at Giverny had a secondary relationship to impressionism. Monet was for them an institution, and Giverny was a distinctive symbolic space as much as a place to work. Americans who came to paint there developed a kind of resort community centered on the Hôtel Baudy; in later years, when they had houses of their own, these became centers of refined artistic sociability, as when Frederick and Mary MacMonnies acquired Le Moutier, the three-acre monastic site that became known as "MacMonastery." Here, life could be arranged to suit the aesthetic Monet had developed, as if that aesthetic had now invented the life it had been invented to imitate. Nature was preempted in gardens designed to look like a garden painted by Monet; women were housed and clothed in high-key textiles and furnishings suited to the idealization of an impressionist vision. It was a world of purified visual delight; one visitor recalled that "life was very pleasant, and much of the pleasure lay in the fine aestheticism" that brought impressions to life.[70] The American colony "could cultivate flowers in accordance with a preferred palette" within walls "closed high to 'keep the vulgar out.'"[71] "How quickly," David Sellin writes, "the Giverny art colony traversed the distance from Bohemia to suburbia!"[72] But Clara MacChesney enthused, "Here was no telephone to interrupt; no rasping street car, no roar of elevated trains, no shriek of motor cars to break the calm. Here reigned peace and privacy."[73] In this seclusion, "safe from the world's whirl," Giverny closed a circle.[74] Monet's impressionism had opened the art of painting to the fuller range of life's effects. Giverny then took that art and made it a way of living, and the second-order art that followed could only be decorative. As a lifestyle pursued in walled gardens, interiors lush with domesticity, and cafés hung with its own imagery, impressionism became reflexive; it became

thematic in a new way, to painters who made their impressionism the subject of celebratory illustration.

But the point here is not that this decorative impressionism was a false legacy, whereas cubism was true. Theorists of the decorative have long rejected such a hierarchy. From Roger Marx to Jacques Rancière and Bill Brown, there have been critiques of this "simplistic opposition between the useful object and the object of disinterested contemplation," and, more than that, a reversal of it.[75] For the decorative powerfully acknowledges a "necessity" mystified by the disinterested aesthetic.[76] In the case of impressionism, it foregrounds questions about the use of beauty—not about how impressionism became a leisure-class lifestyle, deteriorating at Giverny into a sociable habitus, but about what it achieves by proposing to unify aesthetics and habitation, art and the privileged environment. For the Giverny inhabited by American painters at the turn of the century has become the Giverny visited by countless tourists still going in search of Monet. And in the optic associated with it, Giverny's social symbolism still unifies art and life in such a way as to give decorative impressionism real cultural power. Indeed, it helps define impressionism in the public imagination as a way of life much like that which the Giverny Group constructed around Monet. Moreover, decorative impressionism persists as a public art form in the numerous variants now called California impressionism, contemporary impressionism, corporate impressionism—the many legacies of the Giverny Group still enriching public environments with perfected forms of impressionist pleasure.[77] They include mass-market reproductions too, and even the blockbuster exhibitions that are also legacies of Giverny's thematization of the impressionist ethos. Decorative impressionism is largely the face of impressionism today, not in such a way as to have undermined it, but as a critically utopian ideal—enacted to telling effect in the work of the Giverny Luminists.

As we have seen, the critical aesthetic developed by Monet and his fellow members of the Société Anonyme around 1874 inaugurated impressionism's tendency toward reflexive narratability: the impression's "dual nature" provoked critical inquiry into the problem of the aesthetic and its relation to history, ethical value, and nature. This dynamic duality constituted impressionist modernity—certainly its significance to modernism, insofar as critical tension would persistently help to characterize the reflexive form essential to the modernist aesthetic of critical engagement.

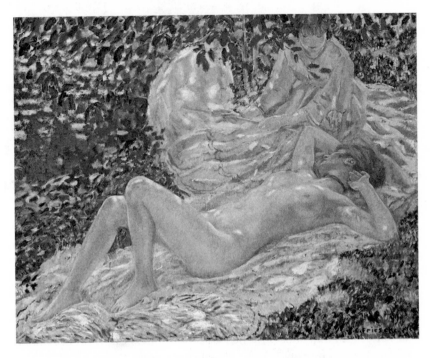

1.4 Frederick Carl Frieseke (1879–1939), *Summer*, 1914, oil on canvas, 45 3/16 x 57 3/14 in. (114.3 x 146.7 cm.), George A. Hearn Fund, 1966, The Metropolitan Museum of Art

Image copyright © The Metropolitan Museum of Art. Image source: Art Resource, NY

But what becomes of impressionist modernity when impressionism as a movement—rather than the impression as a unit of aesthetic experience—becomes the object of thematic reflection? Criticality might increase, and indeed redouble; a reflexive house of mirrors could go up around this double duality. And yet Giverny seems to disarm criticality. To make a nice lifestyle of impressionism and then to make it the subject of painting is to resolve the impressions' conflicts, or, rather, to contain the stories they might tell. Paintings like Frieseke's *Summer* (fig. 1.4) refine the beauty of impressionist imagery—they are quite often more gorgeous even than Monet at his best—but their thematic intention to do so fixes the relationship between sensory experience and aesthetic taste, neutralizing artistic tensions. The result for posterity would seem to be something that enacts the failure of impressionism itself in order to exploit its decorative potential—in other words, to serve the purposes of kitsch aesthetics, as defined by Clement Greenberg. Whereas authentic aesthetic experience

depends on "reflection upon the immediate impression left by the plastic values" of a picture, here the "reflected" effect has already been included in the picture, ready for the spectator's "unreflective enjoyment."[78]

But of course the criticality Greenberg favors is unreflective in its own way. In his account, some impression must make its way immediately to the spectator. The problem of impressionism, however, reminds us that an intervening moment of consumption might critically shape a spectator's reflection. That is, the reflected effect might be part of the impression, not in such a way as to preempt criticality, but to energize it more fully and even to reconcile aesthetic experience and lesser pleasures. And indeed Frieseke's work demonstrates this effect. Moreover, his career neatly matches the process it follows.

Frieseke is unlike other decorative impressionists in that he came late to the style. As a last-generation Giverny painter, he helped create the luminism most dedicated to a perfected impressionism. And he came to that style with special awareness of both its conservatism and its marketability—with strong commitment, that is, to its decorative advantages. Frieseke began his career as a gifted illustrator and a student of Whistler. These different commitments created a conflict his decorative art would resolve, in lastingly useful ways.

In the 1890s, while studying with Whistler, Frieseke supported himself by doing illustrations for Wanamaker's department store. Drawings for advertisements and catalogs enabled him to stay in Paris and ultimately to produce work good enough to earn him membership in the International Society of Painters and Sculptors. Whistler himself was president of the London society when Frieseke was asked to join. That same year, however, Frieseke entered into a new arrangement with John Wanamaker, who offered to purchase a set of pictures every year for the high sum of $2,500. Wanamaker was a major force in American commerce, not only as founder of one of the country's first major department stores but also as the originator of many essential business practices including the price tag, the money-back guarantee, and even modern advertising itself.[79] One of the first to make the space of commerce a luxurious environment, he was also a great patron of the arts. He once said "he could no more help buying pictures than the Paris housewife could help buying flowers when she went marketing," and he was known to be the "le bonpapa des artistes français qui en ont besoin."[80] For Frieseke, his patronage was essential. In itself it did not, of course, compromise Frieseke's status as a free producer

of fine art. But Wanamaker had particular tastes: "he was attracted to canvases where the landscapes were gay. He wanted his skies bright, his trees honestly green, and the girl standing in the field beside the river not too drably dressed. . . . And he was emphatic in his belief that disgusting realism had no place in art or literature."[81] Wanamaker felt that art should "put a glamour on life" and that "a picture that does not give enjoyment cannot be beautiful."[82] These preferences were clearly important to Frieseke's work at this moment. He did not pander to them, but he did proceed to develop a style that could be seen to strike a compromise between aesthetic modernity and department store decoration.

And this was decorative impressionism, which, for Frieseke, had a vibrant optic all the more bright and gay for its subject matter. His subjects were women like the leisured bourgeoise in *Summer*—women whose class, manner, and activity naturally enhanced a luminous impressionism. Critics note that this impressionism is at once selective and conservative—limited to the gratifying distractions of a style that had once been more disorienting, conducive to the sentimental, affirmative aspects of an art for which vibrant color had been a challenge to realist seeing. Symptomatic of this selective conservatism was its approach to the human figure: whereas the original impressionists had willfully dissolved faces in order to shift painterly values away from a humanist assent, Frieseke preserved an academic, monumental form of figuration.[83] One contemporary critic alleged that Frieseke and his colleagues used "color borrowed from the ranks of the anarchists" and only seemed "rebellious" while they held to the "protecting mantle" of the academies.[84] He was mainly a "painter of feminine grace," maker of "invariably gracious paintings" in which "the theme is always presented with a decorative accompaniment that envelops the figure with an atmosphere of correspondence."[85] Barbara Weinberg sees this mode at work in *Summer*, which shows a classic impressionist dedication to rapid rendering, rough brushstrokes, and luminous effects, but also shapes "solid forms" that bespeak "an academic bias," a female form whose clarity treats humanity with optimistic respect.[86] Sentimentalized femininity here conforms beautifully to the sort of expectations set by Wanamaker: it has a modernity that also supports a highly institutional regard for pleasurable consumption and leisured privilege.

Of course, leisured privilege had often been the focus for work by Monet, Renoir, and Manet too. But as Robert Herbert, Ruth Iskin, and others have explained, it was also a focus for critique; the leisure-class

pursuits these artists depicted were seen with a keen historical sense of the changes they entailed.[87] By contrast, Frieseke isolates his figures and purifies their pleasures. And decorative impressionism as practiced by Frieseke is also significantly distinct from the alternatives practiced by his contemporaries. He had much in common with Pierre Bonnard, William Merritt Chase, and George Bellows—three other painters carrying forward impressionist traditions, each in his own way. But whereas Bonnard took part in the postimpressionist interest in aesthetic design at the cost of natural beauty, fully flattening his decorative patterns, Frieseke persisted in fealty toward natural effects. Chase pursued a public sublimity that chastened any merely human pursuit of pleasure; Bellows represented the Ashcan School alternative, for which aspects of dynamic impressionist visuality were a register of strife, conflict, and contingency. By contrast, Frieseke's decorative mode was meant to enhance easy consumption; it was a commercial style, in effect, and this orientation transformed impressionism into a unique form of decoration. We might characterize it in terms of a synthesis of Whistler and Wanamaker. Pressed to reconcile his training in the more aestheticist impressionism practiced by Whistler with the consumerist modernity demanded by Wanamaker, Frieseke went to Giverny, where a second-order thematization of Monet's style could perfect a natural beauty for a finer class of customer. And this equation would prove serviceable for decades to come. Impressionism's future would often depend on the same combination of sheer beauty and cultured taste Frieseke found at Giverny.

So was this kitsch? And did it inaugurate a lastingly kitsch pseudo-impressionism? Before we answer these questions, we need to remember that Monet had constructed Giverny too; before anyone else, he co-opted natural reality in order to enhance natural effects, and all future inauthenticity only extended upon his sense that impressions were, after all, a reality first to be pursued by artful cultivation of the natural world. When he began to make the gardens his eye wished to see at Giverny—landscaping his pond water and secluding it from public traffic, heightening the key of floral coloration, protecting timeless seriality from unnatural change—Monet subjected his impressions to a form of management that shielded them from natural perception. As John House notes, "this was 'nature' wholly modelled to please the artistic eye."[88] Monet himself totalized the duality that otherwise rescued his art from the charges leveled against it—the sense that it was an art only of the eye, or, in other words, no art at all.

And that context for totality—that of Frieseke too—is crucial. If Monet had seemed just visual but became totally beautiful—his art at Giverny a product of beautified nature—he had found a way to recast the duality of his impression. The art of the eye alone is also fully aesthetic if what the eye sees has been subjected to aesthetic design. This totality differs from that of aestheticism, for example, since aestheticism's beautiful environments were not subsequently presented as natural realities. The decorative impressionism prepared for by Monet and perfected by Frieseke performed a very different trick, by which a closed system seemed to dissolve into the open air. Venturing further into the commercial realms of the department store and, later, the tourist site, this particular way of doing impressionist duality has a certain environmental bravado that recapitulates, as much as cubism, the dynamics of the *tache*. For if the aesthetic gesture corresponds to natural reality because the artist has already taken an interest in natural beauty, and if that interest extends to the commercial, any realism becomes that of the motive to beautify, the sincerity of the aesthetic performance. In other words, the *tache* becomes a gesture toward natural fulfillment separate from but parallel to that of naturalist figuration. This might seem to be the unity of *kitsch*—the preemptive inclusion of the reflected effect that Greenberg so opposed—but it actually excludes reflection altogether, by totalizing the natural impression. Without any room for the immediate impression to prompt subsequent reflection within the picture or without, this preemptive aesthetic has nothing to do with criticality, which is what at once creates the sense of a problem and solves it. The solution is easy pleasure, perhaps, but also a more comprehensive impressionism, one that doubles down on duality by aestheticizing nature and then making art environmental. A complex endeavor with radical implications for aesthetic practice and experience, this decorative impressionism could only go forth with a power equal to, if so different from, that of the cubist aesthetic that carried "art" more properly forward.

A DECORATIVE FINALE: IMPRESSIONIST MUSIC

Far less power accompanied this same aesthetic into another form: that of music. Although impressionism is a contested category in all the arts,

its status in music has been the subject of special disavowal. Not only did its main practitioner refuse it, its brief prominence was preceded and followed by emphatic doubt that impressionism could characterize a musical mode without doing more harm than good. Claude Debussy may have innovated a style dedicated to the improvisation of impressions, but he himself questioned the value of the term: "J'essaie de faire autre chose, en quelque sorte des *réalités*—ce que les imbéciles appellent L'Impressionnisme."[89] Others have followed suit—usually only using the term to suggest a comparison to painting that they then effectively disclaim. It makes its first systematic appearance in the 1908 *American History and Encyclopedia of Music*, which calls Debussy a "great harmonic inventor and an unsurpassed poet in mysticism" and credits him with "a vague, impressionist style."[90] In 1910, Louis Laloy published his landmark assessment of Debussy's impressionism, confirming the general sense that Debussy took part in that style of sensory realism.[91] Subsequent reference resources (rather than critical works) included entries for impressionism in the 1910s and 1920s; the 1930s saw more systematic accounts and some critical assessments, but the active use of the term then dropped off, mainly because of a general sense that the analogy to painting raised wrong expectations about musical forms. By 1980, Ronald Byrnside could express a consensus view that "Impressionism seems inevitably to create a frame of reference at whose center is painting, not music," and that it "gives rise to a practice of reading things into Debussy's music which may not be there at all and of obscuring other things which are there and which are crucial to a true understanding of his uniqueness and individuality as a composer."[92] More specifically, applying impressionism to music seems to involve inappropriate theories of representation, and once it no longer helped identify the sheer newness of Debussy's work, it seemed only to hold him to a wrong standard—more specifically, a decorative one. Definitions of impressionism in music coincided with the consolidation of the sense that the beauty of this genre was its artful nature—the naturalness predetermined by the longing for aesthetic pleasure. When dictionary definitions began to explain it, they shared a Giverny sense of what made impressionism desirable, and while that was compatible with (and truly beneficial to) a certain culture of visual art, it could not work for music. And it never did. Musical impressionism was a decorative problem from the start.

Although Renoir spoke with Wagner about the possibility, it did not enter musical discourse until the Académie des Beaux-Arts responded negatively to Debussy's *Printemps* (1887), saying, "His feeling for musical color is so strong that he is apt to forget the importance of accuracy of line and form," and that "he should beware this vague impressionism which is one of the most dangerous enemies of artistic truth."[93] But it became a friend to artistic truth newly conceived as a matter of subjective expression, just as it had in the arts of painting and literature. Primary feeling, registered in spontaneous response to the flux of phenomena, transformed music as it did the other arts, and Debussy's significance was that "he empowered music to create atmosphere, to evoke and suggest, to express in coherent though necessarily elusive terms these myriad subtleties and variations of nuance which had previously remained the exclusive preserve of painters and poets."[94] For Schoenberg, Debussy's impressionism was his way of using harmony without constructive meaning but instead for "the coloristic purpose of expressing moods and pictures," which "though extra-musical," became "constructive elements" themselves and "produced a sort of emotional comprehensibility."[95] Debussy was an impressionist for the way he gave music an improvisatory sound, departing from the system of major and minor keys, inventing strange new discordant harmonies, and giving timbre a new role in the evocation of atmosphere.

Then again, these revolutionary changes could not be attributed specifically to impressionism, which was distinct for the way it put them to certain uses: the reform of melody, experimental harmony, and new instrumental sonorities became truly impressionistic when they became representational. It was when Debussy's new melodies and harmonies evoked feelings—not just feelings, but feelings about life's realities—that critics were drawn to describe them in terms of the discourse of impressions. Picturesque nature (twilight landscapes, romantic seascapes), twinkling light, vibrant color, mysterious voices, the stuff of dreams: these were the ambiguous realities impressionist music seemed to evoke, and they gave a character to the mode, which was all about disruptive innovations geared toward feelings music had never explored. Its crowning moment was the *Prélude à l'après-midi d'un faune* in 1893, "the first fully-fledged Impressionist work of all," where constant flux could be heard to evoke a Dionysian natural rebirth.[96] That mode lasted for the twenty years of Debussy's most sensational work, and if it was actually

impressionist, it was because of the necessary tension between these representational aspirations and the essentially abstract character of musical composition.

The evocation of nature for which Debussy drew acclaim around the turn of the century was not a natural realism. Whereas realism in music involves mimesis of real-world sound, Debussy's sounds are those of an aesthetic musicality, evocative precisely because they have found a musical form through which to express feeling. In other words, his sounds of revelry or the temporality of distant bells are predetermined by what instrumental timbre or harmonics, however dissonant, can produce. Such predetermination is most fully in effect when the sounds involve the other senses—the sound of the sea, for example, or the play of light. Of course, this priority of the aesthetic register is what makes Debussy's music impressionistic; were it true sound, it would only be realistic, and the subjective, evocative alternative depends upon a formal remove from such a reality. But whereas this impressionist alternative might involve at once a finer art and a heightened reality—the aesthetic purchase might enable a keener sense of nature and its effects—musical impressionism must always seem to come at nature with an ear for beauty. Although the problem of impressionism here would seem to be its deconstruction of musical form, in fact the real problem is the construction of nature, the artificiality of the feeling music would invoke if it is taken to have natural correspondences. This is not to say that the musical evocation of feeling must be false, but rather that such evocation ostensibly responsive to natural reality must be artificial. To call music impressionist, then, is to emphasize its artificiality in such a way as to make impressionism itself seem absurd, not because it is too subjective or formless but because it has no basis for its aesthetic departures. Another way to make this point is to interpret the decline in the usage of impressionism as a musical category. In Debussy's day, there did seem to be some correspondence between his innovations and the feelings they invoked: when the innovations were new, they naturally seemed to have more to do with what they expressed than what they were, and they hardly seemed beautiful. But as they became standard to modern music, they detached from natural reality. No longer so likely to provoke an emotional response, they seemed less expressive and more musical—less impressionistic, and more formal after all. It becomes clear that the musical impression never had an intrinsically, lastingly referential aspect

to its style of evocation, and so impressionism becomes a less compelling classification. Because it only names a decorative aesthetic in which nature had been contained by art, it only briefly names an artistic vogue in music.

Leon Botstein's definitive account of Debussy's relationship to impressionism stresses Debussy's actual debt to Whistler, whose aestheticism inspired Debussy's music, because it had a keener sense—more radical than that of impressionism—of the way the artistic sensibility acts upon the world. For Whistler, "Purely aesthetic variables detached from external reality made their point using mundane subject matter by transfiguring it, offering the viewer something that could not be imagined or experienced except through the medium of painting."[97] Debussy followed suit, in music's own way, by taking music well beyond illustration, making it "an act of expression responding to the human being in life, creating consciousness through sound in response to the external world."[98] The external world was no real place, but neither was it predetermined by aesthetic expectations—certainly not those of a bourgeois aesthetic culture, which Debussy had come to revile. "Music's special mode of response to nature created for Debussy, as for Whistler, a mystery"; that more symbolist result finally had nothing to do with impressionism.[99] But Debussy might have allowed the designation if it were not for the fact that its application to music at this moment conjured up the wrong relationship between natural and aesthetic worlds.

Debussy himself seems to have recognized this problem when he dismissed the category as imbecilic. Most likely he resented what critics have seen as a wrongheaded subordination of music to popular painterly visuals—annoying to the cutting-edge artist, and so perverse at a historical moment in which all arts seemed to aspire to the condition of music. But that resentment is of a piece with resistance to the decorative. Debussy must have felt that impressionism was *au courant* because of the appeal of the cultural world the impressionist painters had created. He surely knew that he was meant to feel flattered by the association and pleased to participate in the natural aestheticism through which impressionism was seen to enchant the world. And he was right, probably, to resist that secondary thematic. It did distort his work as a composer, much the way it changed the status of impressionism itself in the years after Giverny. For the decorative thematic celebrates the evocative feeling at the cost of

formal innovation. Its kind of beauty implies that art is a way of life—no shame for the decorative itself, but a perfection that gives the aesthetic impression the status of natural pleasure.

That naturalization characterizes impressionism today. Even if impressionism led to the formal innovations essential to the postimpressionism that became cubism and fauvism, the forms of representational abstraction that would carry forward into conflicts still decisive in the theory and practice of art, it is known for its thematic beauty. This is not the beauty of a realist landscape or a fine design but rather that of natural elements deconstructed so that they are always already aesthetic. It is preempted by the feeling it would produce—the pleasure of taking part in a beautiful life, an enriching environment, a decorative aesthetic. So different to the legacy of criticality that runs through cubism, this decorative aesthetic combines with the avant-garde impulse to disorient us whenever impressionism seems at once to rouse and calm, to jolt and to affirm, as it does most powerfully in its most effective form: that of modern advertising.

2

THE IMPRESSIONIST ADVERTISEMENT

As to the others who—neglecting to ponder and to learn—pursue the impression to excess, the example of M. Cézanne can reveal to them as of now the lot which awaits them. Starting with idealization, they will arrive at that degree of unbridled romanticism where nature is merely a pretext for dreams and where the imagination becomes powerless to formulate anything but personal, subjective fantasies without any echo in general reason, because they are without control and without possible verification in reality.

—JULES ANTOINE CASTAGNARY, "BOULEVARD DU CAPUCINES EXHIBITION:
THE IMPRESSIONISTS" (1874)

All original cultural forms, all determined languages are absorbed in advertising because it has no depth, it is instantaneous and instantaneously forgotten. Triumph of superficial form, of the smallest common denominator of all signification, degree zero of meaning, triumph of entropy over all possible tropes. The lowest form of energy of the sign. This unarticulated, instantaneous form, without a past, without a future, without the possibility of metamorphosis, has power over all the others. All current forms of activity tend toward advertising and must exhaust themselves therein.

—JEAN BAUDRILLARD, "ABSOLUTE ADVERTISING, GROUND-ZERO
ADVERTISING" (1981)

What lot might await impressionism, even advocates like Castagnary could see. Its impressions could become license to subtract contingencies and contexts vital to cultural depth and meaning, enabling a superficiality that would thenceforth quicken and spread to become what Baudrillard, one hundred years later, would deplore: a shallow culture of meaningless sensations. Seen this way, what had been a bracing corrective to academic rationality came to invite unreason. A healthy lust for change became a model for mass-cultural restlessness. Interest in immediate seeing—even if it was never only that, in its moment—lent itself to a purely quantitative empirics, and subjectivism invited quiescent passivity, "fantasy and exaggeration," "self-indulgent mysticism," or, at worst, laziness or perversity.[1] Skepticism became nihilistic hedonism; winnowed information endorsed the production of experiential commodities; evanescence justified distraction. Impressionism devolved into what it never was: the "impressionistic," leading from high consequence to mere diversion, recklessness, and fraud.

It led, in other words, to advertising. Baudrillard's triumph of superficial form may have been secured by the kind of instantaneous, smallest-common-denominator signification specific to the impression. Advertising rewards the impression's inarticulate meaning, its immediacy, and its degree-zero minimalism; Castagnary's worst fears have been realized, if our way of pursuing the impression to excess has given us "subjective fantasies," without control and therefore subject to commercial culture as Baudrillard describes it.[2] For it may indeed be true that the main problem with advertising is its impressionism. Advertising's perceived faults—simplification, distraction, seduction, superficiality—match impressionism's quick takes and lush stimulations. Both trade in semblances, stimulating powerful subjective responses, passing without time for verification, prompting us to mistake their momentary messages for pressing information. These tendencies had at first enabled impressionism to galvanize human perception and enhance aesthetic freedom. But once it gained cultural authority its tendencies could be co-opted, used for different ends, exploited for their special use to advertising's "system of magical inducements and satisfactions."[3] And so we come to one of the more embarrassing questions about impressionism's legacy: do the impressions once so central to aesthetic and cultural renewal ultimately become the *distractions* of that "lowest form" that is the contemporary advertisement?

The larger context for this question is what happened to modernist art more generally. Ever since Volkswagen hired Salvador Dalí, ever since montage became a commercial format and product branding sought to "make it new," modernist art has seemed to exhaust itself in advertising. Whereas modernist aesthetics would seem to disallow the instrumentality essential to advertising and modernist avant-gardism would seem to betray itself by capitulating to materialist prerogatives, "advertising modernism" has been a definitive phenomenon, and one that has seemed to undermine modernism's credibility.[4] Roland Marchand has detailed the many reasons for this unlikely collaboration. Everything from modernism's simplified forms to its "expressive distortions" and "unresolved tensions" made it perfect for this co-optation.[5] And Fredric Jameson, Bruce Robbins, Russell Berman, and many others have drawn critical attention to the result, which not only diverts modernist oppositionality toward commercial pleasures but also makes a mockery of the modernist's adversarial stance. It is not just that modernism has been co-opted by advertising, but that it set itself up to sell out, preparing just those forms and devices that would enable it to enjoy cultural dominance through a hidden, hypocritical relationship to consumer culture.

For a striking example of this modernist hypocrisy, we might turn to Len Lye's 1935 surrealist film *The Birth of the Robot*, relevant for the way it presents the transformation from adversarial aesthetics to commercial advertising in just six minutes (fig. 2.1). Lye's surrealist film shows a robot making its way across the globe, through phantasmatic deserts and wild technological landscapes, finally discovering that "Modern Worlds Need Modern Lubrication"—lubrication best supplied not by the surrealist unconscious but by Shell Oil.[6] In the early 1930s, Shell commissioned work from a number of artists to help the company make the transition to the kind of advertising that builds brand loyalty through affirmations of taste rather than simple assertions of utility. By 1935, through the celebrated efforts of Jack Beddington, Shell had developed a reputation as "patron of artists and educators of public taste."[7] Indeed, Cyril Connolly (writing in the *Architectural Review* for 1934) called Shell "the new Medici," and Lye was happy to court Shell's patronage, as were painters including the Bloomsbury artist Vanessa Bell.[8] But even if Lye tacked on the advertising text adventitiously, to get financial sponsorship, he discovered that reciprocity through which modernist art would come to grease the wheels of commerce—nicely summed up in the title of a 1944 article in

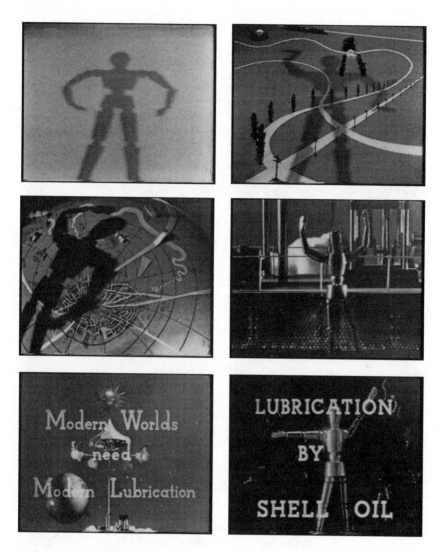

2.1 Len Lye, *Birth of the Robot*, 1936

Courtesy of Shell Global and the Len Lye Foundation

Newsweek: "Surrealism Pays."[9] Irving Howe summed it up too, noting in 1967 how "bracing enmity has given way to wet embraces," and Clement Greenberg feared that "an umbilical cord of gold" had stretched its way to the avant-garde from the world of capital.[10] Leslie Fiedler saw that "from a shocking anti-fashion [modernism] had gone on to become—with the

help of the mass media—a widespread fashion"; Terry Eagleton noted the "devastating irony" by which "the modernist work escapes from one form of commodification only to fall prey to another," delivering itself by its own aesthetic designs into the hands of mass culture; and indeed such lamentations of modernism's "unwitting collusions" themselves became, as Bruce Robbins observed, a "new commonplace."[11] From Greenberg and his contemporaries to Williams and Jameson, from earlier critical theory to Andreas Huyssen, Lawrence Rainey, Gerald Graff, Robbins, and others, cultural criticism has wondered at the way modernism "lights up the shop windows of late capitalism with its dazzling defamiliarizations," how its styles "do not disappear but rather drift into history as empty vessels waiting to be filled with reactionary interests in need of cultural legitimation."[12]

This critical context has special explanatory power in the case of impressionism. More than any other modernist form, impressionism was ready to perform these dazzling defamiliarizations, creating unique opportunities for commercial culture. So easily decontextualized into superficial, fleeting distractions, impressions set the very pattern for advertising's most deceptive work. Indeed, one history of modern advertising begins with a distinction between the kind that offers complete product information and something more simply suggestive—between "hard-sell," "reason-why" ads and what came to be known as "impressionistic or atmosphere" advertising.[13] In October 1911, the American trade journal *Printers' Ink* ran an "interesting assembly of views" on this difference between "'reason-why'" and "atmospheric or impressionistic copy,'" with most contributors still uncertain that simply creating a brand-positive feeling, a striking image without substance, could work best.[14] But a May 1920 article on this subject notes that "now the prejudice is gradually disappearing against impressionistic advertising designs."[15] Innovators including Earnest Elmo Calkins and Theodore MacManus popularized ads that "appealed to the images associated with the use of the product, rarely making any explicit mention of the quality of the product," shifting toward the kind of affective, impulse-oriented, distractive appeal that has since come to characterize branding and marketing more generally.[16] Now, "impression-based" advertising is known to lead both to "a more positive attitude towards the ad and to increased ad believability, indicating that this appeal type has dual effects in strengthening the intention to purchase." Although the debate continues—for example, into a 2010 *Jour-*

nal of Advertising article, "Measuring Soft-Sell Versus Hard-Sell Advertising Appeals"—it seems clear that advertising has developed its modern character through co-optation of the modernist impression.[17]

And yet this whole way of thinking about the co-optation of modernist forms may be too totalizing in its sense of culture industry dynamics. More than that, it may be too one-sided: when advertising co-opts modernism, modernism co-opts back, especially in the case of impressionism, where advertising's adoption of the perceptual dynamics of the impression subjects advertising to the same disorientations and reversals through which impressionism revolutionized the arts of the twentieth century. That is the argument of this chapter—that impressionism and advertising engaged in forms of mutual co-optation in the years of advertising's modern rise to dominance and impressionism's "drift into history." To trace the impression's peculiar apotheosis in impressionistic advertising is to discover a further development of its original duality. It may lead to the "zero degree," but it also goes the other way, emerging into dynamic alternation between distraction and attention, between immediate perception and removed abstraction. The unstable dialectic through which impressionism made such a difference to painting, literature, and film persists into the moment of Baudrillard's "absolute advertising," interfering with the kind of fast practical reason through which advertising achieves its ends, so that even as it appears to have been co-opted, impressionism actually sharpens its critical edge. And possibly rewrites the history of advertising, or at least offers one reason to give up on reactionary distinctions between commercialism and aesthetic value.

Which brings us, once again, to the question of kitsch. As we have seen, kitsch haunts any study of what impressionism has become, and the relationship to advertising only compounds the sense that its persistence happens essentially in the form of kitsch aesthetics. With advertising, however, our subject has a special relationship to this question: because it makes itself available to co-optation, impressionism is the very essence of kitsch as it has been defined in the classic accounts. Clement Greenberg defined it as the rear-guard debasement of avant-garde aesthetics, that mechanical, formulaic marketing of "vicarious experience and faked sensations" that is the "epitome of all that is spurious in the life of our times."[18] It works by borrowing from aesthetic culture but converting its devices into a profitable system, with the effect of making art too easy,

destroying the fundamental distinction between art and life. Impression-
ist advertising would seem to fit this description, insofar as it borrows
from the impression but puts its dynamics in the service of commerce,
making its perceptual vivacity a means of commercial seduction. How-
ever, advertising demonstrates how impressionism, more than any other
avant-garde aesthetic, prepares the way for its own co-optation. Its rela-
tion to minimal perceptual experience easily translates to that alone; the
simple pleasures of kitsch are achieved just by forestalling impressionist
emergence. At the same time, this availability indicates how a co-opted,
advertising impression might respond with a critique of kitsch—not just
to redeem itself, but to show how kitsch might restore the aesthetic it only
seems to debase. This response will be critical to our characterization of
impressionist advertising and also important to the larger argument that
unfolds as we move toward the present moment of apparently kitsch im-
pressionisms across the arts.

Impressionism readies itself for the form of kitsch that is advertising, it
would seem, because its impressions are incomplete observations, super-
ficial forms of understanding. But there is another line of attack on it, less
obvious but just as important, because it first explains how impressionism
could devolve into kitsch and then extends further, into rehabilitation of
both. According to this critique, impressionism was a problem not for its
excessive superficiality and simple immediacy but for its distance, detach-
ment, and—once again—abstraction.

This line of attack would begin by seizing on something like the delay
in Monet's process of production—on the fact that, as much as Monet
may have wanted to catch the light effects of a particular passing moment,
his impressions also required longer durations. Reminiscing about the
earliest motivations for his style, Monet said:

> In Algeria I spent two really charming years. I incessantly saw some-
> thing new; in my moments of leisure I attempted to render what I saw.
> You cannot imagine to what extent I first increased my knowledge, and
> how much my vision gained thereby. I did not quite realize it at first. The
> impressions of light and color that I received there were not to classify
> themselves until later; they contained the germs of my future researches.[19]

Impressions did not rule out classification or research; indeed, they of-
ten compelled such extension and distinction, as they did for James and

Proust. James often spoke of his impressions as *germs* too, or *seeds* that would plant themselves and then actively germinate in the soil of the imagination. He wrote that *The Princess Casamassima* (1886), for example, was the product of impressions received on the streets but then more extensively worked up: "this fiction proceeded quite directly, during the first year of a long residence in London, from the habit and interest of walking the streets. . . . And as to do this was to receive many impressions, so the impressions worked and sought an issue, so the book after a time was born."[20] And as we have seen, when James argues in "The Art of Fiction" (1881) that "a novel is in its broadest definition a personal, a direct impression of life," he is actually arguing *against* the notion (put forth by Walter Besant) that a novel ought to be a matter of direct *experience*.[21] He is out to gain a measure of remove from experience—and to celebrate that power of imagination for what it works up apart from what is actually seen or heard.

The same longer procedure is vastly more elongated in Proust, where walking the streets conjures up impressions that have been seeking an issue for decades. At the end of *À la recherche* (1913–1927), when Marcel trips on the uneven paving stones outside the Guermantes mansion, impressions received long ago finally truly occur to him. Having been sought since the sight of the twin steeples at Martinville and even since the flavor of the madeleine, these impressions turn out to be the product of extensive labor, and proof that in its first instances impressionism took time, work, and attention. Proust's impressions (like those of James) were but provocations to write, intimations of a vocation, and even if they might have seemed to bespeak a hedonistic or passive imagination, they could not end in one.

Product of immersion in the modernities of Algeria and London, these early impressions were worked up at *leisure*. But it is just here that the second line of attack on the impression opens up. At first, the very labor of creation involved promises that impressionism could model a redemptive mode of perception even for the masses. This was Mallarmé's hope, expressed in "The Impressionists and Edouard Manet," which equated impressionist perception with radical vision. To Mallarmé, it was "*intransigeant*"—the radically democratic product of "men placed directly in communion with the sentiment of their time" and willing "to let hand and eye do what they will, and through them reveal herself."[22] But it can be argued that the impression developed at leisure does *not* go directly from

the times to the eye; instead, it has to make its way through a different sociocultural formation, thus becoming subject to radical mystification. The "extension" that made it so much more than distractions might then look like distraction of another kind—a remove from the primal scene of light and color, time away from communion with the sentiment of the day.

Here is a distractive state very different from what "impressionistic" tends to imply, but no less crucial. In it, the relationship between real social worlds and impressionist imaginings becomes a little obscure, as it notoriously did in the case of Paul Cézanne. Cézanne famously wanted to "make of Impressionism something solid, like the art of the museums," and this wish could well have solidified impressions enough to be passed to posterity with their contingencies intact.[23] But then Cézanne was also famously detached—working at "a distance from humanity," and turning impressionism from an art of extensive engagement into one of timeless form. As James Rubin notes, "we should recognize the disengagement from social modernity that facilitated his aesthetic modernity": these impressions made for the museums lacked the contingency essential to their first revolutionary effects, and so they were presented to posterity as things at once too instant and too removed.[24] Either kind of distraction might not have led impressionism so far from its sources; together, they made for a deceptive immediacy, an emptiness of judgment, a superficial presumption—and these are the bad combinations that perhaps shape impressionism's unwelcome legacy.

They give impressionism what T. J. Clark calls its "complaisance at modernity," making it only very briefly *intransigeant* and "very quickly the style of the haute bourgeoisie," whose "dissolution into the décor of Palm Springs and Park Avenue" was "well deserved."[25] At once a leisured and a superficial distraction, Manet's "supreme indifference" vulgarized, impressionism becomes just what Lukács disliked about modernism more generally: a dispersed, detached mode of subjective representation, elitist or precious, without responsibility to the totality of social relations. It becomes what Fredric Jameson describes in *The Political Unconscious*, an effort to revive the human sensorium, to reperceptualize the world, that ultimately amounts to a form of quiescent passivity in the realms of both perception and politics.[26] And it therefore follows the path from Castagnary to Baudrillard, traceable through a series of pseudo-impressionist degradations: what Walter Benjamin called Abel Gance's "invitation to a

far-reaching liquidation" in the world of filmic reproductions;[27] the developments in music whereby "the delight in the moment and the gay façade becomes an excuse for absolving the listener from the thought of the whole";[28] the dynamism in twentieth-century popular art, in which instantaneous effects are less the pattern of shared modernity than the mystical vigor of the heroic auteur; postmodern fragments that are not positive mitigations of totality but failures of feeling; and perhaps most importantly, the moment in which advertising reached its apotheosis in the "zero degree" Baudrillard describes.

It has become common to blame modernism for some of advertising's formal mystifications. Raymond Williams has noted influentially that "certain techniques which were once . . . actual shocks" have become the "working conventions" of "deliberately disorienting" advertising styles, and Andreas Huyssen notes more specifically that "the use of visual montage, one of the major inventions of the avant-garde, has already become standard procedure in commercial advertising."[29] This recrimination leads ultimately to impressionism, which is a special source of the specific kind of disorienting shocks and montage effects useful to commercial tactics. Indeed, it is possible to argue that the nineteenth-century triumph of impressionism was repeated in the middle of the twentieth century to make advertising the truly effective agent of culture industry ideology it had not yet been. This neoimpressionist transition is described in Thomas Frank's *The Conquest of Cool*, where we find that American advertising only got the entranced devotion of a broad populace when it made a key change: it abandoned a pseudo-scientific rationality in favor of the impression's freedom, lightness, speed, and suggestiveness. "In the fifties," writes Frank, "the central principle of the advertising industry was 'science': ads were to be created according to established and proven principles, after thorough research" and in a "reverence for learning"—the result of which was ads that were "hyper-rational," "technocratic," Taylorized, and wordy. What replaced them, in the 1960s, were ads based in "clean minimalism," "hip consumerism," and quick-take imagery.[30] This new dynamic implicates impressionism in the style of mass deception that motivated the dramatic success of such revolutionary advertisements as Ed Vorkapich's 1969 Pepsi campaign. Here, "rapid-fire clustering of images" drew heavily on "the technique of visual montage developed in the photographs of John Heartfield and the films of Sergei Eisenstein."[31] Heartfield and Eisenstein had

drawn on cubism to develop this montage technique: as David Bordwell indicates, "the concept of montage constituted the Constructivists' recasting of the Cubists' practice of collage," and Arthur McCullough too notes that Eisenstein's purposeful version of montage's "connecting shocks" came "partly from collage, which John Heartfield and George Grosz in turn derived from Cubism."[32] If, as we have seen, cubism has a history in the dual dynamic of the impressionist brushstroke, there is a line of development here from impressionism to Vorkapich. In Vorkapich's Pepsi spots, impressions ever more elusively composed together helped revolutionize the relationship between advertising medium and corporate message; the apparent untruth of the vestigial slogan, "You've got a lot to live, and Pepsi's got a lot to give," was easily lost in the distractions provided by quick cuts among scenes of all-American iconography, here and in subsequent advertisements that would follow Vorkapich's lead.[33] The 1969 spot begins with a voice-over introducing a montage of random feel-good moments with no apparent connection to each other: "Recognize it? This is the world you live in. Packed with simple pleasures, places to see, people to love. And Pepsi Cola is the one cola that belongs with every happy hopeful moment you live."[34] Each "happy hopeful moment" then depicted cuts quickly to the next, interspersed with quick-take shots of Pepsi bottles and fizz, as if to suggest that the real pleasure of life is a kind of insouciance that Pepsi bubbles up.

According to this line of argument, impressionism ends up here not only because it popularized promiscuously superficial, minimal, evanescent imagery but also because it licensed such imagery through that other mode of distraction—its detachment, or decoupling from the contingencies that might have kept the impression's immediacies true to their social contexts and social responsibilities. The bad combination of "superficial form" and "complaisance at modernity" is the problem.[35] Yet this same combination should provoke other questions that may lead us to doubt whether what we have here is yet another case of co-optation. Moreover, because this critique replays debates so long fundamental to the neo-Marxist critique of modernism, it may be time to ask if it still holds good. New approaches to cultural history, indebted to but pitched beyond the neo-Marxisms critical of "superficial form" and "complaisance at modernity," encourage us to revisit impressionism with a new appreciation for its combination of effects—with insight into the way its distractions recuperate and redeem aesthetic perception.

According to Jonathan Crary in *Suspensions of Perception*, "modern distraction was *not* a disruption of stable or 'natural' kinds of sustained, value-laden perception that had existed for centuries but was an *effect*, and in many cases a constituent element, of the many attempts to produce attentiveness in human subjects."[36] It was not the violation of some naturally good attentiveness, but rather a by-product (often liberatory and very needfully relaxing) of an attentiveness produced by efforts to make perception fixed, compulsive, and productive. There is a reversal here, not unlike that at work in Benjaminian distraction but more perpetual, because it requires us to think in terms of "regimes of reciprocal attentiveness and distraction."[37] In other words, Crary describes formations in which the two reciprocally coexist, producing and counteracting each other always in the service of regimes of perceptual administration. In his account, both are products of a turn to a subjective model, which Crary places around 1800 and describes as the opportunity for capitalist rationality to take instrumental control over the perceptual capacities of the human subject. Control meant compelled attention, but also regulated distraction, in various and unstable combinations. In these combinations, attention was paradoxically often a problem of savage excess, with distraction as a calming antidote; or attention could be the mode of the automaton, or an excessive fixation on the present—desirable, but from which breaks of distraction were necessary to allow for some form of human agency. Neither is simply good (since both are instrumental and dehumanizing) but neither is fully bad (since each presents some sort of opportunity for mitigation of what instrumental reason enforces). This more wholly critical take on the terms of perceptual management allows for an account of nineteenth-century culture that gets past the more simply agonistic model in which attention and distraction play hero and villain. And it allows for a more incisive account of impressionism (then and now) as a "regime of perceptual attentiveness and distraction"; it challenges us to discover exactly what sort of reciprocities impressions entailed, and exactly how they worked with or against the regimes that have been their contexts of action.

One example is Seurat's "decisive understanding of the synthetic and disintegrative processes within attention."[38] Another is Cézanne: "But the rigor and intensity of Cézanne's quest for presence disclosed to him its impossibility and opened up for him a view of the mixed and 'broken' character of a fully absorbed perception."[39] In this "broken" perception,

attention becomes distraction, and subsequently in distraction there is opportunity for provisionally free forms of attention, viable at least until regimes of attention find ways to cycle them back into administered responses.[40] This mode of broken perception breaks new ground, in Crary, for a corollary theory in which the impression partakes of the "dynamization of attention"—a dialectical process by which attention is not destroyed but produced, intensified, overwrought, resisted, and redirected.[41]

To think that impressions (then or now) cheapen culture may therefore be to think undialectically, to revert to a deadlocked cultural theory too rigidly given to assessing perceptual forms for their potential for subversion or containment alone. And yet it is hardly more dialectically astute to call impressions distractions and then pit them subversively against regimes of attention. Better to see this dynamic of distraction and attention at work within impressions themselves, and to trace its fuller historical and perceptual complexity. If we revisit the history of the impression with this dynamic and dialectical sense of the way the impression participates in "modern attention," we must take a rather different view of both its "intransigence" and its "disengagement." Each would now appear fully produced in and through its opposite, and we would find in the impression a distractive attention or attentive distraction serving the "provisional realm of freedom" Crary defines.[42]

When Henry James masks ideological commitments through the impression's detachment, he does so, as we have seen, in argument against that more direct model for perception that might make art too much a matter of plain experience. But he also does so in order to argue against a model for perception that would keep writers from writing about experience not their own. In other words, the argument cuts both ways: it detaches the effete artist and perhaps encourages his complacency, but it also relieves the less privileged consciousness from compulsory attention to what it is permitted to know and no more. In "The Art of Fiction," James finds "chilling" those theories of the aesthetic imagination that would say, for example, that a lower-middle-class writer should limit himself to subjects appropriate to his class; against such theories James alleges the liberty of the imagination, and the power of impressions to cross class divides and translate experience from high to low. Walter Besant had said that "the novelist must write from his experience"—that "a writer whose friends and personal experiences belong to the lower middle-class should

carefully avoid introducing his characters into society."[43] James counters that such a writer might in fact produce the best depictions of society, since they would be full impressions rather than experiential facts. This is either a strange contradiction or an aesthetic commonplace, but one that makes perfect sense and a big aesthetic difference within the context of "regimes of attention." For James's impression then becomes a way to play attention and distraction off each other so that fiction can meet across class divides. The lower-middle-class writer can "enter society" the more his impressions fail to conform to proprieties designating what one may see, and if we always equate distraction with detachment, we will miss the intransigence of the impressionistic. In the last analysis, the realm of freedom James's impression opens up is one of provisional critique—as by offering, in this case, a staging ground for a lower-class incursion into high aesthetics. Here, then, critical responsibility is not only maintained but heightened, insofar as impressions entail productive failures to attend only to one's own social world.

When Virginia Woolf repeats Manet's "supreme indifference" by proving happiest to work up her impressions in subjective solitude, she also simulates Cézanne's dedication to "the mixed and broken character of fully absorbed perception." Nowhere is the dynamic chiasmus of attention and distraction more evidently productive than in Woolf's impressions, which always partake of both intense focus and subjective dissolution—full presence and absence of any fixity upon objects themselves. To appreciate this state we might return for a moment to Benjamin, who knew that reception in distraction could mean a kind of "high-speed vigilance," a "new kinetic apperception, one opened out and agitated, as it were jolted."[44] As Howard Eiland has noted, Benjamin sought in the apperceptual changes at work in mass culture a "pedagogic function" rather than simply an impoverishment, though he was kept from finding this function by a lingering distrust of the "cult of the ephemeral" that made him unsure about endorsing mass-cultural spectacle on any terms.[45] The case of Woolf suggests, however, how a truly impressionistic appreciation for the ephemeral might purge this distrust and reveal this "kinetic apperception" to be just what Benjamin hoped the perceptual regime of modernity might enable (in spite of itself). In Woolf, the mutual agitations of attentional failure and success, of distraction and absorption, of concrete and abstract modes, jolt up a kinetic stimulation evocative of aesthetic

perception as elaborated by Kant—one marked by propositional junctures of sense and reason, by judgments that activate a critically diverse range of human capacities. Clearly, real resistance to ideological control might demand much more than any such mode of merely aesthetic perception. But if we can see how ideological imagery itself provokes this elemental resistance, activating misprision in the very combination of attention and distraction through which it would do its work, we might change our view of "the ideology of the aesthetic": *aesthesis* (as dynamic perception, rather than judgment of the beautiful or transcendence of the practical) might emerge as the pattern by which spectatorship performs what ideology demands yet in that very performance inevitably opens up chances for resistance.

What essentially motivates these aesthetic failures of attention, these productive distractions, is the broken or mixed structure of the impression itself. The impression's dual nature has enabled syntheses, dialectics, and performances that not only made it the very agent of modernity in its day but also fostered a dynamic structure in the history of modern painting, inviting abstraction in the postimpressionisms of Seurat and Cézanne, then in cubism and beyond. With cubism, impressions became abstractions, and that evolution defines an afterlife that we might now follow into the longer history of consumer culture. There it becomes a kind of perceptual disorientation, or what Crary calls a "creative synthesis that exceeds the possibility of rationalization and control."[46] It becomes a productive failure of sustained attention that redeems the "impressionistic" and even the commercial forms devoted to it.

That it also matches the classic modernist "delay" points the way toward a certain redemption of impressionist advertising. Discussions of modernist art and literature often turn on the classic modernist effort to "forestall instant consumability" and thereby to resist the incursions of the marketplace.[47] But whereas treatments of this delay have tended to see it at work mainly in negation (in the way modernist works obscure what they are "about" or create theatrical withholdings), this reading of the impression's legacy of provisional disorientation finds the delay in an active moment of perception, and thereby makes it something potentially much less available to simple co-optation. Brechtian rhythms or futurist typographies can be domesticated for commercial use, and their adversarial postures do nothing to limit this availability once such postures become a "commercial pleasure." The impression's delay, by contrast, is a

matter of fundamental cognitive misapprehension, which leaps to new attention at its own pace; it is a systemic frazzle that survives even despite the commercial system that would make a pleasure of it.

But even so, can such a redemption make the impression, as realized in Cézanne's legacy to cubism, a truly persistent critical force, a truly disruptive one? And what could enable it to persist as such into the practice of advertising?

The longer historical view has enabled Crary to reconceptualize human attention and to reach new conclusions about the relation between attention and regimes of cultural control. This longer view finds an open dynamic in what much cultural criticism has often seen as totalities or systems closed, by their very nature, to insubordination. If we turn now to a comparable reconceptualization, regimes of cultural control considered "total" in the tradition of cultural criticism likewise invite new consideration. In his history of the culture of advertising, Jackson Lears updates our image of the culture industry by isolating its most pernicious totalization to a narrower phase: advertising took up the project of cultural containment mainly in its mid-twentieth-century moment. Before and after, it entered into far more vulnerable engagements with precisely the form of perceptual dynamism entailed in the impression. In our first genealogy, the impression could be extended into advertising's peculiar combination of intensity and disengagement; it might be responsible for a commercial culture of superficial, instantaneous, irresponsible perceptual effects. However, that side of the impression essentially alternates with its opposite, to model a kind of perceptual dynamism whose effects would be very different—aligned instead with a fundamental kind of aesthetic delay. It remains now to find this dynamic resistance at work in advertising. And Lears's account of advertising's perceptual heritage shows how even the impression's mass-cultural legacy is one of "mysterious shiftiness" and dynamic perceptual intervention.

Lears reminds us that there is nothing essentially reifying in advertising itself. In its earliest phases, it was very much a mode of enchantment and animism, and even if deceptive, it was not fundamentally the mode of ideological deception we often take it to be today. Only when advertising became a corporate profession, and only when a managerial culture developed with an aim to limit and restrain what had come to seem too excessively a "culture of abundance," a "carnivalesque atmosphere of ever-shifting surface sensations," did advertising succumb to "the dream

of a market culture brought under technocratic control."[48] Then there de-veloped the "managerial idiom" that conformed itself and its public to "standards of bureaucratic rationality."[49] This was the moment of totaliza-tion—and, not coincidentally, the moment of *Dialectic of the Enlighten-ment* (1944) and of cultural criticism's greatest pessimism about the cul-ture industry. The great influence of that pessimism can make us forget that advertisements do not in any simple way conform, or conform their viewers, to regimes of social control, and that advertising prior to the mo-ment of "the managerial idiom" opened itself to aesthetic disorientation. The place to look for the legacy of the impression, then, would seem to be not the perceptual structure of advertisements that conform to "stan-dards of bureaucratic rationality," but rather those that, before (and af-ter) the moment of those standards, risked their business in order to try for the impression's perceptual dynamism. Ronald Berman puts together the histories of art and advertising in such a way as to clarify the terms of the risk. He notes that "advertising depends upon recognition" and is therefore "rather nervous about abstract or impressionistic techniques of imaging things."[50] Its "striking visual effects" tend toward cliché, to guar-antee the recognition necessary to simplify human responses. For Ber-man, this tendency aligns advertising with realism—what Kenneth Clark defined in terms of "landscapes of fact."[51] Both pursue an art of "dupli-cation"; each "pictures objects without interpreting them," and "the as-sumptions of advertising come from centuries of representational art."[52] But if "advertising continues a tradition of describing the material lives of a new social class" that perpetually reasserts its realist prerogatives, any turn to impressionism introduces a contrary impulse, one that "has gone from Manet to Minimalism" and entails not superficial distraction but a style of distraction very different for its focus on *form*.[53] If impressionis-tic advertising disallows attention to real circumstances, it is important to note that the reality in question is that of bourgeois realism, and that inattention to it has the quality of the estrangement that formalism, by contrast, presupposes. In other words, Berman discovers Crary's critique of attention in the history of advertising forms, suggesting that impres-sionistic techniques could only unseat realist ones at a cost to advertising's essential social status.

Despite conventional wisdom, modernist forms were not comfortably co-opted by advertising. Advertisers did try to incorporate the images and

styles of impressionism (as well as cubism, futurism, and surrealism), but they found that such incorporation could only be minimal if it was not to interfere with real sales. In Lears's account, advertising flirted with modernism in order to reanimate a dying industry, but then quickly turned back to "literalist realism" once it became clear that modernism created too much ambiguity. "The influence of formalist modernism was short-lived," left behind by the end of the 1930s because of the limits it placed on direct expressivity.[54] Roland Marchand notes that the infiltration of modernist styles into advertising art raised "excited comment" but also "dismayed alarm," because of such things as "the modern artist's absorption in self-expression, and scant concern for communicating his ideas to others," which would render advertisements uselessly opaque. In the next decade there was a return to the "homely," and advertising became "Norman Rockwellish rather than Rockwell Kentish."[55] Marchand and Lears both note that advertising never really went modernist *enough*. Had it done so, it might have amounted to an insider challenge to instrumental reason, to commercial reification, and a help to what Lears sees as the suppressed potential of advertising in its relation to a culture of commodities: "a reanimation of playful relationships between people and things, against the disenchanting power of productivist rationality."[56]

A 1937 *Parnassus* article supports this point. Paul Parker's "The Modern Style in American Advertising Art" notes that "the modern style is ill-adapted to most advertising" because the images it produces "call too much attention to themselves."[57] If "the main way of gaining attention is to eliminate distractions," modernist forms fail advertisers, who need "instant legibility."[58] Because they see "apples [as] apples, not problems in form," advertisers would "hardly purchase the reproduction rights to a Cezanne still-life."[59] Parker's choice of words is helpful here. When advertisers use impressions to get viewers' attention, that attention ends up being a form of distraction; misdirected, it sets up a division in which the instantaneous impression in fact forestalls instant legibility and engages a perceptual dynamic rather than commercial apprehension. Apples become problems just as Cézanne years before had hoped they would.

This reassessment of the relation between advertising and "managerial culture" parallels Crary's reassessment of "attention": in both cases, regimes of cultural control are built upon engagements with perceptual free play that cannot be controlled altogether. We have related this effect

to Crary's history of perception; we can relate it also to Lears's narrative and end up with a parallel commercial formation in which corporate advertising gives itself over to a dialectical alternation between the attention it wants to compel and the distractions it needs to render that attention desirable and even possible. Its apparently superficial, promiscuously instantaneous impressions (the kind that form montage in Vorkapich's 1969 Pepsi campaign) fan out, but aim to rein attention in; their managerial subtext, ironically, enables the dialectic whereby an otherwise "zero degree" mode of information can provoke a substantial perceptual process.

An example that may be yet more telling, both historically and formally, is another of Len Lye's modernist advertisements—one for the postal service, not surrealist but postimpressionist. *A Colour Box* (1935) is a three-minute "direct" film (one in which images are painted directly onto celluloid) made up of wild, entirely nonrepresentational sequences of color (fig. 2.2). Waves, floating spots, and fauvist curves streak in and out of view, and a soundtrack of Cuban dance music lends further vitality to the sheer, liquid display of unrestrained chromatic energy. Absolutely without content, *A Colour Box* seems an unlikely vehicle for advertising, but as in the case of *The Birth of the Robot*, Lye financed the film by finding a commercial sponsor.[60] Here sponsorship entailed superimposition of text advertising new lower rates at the post office. Among the psychedelics float new prices, and finally the phrase "Cheaper Parcel Post."[61] Like *The Birth of the Robot*, this film seems a classic example of modernism selling out. So incompatible, however, are its images and its prices that it proves a striking example of something else.

The lack of representational relationship between image and text makes *A Colour Box* a likely source of that "dismayed alarm" with which advertising executives often received the early combination of modernist forms and commercial messages. The film's postimpressionist effluvia might have helped to convey the new dynamism of parcels sent more cheaply, the new freedom to get messages across, but mainly the film creates a sense of disjunction. Its direct messages seem wildly out of sync with its colors, so that the information conveyed is less about cheaper rates and more about the kind of cognitive disjunction awaiting participants in the impressionist culture of advertising. The impressions never amount to a commercial message; far from it. When that message appears, and the

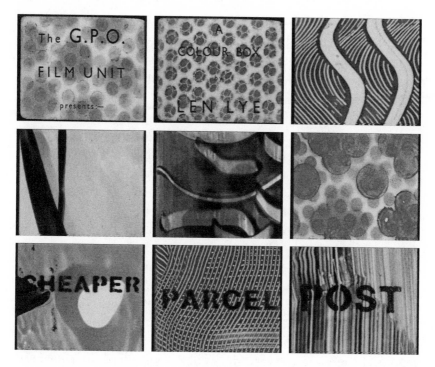

2.2 Len Lye, *A Colour Box*, 1935

Courtesy of the Len Lye Foundation and the British Postal Museum and Archive. From material preserved by the BFI National Archive

viewer tries naturally to imagine how the prior images might support it, they seem both to exceed and to fall short of the concept superadded. And yet, once proposed, this divergence injects itself back into that prior flood of impressions. They too seem to involve an interplay between concrete and abstract meanings—are the waves of color things or forms?—and the overall effect of their play of divergence is to replace narrow commercial recognition with more broadly "kinetic apperception." Happy to watch color designs float across the screen, suddenly confronted with a promotional message, the viewer who reads the text is compelled retroactively to reread the imagery. Did it, then, mean something too? Were those forms things—or does the association work the other way, and does the promotional information accede to simpler evocation, of some epistemic liberty unrelated to any actual commercial pursuit? Such questions multiply

at the level of basic perception, disallowing the "instant legibility" Lye's simple impressions might have seemed to promote, generating instead a set of modernist disjunctions.

And it is this multiplying disjunction that is the legacy of the impression. Not the unbridled, fleeting, superficial color display alone, but its incommensurate linkage to the text, and the way images meant to promote a meaning become the objects of kinetic apperception as we try to read that meaning back into them: this is the authentic dynamic through which the impression makes its way into commercial culture. Whereas Castagnary had worried about the impression's legacy of irrational and subjective fantasy, and Baudrillard has seemed to imply that we might find that legacy in the exhaustion of meaning and triumph of superficial form in advertising, Lye takes part in a different heritage that leads from the impressionists' mixed efforts at perceptual immediacy and abstractive distance to these fitful encounters between free color and managed meaning. This same dialectic would persist in later years, when the "managerial" approach in advertising lost ground and the pendulum swung back toward the use of modernist forms. Impressions put in the service of the commercial message always tend toward this same inadvertent ambivalence, a result that Lye's proleptic and flagrant version can help to theorize. Advertisements like Vorkapich's 1969 Pepsi campaign and its stylistic successors try to make a fleeting series of atmospheric impressions create a positive feeling for their product while also distracting away the possibility of any critical judgment against it. But this very combination of intense instants and distractive movement appears to generate a cognitive effect running counter to, or vitally supplementing, anything that could simply sell the product.

But if impressionism somehow renders dialectically kinetic certain advertising efforts both to compel attention and to profit from distraction, does it therefore make any real difference—for example, to those of us who would want mass audiences to mount more critical resistance to consumer culture, or to those of us who would want to see that culture lose what might seem to be its total control over art and human values? Or to those of us who might want to cultivate impressionist sensibilities against that total control? It can make a difference, if we understand it to be consumer culture's own way of cultivating the perceptual complications, delays, and misrecognitions modernism at its best tried to teach. The critique

of consumer culture could look back to impressionist perceptual practice to find the pedagogical model for adversarial versions of commercial impressions. Retrospective, this possibility is forward-looking too. As Daniel O'Hara and Alan Singer have noted in their work on "reimagining the aesthetic within global modernity," the old utopianism that reached its farthest point in the modernist aesthetic—the "power of the aesthetic to mediate the binaries"—is "paradoxically enough both obsolete and freshly urgent."[62] It is freshly urgent because of the possibility that there is "another line of post-Kantian aesthetic speculation left undeveloped" that could justify a "new aesthetics" with "important cognitive, ethical, and political dimensions."[63] This impressionist version of aesthetic mediation might refresh our approach to the aesthetic within global modernity by restarting the pursuit of modernist *aesthesis*, the locus of what Jacques Rancière calls the "sensible fabric of experience" within which works of art are produced, first finding the link between politics and aesthetics in dynamics of perception and cognition (rather than in standards of taste, qualities of objects, or powers of transcendence) and calling attention to the public styles and languages through which this aesthesis operates.[64] For even if modernism in general has not survived its co-optations, some of its specifically perceptual dynamics have been intensified by commercial forces, creating the opportunity for a neomodernist aestheticism that would also constitute an engaged mode of refusal, an oddly new "regime of perception, sensation, and interpretation of art."[65]

To celebrate this impressionist legacy, we might situate it in the context of the critique that would treat it most skeptically. Adorno and Horkheimer indirectly trace the history of the impression when they refer, in *The Dialectic of Enlightenment*, to the cultural life of the "detail." In this account the detail "won its freedom" in modernism, where it ultimately became a "vehicle of protest."[66] Thereafter the "totality of the culture industry" made the detail serve the formula, crushing its insubordination. This is impressionism's co-optation at its worst—the darkest view to take of the impression's fate in consumer culture, and, because so comprehensive, the least open to debate. But debate reopens if the impression's "freedom" is in truth not lost to advertising but rather what we see in *A Colour Box* writ larger: that surprise of antithesis enacted by totality's very aspiration to manage the full range of perceptual life. Thus if we inhabit a culture of impressions today, we seem to have inherited the modernist

dynamic whereby the detail first won its freedom. And if critics are right to say that this dynamic has been "absorbed and co-opted by Western mass-mediated culture," we may be surprisingly fortunate. For this absorption surely means an enrichment of that culture—and a continuance of the reverse co-optation through which modernism first violated the rules of perceptual management.[67]

The problem of impressionist advertising encourages us to return to that moment and trace forward the history of mutual co-optation, showing one way to take seriously the possibility that "advertising art" is as much art as advertising, or that no valid distinction makes the phrase a contradiction in terms. "Advertising art" is a phrase used as early as 1928, when Gustav Friedrich Hartlaub affirmed that "all art is advertising" in an article that takes a very different view from that for which Adorno and Horkheimer are so much better known. Recognizing that art would seem most often to undermine the effort to sell a product, "suggesting instead a futile nullity," Hartlaub argues for a supplementary effect much like that which we have discovered in the legacy of impressionism: "Art in the service of contemporary business may not be great and good just because the latter is (or is alleged to be) great and good. Rather, art disseminates intrinsic value of its own volition, and, at its best, may subsequently 'ennoble' commercial goals."[68] This peculiarly subsequent ennobling matches the temporality whereby commercial goals are undermined by impressions. Hartlaub asks why the businessman should bother to "bring his commercial needs and the claims of art into ever renewed struggle," and answers with a capsule history very different from that which tends to dominate our way of thinking about this struggle:

> When modern business began to fulfill its task of instructing the masses through advertising, it succeeded, in the midst of an undeniable crisis in capitalist bourgeois thought, in providing a bit of justification, purification, and even "atonement" for its ever more problematic principles of commerce and advertising by way of its respectable advertising esthetic qualities.[69]

Aesthetic atonement for capitalist commercialism: this is a possibility for advertising now lost to us. And yet it is a possibility impressionism continues to create, when its "aesthetic qualities" are those of implicit protest,

of perceptual freedom. Hartlaub saw, in his day, what had begun to subordinate those qualities to advertising as we understand it today. A reaction against "romantic tendencies" (what would characterize the mood of the 1930s) entailed a loss of the balance necessary for a true "advertising art"; "the 'sign' overcame the 'image,'" Hartlaub lamented, so that the modern aesthetic could not assert its redemptive distractions.[70] "Today we are in crisis," but that does not mean that advertising has lost forever its potential for aesthetic atonement.[71] Hartlaub finally speaks to the persistence of the impressionist possibility when he affirms that "an imagistic, joyful kind of advertising art can certainly be introduced again."[72] Its persistence would be no surprise to those of us long certain that nothing distinguishes advertising from art, but it might make a difference to the spirit in which we affirm it. Whereas the long-standing revaluation of pop-cultural forms celebrates commercial aesthetics, the affirmation of impressionist advertising specifically would reconcile that revaluation to older valuations of art itself. It would see in commercial aesthetics not just a progressive leveling of art and commerce but a more truly progressive dialectic in which the two perpetually "ennoble" each other, spurred by the dynamic reversals impressions had begun to enact prior to the very effort either to distinguish or to liken the commercial and the aesthetic, the mere impression from that which founded modern art.

The result disallows kitsch, but also includes it in the process of "atonement." We have noted that the impressionist advertisement might seem to be the very essence of kitsch, insofar as it entails the classic debasement of avant-garde aesthetics while debasing a form always already prepared for the reduction to quick and easy commercial stimulation. Such an assessment may seem valid even if we no longer credit the distinction between avant-garde and kitsch because it lingers in what has been, by comparison, a durable distinction between aesthetic and commercial art. As a version of the latter, the impressionist advertisement would still seem to be a debasement of the former, even if we wouldn't still characterize it specifically as a kitsch violation. But the old terminology is helpful here, for the way it might clarify a more positive assessment. The impressionist advertisement *is* kitsch, since it *does* co-opt an avant-garde aesthetic for a commercial purpose, and because it does co-opt aesthesis itself.

But that is where a new aesthetic emerges, in the way the impressionist advertisement repurposes the old process of art's critical emergence from

raw sensory perception. To explain this emergence, and to conclude this chapter with a summary sense of what yet makes contemporary advertising impressionistic, we will turn finally to an example that is important for the way it literalizes the problem in question.

"The Swimmer," the immensely successful 1992 campaign for Levi's 501 Jeans, a brand renowned for its successful soft-sell, "brand personality" advertising, may be the only advertisement not just co-opted but actually adapted from an impressionistic artwork.[73] The artwork is the John Cheever short story by the same title. Cheever's story famously shows Neddy Merrill swimming home from a party across all the backyard pools in his suburban neighborhood. As the weather changes not just by growing darker and colder but by turning from summer to autumn, it becomes clear that Neddy's perception of his world is unreliable. What he perceives as a single day's frolic has actually taken place across weeks; his mind has composed fragmentary consolation against the reality of his life, which is now a shambles of divorce, insolvency, and disgrace. Despite its surreal quality, the story is a late-impressionist invention, a reprise of the sort of revelation Woolf often enacts: in both cases, radical subjectivism dissolves the story world, and when it is factually contradicted, that only stresses its representational vitality. The story's refrain—"Was his memory failing or had he so disciplined it in the repression of unpleasant facts that he had damaged his sense of the truth?"—stresses a subjective fallibility but also the sort of truer truth that is often recompense in impressionist fiction.[74] The story qualifies as an impressionist text for its highly subjective, fragmentary, sensorially vivid style, as well as its emphatic distinction (at once stylistic and thematic) between appearance and reality. And because Cheever makes Neddy's vivid but wrong impressions a critique of suburban complacency, his impressionism has all the range of this mode at its fullest. It equates the impression's failure to emerge into larger validity with upper-middle-class American insouciance, backing its overt story with classic impressionist perceptual allegory.

When it becomes a Levi's advertisement, however, its dynamics seem to shift into something more superficially appealing, suggesting a kind of kitsch perfection: if impressionistic advertising is already kitsch, and especially so, given impressionism's own kitschy susceptibility, here we have the kitschiest thing possible. The ad begins with a pan up from a white picket fence across children playing in a suburban backyard to a young

man's midsection, clad in Levi's and a white t-shirt, which fills the frame. The young man jumps a hedge into the next yard, where he is met with a surprise that becomes admiration as he takes off the t-shirt and dives into a swimming pool—not having taken off the jeans. Then it is on to the next pool, and the next, with a patrician wave and more admiring gazes over expensive sunglasses and cocktails. This sequence follows the premise of the Cheever story, but with a significant difference: whereas Neddy Merrill's strange itinerary takes place amid complex social banter and interior reflection, the ad's swimmer is just a beautiful body, and his iconicity alone seems to justify his actions. Transforming the story into an opportunity for sexy display, the ad takes advantage of what was impressionist about it to produce something merely impressionistic. It seems fragmentary, dissociative, and random—as senseless as it is sensually compelling. What had been a subtly trenchant social critique, a suggestive moment of suburban satire, becomes a light, fun, glossy chance at instant gratification, literalized when the swimmer grabs a girl off a lawn and takes her on to the next pool with him.

But the ad also risks a complication when it follows the story somewhat too closely. Cheever's version starts to get sinister when summer turns to autumn and Neddy explicably dives into leaf-strewn waters, shivering with the cold. The ad also shows autumn leaves, and although the effect is still pretty—the swimmer dives into water gorgeous for the contrast of deep blue and autumnal orange, all seen dramatically from below—it seems to exceed the terms of advertising instrumentality. The image is needlessly beautiful, as is one that ends the ad. The last pool finds the swimmer and the girl he has stolen from the last garden party (she has stripped down to her underwear) diving together off a high board, careering through the air with symmetrical, choreographed grace. Again there seems to be more aesthetic reward than the ad's thematic purpose could sustain or match. Aesthetic intensity oddly raises the stakes, heightening attention not just to the ad's commercial message but also to its status as information; strangely distracting, it draws focus upon its own priorities, and, given the fact that the ad has not yet revealed any more practical purpose, these aesthetic priorities dominate. Merely kitsch pleasures abound, no question, but the ad lends them excessive freedom, equating their sensuous liberty with that of the swimmer. When ultimately the brand identifier asserts itself, potentially to contain aesthetic energy for commercial

uses, a slogan sustains something very much like aesthetic liberty. One last image of the diver hitting water contains the phrase, "The more you wash them the better they get." As a conclusion that retroactively redefines what has preceded it, these words initiate revisionist narrative action, putting what had been merely wayward visual energy to use at another level. The effect is not unlike that of Len Lye's sudden reference to "Cheaper Parcel Post." Here again a disjunction of word and image, a late legacy of the impression's own duality, gives impressionist advertising an open relationship to its bases in art and commerce.

That openness was initially seen to be a problem by the ad's creators and their clients. "In pre-launch qualitative research response from the consumer on first exposure to Swimmer was one of stunned silence": market researchers weren't sure Levi's should run the ad, given the strong weight of negative reactions.[75] But then, "two months after airing, research uncovered a marked shift in response. Swimmer had become a talking point; new, different, challenging. A further four months later and Swimmer was being widely described as one of the best ever Levi's ads."[76] Not, of course, one of the best ever works of art, or a best way to achieve human insight: the point here is not that this ad transcends its kitsch provenance to become a valuable cultural intervention. Rather, the point is that what is impressionistic about it does constitute a claim to value after all, and a reconfiguration of the determinants of kitsch culture. Whereas the classic account of kitsch views its immediate sensuous pleasures as a function of "insensibility," something that "predigests art for the spectator and spares him the effort, provides him with a short cut to the pleasure of art that detours what is necessarily difficult in genuine art," here a form of difficulty not only reasserts itself but also recuperates what is genuine through truly free association.[77] What has occurred is not just the adaption of impressionism to commercial ends but the adaptation of commerce to the impression's own purposes, which are, despite what kitsch implies, aesthetically purposeless after all. Commerce may well benefit—indeed, Levi's did—but in what we might call a post-kitsch formation, with a different place for "reflection on the immediate impression" and the emergence, as a consequence of the "pleasure of art."[78] Kitsch is no dead end, but a reinvigoration of impressionist immediacy that in turn is a spur to serious pleasure and valid judgment after all, an ongoing project of perpetual aesthetic emergence.

3

PHOTOGÉNIE FROM RENOIR
TO GANCE TO RENOIR

Jean made the ideal movies which Auguste himself would have made if he had abandoned his brushes for the camera.

—ANDRÉ BAZIN, *JEAN RENOIR*

The Seventh Art does not stop at the stylization of an impression as sculpture and painting do. It augments a fact by grafting a feeling onto it by means of a technique that is proper to it.

—GERMAINE DULAC, "THE EXPRESSIVE TECHNIQUES OF THE CINEMA"

Did Jean Renoir inherit his father's impressionism? André Bazin says so, but not because Jean simply imitated his father's style. Indeed, "it would be a mistake to look for the heritage of Auguste Renoir in the formal, plastic elements of his son's movies," for that would be to affirm a bad kind of influence.[1] Too often, Bazin complains, early filmmakers felt obliged to imitate painterly compositions, which were wrong for film. Jean Renoir did sometimes imitate Auguste's imagery, but "playing at being his father" really meant something more profound: showing the "sensitivity and love" so essential to his father's aesthetic.[2] Auguste's real legacy was nothing more and nothing less than a true feeling for art.

"Sensitivity and love" may seem to mean nothing specific for impressionism's legacy in film. This inheritance does, however, correspond to what has essentially defined French impressionist cinema for decades. It is Bazin's version of *photogénie*, that magical quality that was seen to give the impressions of early cinema their aesthetic value. Thanks to the loving sensitivity passed from father to son, from painting to film, Jean Renoir's realism was not just automatic but aesthetic, much the way *photogénie* made an art of cinema more generally. And if *photogénie* has always been a problem category, lacking in semiotic rigor, undermining the credibility of impressionism as a cinematic category, in Bazin's account it does have theoretical substance. Something like this father-son succession might yet define impressionism's cinematic legacy.

Bazin often favored what other theorists have taken to be a problem for film: the way the camera seems simply to record what is before it, its inescapable *indexicality*, its tendency toward objective realism. Indexicality does not preclude but rather prompts true artistry. Bazin calls Jean Renoir "one of the great masters of photographic realism" but then stresses that "simply being realistic is not enough to make film good," since "the principle of a director's style lies in his way of giving reality meaning."[3] A familiar duality defines the art of film—a "dialectic between reality and abstraction, between the concrete and ideal."[4] This dialectic shapes Renoir's signature conception of the screen. No simple rectangle framing the action of the film, his screen does not exclude the real world beyond its parameters; its function is "no less to hide reality than to reveal it."[5] That is, Renoir extends the *mise-en-scène* so that the "action is not bounded by the screen, but merely passes through it." Reality exceeds the frame, and in this way the camera is neither omniscient nor a matter of "stupid, unthinking subjectivity," but something at once freely visionary and concrete in its quality of perception.[6] It departs from mere verisimilitude but therefore achieves the "height of realism," as Renoir at once performs the "necessary modality" of filmic seeing and asserts his own vision.[7] For Bazin, this paradox of realism revolutionized film composition. Moreover, "this revolution was not without analogies to Impressionist painting."[8] The compositional practice through which Jean Renoir made such a historic difference was inherited from his impressionist father. For Pierre-Auguste Renoir too, the frame no longer simply centralized action but had this dialectical force. It performed its modality while allowing

the artist to locate his own eye; it cut off but therefore invoked the reality beyond it. This was his legacy to his son, and it gives "sensitivity and love" a more rigorous definition by making it more technically an expansive mode of cinematic vision.

It also affords unusual rigor to *photogénie*. Bazin's version of this category achieves uncharacteristic clarity and validity through his account of what generates film's higher reality. For this reason, Bazin's account of Jean Renoir's inheritance can serve as a template for the history of impressionism in film. Notoriously, *photogénie* has discredited French impressionist cinema. Crucial to the definition of the movement, it became an embarrassing mystification—a fatally elusive category. Bazin shows how to make it meaningful, and his account of its passage from Renoir to Renoir has inspired, in the pages that follow, a larger argument about the inheritances that link French impressionist cinema back to its painterly predecessor and, moving forward, to the proper future of film.

IMPRESSIONISM AND PHOTOGRAPHY

First, however, there is the question of the photograph. Prior to *photogénie* and its filmic avatar, there was impressionist photography—or, rather, the way photography and impressionism have shaped each other. For this relationship was ongoing. The historical oddity of photography's precedence—the peculiar way the photograph comes before the style of painting that would seem to pre-date it—does not mean that influence proceeds in one direction only. Photography shaped the impressionists' sense of the momentary impression, but that sense, in turn, shaped the aesthetic development of photography. Impressionist duality encouraged the photograph's *analogical* difference from its objects; in turn, photography has prompted impressionism toward ever greater mobility, and this reciprocity finds its fullest expression in the secret history of French impressionist cinema.

The reciprocity in question has been active across much of the history of modern aesthetics. Indeed, the history of modern aesthetics might be said to depend upon the relationship between impressionism and photography, at least insofar as the conflicts and collusions involved have helped

to define the autonomy of the modern artwork. The story begins before the emergence of either one, when the nascent science of the daguerreotype was understood in terms of the rhetoric of impressions, which served well to explain the indexical relationship between the source of light and its notional imprint upon the image surface.[9] Edgar Allen Poe, for example, wrote in 1840 of the way photographic plate received impressions.[10] This reciprocity continued as early photographs served mid-nineteenth-century painters in two ways. "The camera's incorruptible objectivity was a precious aid to the artist," as Siegfried Kracauer notes, providing templates even for those artists dedicated to plein air realism who never acknowledged this aid and, as Carole McNamara has recently noted, "freed the impressionists to embark upon their individual and particularized way of seeing and portraying the land and sea around them."[11] Photographs also revealed the heritage of painting with unprecedented detail and accuracy. As William M. Ivins Jr., argues, old drawings and prints of old paintings, which were never adequate, gave way to photographic images in which modern artists could see "the creative dance of the artist's hand," the actual "syntax of design," which inspired formal innovation in the work of artists including Monet and Degas.[12] Of course, early detractors (including Charles Baudelaire) nevertheless deplored the result—what they took to be an inartistic enslavement to and long-lasting obsession with vulgar realism.[13] Inversely, painting could be seen to mislead photographers into a limiting "photo-painting standard."[14] Not, however, once that standard was set by impressionist painting specifically. Once the impressionist theory of vision became dominant, it helped to clarify for photography what could become its own aesthetic pictorialism, the proper measure of its autonomy.

Henry Peach Robinson noted this effect in 1896, writing about "Idealism and Realism" in the arts.[15] Robinson defines photography in terms of what he calls the impressionist theory of vision, quoting a theorist who had defended it by arguing that what might look like slapdash sketching is actually a form of summary focusing, giving all at once what a realist painter might develop through a misguided accretion of discrete parts. "Unity and order of impression gained by focusing the subject" defines the impressionist optic, "with one focus for a dozen."[16] This unified focus could become, in turn, a model for the photographic aesthetic. Robinson celebrates photographers who "represented not so much the subject

which was before the camera as the photographer's individual impression of the subject."[17] The difference was crucial, since it could liberate photography from its presumptively "mechanical nature," the technological automatism that was seen as disallowing aesthetic distinction. The "individual impression" was the hope for the art of photography, and it is not merely coincidental that the "impression" migrated, across the century, from Poe's 1840 usage to Robinson's 1896 sense of the interrelations of aesthetic autonomies.

These autonomies—impressionism's freedom from contingency, photography's freedom from the mechanical—continued to help each other along, into and then beyond the years in which these endeavors were the focus of such intense critical attention. Most notably, of course, photography was seen as freeing the art of painting from the "resemblance complex," its inartistic penchant for realist representation.[18] Impressionism in particular was the result, since it marks the moment in which painting began to depart from photographic verisimilitude. This departure continued for decades, with a major touchstone in the work of Proust, so often cited by theorists of photography eager to affirm its aesthetic value. From Kracauer to Kaja Silverman, theorists have read Proust for his insight into the photograph's way of combining the realistic and the formative. Kracauer argues that this account of photography matches Proust's own wish to "witness" rather than to see the world through his own expectations and desires.[19] Silverman theorizes the "miracle of analogy" that defines photography in terms of Proust's own analogical phenomenology.[20] In both cases, it is clear that Proust developed his own theory of the impression in response to photography, since the photograph registers impressions just as he would have wished: unconsciously, so that the impression becomes available to later discovery for what it was, rather than what the perceiver might have wanted at the time. In other words, the photograph witnesses in the manner of taste or smell, so that it can become the basis for the discovery of what would otherwise be lost to time. When Proust proposes to transcend time through the impression's free way of witnessing, he has drawn his sense of autonomy in part from what photography enables. His impressionism repeats the freedom gained in response to photography decades before.

In turn, however, impressionism helped photography away from representation, by showing how what has a special claim to indexical

representation also achieves the autonomy of aesthetic discretion. The dual nature of the impression became a resource for understanding what could form the index—how the index could become a pretext for design—not, however, simply by modeling how immediate perception could subsequently become material for artistic work, but rather with all the diverse dynamics impressionism put into play. The modern history of photography, shaped even more than Robinson allowed by the impressionist theory of vision, plays upon the duality that, in the history of impressionism, generates such excessive narratability. Indeed, technological determinants forced it further, introducing yet another version of the duality: the analogy that, for Silverman as for Barthes, introduces radical difference into the photograph's natural immediacy. Just as impressionism prompted productive thinking about the way artistic expression could be two things at once—and thus all the more artistic—photography has profited by its ambivalence. This profit constitutes impressionism's gift to film, to the filmmakers and film theorists who made French impressionist cinema at once a vital moment and an irresolvable problem in cultural history.

WHAT WAS FRENCH IMPRESSIONIST CINEMA?

Not simply a style, not fully a movement or a viable cultural project or period in film history, French impressionist cinema was a vital if odd combination of these different determinants. Most important was its effort to say and to show what made film an autonomous art form—what distinguished it from the other arts, how it defined "cinematic specificity," and why it deserved public regard (as well as private funding). After the war, French filmmakers found themselves threatened by Hollywood and no longer able to count on their usual sources of backing. In response, those who would become the practitioners and theorists of impressionist cinema felt the need to develop a film aesthetic—an art that would merit its own financial support and compete with the Hollywood alternative. Louis Delluc, Jean Epstein, and Germaine Dulac led this effort to show and to say how film could earn special recognition, each supplying different aspects of the argument for cinematic specificity and its special claim

upon what had long been the recognized basis of aesthetic achievement: the imaginative transformation of natural reality. But because film could seem to be a merely mechanical reproduction of unaesthetic reality, its aesthetic transformations needed special, concerted explanation. This effort to elevate film also included work by Abel Gance, Marcel Herbier, and René Clair, not only films but, just as important, the journalistic advocacy and *ciné-club* collaborations vital to French cinema at this moment. So much was necessary to stake out the right location for this first cinematic avant-garde: it had to elevate itself without losing public appeal, to present an aesthetic alternative to Hollywood without going too far into the territory of what would become *cinema pur* and the avant-gardism of the surrealists.

Its balancing act was largely what got it its name: as Dudley Andrew suggests, the association with impressionist painting evoked a prior balance of realist pleasure and arty elevation, and could indicate a nicely mitigated avant-gardism.[21] Of course, the association was authentic, insofar as the art of French impressionist cinema was centered on the creative subjectivity of perception, the experiential nature of truth, the way beauty and meaning emerge through human feeling. Those were the technical and thematic bases for the signature films: Gance's *La dixième symphonie* (1918), sometimes called the first impressionist film; Louis Delluc's *Fièvre* (1921); Marcel L'Herbier's *El Dorado* (1921); Jean Epstein's *Coeur fidèle* (1923); Alexandre Vokloff's *Kean* (1924), and Jean Renoir's *La fille de l'eau* (1925). These and other works of French impressionist cinema invented many of the techniques and effects still used to dramatize subjective perspective and feeling and thereby make film hospitable to human understanding and interpretation. They made good on the promise to elevate the cinema while also vitalizing it—even if the movement they represent quickly ended. Most histories date French impressionist cinema to the years from 1918 to 1928, after which the aesthetic impulse departed for more fully avant-garde opportunities.

Ironically, the impressionist filmmakers rarely mention painting, since they were so eager to distinguish cinema from the other arts. What other arts they did invoke were most often symbolist, given their effort to deny the mere materiality of the cinematic experience. But impressions were essential. Many examples from the contemporary writing on impressionist film show how the rhetoric of impressions could help say what gave

film its special status as a modern art. André Delons puts this rhetoric to work in a typical way when he writes of the careful positioning of the filmic image, "S'ils transposent souvent, c'est toujours pour signifier, et rendre matérielle une impression (on a parlé d' 'impressionnisme') en accord direct avec le cours même du film que la seule vie réelle inspire."[22] Delons's observation reflects the way impressionist discourse helps distinguish the filmic image from its basis in material rendering. To materialize an impression was to do what film does best, because the impression could present at once a moment in ordinary life and its suggestive filmic movement. Louis Delluc's early account claims that "cinema was destined to provide us with impressions of evanescent eternal beauty, since it alone offers us the spectacle of nature and sometimes even the spectacle of real human activity."[23] If such beauty is to be at once evanescent and eternal, at once nature and spectacle, the impression is its ideal rhetorical vehicle.

When Germaine Dulac asks, "Is cinema an art?" (in her landmark 1926 essay "Les esthétiques, les entraves, la cinégraphie intégrale"), she notes that it has heretofore been "drawing its life's breath from the other arts," due to public failure to understand that the mechanical movement of the cinematograph "required a new sense," a "new emotive faculty," in order to be understood.[24] At first, "the cinema was for us nothing but a photographic means to reproduce the mechanical movement of life"; no one imagined that it could offer a new form of expression.[25] "Human existence is movement because it changes position, lives, acts, and reflects successive impressions," but the early tendency was to falsify it through imitation of novelistic and theatrical movement forms.[26] The problem persisted until rhythm emerged, and a truly suggestive cinema came into being. This realism evolved until "another era arrived, that of the psychological and impressionist film," which was all about penetrating human interiority: "By combining the description of manifold and opposing experienced impressions with the unambiguous facts of a drama," film developed a "duality" that its rhythm could supremely coordinate.[27] Impressions could be born out of the facts of the drama but also sublated into motivating feeling, with motion all the more dynamic for its manifold oppositions; movement developed, and the "impressionist era began."[28] Dulac's specific account of the process that brought impressionist film from its rudimentary objects to the status of "symphonic poem" draws heavily upon the impression's history of effecting such a process:

Rails, locomotive, a boiler, wheels, a manometer, smoke and tunnels: a new drama composed from a series of raw movements, and undulating lines appeared, and the idea of an art of movement, finally understood in a rational manner, recovered its rights, leading us magnificently toward a symphonic poem of images, toward a visual symphony outside all known formulas.[29]

The emergent movement implicit in the impression itself helps Dulac explain how cinema might transcend "the photographing of real or imagined life" to become capable of "engendering the immortal works that every art form must create."[30] Her account of the progress from rails to symphony reads like a classic impressionist narrative of the emergence of art from its raw material basis. It is typical for its hope that the energy of impressions themselves might be aesthetic enough.

But French impressionist cinema also had a unique claim to its impressions. There is a striking tendency among early theorists of film to suggest that impressions are only truly realized in the cinematic context. Louis Delluc makes this suggestion in his essay on cinematic beauty, claiming that the natural "impressions of grandeur, simplicity, and clarity which suddenly cause you to consider art useless" are the destiny of cinema, since "it alone" is useful in capturing them.[31] Marcel Gromaire compares film to painting and argues that "impressionism, highly questionable in painting, is here logical since cinema proceeds by a process of decomposition."[32] Elie Faure says the "new plastic impressions that I got at the cinema" outdid those he had received through painting; Ricciotto Canudo claims that "the arrival of cinema heralds the renovation of all modes of artistic creation, of all means of 'arresting the fleeting,' conquering the ephemeral"; and Germaine Dulac notes that the impressionism of "the Seventh Art does not stop at the stylization of an impression as sculpture and painting do," but augments perception through "a technique that is proper to it."[33] This sense that cinema (rather than painting) is the technique proper to the impression is important not only because it suggests that early avant-garde cinema was truly an impressionist art but also for what it tells us about the place of film in the history of impressionism. Film may indeed have a special claim on the mode and a special place in its history, because the filmic impression most fully realizes the transient but performative movement more implicit in other media. Ezra Pound wrote

that "the logical end of impressionist art is the cinematograph."[34] If this is so, film exemplifies impressionism's tendency not only to persist into new conditions but also to realize itself more fully as it does so. Impressionism may seem to have become a belated holdover after painting moved on to abstraction and expression, but its impressions only migrated to another, better host, to thrive in new conditions of action.

Those conditions were a whole set of techniques designed to transcend the filmic mechanism and give cinema subjective resonance, to make it capable of the feelings, interpretations, and transformations essential to aesthetic experience. Most obviously useful was the close-up, probably the main signature of the impressionist focus on the inner life of its subjects. But a host of other techniques also served this purpose, as the impressionists innovated an array of optical devices to suggest mental states, strong feelings, and consuming desires, as well as compositional techniques likewise geared toward the dramatization of the inner life of people and the film image itself. They were adopted elsewhere and often had their origins in other early cinema forms, but in French impressionist cinema, they cohere around an effort to humanize film mechanics and thereby exploit their aesthetic potential.

David Bordwell's exhaustive account of these technical methods remains definitive. Bordwell first stresses the characteristics of the impressionist image developed through camerawork—shifting proximity in close-ups as well as camera angles and movement. He notes that close-ups could serve purposes other than the registration of a character's individual responses or feelings. They work also as symbolic or synecdochal identifiers when highlighting particular objects or people emphasizes a scene's definitive aspects. And they work as "subjective images" when objects are singled out for close attention for the way they matter to characters and situations.[35] Camera angles—the "use of high-, low-, and medium-angles to indicate optical subjectivity"—similarly give images of people and things an interpretive quality, as do various forms of camera movement.[36] Sometimes camera movement corresponds to a character's point of view, but sometimes it is independent, to register the larger significance of an event (rather than a single, subjective perspective upon it), and movement can serve a "graphic" purpose, to emphasize a dynamic quality implicit in the action of the scene. Bordwell also finds impressionistic qualities in the *mise-en-scène*—in lighting (single-light sources, shadows suggesting

unseen action, as well as a variety of other atmospheric effects), décor, and the suggestive arrangement of figures in space across the background and foreground of the spatial composition. And optical devices are perhaps most strikingly suggestive in marking transitions, magical effects, and significant details; conveying abstract meanings; and, mainly, indicating subjectivity. These devices include many that have become highly conventional, naturalized techniques in film art: fade-out and fade-in, wipes, dissolves, and irises; the distortions that suggest disordered mental states or the impaired vision caused by tears, blindness, or rage; superimpositions suggesting interiority and, more specifically, flashbacks or fantasies, which were all essential to the impressionist image and soon stock features of filmic art from Hollywood to the avant-garde and beyond. Bordwell follows Jean Mitry in distinguishing three ways optical devices could convey subjectivity: through purely mental images (of memory, of fantasy); through the semisubjective imagery of thoughts or feelings indicated while the relevant character is present; and "optical subjectivity," or the more basic imaging of what a character sees while deprived of more objective vision by states including illness, inebriation, or sadness.[37] But optical devices for impressionist imagery could also serve as "conveyors of abstract meanings," developing conceptual implications through suggestive focus upon or galvanization of meaningful elements in a scene.[38]

Impressionist editing patterns are crucial, for they often help to distinguish the movement and its styles from those of other film forms contemporary to it. For the most part, these patterns share the character of the impressionist image, in that they go toward emphasis on filmic subjectivity. Most essential to the impressionist style is rhythmic editing—a pattern of joining diverse shots that corresponds, in speed and alternation, to a character's mental or emotional state. Sometimes called "rhythmic montage," it often resembles that which became dominant through the montage forms of early Russian cinema, but it is most often attributed to the impressionists specifically, since it developed from (and so closely serves the purposes of) their effort to give the mere succession of indexical film imagery emotional resonance. Variants on rhythmic montage include the impressionists' version of the Kuleshov effect (which alternates close-up shots registering a subjective viewpoint with the object of that viewpoint), other forms of crosscutting, and the juncture of shots in time rather than space—flashbacks (which cut to a scene on the basis of a subjective

memory) and fantasy (similar, but different in that the scene has not previously occurred, and often requires a different sort of transitional optical effect). Especially this role in conjuring fantasy put impressionist editing in the service of the larger endeavor often seen to encompass all of these technical elements: the quest for the elusive quality of *photogénie*.

WHAT WAS *PHOTOGÉNIE*?

What truly distinguishes the impressionist aesthetic, for better and for worse, is this vexed category that epitomized film art—the essence of cinematic specificity. It was what could justify the moving image—if it could only be defined in any coherent, rigorous, satisfying way. Given the motivation for it, *photogénie* might be characterized as that which transforms the merely indexical photograph into a register of affective, spiritual, or interpretive meaning. Then again, *photogénie* sometimes seems to name the automatic meaningfulness of photography—how it always entails a transformation of what it would seem immediately to present. Most often, it is a matter of movement, the photography specific to the way film generates photoplay or motion pictures. But it has other sources and other effects, all of which have in common a certain mystification, an evasive unavailability to linguistic equivalence or even explanation. That unavailability was important for distinguishing film's unique form of language, but it has been a real problem for the subsequent significance of French impressionist cinema.

The principal expositors of *photogénie* were Louis Delluc and Jean Epstein. Delluc is credited with the first relevant use of the term as well as its most symptomatic exposition in his *Photogénie* of 1920. For Delluc, photography has powers of revelation that distinguish it emphatically from any mere recording of the visible object; those powers partake of film's transformative magic, but not, unfortunately, in any way Delluc can explain in terms of particular techniques, effects, or even theoretical processes. "La photogénie . . . c'est l'accord du cinéma et de la photographie!" is the rare positive statement in a text otherwise dedicated to saying what *photogénie* is not, or, more troublingly, why it remains a mystery to most people.[39] "Peu de gens ont compris l'intérêt de la photogénie":

stressing this exclusivity, emphasizing it further by arguing that even experts often work with a debased notion of this essential category, Delluc equates it with overweening aesthetic discretion itself rather than any valid product of that discretion.[40] Epstein's 1924 article for *Cinéa-Ciné-pour-tous* begins by establishing the main objective—to say what makes the cinema "uniquely cinematic"—and by identifying *photogénie* as the critical opportunity: "*Photogénie* is the purest expression of cinema."[41] A fuller description singles out "any aspects of things, beings or souls whose moral character is enhanced by filmic reproduction."[42] More specifically, "only mobile aspects of the world, of things and souls, may see their moral value increased by filmic reproduction."[43] Morality, however, is construed broadly (or "polytheistically") to encompass any essential value; mobility moves in time and space alike. *Photogénie* is animating, or animistic; it captures the active, individual personality in things as well as people; it lends drama, but by discovering what is essential in what it depicts. Through it, the cinema "grants life," enlivening the souls of things, as long as the "proper sensibility" can "direct the lens toward increasingly valuable discoveries."[44] Inspired authorship makes moving photography the means to produce a "new reality," changing the face of the world.[45] But Epstein's celebratory rhetoric outdoes Delluc's mysticism in its extravagance, even as Epstein offers more specific explanations of the links among directorial genius, mobility, and visionary essentials, so that the category remains an object of semireligious advocacy rather than useful or valid definition.

Epstein admits that "one runs into a brick wall trying to define it."[46] Subsequent efforts reflect this impasse in their sheer variety. Mary Ann Doane has recently characterized *photogénie* as "a supplementarity, an enhancement, that which is added to an object in the process of its subjection to a photographic medium."[47] But she admits that the category is "theoretically incoherent." Sarah Cooper likens it to the "soul" by which "an immaterial realm is made visible"; Ian Aitken stresses the way it "aestheticizes external reality" by revealing "the essence of an object"; Laura Marcus notes that "it was variously described as a form of defamiliarisation, as a seeing of ordinary things as for the first time, and as a temporal category, a sublime instant."[48] But no one sees any coherence in these various descriptions, and even David Bordwell concludes that "photogénie cannot adequately explain how the film image reveals and transforms reality," so that, "as impressionist theory stands, it is unfinished."[49] Or

worse, if elitism is what mystifies the ineffable achievements of *photogénie*, or if the bad result is a form of fetishism. Here we come to the real problem with this category—indeed, the problem with French impressionist cinema more generally, the main reason it has not achieved anything like the critical stature of the Russian and surrealist cinemas of its moment. In essence it is a fetishistic refusal of cinematic meaning.

This fetishism is a programmatic version of what Christian Metz attributes to all cinephilic enchantment with the apparatus, that "love for the cinema" that disavows lack by obsessing over the magic of filmic technology.[50] Paul Willemen notes that the fetishism of *photogénie* is "hardly worth dwelling upon any more," noting its long-standing infamy among film theorists who associate it with a fundamental problem of cinematic looking, but also wishing to explain "what contradictory functions are to be fulfilled in order for such a term to be needed at the centre of a particular aesthetic discourse."[51] Why did French impressionist cinema actually need the "impenetrability" of *photogénie*? For Willemen, its ambiguity was actually essential to the impressionists, since "the point is not that *photogénie* is indefinable," but "rather that the impressionists decreed it to be so and then deployed an elaborate metaphoric discourse full of lyrical digressions and highly charged literary imagery in order to trace obsessively the contours of the absence which that discourse is designed to designate and contain."[52] Not just fetishism but a kind of meta-fetishistic maintenance of its denial—essentially, a "refusal of psychoanalysis"—is behind the problem of *photogénie*.[53] That is, the impressionists' obsession with the aesthetic motive—that need to lay claim to artistic specificity—led them to theories and practices that finessed an empty kind of autonomy. Facing that lack, they worried over it with extravagant intensity, so that any effects of *photogénie* actually become a substitute in its absence. A charged circularity is behind impressionist innovations in cinematic subjectivity, and its techniques can only amount to diversions from the proper business of filmic discourse. In Willemen's account, these diversions were something for which the impressionists paid a high price: "a drift into mysticism and confusion, followed by a long period of total neglect and virtual oblivion."[54] And following that period, film theorists remain vigilant against impressionist cinema and its symptomatic refusals, since "the formulations of the impressionists are sometimes mobilized today as a counter to film theory itself," the "quasi-mystical concept of the cinematic experience" resurfacing as "part of a campaign to censor film theory and

film education in general, freeing critics from the heavy burden of ratio-nality."[55] Willemen would say that the legacy of impressionism today is a reactionary resistance to film theory, an anti-intellectual preference for mere cinematic pleasure. And his anti-impressionism is but an extreme version of that which sets many critics against French impressionist cin-ema as a film-historical category. Richard Abel, for example, prefers to speak of the "narrative avant-garde," and Gilles Deleuze speaks of "the pre-war French school," asking, "Should we call it impressionism in order to contrast it with German Expressionism?" and answering that it might "be better defined by a sort of Cartesianism" for its interest in "quantity of movement."[56] Ironically, Deleuze arrives at an alternative category pre-cisely through a more rigorous definition of one of the main features of a more definable *photogénie*.

But otherwise it commits French impressionist cinema to a kind of nonemergence, a refusal to say how images emerge into symbolic mean-ing, a kind of infantile lust for purity. We have seen that the discourse of impressions enabled the reverse: impressionism's typical gift for the emergence of meaningful art from raw experience—in this case, the de-velopment of cinema through what Dulac called the raw movement of the filmic apparatus. *Photogénie* would seem to be an overdetermined version of that development or an excessive effort to finesse it, to make it a mat-ter of marvelous enchantment. Suffice it to say, then, that *photogénie* is a fetishized version of the impression. More specifically, it is a fetishized substitute for what makes impressions useful to the justification of film art: mobility. *Photogénie* is a fetishized mobility designed to guarantee an immanent transformation of raw movement into that "visual symphony outside all known formulas" toward which impressionist film aspires. It therefore plays a complex role in the history of French impressionist cin-ema. As Bordwell and Willemen argue, it undermined the movement's credibility, failing to give its diverse properties a coherent objective. That failure was responsible for the movement's inconsistency and short life. At first, around 1918, it was a heightened form of the pictorialism that had been important to the earliest films in France. After 1923, it went through a phase in which rhythmic montage was the main focus and the main claim to a distinctive aesthetic. And finally, as early as 1926 it dispersed into an array of subjectivizing techniques most important for the way they ramified into practices elsewhere (mainly *cinema pur* and surrealism). This brief and inconsistent tenure can be attributed to the ambiguity of

photogénie, which was not just an incidental problem but a symptom of a deep ambivalence about the relationship between the mechanics of film and the art that deserved the kind of recognition the impressionists needed to claim for it.

And yet it is precisely this failure that makes French impressionist cinema truly an impressionist genre. What typically makes the label appropriate—a penchant for subjectivizing techniques—does not really distinguish it from cinema all told. The more distinctively impressionist problem at work here is the productive uncertainty over the relationship between raw movement and film art, the proliferation of discourse that seems secondary to the films themselves but is actually essential to them. Willemen argues that *photogénie* becomes a fetishistic obsession over the properties generated by its own failure. That argument might be revised in light of impressionism's characteristic reflexivity, the way doubt about impressions itself generates the meaning and value of the impressionist text. Because *photogénie* intensifies that doubt in accordance with the way film art most fully realizes the impression—if, as Pound claimed, "the logical end of impressionist art is the cinematograph"—French impressionist cinema is actually a landmark aesthetic. In it we see dramatic proliferations of the sort of speculation impressionism always cycles into its efforts at immediate aesthetics. The main target of that speculation is the fetishization of mobility, which may have been nothing more than *photogénie*, but which becomes nothing less than a driving force for film.

That is the opportunity exploited to such brilliant effect in the film often called the most significant production of the French impressionist cinema: Abel Gance's 1922 *La roue*. Gance's film is all about the problem of *photogénie* and its mixed potential to justify film aesthetics. It thematizes the problem of raw movement and reflects upon the fantasy that it might become an aesthetic drive, as well as the fear of its potential for merely mechanical motivation.

FETISHIZING MOBILITY IN GANCE'S *LA ROUE*

La roue has long been recognized as a source text for filmic technique, acclaimed by filmmakers on its first release (Jean Cocteau claimed that "there is cinema before and after *La roue* as there is painting before and

after Picasso") and so widely influential that Sergei Eisenstein is said to have confirmed that it was "assiduously studied by all novice Soviet directors."[57] As much as it was admired for its technical virtuosity—here French impressionist cinema perfects its signature rhythmic montage and continuity editing, and the film is also full of the emotional and atmospheric effects that were the movement's specialty—*La roue* was important for its edgy modernity. Its inspiration is the wheel of the train; it was "a cinematographic event of considerable importance," wrote Ferdinand Léger, for the way "the machine becomes *the leading character*."[58] As Lucy Fischer has recently noted, *La roue* reflects upon the problem of modern machinery and was therefore very much of its moment.[59] But more than that, *La roue* is anxious about filmic machinery: its immersions in human feeling all take place amid a sense that a merely mechanical process might put human feeling at risk. This fraught relationship between film's subjective connotations and the machinery of denotation is the film's thematic focus, for it is about lives lived by "the wheel"—literally beside and among railroad mechanisms that are at once a source of livelihood and of danger, energetic transformations and degrading routinizations of human experience. *La roue* does two things at once: it invents new techniques for filmic subjectivity and it tells the story of a train conductor subject to his machine. Dramatizing what it takes for people to thrive through or despite what the railroad represents, the film also explores what it takes for human feeling to emerge from the filmic mechanism, and this correlation, so typical of impressionist thematics, shows how the impressionist problem of *photogénie* becomes a motivating force for the cinema at large.

The story of *La roue* famously begins with a crash. A train has derailed, and the disaster is immediately a chance for formal innovation, in the montage sequence that evokes the chaos of the scene. Rapid intercutting spreads haphazard attention across sudden shots of injury and rescue efforts, destroyed machinery and onlookers who, like us, try to piece it all together. The protagonist, Sisif, becomes a subjective focus when he must avert further disaster: the next train is coming on, and unless Sisif can act in time, it will collide with the wreckage. Montage now assumes its celebrated rhythmic form, cutting rapidly among the oncoming train, the switching signal, and Sisif's anxious face. And here, rhythmic montage is employed with a literalized sense of what switching might achieve, a reflexive sense of being subject to switch machinery and what it means to use it heroically in the face of the mechanical danger. The scene offers

3.1 *La roue*, 1923, dir. Abel Gance
DVD, Flicker Alley, LLC, 2008

what Deleuze found to admire in the prewar French school's use of the "machine to attain a mechanical composition of movement-images," but, it would seem, with a difference: whereas Deleuze posits an "active dialectical unity" between man and machine, *La roue* very clearly worries over its dependence upon a dehumanizing "energy machine" for its movement effects, suggesting that it will have to reconceive the basis of film's new form of aesthetic, photogenic movement.[60]

That worry has preceded the train wreck, however, because it is suggested in the film's singular title sequence, which shows the filmmaker's own face superimposed over a moving train (fig. 3.1). Gance looks troubled in a composite image that indicates a director's anxiety about the machinery that drives his medium. We must wonder how he will assert himself if film has a mechanical will of its own. And this is the problem of impressionist film as *La roue* enacts it: how to give creative life to something that operates according to an immediate mechanism and overrides human interest in the manner of a runaway train. The film wastes no time in establishing symbolism that sums up this problem: the symbolic meaning of the "wheel," which corresponds at once to the dehumanizing effects of railway modernity and filmic technology, if not the film reel itself. That "creation is a Great Wheel that cannot move without crushing someone" is the film's concern—and the object of an impressionist effort at aesthetic redress.[61]

That effort begins when Sisif performs another, very different rescue: he saves a baby girl thrown from the wreckage, and a title card plainly indicates her significance to the film's project: "Fortunately there is always

a rose in the wheel."[62] Almost diagrammatically, the film sets up a re-demptive relationship between female beauty and mechanical modernity, and we are introduced to Norma, the film's heroine. She becomes the hope for *photogénie*—the chance to enliven the machinery of filmic modernity with the birth of something more aesthetically human, the opportunity for a beautiful version of the mobility trains would seem to epitomize. But Norma is also the focus of a highly melodramatic plot. Immediately following the scene in which Sisif lays her in the cradle beside her new brother, the film cuts forward many years, and Norma, now a grown woman, is the manifestly photogenic object of desire for everyone else in the film. *La roue* explores Norma's prodigious vivacity for ways to make filmic movement escape the wheel—to make it inherent in beauty and immaterial feeling rather than brute matter and its crushing force. Not, however, without the risk of fetishism and all it entails, for *photogénie* and film more generally. From the moment she is discovered, Norma is as much a problem as a possibility, distracting Sisif from his work, exceed-ing her setting much like the railway rosebush under which he finds her. At every subsequent moment, Norma's prodigious visual charisma is an enhancement that is also a danger, to Sisif himself no less than the film in which her glamour and sheer sensuality threaten to diverge into a fetish-istic story of their own.

Norma is an orphan. She had been traveling with her mother, who had left England in search of a new life. Sisif discovers that information in a letter in the railway office but hides it, determined to raise Norma as his own child alongside his son, Elie, not knowing when he first lays the two children together in their crib that they will one day fall in love. Incest be-comes a thematic counterpart to the problem of Norma's excessive appeal. Perverse and madcap romantic complications seem to follow from the film's effort to make female beauty an adequate alternative to the preroga-tives of the machines that otherwise determine life in this world. In the first moments of the film, with strange haste, *La roue* establishes that Sisif and Elie along with Sisif's stoker, Jacobin, and his boss, Hersan, all love Norma, as if no gaze can resist the overdetermined effect of her embodi-ment of *photogénie*. This central dynamic plays out amid an array of other implications that the forms of movement essential to mechanical and aes-thetic meaning are locked in antagonistic struggle. Elie, who makes and plays violins, laments that "this hectic modern life is so exasperating!"[63]

Wishing he "had been a violin maker centuries ago," he reinforces a distinction between aesthetic craft and technological modernity, all the while implying that Norma might be that which can effect a reconciliation, as she draws him out to play along the railway lines and inspires the invention through which he hopes to make a business of his art.[64] She is always aglow, nearly electric herself, backlit with glamour lighting so intense that it seems to erase any distinction between the coal fires constantly stoked in so many of the film's transitional moments and the energy Norma herself would bring to the film's power of movement.

Even more literally energetic is a scene of Norma on a swing—a truly remarkable montage correlating her dynamic physicality, the scopic desire it inspires, and elevated film mechanics. As she vigorously swings herself higher and higher, Norma shows how her legs power the action, directly equating female sensuality with cinematic movement (fig. 3.2). Moreover, watching her from a window, Sisif manipulates the blinds,

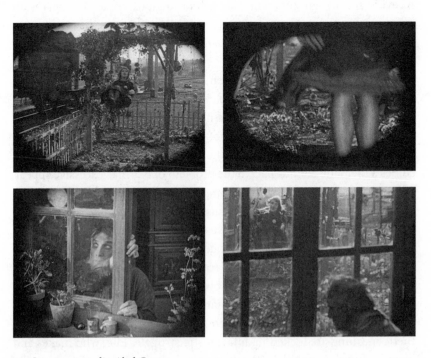

3.2 *La roue*, 1923, dir. Abel Gance

stimulated to work like a director to frame, conceal, and reveal her. And trains run madly by, intercut with these shots of the female body and male scopophilia to produce the very moving image of *photogénie* itself. For the moment, trains cannot compare to Norma as she swings roughshod over the filmic frame, in her own subjective image as well as that which frames her from a distance and can hardly cut away. Georges Sadoul noted that "*le montage accéléré avait été la principale innovation de la roue*," and here we see how Norma's erotic appeal becomes its real driver.[65]

This thematization of *photogénie* as a wishful product of female vivacity makes a critical difference to the many moments in which *La roue* performs its impressionist effects. Although they are very different in style and purpose, they come to share in the larger project of justifying film art through reference to erotic feeling—of solving the problem of film's blank indexicality by treating its objects as objects of desire. Whenever *La roue* dissolves a scene in atmospheric smoke, or condenses to an iris focus upon the *punctum* of a scene in need of special attention, or superimposes fantasy imagery around the head of the character who imagines it—just to name a few of the film's innovative, influential techniques—impressionism designates objects of longing. Their subjective significance is magnified by desire, so that *photogénie* does indeed become a matter of fetishism, but with a difference. The denial involved is different from that which is central to the classic account of the photogenic fetish. For it is not just that we are invited to reify objects in the manner of the fetishizing gaze. *La roue* compels that style of cinematic looking in resistance to reification of another kind—that of commercial moviemaking, or the Hollywood materiality that would reduce the filmic image to mass reproduction. The fetishism in question is an alternative to reification, albeit a questionable one; if it refuses a language for cinema, it also resists the film industry, and that relationship to the very different fetish of modern industrial capitalism must make a difference to our interpretation of it. And, in turn, our reading of *photogénie*. What has been seen as a hopelessly noncritical form of incipient scopophilia looks different in the context of this film's effort to distinguish the mobility of cinema from that of the mechanical engine and thereby to make an art of film. How to make the machine yield *photogénie* is a question that changes the theoretical condition of fetishism itself, by setting up a relationship among the forms

of fetishism available to the film image and choosing the sexual kind in a deliberate effort to exploit its problematic alternative.

Only that choice could explain the advent of "Norma Compound," the train that becomes the object of Sisif's affection once he gives up on Norma herself. She has married his boss, and Sisif first tries to prevent the marriage by killing himself and Norma aboard the train on which he drives her to the wedding. Having Norma aboard his train and planning to destroy them both produces a scene of maximal montage, as if these twin sources of filmic mobility must generate each other into a frenzy of special effects. The film's most frantic rhythmic montage sequence alternates tracks, smoke, tunnel, Sisif, Norma, wheels, and speedometer into a flashing strobe effect. But the plan fails, and upon his return from Paris, Sisif names his train after Norma, "Norma Compound."[66] Metonymy makes explicit the fetishistic logic of *photogénie*, as the train does not so much replace Norma as recoup the energy she had provided: she has left the train, but it can still regain something of her alternative vivacity, reassuming fetishistic preeminence. But this is the worst possible compromise—the most fetishistic *photogénie*. And so at this moment in the film a number of things take place to stress the failure to achieve a sustainable version of cinematic specificity. Most obviously, Sisif is left with a mechanical version of his beloved Norma, as if to reverse any possibility of aesthetic emergence. On top of that, he is actually blinded by the train—by an outburst of steam that temporarily destroys his vision and permanently impairs it. Inversely, other scenes suggest that any *photogénie* that might persist is a matter of mere glamour, as sequences showing Norma fantastically beautified by wealth and fantasy make her radiantly gorgeous but plainly unhappy and unreal. Here, *La roue* implicitly rehearses the critique of *photogénie* and impressionist cinema as a whole: Norma has become a lost object of deceptive desire, the epitome of the fetishized female body described by theorists since Laura Mulvey, and an embarrassment for the art of film.[67]

If this ambivalence about *photogénie* makes *La roue* what critics have called a "mass of contradictions," it is also an example of Gance's tendency to try to "overcome contradictions" and make film "the site of their reconciliation."[68] Norma will, after all, become the vehicle for a photogenic emergence. The blind Sisif, glamorous Norma, and triumphant train would seem to suggest its failure, but things change. Time passes

and Norma, who has been reduced to working as a seamstress, returns to Sisif's abject mountain cottage. Unable to see her—no longer able to gaze at her—Sisif is oblivious as Norma works to restore the cottage and atone for the wrong way her body has functioned to this point. That atonement enables a sentimental but ironic scene of blind recognition. And then an extensive set-piece finale, a scene of gorgeous mountaintop aesthetic movement, sets things right. Norma joins an autumn ritual in which the last tree of the season is burned at the foot of the glacier amid a circle of dancers that proceeds to rotate higher and higher, "spinning higher, in whiter worlds."[69] As the film shows this dance, Norma's contentment, the mountain landscape, and Sisif's dying body—Sisif dying happy, vaguely witnessing everything churning upward—La roue ends with its most exalted montage sequence, a high point for the aesthetic effect of impressionist editing. It too takes on a circular pattern, and it hardly takes much interpretive insight to notice that it gives new aesthetic form to the mechanical wheel that has been so intractable throughout the film. "Is the wheel still turning . . . up there?" Sisif hopefully asks as he dies, and a toy train he has been holding smashes to the ground.[70] Smoke rings rise from his pipe, and a vision of a train's wheels superimposed upon the clouds suggests how much its mechanism has been etherealized (fig. 3.1). Norma is still involved, but her fetishized body now contributes to a larger whole. Montage itself has become sublime—a nonmechanical wheel, something like dancing toward the heavens. La roue becomes a story about the aesthetic exaltation by which montage could transcend its mechanical sources and become a moving art, itself a force for photogénie, which no longer needs special measures to become a practical justification for the art of film. What had been a mystical category dependent on fetishistic denial becomes a matter of practical technique after all—at least in the wishful thematics of the ending.

Deleuze might call this aesthetic exaltation a function of the "*mathematical* sublime."[71] In his account of Gance's contribution to the histories of montage and the movement image, Deleuze argues that "with Gance the French school invents a cinema of the sublime," by putting two forms of time into dialectical relation.[72] There is the time interval, the variable and successive unit that Gance multiplies into greatest quantities through montage, to such a degree that it is impossible to conceive of the whole. And the whole constitutes the other form of time that structures filmic

movement. Unable to conceive of it—confronted by this limit—the imagination becomes powerless, but then arrives at the "pure thought of a quantity of absolute movement."[73] Sublimity is the outcome of impressionist montage, and this result, which is "exactly Kant's mathematical sublime," correlates to the thematic project of *La roue*.[74] The first form of time—the interval, which Gance multiplies and diversifies—is embodied in the machinery of the train, in accordance with the way "the French conceived the kinetic unity of the quantity of movement in a machine."[75] Sublimity arrives with Sisif's heavenly transcendence, since for Deleuze, that which "surpasses all imagination" (as "the set of movements as a whole" or "absolute movement") is "in itself identical to the incommensurable or the measureless, the gigantic, the immense: canopy of the heavens or limitless sea."[76] But whereas Deleuze sees in the prewar French school "no sense of a renunciation of the mechanical"—no problem with the machine, which is sublated into the heavenly sublime of absolute movement—*La roue* very clearly does away with the wheel that has been a brutal master for Sisif and his family, however much he has loved it.[77] The film's use for Norma's mobile body and, subsequently, the sublime dance in which she participates suggest a different dialectical format in which the engine itself finally has no part. Were *La roue* dialectically grounded in its filmic machinery, it would represent something French impressionist cinema never quite had: a rigorous theory for *photogénie*, in which that quality could emerge from the moving image process in something like the manner Deleuze describes. Preferring an even more idealized sublimity, it yet mystifies *photogénie*, making it dependent on fetishistic magic.

This is not to say that *La roue* itself is technically nonrigorous—that its imagery and effects are random impressionistics. Gance does construct his movement imagery in the way Deleuze says, with all the mastery necessary to make him the pivotal practitioner of early cinema as Deleuze describes it. Thematically, however, he theorizes in a manner that reflects the uncertainties of impressionist *photogénie*, the confusion that consumed the impressionists' effort to theorize cinematic specificity. We are left, still, with the problem of *photogénie*, though now with a better way to characterize its fetishism: as *fetishized mobility*, located in the female body through longing for its erotically naturalized movement, which, while problematic, may well improve upon the reifications of film technology. This fetishized mobility is the ultimate result of the anxious effort

to guarantee film the dynamic emergence that should simply be ontologically essential to film art.

FETISHIZING MOBILITY FROM RENOIR TO RENOIR

The thematics of *photogénie* brings us back to Bazin and the Renoirs. Bazin is like Deleuze in supplementing impressionist theory with post hoc validation: just as Deleuze redefines *photogénie* dialectically, grounding its sublimity, Bazin attributes Jean Renoir's "sensibility and love" to effects including his style of filmic framing (which Deleuze would call the "mobile mask"). [78] Bazin could see that cinema's elevation of photography emerged from it, and he could even see that this aesthetic difference had an affinity with that of impressionist painting—the framing technique of Pierre-Auguste Renoir, which had also been mistaken for merely immediate realism. These later revisions to impressionist theory contain everything necessary to complete an account of cinema as an impressionist art form: in French impressionist cinema as always, the rhetoric of the impression at once enabled and confused the articulation of a new aesthetic, which, after the fact, could be explained if demystified—justified, if rendered less magical—by more rigorous phenomenology. This time, it is Bazin and Deleuze who enable us to see that despite the failure of impressionism, there was a true art to it—despite the confusion of *photogénie*, valid emergence. But Bazin is like Deleuze in another way too. Just as Deleuze overstates the impressionist commitment to machinery—missing the extent to which Gance implies that film art must transcend film mechanics—Bazin overlooks the fact that "sensitivity and love" were for Renoir an affective register that undid technical coherence. French impressionist cinema depended—more than these later justifications allow—upon its incoherence, forms of denial still necessary to *photogénie* and founded most dramatically, as in *La roue*, upon the fetishized mobility of the female body. Even as we confirm the significance of the genre—indeed, in order to do so—we must recognize that its *photogénie* may have been nothing but glamour after all.

La roue uses the body of Norma to get from the mere mechanism of the train to the more sublime mobility of a transcendent aesthetic. When

she swings glamorously through the air, her body a shifting montage all its own, *La roue* naturalizes cinematic mobility and gives film aesthetics magical legitimacy. Jean Renoir replays this scene in his *Une partie de campagne* (1936), which famously makes a swinging female body the register of cinematic subjectivity. Of course, he borrowed the scene from his father, whose *La balançoire* (1876) is one of the most notorious idealizations of female beauty in modern art, as well as a symptomatic expression of the artist's scopic erotics (fig. 3.3). Taken together, these three scenes of

3.3 Pierre-Auguste Renoir (1841–1919), *La balançoire*, 1876, 92 x 73 cm., Musée d'Orsay, Paris; *The Swing*, 1876 (oil on canvas), Renoir, Pierre Auguste (1841–1919)

Musee d'Orsay, Paris, France/Bridgeman Images

women swinging visualize an impressionist legacy that continues today: that which makes eroticized movement (or fetishized mobility) the better part of filmic art—the enabling material counterpart to its aesthetic elevation.

La balançoire is but one of many pictures that make a woman's body central to impressionist animation. That the woman in question is dressed and on a swing does not undercut the function of her natural womanhood; indeed, the fact that she swings, shifting displacements, makes her body a thematic motivator for the play of light and vision that animates the scene. If the transience of luminous effects is a source of pleasure (rather than a problem of temporality) for the impressionist painter, La balançoire embodies this stimulating movement, the scintillation that is the sheer delight of the impressionist optic. In this fashion, women's bodies could help solve aesthetic problems posed by the impressionist endeavor. If it was not always clear that raw experience could emerge into aesthetic value, female beauty was a kind of natural mediator, suggesting that the natural will could immediately become a format for pure art. Tamar Garb has identified this equation in Renoir's work, arguing that women enabled Renoir and other impressionists to bridge the gap between the natural and the aesthetic. Renoir's vision of women takes part in a tradition for which "the 'body of woman' operates as an undeclared extension of matter . . . so that the rendering of her flesh is seen to be outside of an ideological construction of womanhood and exists rather as a natural extension of a natural will to form."[79] Very much an ideological construction, this vision had everything to do with sexist debasements of actual women—misogynist definitions of their intellectual capacities, patriarchal limitations to their rights and lives. Garb's main concern is the discursive context for this sexist ideology (as it develops over the course of history and specifically in Third Republic sexual politics), but she also discusses the version of the aesthetic it entails—how presumptions about women's naturalness involved a certain vision of women in the idea of art. It is not just that they licensed an exploitative, scopophilic idealization of female sexuality; they took part in the very sense of what art could take from nature and how this relationship could function. If female beauty guarantees that nature has a will to form, there is no longer any gap between an artist's real impressions and aesthetic value. Moreover, this relationship gains the motivating force of desire: to render impressions of female beauty is to repay nature's will in kind. La balançoire figures this further force of mediation,

this natural movement, by placing a female body on a swing at the center of a deep and open composition. Its mobility figures that of the dynamic interchange essential to the impressionist aesthetic—essential to the impression itself, which shares in the swing's motivating force. The swinging female body naturalizes and resolves impressionism's dual nature, giving it all the dynamic energy of erotic desire. As female beauty emerges naturally from nature itself, as male desire conflates natural feeling and aesthetic appreciation, a heady dialectic develops.

We have seen it in the swing sequence in *La roue,* where the female body naturalizes a dynamic that otherwise troubles art itself: the emergence, through *photogénie,* of cinematic art from the merely mechanical "photography of theater." Just as *La balançoire* contrives its aesthetic modernity through female vivacity, *La roue* justifies *photogénie* by attributing filmic mobility to the seductive dynamics of the swinging, dancing, and more generally vivacious female body. We see its legacy in the cinema of Jean Renoir, where a specifically female mobility (women swinging, women dancing) is made to reflect upon its impressionist history.

When Jean Renoir pays homage to his father in the swing sequence in *Une partie de campagne,* he also submits to the logic of the impression as *photogénie* inherits it, producing a sort of emblem for the way film carries forward the impressionist aesthetic. Factor in the possibility that *Une partie de campagne* is based on an impressionist text—by some accounts, Guy de Maupassant's 1881 source story is a work of impressionist literature—and Renoir's film becomes a kind of impressionist *Gesamtkunstwerk.*[80] In any case, it is aware of impressionist associations among film art, reflexive mobility, subjectivity, and womanhood in its way of representing Henriette swinging amid an array of scopophilic sightlines, as she is watched by her suitors (Henri and Rodolphe, who see her framed through a window) as well as small boys and passing seminarians (fig. 3.4). The remarkable sequence of shots that have her watched swinging from many points of view and then seen in terms of her own excitement (in interest point of view) are the core of a film narrative that then plays out what has been established by Henriette's prodigious vivacity. As in the Maupassant story, Henriette and her family, the Dufours, have come to the countryside for a day of leisure very much in keeping with the bourgeois enjoyments the main impressionist painters liked to represent. Undone by the demands of leisure, however, they sit about aimlessly until two locals, Henri and

3.4 *Une partie de campagne* (1936), dir. Jean Renoir
DVD, Imovision, n.d.

Rodolphe, arrange to take Henriette and her mother boating, stealing them away from their oblivious fiancé and husband. Henri and Rodolphe cleverly steer their boats into separate sites for amorous play—Henri bringing Henriette to his "den" by the river, where the two make love. The scene is a celebrated masterpiece, with Henriette's tearful sadness matched by stormy atmospherics about the Seine. The two couples then rejoin and and the women rejoin their menfolk; reality reasserts itself, and the Dufour family returns to Paris. When years later Henri meets Henriette again by the river, the two wistfully regret their lost love, and the sad conclusion rounds out a suggestively nostalgic piece of pastoral impressionism.

As Renoir films it, however, the story is driven by Henriette's *balançoire* mobility—the erotic vivacity that draws all attention to her and then charges what proceeds from it. What is crucial about the swing sequence of *Une partie de campagne* is its montage interchange of impassioned perspectives, which generates the same desirous significance so critical to *photogénie* in *La roue*. This film too contrives cinematic emergence through the dynamism of the female body. First we see Henriette from below, exalted and lofted above the camera, as if to suggest heights above

the *mise-en-scène*. We see her framed in the window from which she is watched longingly by Henri and Rudolphe. We see passing seminary students and small boys eye her too, and then we see what they see: her pumping arms and legs mobilizing a body ripe with sexual appeal. But we also see her subjectively, so that we identify with her exhilaration as the camera moves with her; the scenery rushes by as she herself might see it. As everyone watches Henriette longingly and she herself builds to a passionate state in which, as she says, she feels a "tenderness for everything," Renoir achieves an overdetermined version of the libidinous mobility that was, for Abel Gance, such a gratifying answer to the question of cinematic specificity. What follows this scene—the boating excursion with its erotic climax, the climatological atmospherics, the final elegiac moment—all seems to be the consequence of this version of *photogénie*, as if film narrative itself were the aftereffect of the filmic mechanism's characterological embodiment. We might describe this potency through reference to a similar argument about it: Seymour Chatman's foundational reading of *Une partie de campagne* in his essay on the limits of camera narration. Chatman reads the film's swing scene as an example of what the film camera must do to attain the expressive power—the power of assertion—more easily available to literary narration. His concern is not unlike that of the theorist of *photogénie*: how does film transcend mere depiction to give its imagery aesthetic value? Chatman's answer lingers over the kinetic exchange of objectifying gaze and subjectified pleasure, voyeurism and vivacity, to suggest that it generates the descriptive power the film camera would otherwise lack.[81] Not just the exchange itself but the erotics of it seem to give cinematic mobility its significance. Which is not to say that Renoir's own prodigious *photogénie* depends upon erotic thematics, but that this film looks back through *La roue* and *La balançoire* to reflect—probably with no small amount of playful irony—upon his heritage of impressionist dependence on the vivacity of the desirable, desirous female body.

"JUST TO LOVE": *PHOTOGÉNIE*, THEN TO NOW

This playful reflection becomes more or less the entire premise of Renoir's *French Cancan* (1954). The film is very nearly a montage of rushing, danc-

ing female bodies—again a tribute at once to that form of cinematic mobility that justifies itself through reference to the female body and the original impressionist naturalization of the same dynamic most saliently represented by Renoir's father. A long travesty of cinematic fetishism, *French Cancan* also very proficiently demonstrates how cinema might *move*, and, by doing so, discover its own specific aesthetic. Bazin sees the film as a leading example of what Renoir actually did inherit from his father. Bazin writes that the film is much more than a remediation of the painter's pictorial style (which is how it is most often appreciated), for "in film there is a new dimension: the dimension of time."[82] *French Cancan* is "like a painting which exists in time and has an interior development." More than that, it reflects the double temporality in which film involves "the objective mode of events and the subjective mode of contemplating these events."[83] Because Renoir gives us so much that is lovely to watch— all those beautiful young women in period tableaux—his film has a kind of timeless pictorialism. But precisely because these beautiful women express themselves in dance and other forms of mobile performance, they drive a highly dynamic diegesis, becoming the natural machinery of a cinema whose movement is its own justification. The film's final scene, in which the cancan is finally successfully performed in all its dizzying erotic display and photogenic magic, is a more practical version of the dance that ends *La roue* in the heavens: cinema has now grounded its fetishistic magic in forms of womanhood that can be performed anywhere.

Again, Jean Renoir's achievement as a filmmaker does not depend upon this version of *photogénie*. His self-consciously impressionist films only lay bare the device, in order to produce a canny combination of homage and critique. His other films, however, are not immune to impressionism. David Bordwell is right to classify his early films among those of the impressionists' signature 1920s productions, but his later, most important films bear traces of the impressionist film aesthetic as we have defined it. *La règle du jeu* (1939) exploits the erotic ambiguities of the close-up to drive its plots of intrigue, erotic and otherwise, making ample use of the mobile mask to capture the elusive sociality of its aristocratic locale. The glamorous optic Renoir thereby develops (in this combination of fervent close-up and elite elusiveness) readies the problematic of impressionist *photogénie* for a new era—that of the reconstructed glamour of postwar Hollywood cinema as well as the liberated female sexualities of the French New Wave. Indeed, there are many ways to argue that the fetishized

mobility at work in impressionist *photogénie* plays a role in the future history of film. Its problem of nonemergence—its mystification of the process by which the mechanical image becomes an aesthetic one, its obsessive thematization of film's ontological mobility—was ironically a result of the effort to elevate French cinema, to advocate for its value above a Hollywood ascendancy. Its fetishism, then, was oddly opportunistic, and its strange result in *La roue*—the naturalized female mechanism—is actually a reflexive fetishism, a double disavowal. Pressed into service, the female body comes to stand for mobility rather than reification, and that makes a significant difference to the problem of the gaze—something Renoir seems to know, in his knowing celebration of the female body and its *balançoire* sexuality. In a related way, this rehabilitation also redeems the impressionistic quality of Hollywood cinema, for if fetishized mobility is the result of an effort to make something more of the merely mechanical mobility of film itself, the racing frivolity of much recent popular film has a significant history. That is, it has a history in impressionism, a reason for its apparent lack of stable substance. The impressionism of fetishized mobility today will be the subject of this chapter's last reflections upon a film that puts its impressionistic style in direct relation to the history in question here: Baz Luhrmann's *Moulin Rouge!* (2001).

Luhrmann's "hyperkinetic" and "frantically ambitious postmodern musical" is contemporary film at its most impressionistic.[84] Here the mobility of *photogénie* launches into manic, madcap, schizoid antics: the film is a pastiche of song and dance of every variety, all meant to ignite the most explosive *mise-en-scène*. Few shots last more than a single second, and the camera rarely stops moving. It pans ceaselessly to and fro—across all of Paris, in the deepest possible tracking shots, and within its dizzying setting in the Moulin Rouge around 1900. Here the film dissolves into the sheer mobility of endlessly gyrating crinoline, and at its center is Satine, who embodies the film's aesthetic hope: that love will be all art could need. For that to be true, however, it seems necessary for Satine to imitate her predecessors and fetishize the mobility specific to film art: she makes her first appearance on a swing, one that first perches her high atop the Moulin Rouge and then launches her spinning body across the top hats of hundreds of adoring men (fig. 3.5). Here is *La balançoire* writ large, a postmodern step beyond Renoir's knowing homage, and a monumentalized version of the energetic mobility of impressionist desire.

3.5 *Moulin Rouge!*, 2001, dir. Baz Luhrmann
DVD, Twentieth Century Fox Home Entertainment LLC, 2014

Moulin Rouge! intensifies the subjectivizing dynamics of impressionist cinema to a breaking point, making a blur of rhythmic montage, over-stimulating its reaction shots, careening around the city, closing in on faces and objects with impossible empathy. All this becomes fragmentary—again, pastiche, in which the aesthetic of impressions seems to become a matter of empty performance and total irony. But if it epitomizes the sort of impressionistic excess that is so often the target of reaction against contemporary commercial spectacle, it also raises the stakes on some-thing dear to the traditional aesthetic: sincere feeling. What Bazin called "sensitivity and love" is here in overabundance as well, in the film's re-frain—ironic and yet idealistic—"the greatest thing you'll even learn is just to love and be loved in return."[85] As excessively amorous as it is im-pressionistic, *Moulin Rouge!* amplifies the terms by which impressionism had previously reinforced its aesthetic specificity, and indeed the film is everywhere indebted to that history. Not just Satine on the swing but her relationship to another "wheel"—the windmill of the Moulin Rouge itself, which turns perpetually in the background, challenging the film's artists to better its movement—indicate this further interest in mobility's forms of aesthetic emergence. Like *La roue* and *French Cancan*, this film ends in a transcendent work of art, figuring the outcome of a filmic aesthetic that can make photography *photogénie*. *Moulin Rouge!* purports to want

nothing other than neo-Bohemian "thrill and excitement," and it amounts to not much more than sensory overstimulation.[86] But it has within it something critical to the avant-garde of French impressionist cinema: the sense that film must show how it hopes to make an art of itself, embodying its singular mobility in special measures that, perhaps unfortunately, undermine that very wish. When the film's hero avers that it is "above all things, a story about a love that will live forever," he makes reference to an abiding use for love, which is to conjure *photogénie*, albeit at the risk of making impressionism impressionistic.[87] And it is that risk that makes it, like its predecessors, so true to the impression, once we know how to read the spectacle of frenetic hyperkinesis for its sources in the impressionist aesthetic.

4

THE "IMAGE OF AFRICA"
FROM CONRAD TO ACHEBE TO ADICHIE

What prompted Chinua Achebe to call Joseph Conrad a racist? It wasn't just the treatment of Africans in *Heart of Darkness*. In his famous essay "An Image of Africa" (1975; 1977) Achebe also takes issue with Conrad's style of depiction—his impressionist mode. For Achebe, Conrad's impressionism justifies representing "Africa" only as one man might see it. In response, Achebe developed the more objective social realism that, in turn, defined so much mid-century literature as well as the postcolonial novel in Nigeria, much of West and East Africa, and beyond. "Conrad is a bloody racist" was, as Stephen Ross has noted, a "remark heard around the world."[1] But much of the world also heard and heeded Achebe's rejection of the Conradian impression, which therefore became one major provocation for postcolonial revision, a prompt for new forms of literary responsiveness.

As much as Achebe hated Conrad's savages, he deplored "the preposterous and perverse arrogance in . . . reducing Africa to the role of props for the break-up of one petty European mind."[2] Conrad's fragmentary solipsism makes the African locale no real place; Africa is a pretext for haphazard, minimal impressions. Impressionism allows for, or even depends upon, the derealization of worlds in crisis, which become nothing more substantial than their psychological disarray. It is the height of corrupt imperialist fraud, this relocation of large-scale cultural trauma to the tragic "consciousness" of those actually responsible for it. Had Conrad

moderated his subjective representations of African chaos with objective narratorial wisdom, getting some perspective on its racism, *Heart of Darkness* might have been the anti-imperialist document for which it has been mistaken. But Conrad instead "neglects to hint, clearly and adequately, at an alternative frame of reference by which we may judge the actions and opinions of his characters."[3] Achebe believes this neglect is hardly secondary. Conrad limited his narration to the actions and opinions of his characters because he actually had no other frame of reference for them.[4] Impressionism redeems this failure, making it an aesthetic virtue, and is therefore not only complicit in imperialist ideology but also essential to its aesthetic. For the vivid immediacy of this racist outlook validates it. The impressionist style is seductively immersive; it enhances empathy, through something like hypnosis. Conrad's "famed evocation of the African atmosphere" induces "hypnotic stupor in his readers through a bombardment of . . . other forms of trickery."[5] It is not just that Conrad fails to give the objective contexts necessary to distance his novel from the racist perceptions of its characters. His subjective atmospherics force proximity to those perceptions, an identification that circumvents readerly resistance.

Ironically, this identification had been Conrad's motivation. He extolled the power of immediate sensations to emerge beyond minimal experience and, in becoming impressions, provoke a shared sense of humanity. For Achebe, this solidarity is entirely specious, or worse. *Heart of Darkness* creates it only to fool readers out of their own humanity. Moreover, it actually confirms racism in the novel, when Marlow dreads the "remote kinship" between himself and the African savages he encounters: a visceral sense of solidarity only makes him mount defensive judgment.[6] Achebe reacts against the hypocrisy that achieves identification while voiding truly inclusive humanity, elsewhere calling it a form of "dispossession." Once, he says, he had fallen for it, but then realized that Conrad "had pulled a fast one on me": "I was not on Marlow's boat steaming up the Congo in *Heart of Darkness*; rather, I was one of those unattractive beings jumping up and down on the riverbank, making horrid faces."[7] Aware that Conrad's style had hijacked his feelings, Achebe came to see that "stories are not always innocent," but "can be used to put you in the wrong crowd, in the party of the man who has come to dispossess you."[8] This dispossession happens because unmediated impressions give racist perceptions a feeling of au-

thenticity. Conrad's direct racism is bad enough, Achebe claims, but even worse is this fraudulence whereby simulation of experiential immediacy short-circuits self-interest.

Achebe's anti-impressionism implicitly determines *Things Fall Apart* (1958). Whereas he felt that Conrad offers only inchoate and personal impressions of a place that never itself emerges, Achebe represents a whole culture in its social, geographical, and political contexts. Whereas Conrad forces identification with characters whose interests do not truly generalize, Achebe leaves room for judgment of a character who achieves universally tragic status. Impressions do not give *Things Fall Apart* any falsely compelling ambiguity; its uncertainties are objectively valid, built into the struggle between the individual will and the social good. And that struggle is the novel's most emphatic assertion of anti-impressionism. In *Heart of Darkness,* inchoate individual feeling can shape collective life with disastrous finality, but Achebe asserts a social realist vision of the dialectical conflicts by which individual and society ceaselessly shape each other. If Conrad's impressionism justifies the imperial mentality, personalizing its impressions, *Things Fall Apart* demystifies imperialism by defining subjective personhood in social terms.

A "vigorous bracketing of subjectivity" is responsible for *Things Fall Apart,* as Nicholas Brown has noted, and the novel works hard to make the private public—in the words of Abdul JanMohamed, to "reproduce the totality of Igbo culture" in its broad "dialectic between self and society."[9] Insofar as this realist impulse is a reaction against Conrad, it entails what we might call a postimpressionist realism, in which bracketed subjectivity persists as a cautionary mode. Kwaku Larbi Korang calls it the "tragic realism" of *Things Fall Apart.*[10] He argues that for Achebe "Conradian impressionism announces the inadequacy of realism in and to the representation of Africa": because it was not possible for a European realist writer to account adequately for African social life, he could only fall back on his own individuality, which, in turn, could only produce perceptions limited to a stunted subjectivity. True realism requires a common social sense. When it fails, Korang argues, representation devolves into a disarray of idiosyncratic, "dizzying and befuddling" impressions.[11] They are no personal response to any true, immediate experience of Africa, but a refusal of true reality to it. Achebe responded to this "onto-geographical apartheid" by writing a novel that effectively reinvented realism as a form

of "mimetic reciprocity."[12] *Heart of Darkness* fails to do Africa mimetic justice because it denies Africa social context; *Things Fall Apart* reestablishes this context, stressing the way individual and social wholes are defined through mutual construction. Okonkwo is important not for his subjective individuality but for the way he embodies, enacts, and resists public, social norms. And tragic realism in *Things Fall Apart*—Okonkwo's tragic fall, which follows his failed assertion of individuality—develops out of the pressing need to socialize subjectivity. It is directly antithetical to Conrad's impressionism because it reflects the power of African social life to overdetermine subjective reality rather than its incapacity to shape it.

This antithetical tragic realism, however, retains a Conradian sense of the problem of the subjective impression. Conrad's way of writing the image of Africa provoked a postimpressionist realism designed to make the impression's duality more reliably one of self and world. Achebe's work, and then the "School of Achebe" that his realism inspired, developed a postimpressionist mode in which perceptions could emerge into political consciousness.[13]

Of course, it is possible to argue, along with Edward Said and others, that Conrad did so too, and that Achebe underestimates the political and even antiracist critique at work in the literary form of *Heart of Darkness*.[14] Indeed, many writers and critics have taken inspiration from Conrad's attack upon imperial hypocrisy and rapacity, even crediting his style for giving anti-imperialist critique a visceral charge. More than that, it is certainly possible to argue that the very gap between visceral perceptions and explicit critique is what enabled the horrors of imperialism to destabilize the implicit cultural core of Western literature—in other words, to cause modernist and postcolonial deconstructions. Conrad has been a touchstone for postcolonial writers because—not in spite of—his phenomenological mode. But whether or not Conrad's impressionism actually was racist, Achebe saw it that way, for valid reasons. He perceived the convergence of the impression's narratability and a certain reactionary story; the irony others have perceived in the duality of perceptions in and truths about Africa was, for Achebe, all too legible in a different register: one of tragic Western individualism. At a moment when the Western individual was in crisis, impressionism could easily lose its structural irony and devolve into a quiescent dramatization of individuality alone.

Such a response to Conrad's impressionism takes part in the larger re-action against this and other forms of modernist subjectivism, the world-wide trend away from psychological aesthetics toward explicit politics from the 1930s onward. As a good deal of recent work has shown, realist writing developed apparently in rejection of modernist subjectivism actu-ally carried it forward into new realist projects. The now-classic example is Mass Observation, which innovated a documentary realism aware of what impressionism had discovered about the subjectivity of experience, knowledge, and truth. Christopher Isherwood's camera eye and the po-litical fiction of George Orwell and John Steinbeck was no simple return to the naturalist aesthetic; existentialist fiction was all about the politics to be derived from feelings of alienation. Even Georg Lukács and his strain of Marxist critique knew that literature could not achieve sociological au-thenticity without encompassing interiority as modernism had redefined it. Lukács offers an argument that closely resembles Achebe's argument against Conrad. He decries the excesses and errors of impressionism, the "surrender to subjectivity," the "excessive cult of the momentary mood."[15] But he does not therefore call for its exclusion from literary aesthetics. Rather, he makes it an opportunity to develop an argument about art's obligation to "all-roundness."[16] For Lukács, "artistic trends determined by either exclusive introspection or exclusive extraversion equally impover-ish and distort reality," and the value of literary representation might be defined in terms of its power to link impressionist perception to public prerogatives and to ground the sociological in the personal moment. This power to make an "indissoluble connection between man as a private individual and man as a social being" is precisely what Achebe brings to his representation of Igbo culture in *Things Fall Apart*, in his effort to redeem the image of Africa.[17] But as we have seen, the result is tragic real-ism—not the "dialectic between self and society" JanMohamed identifies (influenced by Lukács) but something that skews toward social determin-ism. Of course, Lukács too stressed the tragedy of individual lives over-determined by unjust social systems, and Achebe had every reason to at-tribute tragedy to African lives in the social context of colonialism, but it remains significant that his anti-impressionism outdoes that of Lukács's Marxist agenda.

Why, in the context of this larger reaction against modernist subjectiv-ism, is Achebe's reaction against impressionism distinguished for not just

its specific animus but also its subsequent effect upon the literary "image of Africa"? Why, in other words, is this legacy of impressionism uniquely powerful? Achebe had reason enough to reject Conrad's way of imaging Africa, but it became such a comprehensive factor in the history of impressionism because of the way Conrad's writing was involved in another context: that of the colonial university.

Achebe and other Anglophone writers had an ambivalent relationship to the education they received at prestigious African universities in the years prior to independence. These years saw the advent of the Asquith Schools, universities developed in association with the University of London and planned, at least originally, to help with the transition toward greater independence. Achebe's University of Ibadan as well as schools attended by Ngũgĩ wa Thiong'o and other writers of this generation— Makerere College, University College Ghana—were officially and effectively branch campuses. That association, however, was originally conceived to be part of an effort to innovate a "truly indigenous" approach to higher education in Africa and to adapt the British system to local community needs.[18] The African branches of the University of London would combine the prestigious traditions of the British system with topics and approaches specific to African culture. They would stress adaptation. As Apollos O. Nwauwa writes, "The end of the war ushered in a new spirit of partnership whereby the colonial peoples would play an increasing role in deciding their future development. The idea of the university was to foster and expand the class of educated Africans who would lead in this advance."[19] Whereas education had been little more than a means of imperialist enslavement, the hope now was to make a real difference, through a utopian synthesis of British expertise and African interests. But ultimately, and unsurprisingly, the plan actually put into effect—as determined by the 1943 Asquith Report—betrayed this ideal. "Those charged with creating the universities of Africa lost sight of the primary objective," and "a certain implicit conspiracy to resist major adaptations and to preserve the overall pattern of higher education as it is found in England" won the day.[20] British educational subjects and values only became more dominant, and the new schools reinforced a sense that British degrees were "the hallmark of academic achievement" and helped forge "neo-colonial links" between African states and Western authority.[21] By 1960, there was a backlash against "education as cultural imperialism," as African students

came to recognize the fraudulence of the London university system and that the emphasis on the finest education really meant a deliberate failure to train Africans in the entrepreneurial skills necessary to viable nation-hood.[22] Prior to that moment, however, there was a seductive uncertainty about the new project, which could seem to involve something different from the "strategy of containment" that, as Gauri Viswanathan has shown, tended to guide the policies of earlier British colonial education.[23] Promising to adapt Western education to African needs, indeed to let those needs dictate the mission itself, the Asquith Schools were initially fertile ground for confusion about relationships between institutional authority and the life of the mind.

Achebe enrolled in University College, Ibadan, as a member of the first graduating class of 1948. At that time, the English literature syllabus exactly matched that of the degree program at the University of London. As a local school affiliated with London, Ibadan had the peculiar progressivism typical of the colonial institution at this moment. It was no Oxbridge, as Achebe himself wryly notes, but that also meant lesser conservatism; on the other hand, it wasn't the sort of self-governed institution that would slowly emerge in the decades following independence, but had its own untimely freedoms.[24] This in-between status often meant exceptional compromises, nowhere more so than in literary pedagogy. Asquith Schools governed by the University of London taught a more innovative liberal humanist curriculum, advancing well beyond the point at which the standard colonial syllabus had stopped with the Victorian greats. That is, it went modern, and this shift was a symptomatic complication of Asquith ambivalence. As Ngũgĩ notes, African students "were being exposed to more than the King James Bible and Bunyan's *Pilgrim's Progress*. They had studied the English novel from Richardson to James Joyce. . . . They would also read European novelists like Joseph Conrad."[25] They would, in other words, progress to something more critical of the Western mentality. But here was a progressivism that backfired. Because modernist writers were favored as part of a forward-looking, innovative curriculum, because their modernity was associated with new cultural prospects, they were a focus for aspiration. As Nicholas Brown confirms, "the prestige accorded modernist literary texts by colonial-style education . . . cannot be overestimated."[26] But when that educational system proved disappointing, modernist literature became, just as powerfully, a focus of resentment. Its

prestige came to be understood as a force for dispossession—especially when combined with its idealization of modern subjectivity, which seemed to collude in the exclusivity prestige entails. What F. R. Leavis called the Great Tradition became the object of a profound ambivalence. Simon Gikandi has noted that the Leavis definition of literary culture contained an English nationalism contrary to that culture's putative universality. Such great goods as the human "center of consciousness" actually depended upon specifically English centers of knowledge—imperial and colonial universities—that naturalized conditions perhaps inhospitable to postcolonial emergence.[27] In the case of modernist consciousness, and, more specifically, its impressionist mode, this ideological problem quickly became a contradiction, facing Asquith School graduates with the questions critics like Gikandi would later come to ask.

Achebe attests to this problem in his very different attitudes toward great and lesser texts taught at great and lesser schools. Reminiscing about his prior, humbler curriculum at Government College Umuahia (which, he says, "played a conspicuous role in the development of modern literature" by educating not just himself but also Christopher Okigbo, Gabriel Okara, Elechi Amadi, Ken Saro-Wiwa, and others), Achebe identifies "books English boys would have read in England," but these were not ones elevated for their modern prestige.[28] Much to the contrary, they were adventure books: *Treasure Island* (1881–1882), *The Prisoner of Zenda* (1894), and others probably more likely to have racist content, but less likely to combine it with the sophistication that would draw the sort of serious, worshipful attention accorded to exemplars of the Great Tradition. Loving these adventure books as a boy, Achebe would have to learn how to see through their imperial glamour, but doing so was a fairly straightforward, positive, and painless stage of intellectual and personal development. Seeing through the Great Tradition took more doing. Those texts were more likely to colonize the deeper reaches of the colonial mind. Years later, Achebe would not bother to dedicate essays to unmasking the racism of *Treasure Island* or *The Prisoner of Zenda*. His targets instead would be Joyce Cary and Joseph Conrad and modern European novels accorded the most prestige by his colonial-style education, because they glamorized anti-African obliviousness with the sort of subtlety that demands critical resistance. Reacting against *Heart of Darkness*, Achebe attacks its explicit racism and its impressionist method, provoked by the institutional

canonicity that made Conrad someone to be "read and taught and constantly evaluated by serious academics."[29] Had *Heart of Darkness* been an Umuahia school text, it might have been more easily dismissed for its image of Africa at some earlier moment in Achebe's intellectual development. Taught at Ibadan, accorded prestige, it demanded a more serious effort at decolonization. The university context was a kind of paratext that dignified Conrad's style and lent it privileged opacity.

Of course, Ngũgĩ is the best-known source for this critique of colonial education, and in a moment we will turn to his fuller account of the relationship between the modernist text and its university paratext. Let us note first, however, that this critique has a telling counterpart in the work of a very different critic. Lionel Trilling noted that "as the universities liberalize themselves, and turn their beneficent gaze on what is called Life Itself, the feeling grows among our educated classes that little can be experienced unless it is validated by some established intellectual discipline, with the result that experience loses much of its personal immediacy and becomes part of an accredited societal activity."[30] Other critics too explore the problem of institutional modernism—Bruce Robbins, for example, in his discussion of the ways that "in taking institutional forms . . . modernism has also taken power," and Fredric Jameson in his account of the way "being taught in schools and universities" robs modernist texts of "subversive power" and makes them "academic."[31] Many have noted the peculiar way modernist idiosyncrasy shifts into specious authority when it gains institutional sanction. For Achebe, the result is similar—accreditation colonizes experience, transforming literary texts—but also different, in that the "accredited societal activity" also redefines "personal immediacy" of another kind. It also "betrayed" impressionism, giving it new and different meaning to Achebe and his generation of writers.

Achebe suggests that the racist impressions of *Heart of Darkness* might have been useful to postcolonial critique had Conrad framed them within larger contexts and subjected them to critical awareness. Had a further frame narrator reflected upon the limitations of Marlow's vision of African savagery, for example, or had Conrad ventured the subjectivities of his African characters, *Heart of Darkness* might have been a more politically insightful, ethically expansive book. The lapse is especially egregious, as we have seen, because of Conrad's own hope for solidarity. His racist impressions disallow the fellow feeling he wants for literature itself. We

might then say that impressions fail in *Heart of Darkness* because they are not really impressions at all; in effect, Achebe accuses Conrad of pseudo-impressionism, since he feels that Conrad has isolated one aspect of the mode (its affective intensity) in such a way as to limit its further reaches. His impressions are mere sensations, superficial perceptions lacking the emergence toward supposition, abstraction, or more emphatic subjectivity of impressions left to their own devices. Such a failure might not have troubled Achebe much had it been a property of an adventure novel assigned at Umuahia. It might not even have come to his attention, had it not been aggravated by Asquith School prestige. For prestige altered the very structure of the impression. What Conrad began by limiting his impressions to immediate perceptions was furthered in a university context that subjected them to subsequent elaboration—not the perspective Achebe might have wanted, but a kind of sacred value, a canonicity through which rudimentary perception sublimated into elite consensus. Impressionism was a comprehensive mode of understanding after all, not within *Heart of Darkness* but beyond it, where colonial ideology supplied all necessary ideation. This is the crux of the problem. Achebe's anti-impressionism was largely motivated by context—the university prestige that rerouted impressionist emergence into imperialist rationality. It taught Achebe how to read Marlow's impressions—to respect them for their ironic, existential evocation of a universal human despair, as representative of a human transcendental subject rather than idiosyncratically particular. Later reacting against that specious humanism, Achebe could only read it back into the form of the impressions it had speciously completed.[32]

Ngũgĩ accounts for that process in detail. In his discussion of the ways "the colonial student was assaulted by European literatures," he includes an account of the dynamics of the colonial classroom: "Here the racism lay far more in the method than in the content. Their application to Africa and the African experience by hundreds of even well-meaning interpreters in the colonial classroom often carried the racism of cultural diplomacy—a diplomacy of unequal exchange—between generous donors and grateful recipients."[33] Unequal exchange set up a structural imbalance that gave weight to the cultural imperialism within works of modernist literature. Their content was determined by the method, since their relative difficulty seemed to require the expertise of "well-meaning interpreters." Likening them to generous donors, Ngũgĩ equates literary education with the sort

of gift aid that perpetuates underdevelopment. The more prestigious the literary form, the more the method came to seem a countervailing significance that might even contradict anti-imperialist content. For Ngũgĩ and many of his peers, the reception history of modernist subjectivism was shaped by this context, which at first conferred special distinction on modernist writers but then invited special rejection when African writers reacted against the cultural imperialism of literary interpretation. Ngũgĩ's resistance famously developed into a call for its abolition: as a leader in the drive to abolish the English department at Nairobi (an Asquith School established in 1951), Ngũgĩ knew that the "study of the history of English literature from Shakespeare, Spenser and Milton to James Joyce and T. S. Eliot, I. A. Richards and the inevitable F. R. Leavis" put the Great Tradition ahead of one that might include representations relevant to the interests and needs of Nairobi's students.[34] Decolonization would require raising the consciousness falsified by this form of instruction, because "the great tradition of European literatures" presented its writers "in their awesome unassailable heights," "meant to overawe those who, of course, were not renowned for ingenious manufacture and had no arts or science."[35] Thusly positioned, great literature allowed for no continuity between textual content and African readers—that is, no continuity not accomplished through the cultural diplomacy of generous educational donors. This condition, of course, is alienation, in collaboration with ideology. And it is explained as a more general condition of colonial education in Carol Sicherman's account of the peculiar combination of colonialism and progressivism active at the mid-century colonial university. A "legendary mecca" and a "colonial academic hothouse," Makerere "succeeded in creating a sanctuary gratefully recalled by many of the students of the period," because of the liberal ideology that established an ambitious curriculum and intense commitment to higher learning.[36] At the same time—or, rather, because of its intense liberal ideology—Makerere was also a place for profound "unwitting mental subversion," undertaken by staff whose idealization of human universals distanced their students from the specific and the local.[37] As Ngũgĩ suggests, the very greatness of the Leavisite Great Tradition was a force for alienation. It justified a "comfortable paternalism" that "cushioned the all-European staff as well as their grateful students from noticing, let alone challenging, an implicit ideology whose effects were profound."[38] More specifically, its reverence for the "universal" separated

students from their knowledge base in local cultures; it excluded the East African verbal arts from greatness, and, as Ngũgĩ himself notes in his reflections on the "quest for relevance" at the heart of the October 1968 call for the abolition of Nairobi's English department, blocked the development of "a liberating perspective within which to see ourselves clearly in relationship to ourselves and to other selves in the universe."[39]

Ngũgĩ gives Conrad a primary place among Great Tradition writers: "Joseph Conrad is the best representation of this mode," since even if *Heart of Darkness* is "surely one of the most trenchant critiques of colonial conquests," it presumes that "the savagery of colonial conquests was no match for the savagery of Africa."[40] Unassailable images of African savagery led to "the production of Africans permanently injured by a sense of inadequacy about their own achievements," as the rising African middle classes saw themselves "with the same kind of eyes and result that we saw articulated in the literature of the colonial classroom."[41] Ngũgĩ's institutional critique links colonial self-alienation to the problem of African savagery in *Heart of Darkness*, stressing the way the former compounded the latter, which otherwise might not have had the same injurious result. But Ngũgĩ felt very differently about Conrad's *Nostromo* (1904), largely because that novel is all about class struggle—one of the most important efforts to "place conflicts between people in differing classes with their differing and often antagonistic conceptions of world order."[42] All "rooted in class," *Nostromo* was an inspiring precursor to efforts to create forms of social realism useful to postcolonial development. If it still has limitations—Conrad's "bourgeois position limited his vision," making him unable to "see the nature of imperialism and the need for a continuous class struggle against it"—Ngũgĩ nevertheless credits it as a source of his *A Grain of Wheat*.[43] And he specifically credits the influence of Conrad's impressionist technique: "the shifting points of view in time and space; the multiplicity of narrative voices; the narrative-within-a-narration, the delayed information that helps the revision of a previous judgment so that only at the end with a full assemblage of evidence, information and points of view, can the reader make a full judgment—these techniques had impressed me."[44] Ngũgĩ admits that he borrowed these Conradian techniques in spite of his awareness, by the mid-1960s, that Conrad's "ambivalence toward imperialism" made him a problematic predecessor to the postcolonial writer. But he speaks of a "reappraisal"—a re-

valuation of impressionism as an indigenous style that need not carry forward the neocolonialism of a Conradian inheritance. As Simon Gikandi has noted, *A Grain of Wheat* reflects this revaluation for critics who have read the novel as Ngũgĩ's "response to the paradox of writing about collective desires in a genre built on the doctrine of a unique bourgeois self."[45]

What enables this peculiar reappraisal? How could a Conradian impressionism return or persist in much Anglophone African literature as an indigenous mode, despite its Conradian failure? What, in other words, allowed for a postrealist impressionism after Achebe's decisive and influential postimpressionist realism? To answer these questions, it is crucial to see how impressionism has thrived in the literatures of East and West Africa both despite Achebe and in response to what he made of it. To explain that phenomenon, we will turn now to its two different bases: impressionism's life apart from the university system in which it was so fatefully defined by alienating privilege, and its life after Achebe, the reconstructed impressionism designed to give it what Achebe felt Conrad had failed to achieve.

Ngũgĩ explains that he encountered *Nostromo* as part of a "special paper"—not in the colonial classroom itself but in independent work. Institutional methods were displaced by individual agency, undoing the bad alignment of subjective impressions and institutional affirmation that had been the problem for *Heart of Darkness*. Aligning the subjective impressions of *Nostromo* with his own effort at intellectual discovery, Ngũgĩ undertook a reappraisal that happened elsewhere, among Anglophone writers who did not receive Asquith School-style training in literature. Crucial to the history of impressionism is the fact that colonial education gave a set of major, mainly male writers reason to react against it while a different set of writers were never directly prompted to associate impressionist technique with cultural imperialism. Achebe and Ngũgĩ are typical of the anti-impressionist reaction that also includes Ayi Kwei Armah, whose unhappy years at Groton and at Harvard put him on a similar path. First he wrote *The Beautyful Ones Are Not Yet Born* (1968), an impressionistic novel that drew criticism from Achebe, who called Armah "a modern writer complete with all the symptoms" and reminded him that Ghana was "not a modern existentialist country" and therefore not one to represent in terms of its merely subjective forms of human anguish.[46] Armah subsequently joined the anti-impressionist reaction, turning to

historical fiction and issuing "withering criticisms of higher education."[47] His transformation was paralleled in poetry by a similar shift in the work of Christopher Okigbo, who was at Ibadan just after Achebe. His combined studies of classics and literature produced poetry comparable to that of Pound and Eliot, indeed inspired by them and "essentially private, concerned with the artist as a seer and as a visionary, rather than as an active social agent."[48] Chinweizu notes that "after undergoing that unfortunate westernizing miseducation . . . Okigbo, like most western-educated African poets, came out Pound-struck."[49] Ultimately, however, he "staggered toward home," Africanizing his modernism and influencing a generation of younger poets, primarily those of the Nsukka School, to reject "what they saw as the politically disabling complexity of much of the writing of the first generation" of those influenced by European modernist subjectivism. Nsukka pursued work focused on "directly influencing the ethical and social decision-making processes by addressing ordinary people," in this way the opposite of impressionist mystification.[50] Ama Ata Aidoo shared her contemporaries' educational privileges, as well as their subsequent resistance to its colonizing effects. She studied English at the University of Ghana in the early sixties, and her 1977 novel *Our Sister Killjoy: or Reflections from a Black-Eyed Squint* takes part in the realist political critique of colonial mentalities. Flora Nwapa studied English at Ibadan in the 1950s, and her *Efuru* (1966), often called the first novel written by an African woman, is a feminist corrective to *Things Fall Apart*. Nwapa supplies the female perspective necessary to develop a fully objective realism geared toward local needs; there is no gap between what is discovered through perspectival character narration and larger social experience. Bringing this further sociopolitical exactitude to the image of Africa, Nwapa's fiction continues the anti-impressionist reaction into fuller correction of a heroic individualism even Achebe maintains.

In all these cases, forms of mid-century African writing that developed through postimpressionist realism react against the high status of modernist subjectivism in the Westernized university. Contrast the career of Ezekiel Mphalele, who discovered modernist writing after his school days were done. Only when he himself was a teacher did he come to value Faulkner, Hemingway, and other modernists, so that he did not associate styles of perceptual delimitation with liberal humanist dispossession. It is not that Mphalele failed to perceive the conflict between modernist

subjectivism and sociopolitical exigency or that Western aesthetics could not meet African cultural needs. He less strongly associated the styles and forms of subjectivism with the West. His own sense of the Great Tradition detached it from European modernism and made it more authentically universal—even indigenous. He discovered, to borrow a phrase from Jahan Ramazani, that "indigenization and aesthetic modernization . . . are not polar opposites but closely linked."[51] When he spoke out against the radical, complete departure from "metropolitan" forms of aesthetic engagement, he did so believing that what his peers saw as Western could just as well be African:

> What I am trying to warn against is the danger of finding ourselves having, out of sheer crusading zeal, dismissed elements of Western aesthetics which are either built into our new modes of expression or which have been or are already being challenged by Western critics. In the event, we cannot then imagine that we are doing anything uniquely black. We may just have been doing the same thing separately, for ourselves.[52]

Mphalele had not been overawed by the prestige of European modernism, so he did not tend to associate its modes of expression or its institutions with anything uncommon. He could see how "meanings radiate or vibrate from the thing perceived" without feeling the need to bracket that immediate perceptivity; he felt more certain that all art "integrates private instincts with those common to man in general within a cultural context."[53] In this way, he was more likely to see a correspondence between styles innovated by Great Tradition writers and indigenous forms long undertaken "for ourselves." Chinweizu observes the difference, in his account of those artists "spared the alienation of those who have been through the university," who "naturally and unaffectedly draw inspiration from their environment" and are willing and able to "present it as they see it."[54]

Mphalele's syncretism indicates a different possibility for impressionism. Achebe's influential rejection of Conrad associated impressionist styles with unmindful racism, giving the realism of the School of Achebe a postimpressionist character. But if this rejection blocked the persistence of impressionism in postcolonial writing, other writers found ways to develop a postrealist impressionism, in which individualized, immediate perceptions could link to the larger forms of social judgment and action

necessary to postcolonial transformation. It would not have to reassert European modernist ideology or capitulate to prestigious metropolitan styles; undertaken by writers who had not been compelled to respect and then reject those styles in the colonial university classroom, it could be written just "for ourselves." This postrealist impressionism could generate representational strategies in accordance with local impulse and agency. Lasting impressions in Nigeria, Kenya, Ghana, and other Anglophone locales were less a matter of the persistence of any Conradian project than a more complex dynamic whereby Conrad's negative influence ended impressionism at one level so that it could thrive at another. This persistence includes mid-century writing in which personal impressions "naturally and unaffectedly" take part in social critique; it develops into newer forms of realism in which impressions come from multiple human sources or become a new basis for forms of communication that join the individual to the social.[55] Through a "dialectic of negative influence" (to use JanMohamed's phrase for the "Manichean" development of aesthetics in colonial Africa), Conrad's impressionism is vigorously bracketed by Achebe so that impressionism thrives in a postcolonial aesthetic. Here, the postcolonial transcends what Henry Louis Gates has called the "false distinction" between "originality and imitation" in the interpretation of minority discourse, working according to what Edward Said calls a process of "reinscription," whereby what resembles a Western style actually follows upon its erasure.[56] Byron Caminero-Santangelo has found this kind of "postcolonial intertextuality" at work between Conrad and African fiction more generally, and the persistence of impressionism is another example of the way this intertextuality succeeds by undermining any possibility for Western originality.[57]

What did Buchi Emecheta learn about literature in her years at a Methodist high school in Lagos and her degree work in sociology in London? Not much about literary impressionist subjectivity, since she read Chaucer, Shakespeare, Wordsworth, Byron, Austen, Tennyson, and others, but no Pater, James, Proust, or Conrad, and nothing past Rupert Brooke. Even if her "greatest escape was in literature," she did not experience it as an escapist Great Tradition that compelled adherence to speciously universal subjectivism.[58] What made her want to write literature herself was a combination of love for the classics, the example of the Ibo storytelling of her father's eldest sister, and the influence of the sociological theories she encountered while working toward her degree. And, of course, her

feminism, which directed her other impulses toward a different view of the relationship between power and literary expression. Whereas Achebe and Ngũgĩ had reacted against the bad sublimation of idiosyncratic impressions into institutional authority, Emecheta realigned the personal and the political, giving momentary individual intuition new subversive potential. Feminism demanded her own impressions, which she could hardly associate with the prestigious ones showcased by a writer like Conrad, and she began her literary career writing "observations" of life for immigrant black women in London. These fictionalized observations, which became her first book, In the Ditch (1972), often ground sociological critique in the felt, lived experience of sensory perception. They are impressions refit for sociological contingency. They tend to let passing perception stand for critique—to make critique impressionistic—and if they differ from Conradian impressions mainly for their antiracism, they also differ in the way they lay claim to authority. Emecheta allows for no difference between sociological and personal truth: showing "my social realities, my truths, my life in London," she produces observations more real for being her own, more true for being radically personal.[59] She boasts an emphatic lack of objectivity: "I just let it all pour, all my anger, all my bitterness, all my disappointment."[60] And the result is a telling hybrid of fact and fiction, a "documentary novel of the daily happenings of my life," undertaken with the presumption that no conflict between the documentary and the personal could invalidate her observations.[61]

In the Ditch proliferates unaccountable detail and atmospheric descriptions not disciplined to serve the text's documentary function. "My own truths as I saw them" contain a lot of the process of seeing, which sometimes tells a story of its own.[62] Although the effort to "write about myself as if I was outside me, looking at my friends and fellow sufferers as if I were not one of them" gives In the Ditch sociological objectivity, it also allows a free play of fictionality, enabling Emecheta to innovate her own combination of social and psychological realisms.[63] It risks apolitical ambiguity, however, as in the opening of chapter 2, where the autobiographical protagonist enjoys the weather despite the general misery of her social condition:

> After a cold and rainy night, the day was warm. It was early spring. Adah found a space on a bench beside two women who were talking about death, and sat down. It seemed very odd to be talking about death on

such a beautiful afternoon, and in such a beautiful park. She looked at the two women momentarily and decided that the day was too fresh, too pure and too lovely to listen to death-talk. . . . The blue sky was liberally dotted with white clouds. The flats opposite had window-boxes display-ing the first flowering shrubs. There were daffodils everywhere. Daffodils in the park, daffodils in the front and back gardens of houses, daffodils edging the park's footpaths, all planted with the type of carelessness that has a touch of calculation. . . . She inhaled the pure fresh air around her and said under her breath, "I feel so happy I could burst."[64]

Sensibility sidelines sociology here, giving Emecheta's observations expe-riential richness while risking contradiction to the argument of the text: if the weather alone can bring such perfect happiness, social injustice is secondary to the human spirit, and we are in Conrad's territory, distracted by atmospheric abstractions from such things as real talk of death. And yet there is more than a touch of calculation in this carelessness. Fictional-izing impressions help Emecheta elicit identification, much the way Con-rad does, though without the effect of dispossessing the reader for whom identification would mean a loss to critical political agency.

Conrad's impressions might have passed for the feelings of one be-nighted individual had they not been backed by university prestige; Em-echeta's impressions, by contrast, have no such backing, leaving them free to become a true focus for solidarity rather than what Achebe calls dis-possession. If anything, Emecheta's impressions were institutionally con-textualized by just the sort of social realist framework that accompanied, in the School of Achebe, the turn away from modernist technique: *The New Statesman*, which published *In the Ditch* in its original, serial article form. *The New Statesman* was founded by Fabians and helped shape the socialist priorities of 1930s culture in Britain; by the early 1970s, it had long been, in Emecheta's words, "*the* Socialist paper," and "one simply had to read it in those days."[65] Her editor was Richard Crossman, the Labour MP who had spent the prior years working toward greater equity in the state pension system. Although Crossman did not exactly make Emecheta feel like a welcome part of his enterprise, his politics—or that of *The New Statesman* more generally—gave her impressions a kind of epistemic au-thority wholly different from that which consolidates the racism of *Heart of Darkness* for African writers. Her personal impressions became prop-

erly sociological by implication, without any need for her to compromise "my truths" or "my anger." Of course, the primary difference here is that between the racist perceptions of a fictional European imperial agent and the antiracist experience of an impoverished Nigerian single mother living in London. No content-based equivalence justifies the comparison; rather, the different institutional contexts magnify the difference between what might otherwise have been similar impressionist styles. If schooling meant an end for impressionism in African fiction as well as literatures influenced by Achebe's ideology, Emecheta's very different experience of the collaboration between public institutions and personal impressions meant the persistence of an African impressionism, one matched elsewhere. *In the Ditch* was not as influential as *Things Fall Apart*, but it embodies a widespread alternative to that novel's configuration of literary perception.

This is not to say that Emecheta perpetuated a European modernist style rejected by her Asquith School counterparts. She never associated her literary subjectivism with Conradian modernism, and the persistence of impressionism in her work is less Conrad's legacy than the legacy of his relative irrelevance to her project. Emecheta attributes the affective vivacity of her writing to her Igbo heritage: "Igbo is my emotional language," she has said, and she credits Igbo storytelling for the immediacy and energetic compression she cultivates in her fiction.[66] European impressionism is not responsible for it; rather, European impressionism invalidated certain styles of vivid immediacy and thereby encouraged others, including Emecheta's approach to recording "my social realities." Moreover, European institutions are not all negatively implicated in impressionism's invalidation: *The New Statesman* provides evidence that institutions other than the Westernizing colonial university could nurture an African writer's own impressions as well as her politics, much the way other such Western institutions aided in the emergence of postcolonial aesthetics.[67]

For other writers, this emergence even reshaped the African university. Kojo Laing studied at the College of Management at Ghana and at the University of Manchester and Glasgow University, where he did an M.A. in political science and history. Originally a poet and a teacher, Laing turned to fiction with *Search Sweet Country* (1986). At a moment in which magical realist and postmodern forms were becoming the preferred modes for postcolonial representation, Laing's novel represents the upheavals of

life in Ghana (in 1975, eighteen years after independence) through the kind of fragmentary, dissociative perceptions characteristic of impressionist realism. The novel is sometimes called surrealist, but only because of a misunderstanding of Laing's realist reasons for psychic dissolution. His phantasmagoric imagery tends toward the epiphanic concretion of the impression—for example, in this typical moment of visual luminosity generated as Kojo Okay Pol surveys the city:

> And all the lights showed the different angles at which the rain cut this city into bits; into jig-saw puzzles, in restrained African razzle-dazzle; and through the beams, there was yellow rain and white rain, but most of the vast stretches of wall where the concentrated light could not reach were shadows, were black rain. There was a lot of running for shelter, from the gods of sudden puddles. But those that decided to be leisurely and get wet, were speaking in flooded words . . . they talked about the wet country that was yet thirsty.[68]

Such impressions make up one of the novel's twenty-two chapters, each of which enters the mind of a different character, and each of which would isolate the novel to solipsistic enclosure were it not for the multitude of minds represented in total. This particular account of the Osu section of Accra exemplifies what impressionism could become post-Achebe and despite the Great Tradition: an immediate register of perceptions capable of interpretive insight without risk of vulgar bias or hasty judgment. What makes the difference is the way political critique (of the thirsty country) is a suggestion based in observation and not elaborated beyond the terms it establishes. Conrad might have generalized more broadly; Achebe, in reaction, might have taken pains to provide a more objective framework for a character's personal experience. Laing gives a puzzle of rain diverse racial implications and then lets them flow into language, so that contextual interpretation has direct metaphorical sources. We might draw from this example some preliminary terms for a characterization of the impressionist style that persists in the Anglophone novel despite Conrad and despite Achebe: it is postimpressionist for its evaluative politics, as Achebe might have hoped, and it is postrealist for its reactivated sense that individual, fleeting, fragmentary perceptions might also be a Ghanaian "razzle-dazzle," in angles that shape out new countries of understanding.

Search Sweet Country ends with a peroration delivered by Professor Sackey, whose relation to the Ghanaian academic community explicitly links the novel's indigenous impressionism to its academic self-determination. Sackey speaks in response to questions from a British woman doing her doctorate on "Development and the Informed Ghanaian Psyche," a topic that could only provoke reflection upon the politics of subjectivity.[69] Professor Sackey is skeptical: "How do you expect to trap the Ghanaian psyche?" he asks, knowing that this British woman is likely to "take [her] information home, and become an instant expert on Ghana."[70] Sackey is all too aware of what happens to the African mind back in the Western metropolis. Even so, he warms to the theme, and offers an account of the Ghanaian psyche that denies any "ivory tower" exaltation of the intellect.[71] He almost seems to speak against the broken unity of the Conradian impression when he notes that in Ghana "the mind that finds itself among concepts and the like . . . does not yet want to lose touch with common-sense reality."[72] Moreover, he stresses the possibility of homegrown versions of Western concepts when he notes that for the Ghanaian "in the psyche may lie the concept of, say, Marxism," but that it would "invert itself, and stretch towards the onion, because the onion pushes his pretensions down, reminds him of the vast rural stretches that have nothing to do with such alien concepts."[73] "Marxism itself would rarely take transformed or original forms in his mind," since his mind's originality would invent its own version of Marxism, and, more generally, the Ghanaian psyche "has a breadth, an expanse of experience beyond the narrow Eurocentrism" that would distinguish among "abstract, symbol, action and thing."[74] The psychological rhetoric here frames the impressionistic style of *Search Sweet Country* with a justification of its local originality, which is, in turn, an undoing of Eurocentric sublimation. It makes perfect sense that this rhetoric is offered by a Ghanaian professor, who represents an institutional culture so different from that which had given impressionism its sublime ideology.

Through the dialectic of negative influence, Conrad invalidated impressionism for Achebe, who in turn invalidated it for postcolonial social realism. Achebe's postimpressionist realism was a challenge for any persistent or renewed subjectivism focused, in the manner of impressionism, upon the emergent value of immediate, minimal, experiential perception. Any postrealist impressionism would have to register impressions

without lapsing into Conrad's mode and without failing to achieve the sort of sociological emergence necessary to give impressions total, post-colonial validity. And because these failures are linked to the colonial in-stitution, postrealist impressionism would have to stress alternative in-stitutional contexts, not only as its field of action but also as the target of emergence—the model for the public, abstract, or conceptual component of impressionist duality. As we have seen, the colonial university was a bad outcome for impressionist emergence; its empty prestige was a pseudo-impressionist result, shifting the structure of the impression toward a lib-eral humanist affirmation of perceptual universality, and dispossession. *The New Statesman* was better, and other contexts would likewise allow for post-Conradian redemptions. Other writers not directly subject to institutional dispossession also found room for a reconstructed impres-sionism, and later writers schooled by Achebe were careful to give it forms for African self-possession. Laing's fiction and Emecheta's "observations" are examples of a non-Conradian impressionism. For examples of a post-Conradian, postrealist impressionism, we now turn to two global texts that react to Achebe's reaction to Conrad's image of Africa: Barbara King-solver's *The Poisonwood Bible* (1998) and W. G. Sebald's *The Rings of Saturn* (1995), both of which reconfigure impressionism for postcolonial insight.

Kingsolver gives Conrad's Congo a perspectival refit, diversifying an array of views that register Congolese realities in different ways. Here, it is a missionary and his family—his wife and four daughters, "a sink-ing mess of female minds"—who venture into the heart of the Congo, although years later, and positioned to see the situation there with limita-tions justified by young female innocence.[75] Critics have placed the novel in "the *Heart of Darkness* 'undertow,'" explaining its intervention in the "literary debate" surrounding Conrad's views on race and imperialism.[76] But if Kingsolver's novel very clearly develops a diverse narrative struc-ture able to "offer a greater possibility than *Heart of Darkness* for multiple truths," that is not the only way it innovates a postrealist impressionism.[77] Whereas Conrad's Marlow had, according to Achebe, proceeded blindly from one man's prejudicial panic to lost generalizations about a continent, Kingsolver's girls enable impressions to emerge gradually from immedi-ate experience to local reality to global history. Each of the four daughters plays her epistemological role. The youngest, Ruth May, registers the most immediate impressions; her older sister Leah has them too, but poses

epistemological questions about them; Adah has a linguist's sensibility, getting her impressions indirectly from foreign words; and Rachel takes a sassy American teenager's refractory point of view. These different forms of consciousness compose various perspectival sequences through which conversations, radio reports, public speeches, indigenous folk practices, neocolonial government procedures, and regional market forces all begin in raw impressions and gain in contextual awareness. And as the girls grow, the novel harnesses the developmental force of *Bildung* for the emergence of impressions.[78] It all culminates in the historical consciousness the girls' mother develops. Orleanna Price offers up the historical contexts necessary to know the truth about the global politics shaping mid-century life in the Congo, but that realist framework is undergirded by shifting impressions of "Africa," the better to dramatize political reality's basis in the perceptual experience it ideologically determines.

Kingsolver says *The Poisonwood Bible* was based largely on her own experience living in a region of the central Congo as a girl, "very visceral memories without any adult content."[79] She had hoped to return to the Congo in order to supplement her memories with truer knowledge, but, in the meantime, she invented a story in which a white missionary family would allegorize the problem of Congolese independence: "I began to imagine a household of teenage daughters under the insufferable rule of an autocratic father, as a microcosm of the Congolese conflict." What seems at first an absurdly reductive way to treat an African locale— a worse way to make a "backdrop" of it—actually reverses the Conradian situation in which "Africa" is only allegorical for a white crisis of the mind. Kingsolver's initial inspiration was Jonathan Kwitny's 1985 *Endless Enemies*, an indictment of American foreign policy in the developing world. Wanting to novelize it, Kingsolver remembered her time in the Congo; "The story of the CIA-backed coup in the Congo in 1960 struck me as the heart of darkness in a nutshell."[80] Hoping to return there to supplement her visceral memories with adult content, Kingsolver found that she was actually barred from returning. She had spoken publicly against Mobutu Sese Seko and could not enter the country. For a long time she felt that "as long as Mobutu kept me out of his turf, I could never write the damned Africa novel," but ultimately she decided to go with the knowledge she did have, but to hedge against ignorance and error by splitting allegorical consciousness among four different impressionist sensibilities—each

yielding an alternative interpretation, "a gaggle of sisters under the domi-
nance of a fierce patriarch, each of whom would try to survive him in her
own way."[81] Neocolonial politics (in the form of American foreign policy
and then Mobutu's prohibition) limit awareness, and in response, King-
solver develops this diversified impressionist register: reverse allegory,
populated with underdeveloped sensibilities, developed to remediate the
disabling conditions of neocolonial ignorance. And this set of circum-
stances gives Kingsolver's work a telling institutional context of its own.
Neocolonial foreign policies absolutely polarized Kingsolver's sense of the
Congo, limiting it first to what a seven-year-old child of American inter-
national aid workers could experience, then to what an adult American
could research.[82] *The Poisonwood Bible* shows how a postrealist impres-
sionism might enable a Western writer to reconcile these epistemological
modes.

Postrealist impressionism develops in Sebald's *Rings of Saturn* through
a very different revision of *Heart of Darkness* that begins, in the novel's
section on Conrad, with failing consciousness: Sebald's narrator watches
a BBC documentary about Roger Casement but falls asleep just as he is
beginning to hear about Casement's fateful encounter with Conrad in the
Congo. Right away Sebald indicates his way of revisiting Conrad's locale.
He does not envision it in an impressionistic mode that might develop
as "waking consciousness ebbed away"; instead, "shadowy images" spur
efforts to "reconstruct from the sources" the story he "slept through."[83]
He embarks upon a rigorous research project, but one that is, of course,
distinct from the documentary—written in his own unique cosmopoli-
tan style. It takes what Rebecca Walkowitz has called Sebald's "panoramic
view," which puts concrete historical perceptions into comparative rela-
tion.[84] When he arrives at Conrad, it is not to contradict what Conrad saw
in the Congo or to supply details left out, but to extend Conrad's phenom-
enology to the Western imperial metropolis. Sebald's narrator notes that
Conrad saw Europe differently after his experience in the Congo: he "now
saw the capital of the Kingdom of Belgium, with its ever more bombastic
buildings, as a sepulchral monument erected over a hecatomb of black
bodies, and all the passers-by in the streets seemed to him to bear that
dark Congolese secret within them."[85] Achebe did not observe this result
in *Heart of Darkness*. He did not consider the possibility that Conrad's
blighted style of seeing—that which is so hopeless about Africa—was the

product of his traumatic encounter with imperial violence. Achebe did not read for it because its effects were, nevertheless, colonizing, since they remanded to style the politics that should have been more explicit. Sebald converts that mystified style into a fuller political resource—for example, by extrapolating upon Conrad's view of Brussels:

> And indeed, to this day, one sees in Belgium a distinctive ugliness, dating from the time when the Congo colony was exploited without restraint and manifested in the macabre atmosphere of certain salons and the strikingly stunted growth of the population, such as one rarely comes across elsewhere. At all events, I well recall that on my first visit to Brussels in December 1964 I encountered more hunchbacks and lunatics than normally in a whole year.[86]

Describing other Belgian grotesques, Sebald develops his sense that the "representation of history" overlooks these symptoms of its evils through a "falsification of perspective," as we "the survivors" fail at immanent perception.[87] Very clearly, his alternative restores "the corpses and mortal remains," rematerializing spectral traces in the way *The Rings of Saturn* enriches the documentary mode.[88] Enriches it, that is, with an impressionist style developed in a postrealist dialogue with Conrad's stylistic detachment. Achebe might have wanted a more realistic account of what had produced corpses in Africa or a more historical representation of their real lives, but Sebald delivers instead an impressionist historicism, which documents the semblances of history.

This historicism complements Kingsolver's reverse allegory: in both cases, the institutional version of impressionist subjectivism is revised, post-Achebe, into a form in which its emergence is rendered sociohistorically responsible. Together with Emecheta's mode of "observation" and Laing's urbanized phantasmagoria, these postrealist impressionisms give a future to the legacy Achebe refused. At times deliberately modeled in response to Achebe's refusal, at times an impressionist mode developed "just for ourselves," this postrealist impressionism bears the diverse traces of its history of negative dialectics, the form of influence through which impressionism has come down to us through a complex set of reactions, sidesteps, and reversals. It also bears traces of the institutional histories that have differently positioned the impression's dual nature. All of these

writers had educational backgrounds likely to offset the kind of Asquith School positioning that gave impressions a neocolonial outcome.[89]

If any single writer embodies this dynamic, representing the contemporary impressionism that has developed through these many legacies, it is the writer whose relationship to Achebe is at once direct and surprisingly complex: Chimamanda Ngozi Adichie, author of *Half of a Yellow Sun* (2006) and *Americanah* (2013), both of which indicate what contemporary global fiction owes to the history of impressionism.

Adichie sounds a lot like Conrad himself in talking about her literary education. She says she grew up reading British stories and "didn't know that people like me could exist in books."[90] Then she read a book that was a "shock of discovery" and a "huge mental shift." But unlike Achebe, Adichie was educated at a University of Nigeria that had long since changed its relation to the liberal humanist Great Tradition, and her transformative text was *Things Fall Apart*. Her father was a university professor, and Adichie grew up on campus—in a house once occupied by Achebe himself. Much has been made of this coincidence: "Since then, the fact that I grew up in a house that Chinua Achebe himself had previously lived in has become possibly the most important fact that people know about my life." Adichie confirms that living there meant "hearing literary spirits whispering in my ear," and says, "I would not be the writer I am if it weren't for Chinua Achebe." She defines this legacy in terms of the way *Things Fall Apart* restored to her the precolonial past, counteracting "accounts of Africa as a place of anarchic darkness until colonialism came, accounts in which Africa was defined by negatives," and yet she modestly overestimates the extent to which Achebe's novel actually inspires her own account of Africa.

Half of a Yellow Sun, Adichie's novel about Biafra, is everything Achebe could have wanted from a realist African novel, but it shares with much contemporary fiction a tendency to represent its critical moments impressionistically. Characters in crisis lose coherent awareness, and their fragmentary, intensely immediate perceptions give vivid presence to the horrors of the Biafran War. This tendency reflects a larger sense that realist literature ought to center itself on intense moments of perceptual limitation—that diminished sense is paradoxically the best record of what becomes historical and how it does so. Historical critique in *Half of a Yellow Sun* turns upon essential moments of emergent sensory experience. Of course, this does not mean that Adichie betrays Achebe's legacy after

all, but rather that she has found ways to make subjective specificity serve political awareness. If *Heart of Darkness* turned upon imperial solipsism and produced no real Africans, and if the liberal humanist university prestige compounded the problem by equating this failure of emergence with elevated consciousness, Adichie subjects it to reflexive reconsideration. *Half of a Yellow Sun* details the advent of African imagery in the diverse minds of a failed white novelist, a woman academic, and a native informant. The novel writes a postrealist impressionism by converting the single register of imperial impressions into a triple form of postcolonial awareness that fulfills the potential of Conradian perspectival complexity for Achebe's realist project.[91]

One register is Ugwu, the houseboy, who at first receives his impressions uncritically and without the power to take ownership of them. At one early moment, his style of perception is presented as simplifying the built environment of the neocolonial university city of Nsukka and unable to convert impressions to interpretation: "He would never be able to describe to his sister Anulika how the bungalows here were painted the color of the sky and sat side by side like polite well-dressed men, how the hedges separating them were trimmed so flat on top that they looked like tables wrapped with leaves."[92] These metaphorized impressions could form the basis for critique of an excessively cultivated elite environment; instead, they are minimal perceptions, and metaphoricity is but a function of their unavailability to more pointed description. At this point, Ugwu, an uneducated local worker, is unable to make anything of his impressions, but as the novel proceeds, he gains in critical faculties, so that ultimately he becomes the novel's primary authorial figure. As many critics have noted, *Half of a Yellow Sun* has a parallel text within it, an interpolated history of Biafra that complements the novel itself with a more documentary-style, directly historical version of the events the story relates. At first we think this text is authored by Richard, the British journalist, but a final surprise twist reveals the author to be Ugwu. His trajectory takes him from inchoate impressions to documentary realism, indicating a similar trajectory for the novel's own reception of its impressionist legacy. It demonstrates how homegrown impressions might develop into the proper stuff of history in the new African novel.

Richard's own trajectory takes a different course, one that proves that mere impressions need not be inconsistent with history. He goes from the imperial coherence of an anthropological project to a more valid loss

of integrity and authorial purchase. Richard comes to Lagos to research and document the aesthetics of Igbo-Ukwu art, specifically the practice of making the "magnificent roped pot" that has become the object of his most enthusiastic admiration.[93] Despite his real interest, he is satirically received as "a modern-day explorer of the Dark Continent," and his objectives do seem potentially exploitative until they begin to unravel his own authority.[94] He is unsure how to write about Igbo aesthetics: "Perhaps a speculative novel where the main character is an archaeologist digging for bronzes who is then transported to an idyllic past?"[95] But the book he begins to write "did not make any coherent whole"; a draft of a better version is destroyed by fire, by his Nigerian wife in a moment of vengeful anger, and his failure seems to have something to do with his inauthentic relationship to Biafra.[96] His view of it, he comes to fear, is detached: "Then he felt more frightened at the thought that perhaps he had been nothing more than a voyeur. He had not feared for his own life, so the massacres became external, outside of him; he had watched them through the detached lens of knowing he was safe."[97] This self-critique of falsely stable vision is a surprising defense of the impressionist alternative, and indeed, Richard develops toward that alternative, becoming more immersed in the Biafran experience and, as a result, losing the vantage point necessary to authorship on his terms. He develops a form of journalistic engagement oddly inspired by Rimbaud's phrase, "I is someone else," but this dispossession is undertaken as a form of civic responsibility.[98] And at the moment in which he seems to have composed enough authentic journalistic observations to complete his book about Biafra—the documentary account we have been led to believe he has written—he realizes that "the war isn't my story to tell, really."[99] He cedes the project to Ugwu, and their trajectories have crossed, creating the chiasmic structure upon which *Half of a Yellow Sun* builds its theory of postrealist impressionism.[100]

With that structure in mind, we can read, interpret, and evaluate the impressions the novel features at critical moments—the impressions that might otherwise seem to be a reflexive stylistic routine or, worse, a heedless capitulation to a stylistic norm shown to foster reactionary presumptions. In the context of the narrative's perceptual trajectories, which allegorize an effort to remedy the imperialist subjectivity of impressionist fiction, the impressions featured in *Half of a Yellow Sun* attain a fuller critical reach. They carry with them the whole history of the impression-

ist mode, its failure to meet postcolonial needs and its contemporary reformation. The character who has these reconstructed impressions is Olanna, who takes a teaching job in sociology at Nsukka University over the objections of her father, who argues that "Nigeria was not ready for an indigenous university, and that receiving support from an American university—rather than a proper university in Britain—was plain daft."[101] When Olanna registers impressions, they have all the sensitivity of the immediate, immersive form of experience the novel otherwise values for its vantage point, but they do not displace experience into individualistically personal forms of interpretation; they stay in the moment, so that the moment can remain historical. Keeping them simple, Adichie keeps them honest, so that they become the experiential counterpart to the mode of indigenous observation Ugwu achieves in his history of Biafra. One typical passage begins with a moment of "delayed decoding" right out of Conrad, but instead of keying a Conradian response, it compels a perceptual abeyance: "A shrill sound pierced the air, and at first Olanna thought it had come from the radio before she realized it was the air-raid alarm. She sat still."[102] As events proceed, Adichie keeps to the bodily experience of them, careful not to extrapolate to the sort of response that would draw excessive conclusions from a bodily unease:

> Neighbors were running, shouting words that Olanna could not understand because the stubborn searing sound had shrilled its way into her head. She slipped on the wine and fell on her knee. . . . Olanna slapped at the crickets; their faintly moist bodies felt slimy against her fingers, and even when they were no longer perched on her, she still slapped her arms and legs. . . . Voices around her were shouting. . . . Her bladder felt painfully, solidly full, as though it would burst and release not urine but the garbled prayers she was muttering.[103]

Such a passage is important for its nonsignificance. It doesn't imply any universal meaning to the chaos it presents; no moral allegory readies the impression for academic exegesis. In the context of what such impressions have conveyed, and in the immediate context of this novel's reconfiguration of the impression's narrative sensorium, Olanna's mere impressions are just that; they link individual psychological response to larger social implications by refusing to do so only by implication.

When impressions do become meaningful, Adichie is careful to maintain the interpretive ambiguity that balances immediate perception and potential larger import—for example, when this scene of crisis finally allows for a moment of genuine reflection. Then, back in her classroom, Olanna's personal experience attains to a valid momentary meditation on the problem of violence:

> All the windows were blown out, but the walls still stood. Just outside, where her pupils played in the sand, a piece of shrapnel had drilled an elegant hole in the ground. And as she joined in carrying out the few salvageable chairs, it was the hole she thought about: how hot, carnivorous metal could draw such pretty ringlets in the soil.[104]

Achebe had complained that Conrad's impressionism perpetuated a dangerous fiction that "Europe's devastation of Africa left no mark upon the victim."[105] Ironically, shallow impressions in one area allowed for shallow ones in another, as the marks of violence in Africa could seem as fleeting and notional as Marlow's impressions of them. Olanna seems to meditate on the same problem, in what we might read as a meta-impressionistic reflection: the terrible violence she has just experienced seems somehow capable of elegant designs, drawing pretty ringlets where it has actually wrought destruction. But ironically this reflection is itself an impression—albeit of a very different kind. Whereas Conrad's impressions could leap to conclusions, scattering wild surmises, but then end up leaving no mark, Adichie's impressions withhold judgment, and only at the right moment deliver their incisive critique. It is a postcolonial critique—a function of contemporary, postrealist impressionism—because it bears within it the legacy of impressions complicit with colonial racism as well as the reaction against them, to compose a pattern for the coordination of individual and political consciousness.

But it is with her next book, *Americanah*, that Adichie most fully realizes this form. The novel begins with a self-consciously negative impression not unlike that which strikes Ugwu at the beginning of *Half of a Yellow Sun*:

> Princeton, in the summer, smelled of nothing, and although Ifemelu liked the tranquil greenness of the many trees, the clean streets and

stately homes, the delicately overpriced shops and the quiet, abiding air of earned grace, it was this, the lack of smell, that most appealed to her, perhaps because the other American cities she knew well had all smelled distinctly.[106]

To begin a novel by an African writer about an African woman in America with an impression *manqué* is to announce from the start a complex relationship to literary-cultural heritages. Ifemelu has no immediate, sensory impression of Princeton, and that is why she likes it.[107] Perhaps an ideological fantasy, this sense of Princeton as a place so stately and cultured that it has no smell is a provocative way to defy expectations about what an African woman ought to like about an American place of prestige. But it is also, more specifically, a clever way to defy expectations about impressionistic representation. Ifemelu's impressions will not stick to primary associations, and if they adhere to ideological ones, it is with the self-conscious, critical sense Adichie demonstrates here and in her previous work. Subsequent impressions prepare the way for a larger such transition, as Ifemelu's life in America and then back in Nigeria takes her first through the bewildered impressions of a dislocated exile to the reconstructed impressions of a global cosmopolite.

At first, the novel registers impressions of the kind that could convey the experience of any immigrant anywhere: "She was bloodless, detached, floating in a world where darkness descended too soon and everyone walked around burdened by coats, and flattened by the absence of light. The days drained into one another, crisp air turning to freezing air, painful to inhale."[108] Such a description bears traces of Conrad, in the way it links primary perceptions of light and dark to fundamental judgments against a meaningless existence. Conradian bewilderment characterizes Ifemelu's efforts to adjust to Philadelphia: "And she had the sudden sensation of fogginess, of a milky web through which she tried to claw. Her autumn of half blindness had begun, the autumn of puzzlements, of experiences she had knowing there were slippery layers of meaning that eluded her."[109] Sudden sensations that equate to epistemological crisis in terms of figures for elusive meaning seem to suggest, at this early moment in the novel, that Adichie might rest content with an unreconstructed pseudo-impressionism. But Ifemulu reaches an important turning point in her life, and in the novel, when she develops a different mode for her impressions.

A new representational project begins when Ifemelu finds a way to give form to her impressions of America—a text within a text not unlike the book that develops when Ugwu transcends primary impressionism in *Half of a Yellow Sun*. Ifemelu begins to blog. The title of her blog is interesting for the way it makes use of a synonym for "impression" that hearkens back to Buchi Emecheta's similar use for the same terms: "Raceteenth or Curious Observations by a Non-American Black on the Subject of Blackness in America."[110] "Curious Observations" are very much impressions, but rendered sociological, masking their sociological incision in the kind of epistemological modesty impressions also tend to entail.

In fascinating ways, Ifemelu's blog enables her to transform her impressions into antiracist performance. The contrast to the original impressionist mode of Conrad's fiction as seen by Achebe could not be more telling. Whereas Achebe felt that Conrad had offered emphatically private perceptions whose lack of true public verification made them susceptible to a racist version of judgment, Ifemelu's blog goes public with antiracist pronouncements validated by their apparently minimal authority. They are just observations, and Ifemelu is a non-American black, but the reconstructed dynamic of the impression gives them a powerfully responsive form of understanding and communication. No technophilic idealization of social media democratics is necessary to explain why Adichie's blog should make such a difference. The novel itself provides the evidence that her way of disseminating her "curious observations" reinvents impressions after Achebe. Most often, her blog posts begin in disturbing experiences, which Ifemelu then reformulates into public questions; she retains the experiential motive, but generalizes it into speculation about the problem of race in America. What is crucial is not so much the range of these curious-observation impressions from personal experience to public provocation, but how a new media possibility enables it: searching for a way to get beyond available alternatives, Adichie lights upon one that reinvents impressionism in terms of intermedial dynamics.

Ifemelu pursues her blog alongside persistent reference to the failure of literary fiction to do the sort of antiracist work she accomplishes. In the words of one character,

> You can't write an honest novel about race in this country. . . . Black writers who do literary fiction in this country . . . have two choices: they can

do precious or they can do pretentious. When you do neither, nobody knows what to do with you. So if you're going to write about race, you have to make sure it's so lyrical and subtle that the reader who doesn't read between the lines won't even know it's about race. You know, a Proustian meditation, all watery and fuzzy, that at the end just leaves you feeling watery and fuzzy.[111]

And contemporary American fiction is a failure for another Nigerian character who "hoped to find a resonance, a shaping of his longings, a sense of the American he had imagined himself a part of"—in other words, a representation of the totality of relationships that make individuals part of a cultural whole.[112] But "he read novel after novel and was disappointed: nothing was grave, nothing serious, nothing urgent, and most dissolved into ironic nothingness."[113] These disappointments recapitulate the sense of Conrad's failure and frame expectation for a literary mode that could represent problems of race and sociality in spite of the persistence of impressionism. That mode takes its cue from social media, mapping the old dynamic of the impression onto new possibilities generated by cyberspace sociality, in which fleeting impressions notoriously attain to massive public awareness and persistence.

Ifemelu's antiracist observations find a technological form for the observations Emecheta had offered more adventitiously in *The New Statesman*, serendipitously founding a social project for impressions despite Achebe's sense of their dispossessive antagonism to the project of social realism. That antagonism had been aggravated in Conrad by the colonial context for the impressionist dynamic—the institutional context that converted the suggestive power of inchoate perception into the political power of Great Tradition authority. Substituting now a very different institutional framework, Adichie undoes the dispossessive antagonism Achebe rejected, converting it into a form of public ownership, albeit a mitigated one, since Ifemelu's blog actually has no authority beyond that of experience reinvented by virtue of the dynamics of new media sociality. This prodigiously complex public relevance gives Adichie's impressionism real contemporary value. Whereas a holdover of Conradian impressionism might replay his atmospherics to lend literary value to decorative description, Adichie's impressionism embodies a whole history of efforts to find a perceptual form for antiracist subjectivity. When

Ifemelu restarts her blog in Lagos, having finally left the United States, she finds herself "reveling in the liveliness of it all, in the sense of herself at the surging forefront of something vibrant."[114] The same might be said for the cultural form she has revitalized, which surpasses the ironic nothingness and watery fuzziness of pseudo-impressionism to achieve its truly vibrant resurgence.

5

THE IMPRESSIONIST FRAUD

Klein, Saito, Frey

To early audiences, impressionist pictures looked incomplete or incompetent, sketched without proper skill or effort. Or worse: deliberately hasty and sloppy work, a tricky way to make money off the sort of pictures that typically never left a true artist's studio. In other words, impressionism looked like a fraud, and the public reacted accordingly, not just with the laughter and derision said to have greeted the first exhibitions but with the anger and indignation provoked by swindlers and cheats. Although a great deal of effort had gone into these works—indeed, even the most improvisatory brushstrokes were often the product of extensive labor—viewers often naturally saw them for what they appeared to be: rush jobs rather than masterpieces, flung before the public in the opportunistic hope that this new vogue for impressions could transform barely presentable pictures into saleable ones.

This sense of its fraudulence was no mere misunderstanding, even if impressionism was hard work. As we have seen, the first painterly impressions were at once sensory traces of real-world imagery and expressions of artists' individual designs. They lent themselves to forms of attention that deferred to distraction, and they often prompted their later practitioners to mystify the very thing they would accomplish, be it political recognition, cinematic magic, or simple beauty. Honest, candid availability to real visual sensation and unprejudiced openness to atmospheric and social conditions may have been the basis for the impressionist sketch,

but sketchy impressions looked like dishonest deception, not just because the public got it wrong, but because of the trickery built into the impressionist project. It partakes of the untrustworthiness of perception itself, compounded by the confusion that always accompanies any speculation about the way basic perception emerges into aesthetic experience. If that process has been the object of such diverse theoretical explanation, it is no wonder that spectators encountering perceptions more emergent than ever before would greet them with unprecedented suspicion. The same dynamic that guarantees impressions their lasting influence—that availability to compelling narratives about the emergence of perception in and through art, into cultural history—also virtually ensures this negative response.

The most famous was probably John Ruskin's case against James McNeill Whistler. Ruskin saw in Whistler's pictures an outrageous instance of fraud: lazy incompetence passing for superior verisimilitude, smears pretending at aesthetic vitality—"imperfections gratuitously, if not impertinently, indulged," and, famously, a "coxcomb . . . flinging a pot of paint in the public's face."[1] For Ruskin, Whistler's *Nocturne in Black and Gold: The Falling Rocket* (1875) seemed to fake a virtue of its failings. Whistler ought to have tried to become a better painter, through education and hard work; instead, he indulged his mere impressions, exploiting the uncertainty of the link between inchoate perception and true art. Adam Parkes perfectly describes the conflict: Ruskin and Whistler were working with two very different ideas of what it means to do justice to the visual world, both of which were really versions of impressionism. If Ruskin stressed public accountability while Whistler favored a personal vision, these were but different ways to realize impressions, and the dispute was "a dramatization of certain tensions *within* impressionism."[2] In other words, what created such complex interest within the artwork could generate controversy around it, even to the point where one artist's impressions could be a scandal to another. Perhaps the best phrase for this type of scandal—this inherent impressionist trickery—is what so many people have said about modern art since impressionism: "My child could paint that." Emile Cardon was among the first to look at impressionism and see "the scribblings of a child."[3] It was a common mistake, given the effort to cultivate the innocent eye and to dispense with academic teaching, and given the potential of impressionism to look like a primitive unity of sensation and

expression. It makes good sense that so many modern artists have had to answer this charge, given the legacy of impressionist fraudulence, which might be said to culminate in *My Kid Could Paint That*, Amir Bar-Lev's 2007 documentary about a brilliant child artist and the controversy surrounding her. Here, the problem of the impression goes wild, as Marla Olmstead's childish innocence is at once the very thing that confirms her genius and that which proves her a hoax. At stake is the old question of immediacy and its aesthetic, which continues to question aesthetic authenticity. Charges of fraud continue to face those for whom the value of art is a product of minimal apparent authority, maturity, or work.

Whistler and Olmstead are avatars of the personage that is the subject of this chapter: the impressionist trickster. A survey of the years between *Nocturne in Black and Gold* and *My Kid Could Paint That* finds many con artists, cultural figures seen as frauds because they seem to traffic in merely insubstantial, superficial, or transitory wares, usually for personal gain. In some of these cases, however, the more impressionistic the fraud, the more truly valuable the contribution—the more it extends to real public gains. This unlikely nonfraudulence is what unites the three tricksters this chapter reevaluates.

Their trickery goes back a long way, as Claude Lévi-Strauss might attest. In "The Structural Study of Myth," Lévi-Strauss argues that trickster figures of Native American mythology are important for a tendency very much relevant to the problem of the impression: collapsing oppositions that structure human culture. Lévi-Strauss explains that the "trickster is a mediator," with a position "halfway between two polar terms."[4] Mythical thought tries for resolution of opposites, in Lévi-Strauss's foundational account, which might be applied, in this context, to the logic of the impression, which also goes toward the resolution of the oppositions that preoccupy aesthetic theory. It too is a mediator, and like the mythic trickster figure, "must retain something of that duality" it would resolve—"namely an ambiguous and equivocal character."[5] Lewis Hyde builds upon this account of the way "trickster narratives appear where mythic thought seeks to mediate oppositions" to equate the trickster's "polytropic" activity with vital cultural creativity.[6] Breaking rules, eluding restraint, crossing boundaries, sometimes causing problems by solving them, trickster figures lie, cheat, and steal, but in doing so, they innovate and invent, enhancing the world to the extent that their tricks undo the difference between matter

and spirit, low and high, loss and gain. Such trickster creativity was essential to the mythos of impressionism, and it can help explain what happens when the impression's "ambiguous and equivocal character" becomes embodied in people like Whistler and Olmstead. Personified, it draws upon human qualities, conflating the aesthetic with characterization; thusly characterized, the impression returns to the field of perception with new powers of disruption and change. In this way, new possibilities develop, in which impressionist projects assume a fraudulence perhaps special to them. The more they matter, the more false they seem, and this falsity is the clue to the good that they do. In other words, some basis for truth vanishes with impressionist trickery, provoking our displeasure, only until we discover what new potential has taken its place.

We have seen it already in the modernist advertisement, in which the mediation of attention and distraction undermines the truth of the verbal message, for better and for worse. Filmic mobility shares this trickster quality, mediating art and machinery sometimes to achieve cinematic specificity and sometimes to devolve into fetishism. These phenomena, however, have no single human representative—no one to draw the blame for them and, in turn, lend them the culpability, or the creativity, of persons. Personhood gives the impressionist fraud special status. Although this fraudulence is really in play whenever impressions are at work—that is, insofar as impressions are trickster perceptions—it becomes a real troublemaker in matters of human motives and actions. We turn now to three cases of this trickster behavior, three characters whose exploits dramatize the ambiguous and equivocal nature of impressionism in the fields of performance art, high finance, and autobiography. In each case, a notorious ruse turns out to be a problem of the impression, made worse by the deceptive behavior of a crafty character. But in each case something of real value emerges. Impressionism inspires a trickster who, in turn, gives it new cultural usefulness, despite all appearances.

YVES KLEIN'S BLUE AGE

On March 9, 1960, Yves Klein orchestrated his *Anthropometries of the Blue Age* at the International Gallery of Contemporary Art in Paris. Klein en-

tered the space in black tie and white gloves, stood quiet for a moment, and grandly cued a string ensemble to begin his Monotone Silence Symphony, a single chord lasting twenty minutes. Then he cued the entrance of naked women carrying pails of blue paint—his own International Klein Blue (IKB), which he patented later that year. The women applied the paint to their bodies and then began to press and slide themselves upon white papers laid out on the floors and walls of the gallery. Klein had special rules for his "living brushes": the models had to paint only with their "trunk and hips, and nothing more," certainly not the "hands and feet, the psychological parts of the body."[7] Photographs of the event show the women dragging each other around the papered floor of the space while Klein directs their progress. A film version of the event—a sequence from *Mondo Cane* (1962)—amplifies the erotic aspect of naked women caressing each other with IKB and painting walls with their hips, images slowly emerging in the aftermath of the spectacle (fig. 5.1). Of course, the spectacle was Klein's primary interest; the event was a "happening," the first in a series that would define his career and his significance to the mid-century art world. Living female paintbrushes were a shocking sight and a canny combination of art joke, sexual exploitation, and good fun. But if Klein's *Anthropometries* earned him a reputation for "unique mastery of the ruse," it also had something seriously to do with his larger project, which had very good reason to have the female body paint directly in pure color.[8] A piece of foolery, *Anthropometries* sought to expand pictorial sensibility in such a way as to make it truly physical and newly elevating. A fraud, Klein was also a truly messianic figure, important not only to the history of aesthetic abstraction and performance practice but also to participatory art. His effort to locate real-world bases for spiritual freedom is essential to the ethics of participatory art as it has developed over the last century.

When Klein staged *Anthropometries*, he had already become notorious for his monochromes. Mainly done in IKB, his single-color canvases and objects seemed to bring pure abstraction to its limit, and they were designed to have a powerful effect: Klein hoped they would provoke a state of pure sensibility and thereby free up a fuller, truer habitation of spiritual space. But of course these single-color productions could seem like frauds, especially in the context of stunts apparently designed merely to shock the public. In addition to the "Anthropometries," there were his interests in Rosicrucian spirituality and in judo (Klein became the fifth

5.1 Yves Klein, "Blue," *Mondo Cane*, 1962, dir. Gualtiero Jacopetti and Paola Cavari, Cineriz DVD, Blue Underground, 2012

Frenchman to achieve a fourth-grade black belt and wrote a book on judo fundamentals). There was his 1958 exhibition, *Specialization of Sensibility from the State of Prime Matter to the State of Stabilized Pictorial Sensibility*, better known as *The Void*. Invitations were issued with IKB postage stamps (meant to defy governmental circulation) and Klein prepared the space (Galerie Iris Clert in Paris) by emptying it completely of furniture as well as color. Once he had more fully purified the space by projecting imaginary images of immateriality upon its walls, Klein admitted the public, serving guests an IKB cocktail that turned their urine blue for a week. Thus "sensibilized," these visitors had the opportunity to purchase Klein's immaterial paintings, pieces of the Void. Klein later sold these *Immaterial Zones of Pictorial Sensibility* for pure gold, half of which he threw into the Seine as his buyer burned his receipt. Then there was his *Leap Into the Void*. In 1960, Klein took a flying jump off a rooftop in Fontenay-aux-Roses and showcased a photo of the event on the front page of his fake edition of the newspaper *France-Soir*, his "Newspaper of a Single Day" for Sunday, November 27, 1960. Among various articles on subjects including "Theater of the Void" and "Pure Sensibility," Klein included the photo, captioned "A Man in Space!" and "The Painter of Space Leaps Into the Void!" This remarkable act of liberation was soon revealed as a fake; the photograph had been doctored to remove the net into which Klein had actually leaped.

So Klein was "a showman and a clown"; his tricks were "vaudevillian" and "only stuntsmanship."[9] The usual explanation associates him with Dada. His reputation "solidified around a series of neo-Dada art jokes," and he could be dismissed as "the latest sugar-Dada to jet in from the Parisian common market."[10] But Klein himself did not make this connection. He had goals and intentions more theoretically involved than those entailed in Dadaist disruption—ambitions that lent deep coherence to his apparently random interests in pure color, the body, and the void. No merely stunt-driven bids for public notoriety, these were part of a larger hope to link minimal material singularity to absolute spiritual plenitude. For this project, not Dada but impressionism is the relevant explanatory precursor. Impressionism helped Klein hope that purely immediate color could mean much more than its visual appearance. His many spectacular endeavors derived from impressionism's mediations of immediate

sensation and expansive perceptual experience. Which is to say not that he was not a showman and a clown, but that his "stuntsmanship" was like that of the impression, fooling the eye into performance of modal alternatives to itself.

On August 23, 1957, while traveling in Chamonix, Klein proclaimed his aesthetic principles to the Alps: "My monochrome propositions are the landscapes of freedom," he cried aloud to the mountaintops, "I am an impressionist and a disciple of Delacroix."[11] It was not unusual for him to claim this surprising heritage for his pure-color productions—to speak reverentially of "the impressionists of whom I consider myself a descendant."[12] Although his monochromatic paintings seemed abstract, Klein distinguished his work from the abstractionist tradition, which he said began in Ingres and ran through Courbet, cubism, and Dada to Malevich. He affiliated himself with the impressionist tradition that had developed "the resources which are opened up by the prismatic decomposition of light into the elementary colors of the spectrum" and thereby plotted "the vast plan for the liberation of color."[13]

Klein had two impressionist advances in mind. One is summed up in the declaration he made as a "Knight of Color": "For Color! Against Line and Drawing!"[14] The impressionists had abandoned line and drawing as a basis for modeling imagery, moving to contrastive and complementary dynamics among colors to shape pictorial forms. Klein takes things further by enhancing the pure shaping power of color on its own, and although it would seem impossible to achieve any modeling monochromatically, Klein's theory of space holds that single colors shape pure space itself. Monochromes do for essential spatiality what the impressionists' color drawing did for sensory spatial immersion. Klein could therefore consider impressionist prismatics an inspiration for his efforts to move beyond the merely material forms that inhibit true achievement of spatial liberation. Also important to his theory of color was the impressionist synthesis of representational and abstract modes. Although the impressionist application of color followed real-world sensory prompts in order to represent their sources, the results and effects frequently abandoned verisimilitude for expressive or formal relationships among the colors themselves. Always short of abstraction, these formal color relationships were the necessary first step toward what Klein called "the liberation of

color" because they did not completely depart from real world engagement. In his quest for sensible presentations that would disseminate pure space, the semiabstracted colors of impressionist painting were an inspiring point of departure because they had a mitigated relationship to real spatial experience.

The form of abstraction that followed differed from that of the major abstractionists—"My vision has nothing whatsoever to do with that of MALEVICH or even MONDRIAN"—because it had a lyric orientation.[15] What Klein called "the mark of the immediate" was not an end in itself but ground for subjective freedom—the occasion for advancement from pure color to existential liberation. Klein said he explored pure color as a "pictorial-sensorial phenomenon" geared not toward pure painting but toward the achievement of an effect. His blue revolution was an effort to "recapture the primary sensibility of color" and make it a "ladder" for the exalted soul.[16] He hoped to enable those who saw IKB to return to a primal state of pure sensibility that would enable a spiritual transcendence. As Sidra Stich explains, "More than merely appealing to the eye or mind, the paintings aim to affect all the senses and to go beyond thinking into the realm of feeling, to combine corporeal with spiritual invigoration."[17] Thomas McEvilley discussed the same range in his 1982 *Artforum* retrospective, which calls Klein's monochromes "anti-paintings" that link "sensory immersions and prophetic allegories": "Klein's concept was to fuse concept and *sensum* so that each would lose its autonomy, and the work become . . . a shifting structure involving both conceptual and sensory elements in a meta-system."[18] This shifting structure is the mediation that makes Klein's work a legacy of impressionism. It gives immediate sensory experience the tendency to become fuller human understanding. Hoping to enable a process that would draw primary perceptual attention only to route it toward further revelation, Klein sought to advance the work done by precursors who originated this sort of use for primal color sensibility.

Of course, advancing this work means carrying it further and extending the range of its phenomenological use, so Nuit Banai is correct to say that Klein "promises the spectator of his monochromes a condensed, embodied moment of everyday life experienced in its most unalienated form and an unbounded feeling of total assimilation with the sacredness of the universe."[19] Banai's bombastic critical language nicely reflects the

outsize ambition of Klein's work: whereas his impressionist precursors had provided condensations of unalienated everyday life in their impressions, which, in turn, were expansions of aesthetic sensibility, Klein targets the most expansive result. Unbounded assimilation with the sacred is a rather hyperbolic outcome for his color impressions, which would range from the barest sense (blue itself) to the fullest religious transcendence. This hyperbolic pretense at mediation indicates Klein's trickster stylization of the impression's dynamic: it is not so much what he would mediate (this characteristic juncture of immediate sensation and conceptual recognition) but how he would do it—his seemingly fraudulent pretension toward such unlikely prophecy—that makes Klein such an exemplary impressionist fraud.

Had he only produced the IKB monochromes, Klein's wish to make primal color sensibility a ladder for spiritual exaltation would have remained merely implicit, just the sort of possibility latent in any number of aesthetic artifacts. But of course Klein's whole career, with its extensive range of promotional and performative endeavors, became interpretive context for the trick by which a sense of color could become the soul's exaltation. Wanting to unite the feeling of seeing blue with the freedom of the soul—wanting, in other words, to achieve a utopian expansion of the classic terms of aesthetic experience—Klein did what was necessary and gratifying to bolster each moment in this process of perceptual enhancement. That meant articulating everything from the embodied materiality of color imagery to the exuberance of aesthetic abandon to the emptiness of the void of the soul's transcendence. It all earned him his reputation for bogus hoaxing and rampant mischief, but there was a method to it. Many of Klein's artistic statements reflect his effort to meet these demands even as he sounds utterly fraudulent—for example, this claim in "The Monochrome Adventure":

> What I desired, at the time, was to present, in a perhaps somewhat artificial style, an opening onto the world of represented color, a window opened onto the freedom to become impregnated with the immeasurable state of color in a limitless, infinite manner. My goal was to present to the public the potential for the pictorial matter of color itself to be illuminated, for all things physical—stone, rock, bottles, clouds—to become an

object for the journey of the viewer's sensibility into the limitless cosmic sensibility of everything in order to be impregnated.[20]

Such a statement seems to read like an excuse to perpetrate Dadaist bafflement, merely a summary description of the pranks Klein pulled in the form of his monochrome exhibitions, anthropometries, and Void manifestations. But it is also a fair account of a process that authentically joins together Klein's various pranks into a significant feat: the expansion of an unfettered sensibility, unrestricted by the conventional uses of color, which subordinate colors' limitless spatiality to illustrative placement. Understood as parts of this process, Klein's activities become methodical stages in the expansion of perception, and their prankster energy is what enables dynamics otherwise subject to inertia. McEvilley recognizes this relationship among Klein's works when he explains that "the reciprocal appropriations and dissolutions of his works, his personae, and his world, form a shifting conceptual piece whose inner life is the driving force of paradox and mutual containment."[21] For Jean-Michel Ribettes, Klein's essential monochromaticity proceeds from pure space through embodied pictoriality back into an enlightened intangibility, and Klein's projects attempt to stake out different positions along that cycle.[22]

Klein's monochromes are central to a performative complex necessarily composed of small hoaxes. Taken together, however, they obey the logic of sensibility as Klein defined it. If we begin with the monochromes and proceed, as Klein did, through his further efforts to sensibilize the public, we can see how his apparently derivative Dadaism is better understood as a perfected impressionism. The monochromes fully realized the impressionist liberation of color. In so doing, they were really all Klein needed, for they enhanced his own sensibility with the spiritual aspect of space so essential to his ethics as well as his aesthetics. But Klein was a crusader who felt that no spiritual plenitude could be complete without everyone's participation; once he himself had become "pure space," he felt compelled toward a messianic expansion of it, not just out of some exaggerated sense of his own importance, but out of a legitimate feeling that pure space knows no personal limit. That compulsion took him first to anthropometric dissemination, and indeed Klein himself tells how he went from a monochromatic impasse to his anthropometric breakthrough:

Then while pursuing the adventure of "the immaterial," little by little, I ceased producing tangible art, my studio felt empty, even the monochromes were gone. At that moment, my models felt that they had to do something for me. . . . They rolled themselves in color, and with their bodies painted my monochromes. They had become living brushes.[23]

Klein had dematerialized himself out of artistic existence and had to await the emergence of some way to represent that achievement without compromising it. His models' bodies delivered this next stage in his perceptual dialectic, and with that dynamic in mind, and in the context of Klein's perfected impressionism, we can see how the *Anthropometries* are a transformative trickster performance rather than the sensational stunt they otherwise might seem to be.

The purity of color necessary to sensibilize space is too pure for its own good. Klein's IKB monochromes turned out to be a record of his own perceptual freedom rather than opportunities for others. Klein noted that these pictures were actually the "ashes" of his aesthetic process, and, as such, they were the afterimages of his visionary experience. That experience originally took place when Klein gazed for hours at the blue skies over Nice and Oceanside, California, in 1947 and 1948. That blue was his "first and greatest monochrome," he said, and he claimed he had "inscribed the sky with his signature to take ownership of it as his greatest and most beautiful work of art."[24] IKB was a tribute to this possessive unity but only a minimal occasion for its promulgation. Klein needed some way to restore monochromatic blue to its encompassing agency, its cataleptic effect. Too purely abstracted, the monochromes actually failed to secure the kind of purchase necessary to motivate liberation through its stages from negation to transcendence. When his models became his brushes, they contributed a vital somatic agency to this process, best appreciated in terms of the simple difference between the pure monochromatic plane and the embodied blue of the anthropometry. As the body dissolves into the blue, it enacts the dematerialization Klein attributes to pure color, making it a process that could then extend into the further stages of sublimation ending in the Void. Female bodies especially: the exploitative endangerment and degrading objectification at work in this performance purposefully maximize the body's abject vulnerability, the better to vacate

its space. If the problem had been to render monochromaticity processual, to mitigate its purity, the immediate tracing of female bodies is a remarkable solution, because it yields a dynamic *tache* at once purely blue and representative of the process through which pure color transforms sensibility from an embodied obligation to an expansive spiritual state.

That result emboldened Klein to follow dematerialization through subsequent simulations. The hope to proceed dialectically up through sensibilized space to the freedom of the Void explains his tendency to perform process in works that span diverse stages. So he leaped from a roof in suburban Paris and then staged a subsequent version of that event to be photographed; so he doctored the photograph and published it in a hoax newspaper alongside pseudo-sensational pieces of self-promotion. Once again there is the unlikely linkage of modes, this time adding the ultimate gesture to quotidian discourse in the hope that the everydayness of the Sunday paper might set off radical disembodiment. And so he cleared out the Galerie Iris Clert but inscribed a compensatory monochrome into the very bodies of the public. When he sold pieces of *Immaterial Zones of Pictorial Sensibility* but then dispatched the gold paid for them into the Seine—back into the "matrix of potentiality"—Klein continued to run roughshod over the categorical differences that distinguish so many forms of matter from so many forms of spirit. That activity was itself his aesthetic, in part because he was such an exuberant showman, but also very much because he genuinely felt that some spur to engagement could provoke larger participation in the spatial sensibility responsible for his exuberance. Jean Tinguely once called Klein "the greatest provocateur I have ever known."[25] That characterization indeed aptly celebrates an important duality: Klein was often merely provocative, but he sincerely wished to enact provocations, to call us forth toward utopian apotheosis.

Taking Klein seriously does not oblige us to perform some aestheticized Rosicrucian contemplative practice but rather to understand that his highly influential contribution to the art of the happening links nineteenth-century impressions to twentieth-century performance art. A wish for the further liberation of color led Klein to stage performances in which naked women pressed pure blue to the picture plane. His leap into the Void and his antimaterialist sale of pieces of sensibility were further

enactments of the dispossession he attributed to impressionist chromatics. The forms of performance that Klein's exploits helped develop—the future of the happening and similar styles of performative simulation—have origins in pure color, or, rather, the mediation of body and spirit Klein attributed to it. Because his sense of pure color had its origins, in turn, in the impressionist rejection of line and drawing in favor of chromatic modeling, an important aspect of performance art—the *participatory*— goes back to what the impression enacted. Claire Bishop has recently redefined participatory art in terms of its aesthetic practices. Noting that our tendency to define it ethically fails to account for its status as art—and fails to do justice to its real ethical potential—Bishop rewrites the twentieth-century history of the participatory mode to discover critical scenes of its ethical aesthetics. One example is GRAV, the 1960s group that constructed "polysensorial environments," and, in works including *Labyrinth* (1963), sought to "expand the perception of viewers who participated in their visual research."[26] Klein sought a similar expansion and pursued this same participatory aesthetic, which in Bishop's account is the critical exception to our controversial present-day departure from art's objecthood into purely ethical effects. As we will see in chapter 7, this sort of exception revitalizes the *aesthesis* at the heart of impressionism. For now, we have Klein's version of it: participation in what would seem to be a farce that actually has the true potential to guide us from color to enlightenment, on the basis of that trickster mediation whereby impressions do away with the difference.

RYOEI SAITO'S BUBBLE

On Tuesday, May 15, 1990, Christie's New York auctioned Van Gogh's *Portrait of Dr. Gachet*. Bidding began at $20 million but soared to unprecedented heights: the painting sold for $82.5 million, the largest amount ever paid for a painting, beating the record by more than $28 million. The Van Gogh went to an art dealer bidding on behalf of an unknown collector who turned out to be Ryoei Saito, chairman of Daishowa Paper Manufacturing, Japan's second-largest paper company. Not two days

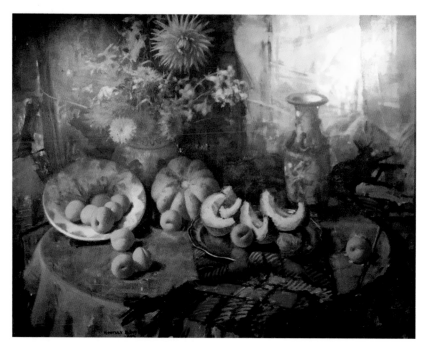

Béla Kontuly, *Still Life*, 1963, oil on canvas, 77 x 98 cm., private collection

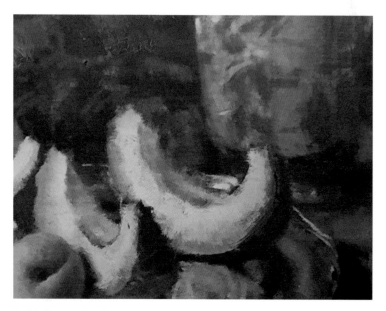

Still Life, 1963, detail

Béla Kontuly, *Portrait of Magduska Pacher*, 1937, oil on canvas, 80 x 81 cm.,
collection of Károly Lászlo

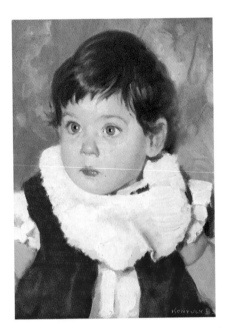

Béla Kontuly, *Portrait of Patty Matz*, 1964, oil on canvas, 50 x 30 cm.,
private collection

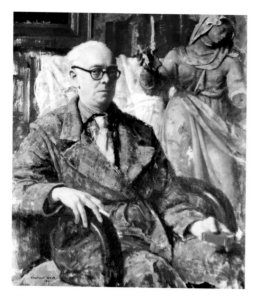

Béla Kontuly, *Self-Portrait*, 1961, oil on canvas, 80 x 70 cm.

Béla Kontuly, *Self-Portrait*, 1932, oil on canvas, 80 x 80 cm., JPM MMK, Pécs

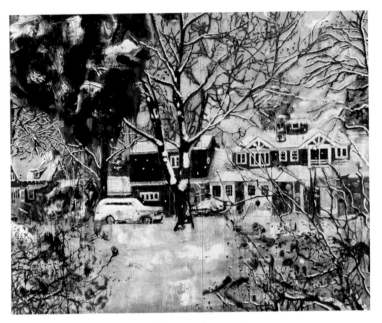

Peter Doig, *Bob's House*, 1992, oil on wood, 72 x 90 in.

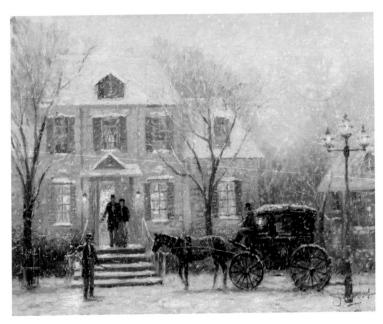

Thomas Kinkade, *An Evening Out*, print, 21 x 26 in.

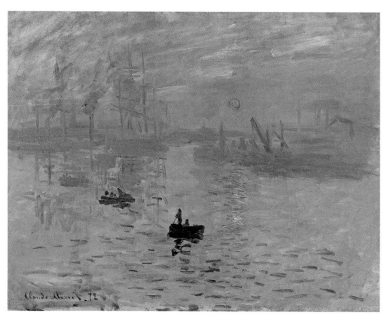

Claude Monet (1840–1926), *Impression: Sunrise*, 1872 (oil on canvas), 48 x 63 cm.

© Musée Marmottan Monet, Paris, France/Bridgeman Images

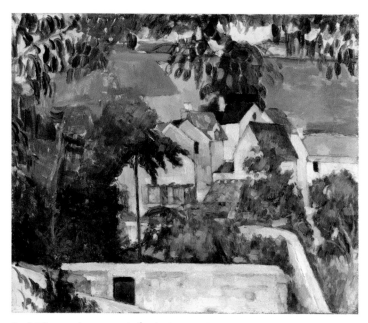

Paul Cézanne (1839–1906), *Étude: Paysage à Auvers*; *Quartier Four, Auvers-sur-Oise* [*Landscape, Auvers*], c. 1873, oil on canvas, 18¼ x 21¾ in. (46.3 x 55.2 cm.), The Samuel S. White 3rd and Vera White Collection, 1967

©The Philadelphia Museum of Art/Art Resource, NY

Frederick Carl Frieseke (1879–1939), *Summer*, 1914, oil on canvas, 45 3/16 x 57 3/14 in. (114.3 x 146.7 cm.), George A. Hearn Fund, 1966

© The Metropolitan Museum of Art. Image source: Art Resource, NY

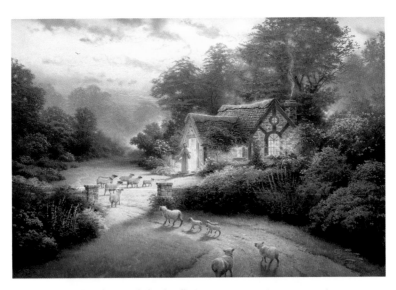

Thomas Kinkade, *The Good Shepherd's Cottage*, 2001, print, 25.5 x 34 in.

© The Thomas Kinkade Company

(*opposite page*) Len Lye, *A Colour Box*, 1935

© Courtesy of the Len Lye Foundation and the British Postal Museum and Archive. From material preserved by the BFI National Archive

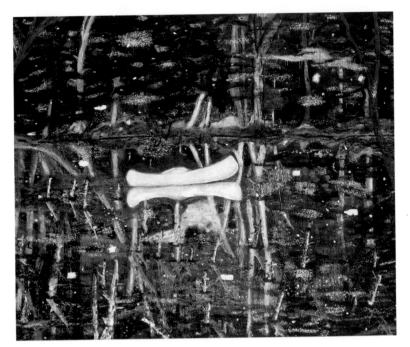

Peter Doig, *White Canoe*, 1990–1991, oil on canvas, 79¼ x 95½ in.

Peter Doig, *Concrete Cabin II*, 1992, oil on canvas, 200 x 275 cm.

later he did it again: Sotheby's auctioned Renoir's *Moulin de la Galette*, for which Saito paid $78.1 million, more than four times the top price paid for a Renoir. The two-painting total was a massive shock to the worlds of art and finance and even to the mainstream press, which ran breathless articles about "Japan's Highest Bidder" and the "2 Priciest Artworks Ever" that relished the peculiar and sensational details of the case.[27] Saito had no plans to display the paintings, saying only that they had gone into storage and might be put on view "in about ten years' time."[28] He said he planned to be cremated with them—just a joke, he later explained. The outlandish purchase was part of an alarming trend: excessively rich Japanese businessmen were hijacking the art market just as they were taking over Western companies and properties. The art world was "aghast that the European masterpieces were to be spirited away by one of Japan's bubble-economy nouveau riche."[29] Saito was the face of a "Japanese buying spree" that created a heady impressionism boom as thrilling and awful as the most extravagant high-finance events of the moment.[30]

But this boom, too, was a bubble, and Saito was a fraud. He didn't really care about art, and he wasn't a viable investor. He had used his company's land holdings as collateral for his big bids at Christie's and Sotheby's just when reckless real estate expansion had put the company into massive debt. [31] In November 1993, Saito was arrested for bribing the governor of Miyagi prefecture for planning permission necessary for a fraudulent land deal. Saito was trying to get much-needed cash for his company through development of protected forests; the bribe of ¥100 million got him permission to build a golf course and upscale housing that earned him 44 times his investment in the property.[32] And there was other malfeasance, revealed, for example, when a restaurant owner sued Saito for buying sex from his wife—further confirming Saito's reputation as a "roughneck provincial businessman who thought he could use his money to buy anything he wanted."[33] After the arrest and at the moment of his death three years later, Saito was ruined, and the Van Gogh and Renoir went to his creditors, worth much less now that the bubble had burst. Impressionism's high prices had collapsed along with the rest of the economy, and the man who was "once a symbol of the swaggering wealth of Japan" now "epitomized its economic stumble": Saito became symbolic of his nation's excesses, the blind exuberance of the boom years. His downfall became

leading proof of how and why impressionism's boom was a bubble and a telling symptom of what was ailing global commerce.[34]

He had not been alone, of course, in blowing and bursting the bubble. Financier Yasumichi Morishita paid $100 million for 100 impressionist pictures in the fall of 1989. Known locally as the "King of Shady Money," Morishita ran a gallery where he sold lesser works by important artists to people willing to pay inflated prices. There were many, because inflated prices for impressionist pictures had become a routine factor in business dealing. The government had set a cap on real estate prices, in an effort to cool an overheated real estate economy. But there were ways to get around the rules, including the practice of *zaiteku*, or financial engineering, which often involved art: to sell above the limit, a seller would accept pictures as part of the deal and then sell them back to the buyer at a higher price. As Philip Hook explains in his account of impressionism's great rise "beyond price" at this time, "you got round that as a purchaser by throwing a bunch of Monets into the deal, selling them to the vendor for 10 million and then buying them back a month later for 20 million."[35] Beating the cap also meant inflating the value of the artworks.[36] But investors could stomach the inflated value because of the strength of the yen. Surges in the Nikkei index reached a three-year increase of 106 percent in 1989, and as the yen grew to epic strength against Western currency, Western artworks became the ideal commodity for yo-yo pricing. They could be bought cheaply but still valued highly, so steep increases could seem to be a product of proportional assessment. And impressionism was most "aggressively bid"; it was "French impressionism that [was] most correlated with Nikkei," and most inflated by the bubble.[37] When the Nikkei dropped with the larger collapse of the Japanese economy in the early 1990s and real estate values dropped along with it, the market for impressionist pictures collapsed as well, with comprehensive effects throughout the international art market.

Several things made impressionist pictures perfect for *zaiteku* and the high-profile sales through which Saito and other major players did their business. As a traditional form of modern art, impressionism was poised perfectly between safe and speculative pricing. It was a sure thing, certain to maintain a good high level of basic value, but also yet available to plausible spikes, since it was of a piece with a fraction of modern art not yet

assessed with any final certainty.[38] Renoir and Van Gogh were among the oldest painters with speculative appeal but the newest with investment security.[39] But it wasn't just this status as a traditional modernism, this old newness, that suited impressionism to the moment's bubble-style specula- tion. Its great practitioners had produced so many lesser works. Having exhibited their sketches—their *esquisses* and *pochades*—in the 1870s and 1880s, the impressionists provided the Kings of Shady Money with the perfect vehicles for the sort of creative valuation necessary to their busi- ness model. Relatively inexpensive pictures that could be plausibly over- valued were easily found among the Monets and Renoirs never meant for prime recognition but often originally exhibited alongside pictures that were. At once important and marginal, traditional and novel, impression- ism lent itself to unscrupulous behavior, as it did even in the notorious ambiguity of its subject matter, where speculation could find a focus for all its many meanings.

And if impressionism lent itself to speculative exploitation, it seemed to encourage the cheapening of art; complicit in bubble economics and its financial chicanery, impressionism developed a reputation for double- dealing, becoming responsible for a growing public tendency to equate success in art with high price tags, fueling suspicion that matters of taste had entered into new conspiracy with the marketplace. At its worst, this reputation conformed to racist stereotypes, as impressionism's bubble- economy incarnation was seen to take part in an Asian sacking of aes- thetic authenticity. Although it was not common to make direct refer- ence to the "Yellow Peril," as did the Swiss *Tribune de Genève*, that sort of "Japan bashing" did certainly target the Japanese pursuit of impres- sionism and came to characterize the taste for it around 1990.[40] A loss of cachet—and, soon enough, dollar value—had much to do with guilt by association with non-Western greed. It became fashionable to give up on impressionism the way high culture will cede formerly elevated objects of discretion to mass culture. A satirical piece by Art Buchwald in the *Los Angeles Times* posed the question, "Why didn't you buy van Gogh's 'Dr. Gachet' for $82.5 million or Renoir's 'Moulin de la Galette' for $78.1 mil- lion," and suggested a number of possible answers, including, "I intended to bid, but the Japanese had their heart set on the pictures, and they have so little of anything as it is."[41] This snide reference at once to Japanese

financial wealth and cultural impoverishment sums up the attitude of those for whom impressionist art and Japanese finance had devalued each other.

And yet if "Japan bashing" enabled this set of associations, the impressionism bubble and its implications were not what they seemed. A 2011 study of the "1980s Price Bubble on (Post) Impressionism" takes a very different view of the situation. Published by a team of researchers associated with Tutela Capital, a Brussels-based company specializing in managing art as an alternative asset, the study argues that there was no bubble at all—or rather that the bubble was a Western fiction and looked very different in Japan. Complex and extensive statistical analysis shows that inflated prices for impressionist pictures did not outstrip increases in the Nikkei average and the favorable dollar-to-yen exchange rate. In other words, prices were proportional to the general strength of the economy after all, not significantly leveraged by *zaiteku*, which was exceptional. Increases were nothing more than the product of "common consumption" and a clear-eyed sense of "investment good": "Japanese themselves never felt they were riding a bubble as the price level at which they were buying was not historically high" but rather a function of the booming economy and a long-standing, steady appreciation for Western art.[42] The question, then, is not one of irrational or corrupt price ballooning, but why the Japanese would have wanted to load wealth into impressionist pictures rather than other investment vehicles. The answer returns us to the nature of impressionism itself—this time not with a skeptical sense of the impressionist artwork's complicity with corruption but a more optimistic sense of its truly cosmopolitan credibility.

"It is more likely that the roots of the bubble may be found in the historical links between impressionism and Japan": Japanese prints and other pictures had been a primary influence upon Manet, Monet, and Degas, and to Van Gogh and Cézanne, Japan was a kind of aesthetic utopia for its vividly pure artistic forms.[43] Just about every impressionist had a fascination with *le japonisme*, with its spontaneity, color modeling, and graphic patterning, all of which looked so revolutionary to Western eyes weary at once of realist representation and the alleged impressionist tendency toward radically haphazard impressions. In 1988, an international exhibition titled *Le Japonisme* had taken place at the Galeries nationales du Grand Palais in Paris and the Museum of Western Art in Tokyo. It

emphasized a point already clear enough to Japanese collectors: they were not coming late to the vogue for impressionism, degrading it with inappropriate forms of appreciation, but reaffirming a fundamental role in the advent of this form of global modernism.[44] As the 2011 study confirms, "In this context, for a Japanese to buy late XIXth century art in the eighties was not simply obtaining a European painting, it was also acquiring part of Japanese history: the early international Japanese influence in the modern world."[45]

The history of that influence is critical not only to our assessment of the Japanese impressionism bubble but also to a revisionist history of impressionism itself. *Le japonisme* was not just one important inspiration to the movement but a decisive factor: it enabled the turn to abstraction through which impressionism really established its place in the ongoing development of modern art. And that was because Japanese abstraction was both an aesthetic inspiration and a cultural elevation. Japanese prints did show one way to move beyond illusionism—to subject vivid impressions to planar design and rhythmic pattern—but they also enabled the impressionists to aspire toward abstraction without giving up fine art. As Klaus Berger has shown, *le japonisme* shaped impressionism in larger part by creating a "rapprochement between fine and decorative art."[46] "Japanese culture had never perpetrated, or tolerated, a separation of the decorative from the rest of art," and the popularity of Japanese decoration at the moment of impressionism made it possible to create an art that looked decorative without risking loss of aesthetic status.[47] This was the moment of the Universal Exhibitions that produced such a craze for Japanese objects and designs—when the Meiji Revolution of 1868 had opened Japan to international markets and for the first time made exclusive collections available to Western connoisseurs. In this context, what Berger calls "the rebirth of art from the decorative spirit" was crucial to impressionism's special tension between the concrete and the abstract and, decisively, its legitimacy as a leading aesthetic.[48] Even if the equation of Japanese art with viable decoration was a misunderstanding—not only of Japanese aesthetics but also of the many differences among Japanese styles of decoration and their relative cultural status—the misunderstanding was enabling to impressionism.[49] And it enables a better understanding of what happened at the later moment of negotiation between Japanese culture and Western impressionism. When, a century later, the impressionism bubble seemed

to involve Japanese businessmen merely decorating their offices with overvalued Western pictures, it actually invoked the moment in which Japanese decoration gave new value to Western art.

The bubble, then, was no questionable product of Japan's effort to dominate the world economy but a reiteration of the country's long-standing centrality to world culture. Indeed, the bubble was actually an effort to assert cultural values in spite of economic dominance, as if investment in aesthetic artifacts could remind the world that Japan's new financial ascendancy was but a further realization of its cultural preeminence. The immediate cause may have been *zaiteku* and the extravagant aspirations of the likes of Ryoei Saito, but they would have been nothing without the general national interest in impressionist cosmopolitanism. And the bubble was just as much a product of misunderstandings and hostilities created by global finance. Western collectors, alarmed that skyrocketing prices were forcing them out of the market, attributed the problem to inappropriate behavior—in turn associating it with racialized cultural defects—because they presumed high prices to be a sign of false motives. What they didn't realize was that interest in impressionist art was a moderating restraint upon merely financial interests, pursued in just the way Western elites themselves had typically legitimated wealth through cultural refinement. But with fuller authenticity: the refinement in question had been the legacy of a Japanese culture for which decorative display was not distinct from true art.

Saito may have been a fraudulent avatar of this legacy, but it nevertheless changes our sense of what happened when this apparent bubble seemed to result from impressionism itself. Understood as a heightened interest in Japan's own global legacies, this boom exploited a fraudulence of another kind: the fungibility of the impression. What meant one thing in the history of Japanese art could mean another to the impressionists it inspired; techniques and patterns could be put to a very different cultural use in impressionist pictures with Western avant-gardist ambitions. Impressions did produce sketches that could be overvalued as masterpieces and commodities that looked both securely traditional and speculatively new—they did lend themselves to *zaiteku*—but more fundamentally, they floated free of cultural origin. Their immediacy, minimality, and patterning could seem universal even as they provoked a will to assimilate

them—into an aesthetic project, into a cultural tradition. The Japanese impressionism bubble or boom of the 1980s nicely illustrates the long-term result of this larger fraudulence that enabled a co-optation of Japanese aesthetics and, a century later, its reversal.

We might judge it, finally, by its aftermath. Philip Hook, who is senior director of Sotheby's Impressionist and Modern Art department, offers this account:

> The Japanese debacle devastated the market for impressionist pictures like an earthquake. When the dust settled, a new and unfavorable landscape was revealed. It wasn't that impressionism had lost any of its glamour and appeal: museum exhibitions featuring the major names of the movement were as popular as ever, and lavishly illustrated books about them were bought by the public with undiminished enthusiasm. It was just that no one was now sure what the paintings themselves were actually worth, once you subtracted the Japanese from the financial equation.[50]

In Japan, investors steered clear entirely, to avoid guilt by contact with investment vehicles so closely associated with corrupt practice. Internationally, all art prices remained depressed, as the markets persisted in what had become a dominant habit of using impressionist pictures as a benchmark. When prices once again began to rise, impressionism took a different place in the landscape, becoming a more secure investment alternative to contemporary work—and therefore ever more able to attract the money of "every succeeding generation's new wealth." Hook notes that its "perennial appeal" is a magnet for the super-rich of emerging markets, so that "the allure continues, more globalized than ever."[51] Japan's impressionism bubble may actually have been an expression of authentic cultural interests, a legitimate investment boom, but it has set a new standard for conspicuous consumption, a challenge to Ryoei Saitos everywhere: make your name by pegging your wealth to the universal currency of works of art endowed with the most dynamic combination of traditional security and modern volatility, familiar imagery and avant-garde style, old-world themes and new. Yet to emerge are future variations upon this double dealing, this impressionist speculation, which will likely take new forms as new markets enter into the history of the impression.

In Japan itself, the aftermath of the boom has been a radical redefinition of art itself. In his "Theory of Superflat Japanese Art" (2000), Takashi Murakami credits the collapse of the 1980s market with a radical shift in which "Art has begun to disappear."[52] That actually began, for Murakami, with the rampant commercialism of the boom years, when "the Japanese painting and Western painting industries were only interested in the money game," and the result was that "the creation of a sense of value and vision for the present and future—what people really wanted to see—was completely forgotten."[53] What followed was an interregnum in which forms such as celebrity art, "happy illustration art," and, eventually, properly Japanese forms of expression became dominant. At first, the collapse of interest in Western art left the Japanese art world with nothing comparably significant in aesthetic or cultural value, but the vacuum opened up opportunities for something truly new and more authentically Japanese—for Murakami, the "superflat" aesthetic. Because that aesthetic hearkens back in many ways to the imagery that had been an inspiration to the impressionists—the extreme planarity they read as an impulse toward decorative abstraction—superflat art occupies a next stage in the history of impressionism. If impressionism became popular in Japan in the 1980s in part because Japanese art had played a role in its early development, and if that popularity could not survive the economic downturn of the early 1990s, impressionism's subsequent absence became a necessary condition for the reemergence of local aesthetics—a revisionist return to a historical aesthetic reconceived in response to the evacuation of the category of art caused by the commercialization of the boom years. A long history of boom-and-bust cycles has now resulted in an aesthetic that bears the traces of that history in ways we might not perceive if we did not know that today's superflat art is a legacy of impressionism's Japanese career.

JAMES FREY'S LITTLE PIECES

On January 26, 2006, James Frey appeared on *The Oprah Winfrey Show* for what has become an infamous moment of reckoning. Frey had been on

the show the previous October to promote *A Million Little Pieces* (2003), his memoir of addiction and recovery, which Oprah had chosen for her book club. Now, he had to answer to Oprah for massive and shameless fraud. It had been revealed that the memoir was almost entirely a fabrication. "A million little lies" was what *The Smoking Gun* called it in the article exposing Frey's limitless deceptions.[54] "I feel really duped"; "I feel that you betrayed millions of readers": so Oprah reproached Frey and forced him to confess the hoax.[55] Frey's career was ruined, and his disgrace was a major cultural moment too, insofar as it prompted a widespread public loss of faith in the literary memoir. The kind of subjective, emotional truth built into the project of the memoir became suspect; a certain forgivable impressionism, so important to the genre, became associated with Frey's style of crooked self-promotion. This fraud became the year's leading example of "truthiness," the term invented by Stephen Colbert to satirize the deceptive appeal to heartfelt feeling over fact.[56] It became the bellwether for the many troubling ways public figures were passing off their felt impressions for reality.

James Frey lied and lied. *The Smoking Gun*'s report for January 4, 2006, details extensive examples of exaggeration, adaptation, and outright fictionality. *A Million Little Pieces* begins with Frey aboard a plane bound for Hazelden, the addiction treatment facility in Center City, Minnesota. He is a bloody mess and a human disaster after a fight and years of drug and alcohol abuse. Rehab begins with harrowing, violent illness, and Frey's physical condition is notoriously brought to its lowest point in the dentist's chair, where he must undergo root canal and dental reconstruction without anesthesia. As rehab proceeds, we learn of his monstrous past— his early childhood love of mayhem, his role in the deaths and violations of beloved young women, the drinking and drugs that had him blacking out daily and doing anything for his next fix, the fights, the arrests, the near-suicides, and the endless violence done to himself and others. Frey also tells the stories of fellow patients, which supplement his account with further details of bodies destroyed and lives ruined by other drugs in other situations. Eventually, with the help of these people, Hazelden's staff, his family, and the love of a fellow addict named Lilly, Frey recovers and beats addiction—not with the help of the classic twelve-step program or the religious faith essential to it, but because he himself decides to do

it, to take full personal responsibility rather than concede any agency to higher powers.

But according to *The Smoking Gun*, there were no serious crimes or major arrests, and those who knew Frey in school remember an ordinary young man prone to nothing worse than the usual adolescent misbehavior. No alleged Hazelden patients survive to corroborate any of his stories about them, and the police who did have encounters with him—nothing like the epic fight central to Frey's account of what landed him in rehab—remember situations "as mundane as they get, as vanilla as the arrestee himself, a neatly dressed frat boy five months out of school and plastered on cheap beer."[57] Once *The Smoking Gun* exposed these lies, many other implausibilities became subject to doubt. Frey couldn't have flown to Minneapolis in the condition he describes. No dentist would have subjected him to root canal without anesthesia. Too much of the story conforms to a plot of romantic redemption, which now rang false even to those who had found Frey's book inspiring to their own efforts at recovery.

In response, Frey developed a defense that was half apology and half aesthetic theory. His "Note to the Reader," now included as a preface, admits that he "embellished many details about my past experiences, and altered others in order to serve what I felt was the greater purpose of the book."[58] After apologizing, Frey explains motives for writing the book other than truth-telling. He says he didn't have any particular genre in mind (memoir or fiction, nonfiction or autobiography) but that he "wanted to use my experiences to tell my story about addiction and alcoholism, about recovery"; he "wanted to write a book that would change lives," and that dictated its own approach to his use of his experiences.[59] And because he needed the book "to have the dramatic arcs, to have the tension that all great stories require," he altered the facts throughout. In other cases he claims just to have misremembered, despite his best efforts, or to have made himself "tougher and more daring and more aggressive" than he was in order to "cope."[60] His biggest mistake, he says, was to write "about the person I created in my mind to help me cope, and not the person who went through the experience."[61] But his main justification is more theoretical. In his definition, "memoir allows the writer to work from memory instead of from a strict journalistic or historical standard," since it is "about impression and feeling," a "subjective truth," and, ultimately, "a story."[62] This theory that memoir licenses the subjective

truth of impressions rather than the objective facts of journalism or history combines with his error (writing about the person he created) and his objective (to change lives) to constitute Frey's signature version of the impressionist memoir.

Unfortunately the impression is party to fraud at every level, it would seem, as it gives license to indiscriminate styles of description and interpretation at virtually every moment in Frey's story. Past memories disordered by drug use are presented in fragmentary form; dissolving his consciousness then as well as now, Frey's impulses are distracted, dissociative, and destructive to any sustained or coherent account of his experiences. Notoriously extensive repetition enhances the pattern of incoherence rather than acting as a force for orderly arrangement: a sort of anaphoric leveling reduces Frey's observations to a neutral stream of impressions. Upon his arrival at "the Unit," Frey looks at the men there:

> They are black and white and yellow and brown. They have long hair, short hair, beards, and mustaches. They are well dressed and they wear rags, they are fat and they are thin. They are hard, weathered, worn-out and desperate. Intimidating and thuggish, addicted and insane. They are all different and they are all the same and as I sit there smoking my cigarette, they scare the living shit out of me.[63]

This typical passage confirms the problem of impressionism's way of degrading information. Disregarding differences among forms and kinds of information in order to expedite the mere flow of perceptual data, building to a sensational emotional climax, this sequence exemplifies Frey's bad impressionistic tendency to let emotional truth exclude other necessary forms of judgment, interpretation, and understanding. Parallel forms of simplification compromise his story as it builds to its moments of epiphany:

> Everything I know and I am and I have seen felt done past present past now then before now seen felt done hurt felt focus into something beyond words beyond beyond beyond and it speaks now and it says.
> Stay.
> Fight.
> Live.

Take it.
Cry.
Cry.
Cry.[64]

Here a dissociative rush of thoughts and feelings only amounts to minimal affirmations, in just the kind of debased mess of passing fancies into which impressions devolve once they lack the backing of a more worthy project. These pieces of perception allow Frey to get away with his deception because impressionism has licensed an expressive form in which incoherence and brevity stand for authenticity and achievement. This is how we might describe impressionism's legacy to memoir as Frey writes it, and the problem becomes systemic in his theory of subjective truth, which allows him to invent events that neatly condense or concretize complex and diverse situations, processes, and even people into handy fictional moments.

Frey is not alone in making an impressionistic hoax of modern memoir. Contemporary debates identify a general problem—a sense that it "feels somehow different, somehow 'worse' than ever before," to quote Daniel Mendelsohn's discussion of the increased tendency toward this kind of falsehood.[65] Frey's disgrace touched off a renewed anti-impressionist reaction to what seems to be a reckless increase in the vagaries of subjectivism. Invoking the "subjective truth" of "impression and feeling" to defend himself, Frey speaks for the many contemporary memoirists who also lie in the name of truth to impression, and the gap between truth and verisimilitude has become the focus for much recent discussion of the nature and function of autobiography today. But of course, Frey's defense of the person he "created in my mind," his sense that memoir is "about impression and feeling," associates autobiography and impressionism in a manner that goes back to the modern origins of both forms of engagement. Max Saunders has shown how the effort to narrate the self amid modernity—in response to the nineteenth-century loss of religious, psychic, and social foundations to coherent selfhood—threw autobiographers back upon fictionality. Selves were to be constructed through forms of impersonation; "autobiografiction" became essential, and it was a major source of the creativity we now attribute to aesthetic modernism.[66] Bewildered or inspired to discover that they were made up of little more

than a subjective story about the people they had become, early modernist autobiographers developed new forms of personal truth, generating innovative styles of writing as well as the questionable forms of truth that have become so controversial in life writing. If James Frey seems to take unethical liberties with the truth, there is ample precedent for it in the versions of selfhood developed with such influential resourcefulness by, for example, Walter Pater, the original impressionist life writer. Doubtful of any "earnest transcription" of his own experience at once because of his reading and his sexuality, Pater found himself in his "imaginary portraits" of others, which were also "portraits of his imagination."[67] This relationship between self and other became a positive version of the impressionist belief that "the self exists only in its disappearance," and it led to aesthetic autobiography, in which the realization of the self really reflects the advent of subjective creativity.[68] The "radical subjectivity" of impressionist selfhood becomes inventive personhood in the impressions of James, Conrad, and Ford; in the imaginary authors of Joyce and Stein; and then in the meta-selves of Nabokov and other postmodernists.[69] Their example goes a long way to lend aesthetic authenticity to what Frey has done, even if Frey extends the "counterfactual" project into something beyond postmodern double-dealing.[70]

But that double-dealing also has its justification. The poet Andrew Hudgins admits that his autobiographical work *The Glass Hammer: A Southern Childhood* (1994) is full of lies. Worst of all—the most egregious autobiographical "felony"—is the lie of impressionism. "Impressionism lies," Hudgins admits, by changing the facts in whatever way necessary in order to convey the way things feel. His example is his book's account of his upbringing.[71] Although he went to high school and college in Montgomery, Alabama, "The book may give an impression of a more rural childhood than the one I actually lived," but then again "it does give a true reflection of one way I perceived my life, a true reflection of how large those visits to Georgia loomed in my memory and imagination."[72] This distinction between a true impressionist reflection and the actual facts of his life leads Hudgins to alter his account of the fictions of autobiography. Although the "lie of impressionism is the biggest lie, the least defensible logically, ethically, or morally," it is also "inescapable for a writer attempting to create an artistically coherent work."[73] More than that, it is no "felony" at all, since there really isn't anything other than fiction in au-

tobiography, given the problem of memory. True memories fade as false ones become vivid; imagined memories are truer to the past, or at least more true to the past of the present self. Autobiography is all about how the present self perceives and evaluates the past, and "subjective truth" or "emotional truth" is essential to it.

More fully to justify this endeavor, following Saunders and Hudgins, we might return to another moment of anti-impressionist resistance: T. S. Eliot's insistence upon the "objective correlative" in the transformation of personal feeling. Eliot argued that personal feeling was too unaccountably idiosyncratic for public literary self-expression. Poets must translate it into something more objectively meaningful—words that correlate to personal emotion while giving it public shape and significance. Eliot's familiar definition states that "the only way of expressing emotion in the form of art" is through "a set of objects, a situation, a chain of events which shall be the formula of that *particular* emotion; such that when the external facts, which must terminate in sensory experience, are given, the emotion is immediately invoked."[74] The famous example is Shakespeare's *Hamlet*, whose problem, unfortunately, is too obscurely singular; it makes no sense to the wider world because Shakespeare has failed to find a formula through which to reproduce Hamlet's emotion. Hamlet's subjective feeling has no objective correlative. However, it also has no *subjective* correlative. Eliot presumes that emotional experience and subjective significance are one and the same—both to be transformed through objective correlation. But subjective correlation is a necessary first step in the process of self-expression he describes. Emotional experience is not necessarily or automatically felt or perceived as personally contingent. Indeed, this is one of the primary tenets of new theories of affect and its relationship to subjectivity. Feeling can be unavailable, and not only insofar as it might be unconscious or subconscious in a psychoanalytic sense. Raw immediacy may make it as strange to subjective recognition as the experience of another. Sometimes the problem with personal emotion (as Eliot defines it) is that it does not really become personal, and for that reason does not become subject to the kind of creative agency necessary to selfhood. To do that, it must correlate to some personal formula through which to emerge into self-recognition. Saunders takes a similar view, in his account of the way modernist "im/personality" entails imper-

sonation—the creative adoption of a version of the self.[75] Subjectivity too takes this effort, so it is necessary to add to Eliot's account of correlation a *subjective correlative*, an earlier moment in the process by which feeling might become personal and then public.

An impressionistic version of personal experience might just be a lie, but it might also be this effort at subjective correlation—the formulation of feeling such that it emerges into self-recognition. It is what Hudgins has in mind when he explains the lie of impressionism, for it justifies "the way I perceived my life," making it not merely willful, selective, or opportunistic but an essential part of the process of self-making.[76] In other words, the autobiografictional impression is to be contrasted not with a reality it distorts but with a lack it redresses, the personal meaninglessness of raw perception. What Frey calls subjective truth is not just an evasive trick used by the memoirist for self-aggrandizement; it is a constructive practice without which there is no self at all. It is a version of experience that gives contingency correspondence. In a sense, it is the essence of the truly autobiographical event. In Frey's case, the event in question is the progress toward recovery, the reparation rather than just the making of selfhood. The subjective correlative of what may actually have happened to him is what it took to impersonate sobriety.

A Million Little Pieces may not be credible, but it does reflect this recovery project. An important part of it, for example, is an ironic stress upon the necessity of truth. Frey repeatedly insists that the truth is "all that matters" to an addict hoping for redemption. So much conspires to falsify what is important, and vigilance is crucial, as Frey notes when he imagines how an obituary might travesty his life: "I can imagine my obituary. The truth of my existence will be removed and replaced with imagined good. The reality of how I lived will be avoided and changed and phrases will be dropped in like Beloved Son, Loving Brother, Reliable Friend, Hardworking Student. People will change their view of me."[77] In resistance to such fictions, Frey emphatically restates who he really is: "I am an Alcoholic and I am a drug Addict and I am a Criminal. That is what I am and who I am and that is how I should be remembered. No happy lies, no invented memories, no fake sentimentality, no tears. I do not deserve tears. I deserve to be portrayed honestly and I deserve nothing more."[78] But the reason for this insistence on the truth has less to do

with factual content and more to do with a version of the emotional truth Frey stresses in his later note to his readers. When he speaks against those whose accounts of addiction "romanticize it, glorify it, make light of it or portray it in a way that is wholly inaccurate," he tends to reject failures to model emotional emergence.[79] Frey responds negatively to a recovering addict who has just given one of the lectures that are part of the program at Hazelden: "I do not relate to this man in any way whatsoever. . . . I do not connect these things to any sort of true and dangerous addiction. I do not connect these things to any sort of need for recovery."[80] Frey does find this sort of "connection" in other situations he characterizes, perhaps paradoxically, as performances of genuine feeling. There is, for example, the very different addict's story told by his friend Leonard: "We stare at each other. I am listening to him and respecting him and respecting the words that he is speaking. They are true. They come from a place of experience and feeling. I can believe in those things. Truth, experience and feeling. I can believe in them."[81] Truth *as* feeling governs Frey's life, not because he mistakes emotion for belief (in the manner of subjective error) but because felt truth is essential to recovery. Emotional performance models the process of self-making; it demonstrates how feeling becomes subjectively sustaining, and, as Frey works toward recovery, assumes a central role among other such parts of the process.

Alternate selves also play a role. *A Million Little Pieces* is made up of many stories, not just Frey's own, and though *The Smoking Gun* sees them as further evidence of his dishonesty—they tend to come from people who are unavailable for corroboration—they reflect a genuine need to imagine other lives. That need is suggested by the pattern according to which Frey locates the interpolated stories in relation to his own: others' stories often involve worse suffering, and they precede or even occasion progress in his own recovery. After hearing the story of "John," whose addiction and its destructive effect on his family have a primary source in childhood sexual abuse, Frey ends a chapter "smiling," not because he takes John's story lightly, but because an enabling displacement has led to an affirmative moment in his own life.[82] After hearing of the "bald man's" abjection and fruitless endurance, Frey is able to make a series of redemptive phone calls to old friends.[83] This dynamic is summed up in an oxymoronic reflection about Lilly: "This hard, damaged, drug-Addicted Badass

Girl sitting in front of me . . . makes me feel safe and calm."[84] At these moments it becomes clear that recovery requires the creative imagination of worse versions of the self—alternative personae whose greater abjection or incorrigibility makes recovery seem more viable. This comparative tendency mitigates Frey's apparent dishonesty. To fake versions of the self that are more criminal, destructive, and dangerous may simply be dishonest, but in the context of this larger tendency to associate worse selves with pivotal moments of recovery, this habit of composite autobiography, dishonesty has a constructive purpose. In his "Note to the Reader," Frey says he regrets the error of "writing about the person I created in my mind to help me cope, and not the person who went through the experience."[85] We might presume that Frey's made-up self was designed to make himself seem more romantically heroical, but it was a worse self, and not meant only to romanticize extreme hardship and suffering. It was a worse self because it serves the same function as the book's supporting characters: to correlate progressive steps on a road to recovery.

But of all Frey's lies, the most provocative is his claim to have beaten addiction by this process of his own—without the support of the twelve-step program or other systems designed to supplement the impaired human will. Presenting himself as a "poster boy for unconventional recovery," Frey sets an impossible standard, and, for critics including Janet Maslin, only replaces the twelve-step program with a phony memoirist's fantasy version of it.[86] Maslin summarizes *A Million Little Pieces* into twelve specious "steps" including "suffer remorse," "cry," "recognize your strengths," and finally, "publish."[87] There is no gainsaying Maslin's satire of Frey, but it does overlook something valid in his effort to construct a nonreligious process of self-reparation. Frey refuses the twelve-step program and develops his own version of it because he does not want to rely upon a "higher power." Whether or not he truly succeeds, he does try for a process that redefines the subjective will according to a process of subjective correlation in which the will really emerges on its own terms. Frey claims that his lack of faith defines a new sense of responsibility: "There is no God and there is no such thing as a Higher Power. I will do it with me"; "I'm a victim of nothing but myself. . . . I call it being responsible. I call it the acceptance of my own problems and my own weaknesses with honor and dignity."[88] This sense of responsibility—the

peculiar recourse implied in the ungrammatical phrase, "do it with me"—establishes a dynamic relationship among Frey's selves; what would seem to be irresponsibly subjective (his false assertion of the truth of feeling) becomes a subjective correlative (a formula for self-making). Frey calls it "decision": "Every time I want to drink or do drugs, I'm going to make the decision not to do them. I'll keep making that decision until it's no longer a decision, but a way of life."[89] As this way of life takes shape, Frey recovers; against all odds, his decisiveness works. He ends his story facing down a forty-dollar glass of Kentucky Bourbon, able to see and to smell it without having to take a drink, cured of his addiction. Of course, this impossible heroism is his worst fraud. As experts within and beyond the book confirm, this "shiny, relapse-free success story" of "a man who beat formidable odds with steely resolve" is a pernicious fiction, likely to create false expectations and real disappointment in the wider world of addicts seeking recovery.[90] At the same time, however, it sets a pattern important to recovery.

To explain that pattern we need to distinguish between the enabling fiction and the more specifically impressionist kind. Were it simply the case that Frey had developed, and hoped to share with others, an inspiring story, there might be nothing in his book worth redeeming. It would just be a dangerous lie. But Frey's "lie of impressionism" makes something valid of "emotional truth": a model for self-reparation in which fictional selves collaborate in the process of recovery. It is justified by the structure of "impression and feeling" as Frey employs it, since his impressions perpetually work toward mediation, giving his differential selves their developmental vitality. That is, these fictions made out of feeling—these people and events fabricated according to their semblances—demand transformations of raw experience that parallel what must happen for Frey's selves to progress. They oblige him to reflection, interpretation, and resolution, so that even if these impressions seem to disallow valid objective judgment, they actually make it a more personal responsibility. Frey finally defines it as a form of answerability. In the provocative last pages of his book he boasts, "I only answer to myself," and this last lie would seem to indicate all the self-importance and delusional grandeur that has made *A Million Little Pieces* so infamous.[91] But the phrase is also a complex reflection upon Frey's impressionism—the trick that here distinguishes "I" from "myself" so that the one can answer the other in a positive, produc-

tive way. Frey only registers self-impressions, he seems to say, because then the self can truly change; what makes him deceptive also makes him able to exploit the force of feeling, not in misleading reason, but in subjecting it to the mutability of impressionist experience. This explains why Frey could feel justified in creating a version of his story designed to have an emotional effect. It draws attention to the perceptual and expressive dynamics that give his fabrications their correlative function. To be a fraud in Frey's case is to participate in a purposive effort at seeming— faking it, perhaps, but doing so with a passion for the subjective productivity of the impression.

And with a now familiar pattern. In each of these cases—Yves Klein's blue age, Ryoei Saito's bubble, the truthiness of *A Million Little Pieces*—an outsize ambition is enabled and disgraced by the trickster impression's polytropic activity. Klein tries to make the pure sense of color, what he calls sensibilized space, a transcendent experience, but comes off as a showman and a clown. Saito helped to run up prices on impressionist pictures, enabled by investment practices confusing the sketch with the masterpiece, but he seemed to inflate aesthetic value beyond sustainable levels—to blow a bubble that had to burst. And Frey's impressions of addiction and recovery mistake subjective experience for reality, destroying both his career and the reputation of autobiographical fictionality. But once we understand these failed ambitions as trickster performances, we appreciate their purposive dimensions. Klein's frolicking among abstract painting, madcap stunts, and self-marketing becomes a coherent and compelling participatory performance. Saito now takes part in a cosmopolitan effort at cultural reclamation, and Frey has practical designs upon affective response. So it is not just that the ambitions encouraged by the legacy of impressionism are rendered questionable by it as well—not just that these frauds get tripped up by the impression's trickster dynamics. Those dynamics also justify what might otherwise seem to be mere fraudulence, by demonstrating the sort of valuable creativity at work as they undermine categories fundamental to the very determination of value. Beauty, money, and truth have been devalued and degraded by these frauds but then put into new and profitable relationships to each other. And if there is value in attributing that result to the legacies of impressionism, there is also something to be gained for impressionism itself, which emerges as a practice of provocation, troubling, trickery, and imposture

more extensive historically and more culturally widespread, but also more far-reaching in its designs upon the relationship between appearance and reality. That relationship had been reinvented by impressionist pictures that made fleeting, incomplete appearances more real than anything else and by fictions showing how what *seems* trumps what *is*. Klein, Saito, and Frey show where it all could lead and why it should matter—how impressionism has become more playful with age.

6

CONTEMPORARY IMPRESSIONS, KITSCH AESTHETICS

Kinkade/Doig

Peter Doig and Thomas Kinkade are worlds apart. Doig is a celebrated art world figure at painting's cutting edge; Kinkade, the "Painter of Light," made his name at the shopping mall, peddling the imagery of nostalgia. But both found inspiration in Claude Monet's snowy landscapes. Doig says of his own "snow paintings" of the early 1990s, "when I was making [them], I was looking at a lot of Monet, where there is this incredibly extreme, apparently exaggerated use of color."[1] What looks artificially pink in these pictures is actually a true effect of sunset, as Monet himself demonstrated in paintings that seem unnaturally keyed up but do represent natural light (see fig. I.10). Kinkade cites Monet as a formative inspiration: thanks to Monet's vision, "art had broken out of the dark, dreary walls of the museum and into the bright sunshine," and "this association between fresh air, sunshine, and inspiration was deeply rooted in my life."[2] Kinkade's plein air series and the pictures he made under the pseudonym Robert Girrard—"my impressionist persona"—are Monet exaggerated, the work of a painter who could and would "out-Monet Monet."[3]

Of course, Monet means different things to these very different artists. For Doig, he is distant source material to be reinvented, reimagined, and remediated. In Doig's snow paintings, Monet's pink is but a memory trace—a "mnemonic charge" that spends itself in the postconceptual painterly work characteristic of Doig's pictures.[4] If Monet's example

helped at the beginning, it hardly persists into the end result. By contrast, Kinkade does indeed out-Monet Monet, putting no distance between his work and an aesthetic he reimagines only through the most excessive adherence to it. He exaggerates Monet in order to maximize the sentimentality of the impressionist aesthetic and exploit its prestige (see fig. I.11). Kinkade's Monet is a high-culture touchstone and an object of mechanical reproduction; Doig's Monet is singular, and becomes prestigious only insofar as Doig's contemporaneity can assimilate him. Which is to say that Doig is a contemporary artist in spite of the legacy of Monet, and Kinkade is a commercial artist because of it.

This difference maps the great range of impressionism's afterlife in painting today. It demonstrates the very different conditions in which Monet's legacy inspires what is to be called art. At Doig's end of the spectrum, contemporary artists implicitly incorporate impressionist techniques and examples, operating with an impressionist painterly unconscious that distantly energizes new forms of nonretinal creativity. Any impressionist style comes to them mediated through a history of reiteration that is at once a layered optic and a further spur to avant-garde reinvention. At Kinkade's end of the spectrum, impressionism does not reassert new versions of its critical dynamic, but stabilizes pictorial pleasure. What was truly scintillating becomes merely pretty; provocative facture becomes a calming soft focus; avant-gardism becomes high-culture citation, and, in turn, a force for commodification. Doig shows how impressionism has remained implicitly current. Kinkade's explicit version demonstrates the opposite: how impressionism has been put to use for commercial purposes that require its aesthetic obsolescence—that is, its pleasant familiarity and confirmed value. The difference is clear—one of the more decisive and durable distinctions in the history of art. It is the difference between authentic art as such and the inauthentic nonart of kitsch.

To put it this way, however, is to invite an equally automatic rebuttal. Once we call him kitsch, Kinkade invites the kind of revisionist thinking that discredits any such distinction between authentic aesthetics and the kind of nonart that would out-Monet Monet. Indeed, revisionist thinking has already begun to redeem Kinkade's work, encouraging a different reading of the failure at work in his explicit impressionism. Moreover, Doig's authenticity has always been in question: his painterly commitments are such that he too has been called kitsch. Applied to his work, the allegation suggests a certain anxiety about impressionistic beauty of

any kind—implicit too—in art today. If there is something kitsch even about Doig's edgy aesthetic, if Kinkade's kitsch aesthetic now seems edgy in its way, the persistence of impressionism cannot be mapped according to this fallback determinant of aesthetic authenticity. Not only that: by disallowing this determinant, the persistence of impressionism demands further advances in the kind of thinking about art that has been rethinking kitsch. At first forbidden, then ironically celebrated, key elements of kitsch have lately gained new cultural standing. Impressionism argues for this new standing, and this alliance, more than anything else, explains its relevance to contemporary art.

———— ⧜ ————

Thomas Kinkade left art school at Berkeley for the Art Center College of Design in Pasadena, and that decision became part of his personal mythology. Berkeley would have given him art world objectives, but Pasadena at that time offered latitude for more mainstream work. That alternative matched his background—Kinkade had grown up in humble circumstances in Placerville, California—and it was crucial to another pivotal decision. In the early 1980s, when his accomplished pictures of the western American landscape began to sell, Kinkade wondered why they should simply disappear into individual collections. He felt that he "wanted to give more people than just one family access to the art."[5] Thus began Lightpost Publishing, the company that reproduced Kinkade's pictures in the form of limited-edition prints. And thus also began a new style for Kinkade. He had been painting like a Hudson River School artist, and while that style persisted throughout his career, it gave way to something more nostalgic, sentimental, and marketable, in images of comforting American domestic structures and built environments. The painter of sober, heroic landscapes became the "Painter of Light," his landscapes now comparable to the projects of Normal Rockwell and other sentimental mythologizers of American culture. After his first limited-edition print, *Sawson: The Yukon River with Gold Seekers Landing by the Moonlight in 1898* (1984), Kinkade began to focus on the vividly inviting cottages, villages, and street scenes that would become his signature subjects. The crucial element was indeed light—the nearly supernatural glow that illuminates his work communicating at once an idealized domesticity and the religious illumination he adopted in response to a spiritual awakening

that coincided with his turn to mass production. A typical Kinkade picture centers on a cozy home resplendent with inner radiance at dusk or evening, festooned with a full spectrum of high-key color, with figures engaged in iconic scenes of domestic or civic sociability. Sunsets, flowers, and festive décor richly color every inch of the canvas; compositional formulae lock in the effect by placing the spectator in an expectant position in relation to pure domestic satisfaction, often welcomed by pathways, gates, and doorways promising easy access to the scene. Although the total effect is meant to be all too real, broken brushstrokes blur and soften it, in part to allow for a calming variety of impressionist stimulation and in part to invoke it—to thematize an impressionist ethos, albeit one determined by vivacity and pleasure rather than alienation or other effects of modernity.

Pure sentimentality leaves nothing to the imagination in pictures that overdetermine everything that might make a world inviting. Always clear of any modern element, open to the viewer through their gates and doorways, Kinkade's places promise all the comforts of homes and towns that never were—places utterly confused in their hodge-podge pastiche of grace notes drawn from different times, classes, building styles, and cultural mythologies. They offer domestic and communal spaces framed by instantly gratified desire, as both eye and heart are drawn to glowing central sites that are also hubs of allegorical closure. One enters into these spaces immediately and securely, and with all the certainty of a small spiritual conversion, given Kinkade's compulsive associations of domesticity, beauty, light, and faith. Although explicitly religious iconography is rare in his work, it all might be said to share the project of *The Good Shepherd's Cottage* (fig. 6.1), which shows Jesus in the doorway of an illuminated house. In Kinkade's words, "His house is an utterly comfortable and secure cottage, radiant with light. The air is luminous with sunset; the sound of His voice thrilling as He calls His sheep into a verdant meadow."[6] Luminosity intervenes at every level to secure Kinkade's success. "The underlying theme of all my work is light," he says, but it is also his art historical source, his material practice, and his spiritual subterfuge, for imagery that extrapolates impressionist color luminosity into commercial art magic.[7]

It was a winning formula. Runaway success led Kinkade to develop the uniquely effective channels of production and marketing that became, as much as his signature imagery, his claim to fame. Hundreds of Thomas Kinkade Signature Outlets located at malls across the United States trans-

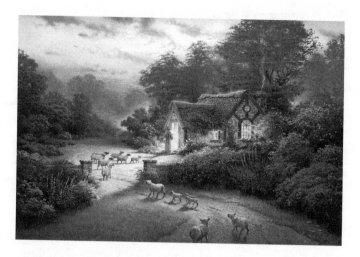

6.1 Thomas Kinkade, *The Good Shepherd's Cottage*, 2001, print, 25.5 x 34 in.

© The Thomas Kinkade Company

formed his mass reproductions into special collectible editions. At these galleries—or "malleries," as one critic aptly calls them—patrons could select a limited-edition print made to look like a painting through application to textured canvas and authenticated by a signature containing a trace of Kinkade's DNA.[8] The print could then be enhanced and individuated by a "Master Highlighter," an apprentice trained to add dabs of paint to intensify the print's color and light effects. The process has been satirized by Susan Orlean:

> Highlighting a picture is not that different from highlighting your hair: it entails stippling tiny bright dots of paint on the picture to give it more texture and luminescence. The customer could sit with the highlighter and watch the process, and even make requests—for a little more pink in the rose-bushes, say, or a bit more green on the trees. Some highlighters . . . would even let the customers dab some paint on the pictures themselves, so it would be truly one-of-a-kind.[9]

Highlighting could last no longer than fifteen minutes, measured by a digital kitchen timer. Orlean's gentle mockery of the result—the painting as well as the madly sentimental reverence Kinkade inspires—throws into

high relief the difference between what she expects from art and what Kinkade's mallery patrons get. Telling of a young couple "bashful and pleased because they had never bought a family heirloom before" and certainly "had never bought a painting before," Orlean admits that "they still hadn't bought a painting, since what they were buying was not a painting *per se* but a fifteen-hundred-dollar lithographic reproduction of a Thomas Kinkade painting, printed on textured-brushstroke canvas with an auto-pen Kinkade signature on the lower right-hand corner."[10] Still, "Evening Majesty," featuring "mountains and quiet shadows and the purple cloak of sunset," is an artifact with cult value—"twee and precious" to some, but wholly affirming to those who never tire of enjoying its transcendent ambience.[11]

This combination of sentimentality and big business is typical of an enterprise that generated massive income. After Lightpost Publishing gave way in 1990 to Kinkade's Media Arts Group, Inc., a company traded on the Nasdaq from 1994 until Kinkade took it private again years later, sales soared. A representative earnings report for a top-earning year (2002) lists net sales of $103 million; the highest annual figure was $140 million, and Kinkade himself, as owner of 37 percent of the company at its peak, was "one of the wealthiest artists in the world."[12] This financial success depended upon a mass-production business model in which assembly-line factories affix transfer images of Kinkade's originals to textured canvas backing at a rate of hundreds per day, in which the popularity of the imagery is enhanced and exploited through the ancillary production of an array of tie-in items from the inevitable greeting cards, mugs, and screensavers to enterprises as vastly audacious as The Village, a Thomas Kinkade gated community in Vallejo, California. Media Arts Group may have overextended itself, and signs of trouble—lawsuits, failed franchises, Kinkade's own increasingly odd behavior—did soon indicate lesser financial ascendancy. But even after its loss of market profile and Kinkade's death at 54 in 2012, his reproduction artworks remain profitable and ubiquitous, still very much the face of a sector of the art market he continues to define.

All this makes him very much a commercial artist. He gives that term new meaning, enabling commodification to exert new mastery over visual culture. Alexis Boylan has discussed the meaning of Kinkade's success as a "marketing phenomenon," noting that for most critics his pop-

ularity is "merely a sign of the commodification of art and the way in which contemporary audiences are easily seduced by kitsch and marketing through the disassociating mechanisms of capitalism."[13] His popularity also exploits a dangerous kind of aesthetic nominalism. Laying claim to the distinction of "Art," Kinkade has irreversibly cheapened aesthetic experience, and his work "is thus a nightmare about the future of culture manifested in a poster, sold as a painting, hung in a gold frame, and named 'art.'"[14] But Boylan wisely questions this critical consensus, seeing the problem of "art" in this instance as a chance to ask questions about the rules Kinkade has broken. Noting that "his art, and indeed his vision of himself as a specific kind of artist, are born out of dialogues that have important intellectual and social currency," Boylan repurposes Kinkade into a critique of the aesthetic, and with powerful results.[15] He becomes the basis for an updated reading of the problem of commercialized taste—more specifically, the problem of kitsch. For Boylan, Kinkade represents a kind of *useful* kitsch that cannot help but be reflexive in its representation of an impossible object of nostalgia.[16] This more balanced reading of Kinkade's commercial aesthetic also begins to explain what Kinkade means for the history of impressionism. His bold amplification of what is kitsch about impressionism is useful as well. It becomes reflexive—demonstrating how and why a version of impressionism is so useful to commercialism, to nostalgia, to art's popularity—but it also identifies a real need for kitsch in art that is not just commercial but contemporary.

Kinkade explicitly identified as an antimodernist painter, opposed to what he saw as the illegibility, cynicism, and elitism of modern art. If modernists defined art as confrontational, intimidating, and antisocial, Kinkade rejects a sense "that art is about the artist's self-fulfillment rather than . . . a socially-conscious service for others," and he refuses an art world ethos that elevates the radical sensibility over the needs of ordinary people.[17] But Kinkade also exploits a modern aesthetic, in his forms and styles as well as his use for the prestige of high art. To achieve his special combination of popular and modernist artistry, he develops a fairly revisionist art history, which profits him mainly by repositioning impressionism, locating it to a moment decisively prior to the advent of aesthetic modernity. His impressionism is no late-nineteenth-century confrontation with revolutionary history, urban life, suburban change, new gender roles, or capitalist leisure. Instead it takes place before these things became

the objects of cultural recognition. Needing impressionism's modern art prestige without its modernity, making it a "'classic' mode of painting," Kinkade applied its styles to the classic subjects of academic painting.[18] In this he repeated what had been done by decorative impressionists who moderated impressionist modernity with academic restraint and domesticated its styles through engagement with the beauty of feminized environments. Impressionism and its modern uncertainties were doubly excluded, and Kinkade repeats this antimodernist exclusion, increasing his work's potential for popular and commercial appeal. But whereas the decorative impressionists had made their art a way of life, Kinkade achieves a further degree of thematic co-optation: invoking impressionist insouciance even as he subtracts the basis for its liberatory urge, he turns impressionism against itself, it would seem, making its style an affirmation of false populism, of empty desire. Were it just a beautiful style, it might have a certain pseudo-impressionist appeal, but because it trades upon aesthetic distinction, it becomes a matter of kitsch co-optation.

This happens at the level of the brushstroke as well. The "highlight" that is Kinkade's signature is an intensified *tache*, brightened and magnified by new coloration, fantastic internal light sources, and, of course, the highlighting procedure, which introduces the new contrast between mechanical print and actual paint. But there is also a spiritual component to Kinkade's super-radiant *tache*. His work "has a visual characteristic that we might describe as light," he notes, "but the light people see in my paintings is also a spiritual conversion or a hopeful feeling. I view it as an outgrowth of my faith in God."[19] When Kinkade's brushstrokes scintillate, they signify a spiritual transcendence as well as living spontaneity; they bridge the widest gap, between visual experience and heavenly illumination. And it is wider still, since the highlights that manifest God's grace are applied in a commercial setting, at the behest of the viewer. Brushstrokes that had once betokened the impressionist erasure of values here are broadened and fixed: they become lock-stepped into a sequence leading straight from earthly consumerism to divine redemption. This bad allegory may be kitsch at its very worst. As impressionisms go, it may be the worst sort of travesty, insofar as it puts the impression's perceptual dynamic in the service of all the forms of bad faith, dispossession, and distraction its history has seen.

Unless this result has actually put impressionism in the service of some powerful collaboration of material practice and spiritual uplift, which is what Kinkade might have claimed, with the support of patrons who vehemently confirm both the pleasure and the value of the experience of owning and viewing his work. Has impressionism been co-opted or confiscated by a process of shameless commodification and opportunistic religiosity, or has it achieved a fuller expression of itself in an enterprise that ought to contribute to our larger definition of it? Did Kinkade hijack the highlight, or has he only accomplished a true contemporary equivalent to its impressionist original? These questions are essentially challenges to the category of kitsch. The highlight is the epicenter of the excessive sentimentality, specious immediacy, and tasteless prettiness that are always named in criticisms of Kinkade's kitsch aesthetic. Moreover, the highlight's complicity in mass production—its way of aestheticizing the mass-market commodity—gives it a sort of para-kitsch status: it is a vehicle for the production of kitsch as much as a factor in kitsch imagery. Then again, this potential for kitsch reflexivity might well disallow any such categorization, which, as we have noted, must in any case seem insufficient to the problem of commercial aesthetics today. What is the status of Kinkade's art?

On one hand, Kinkade has co-opted what was once an avant-garde aesthetic, so he fits Clement Greenberg's foundational account of the relationship between avant-garde and kitsch (and the way the former is "looted" by the latter), and his process and audience match those Greenberg describes in his attack upon "rationalized technique" and its mass public "insensible to the values of genuine culture."[20] The combined "virulence" and "attractiveness" of Greenbergian kitsch account for the spread and appeal of Kinkade's work, and Greenberg describes the specifically aesthetic failure of kitsch that explains the problem with Kinkade's version of impressionism. Contrasting the experience of a "cultivated spectator" of Picasso and a lesser viewer of a kitsch picture, Greenberg argues that "the ultimate values which the cultivated spectator derives from Picasso are derived at a second remove, as the result of reflection upon the immediate impression left by the plastic values."[21] In kitsch, however, this "reflected effect" is already "included in the picture," so that kitsch "predigests" what ought to be a function of aesthetic reception. A painter

like Kinkade, then, produces kitsch by painting impressions that require no reflection—indeed, impressions that disallow it by reducing aesthetic provocation to "unreflective enjoyment."[22]

The "parody of catharsis" at work in kitsch experience for Adorno is performed by Kinkade's allegorical invitation to return to redemptive domestic space. The "specifically aesthetic form of lying" Matei Calinescu makes definitive is what we see in Kinkade's falsified art, and Calinescu offers a relevant account of the need kitsch meets—how in spite of the "transparently commercial" aspect of its "atmosphere saturated with beauty," it actually responds to a middle-class sense of existential emptiness with instantly fulfilling pleasures.[23] Herman Broch gives the longer history contextual to the larger progress of kitsch from its advent to impressionism to Kinkade: claiming that art before Romanticism had always entailed a transcendent aesthetic ideal, Broch locates incipient kitsch in the subsequent relocation of the aesthetic ideal to "its immanence in particular, finite works of art."[24] Kinkade overdetermines this localized ideal, in exaggerating repetition of the merely material particularity of the painting of modernity.

Of course, these critiques of kitsch pre-date its postmodern reappraisal: artists after modernism often defined their ironic projects precisely in terms of kitsch excess and the celebration of its insouciant non-art. Postmodernism sought to overturn Adorno's hierarchy of avant-garde and kitsch to negate aesthetic autonomy and inhabit the contingency of popular sentimentality. And claims have been made for Kinkade's postmodernity. In her introduction to *Masters of Light*, a Kinkade catalog, Wendy Katz affirms Kinkade's popularity in terms of this subversion of avant-garde priorities. Whereas avant-garde artists had presumed a need to respond to modernity with shocking, alienating difficulty, Kinkade undertakes a restoration of a reparative aesthetic in which a "desire to reconstruct the very measured space that Picasso and the early modernists had fractured" justifies hope for "stability and security in a chaotic society."[25] "Affirmation of the viewer's desires" makes Kinkade a truly popular, or populist, artist; he fulfills needs, and if that makes his work seem kitsch, it only takes postmodernism to redeem him: "Perhaps in spite of himself, Kinkade . . . is a postmodernist: someone who, albeit in his case without irony, unabashedly draws inspiration from several historical styles in order to create artworks that serve a traditional, symbolic, medi-

ating function for viewers and collectors, as they affirm the legitimacy of their tastes."[26] Katz's complex interpretive bricolage combines Kinkade's popularity, pastiche, affirmation, and traditionalism into a rather peculiar form of postmodernism, but it does justify kitschiness in contemporary terms. His work takes on a valid function, insisting upon the legitimacy of popular taste, pushing back against the critique of kitsch without the kind of irony that might only reaffirm that critique's fundamental validity. And yet the omission of irony also leaves no room for such a function to take effect. Too innocent of its implications, Kinkade's violation of the rules of taste remains available only to commodification, and not the kind redeemed by postmodern skepticism.

But kitsch has found new justification beyond postmodernism. Alexis Boylan invokes it in her claim that "Kinkade is kitsch at its most useful," based on a sense that kitsch is a valid and serviceable variety of aesthetic experience.[27] Once postmodernism has closed the gap between kitsch false consciousness and aesthetic criticality, kitsch takes a simply minor role among forms of aesthetic presentation—no longer villain or hero, just one potential quality among many. For Boylan, it is a form of fantasy that must always run afoul of reality. Kinkade's patrons fervently wish for what he shows them, knowing all the while its limits, its impossibility; a dialectic does obtain, compromising the "unreflective enjoyment" Greenberg warns against.[28] Boylan cites Celeste Olalquiaga, whose work takes the next step beyond the postmodern version of kitsch by making an important distinction between two varieties. In Olalquiaga's account, there is "nostalgic kitsch," which aims to "repossess the experience of intensity and immediacy through an object" without the necessary recognition that this aim must fail.[29] By contrast, "melancholic kitsch" revels in feelings of loss, and its object is the failed commodity that achieves a dialectical status as an object "whose decayed state exposes and deflects its utopian possibilities, a remnant constantly reliving its own death, a ruin."[30] Nostalgic kitsch is noncontingent, limited, and unsatisfying, precisely because it is too easily satisfying—too little engaged with what empowers wish imagery. But as the object of melancholy kitsch retains the true intensity of experience in all its disruptive, self-defeating complexity, its "mythic quality enhanced by this ungraspable condition."[31] For Olalquiaga, this disruptive ungraspability gives melancholic kitsch an aesthetic value after all, and it could mean Kinkade's redemption. Do his commodities fail in

such a way as to deflect the utopian hopes they would embody? Despite their perfectionist iconography, do they show us ruins?

Kinkade's redemption could also be that of his impressionist style. These varieties of kitsch match versions of impressionism. The nostalgic kind is that which would simply enjoy "intensity and immediacy through an object" without the criticality essential to the impression. The melancholic kind is that which devolves into discord despite its utopian immediacy—despite the synthesis that would make full value inherent in minimal and momentary experience. When Kinkade co-opts Monet's approach to color and light, does he exaggerate its potential for nostalgic intensity or amplify the disruptive ungraspability of Monet's original impression? Kinkade would seem to represent only the heedless and dishonest kind of kitsch impressionism defined by the nostalgic motive. His work would seem to be evidence that impressionism persists as a nostalgic commodity designed to profit by undermining the value of true aesthetic experience. But if there is anything melancholic about it, this persistence might actually redefine aesthetic experience. Even if Kinkade himself has made a mockery of impressionist art, the result might be to art's benefit. To say so, however, we need to know more about the nature and function of what Olalquiaga describes as melancholic kitsch. How exactly does it deliver true intensity and truer art, even as it disrupts it? Answers to this question will take us beyond the old problem of kitsch to new solutions in the theory and practice of the aesthetic—to Peter Doig and his debt to impressionism, new accounts of the way kitsch impressions repay that debt in kind.

<p style="text-align:center">⸎</p>

In 2007, Doig's *White Canoe* (fig. 6.2) fetched the highest price ever paid for a work by a living European painter. That success surprised the many contemporaries who would have thought that no landscape picture—certainly not one so lush, romantic, and whimsical—could even get such serious recognition, let alone top regard among the work of what were then called the Young British Artists. *White Canoe* seems artlessly to celebrate painterly expression, with its happy reflection in water of the sort of landscape beauty captured by impressionist art; by contrast, the contemporary art of the moment did everything to violate painterly pleasure.

6.2 Peter Doig, *White Canoe*, 1990–1991, oil on canvas, 79¼ x 95½ in.

That sort of contrast had been a problem for Doig throughout the early phases of his career. In the 1980s, when he was getting his start, Doig says a British take on abstract expressionism was still dominant and a "cool processed aesthetic" set the standard.[32] Conceptual art dominated—along with its doppelganger mode of ironized mediatization. In the years between his first solo exhibition in 1984 and his Turner Prize nomination in 1994, Doig often seemed too "reassuringly painterly" to "powers that be" who were "embarrassed by painting."[33] He received "no interest whatsoever from the commercial world," he recalls, because he seemed to be a kind of throwback, and what made his pictures appealing—their sheer beauty, their "sweetie colors"—also made them seem suspicious to a public that naturally expected visual art to engulf any purely aesthetic experience in critical processes usually destructive to anything simply beautiful.[34] Someone even told Doig that his work looked like "a Christmas card painted by mouth," so much could his innovative forms seem to lapse into a kind of uncool, uncontemporary ineptitude.[35]

Gareth Jones helped change the conversation about Doig's work in a 1992 article in *Frieze Magazine*. "Large scale figurative oil painting" it may be, Jones's review begins, but it delivers "the kind of jolt commonly associated with more esoteric media," and thereby throws down a real challenge to the radical establishment.[36] His work "remains aggressively outside of the main-stream," unironic painting that resists "the artificial closures of concept and process" typically necessary to make painting viable today. What it offers instead is an innovative aestheticization of personal imagery.[37] Doig works with sincerely valued images drawn from memory and remediated through processes aligned with the actual mental and cultural life of the image. That is, as Jones notes, Doig's early paintings are based at once on the trace of a remembered image and some photographic source that corresponds to it, and is, by virtue of its photographic objectivity, an "[intermediary] for the scenes in his head."[38] Doig then remediates the photograph in turn, as paint eliminates what is left of the real quality of the image. Despite the apparent painterly conventionality of the work, no present landscape is immediately before painter or viewer. Doig departs from it, subjecting his personal imagery to the diverse requirements of different modes of image production. His paintings are comprehensive registers of what we might take to be objects of momentary perceptual attention. Jones's account was important for the way it acknowledged Doig's apparent inadequacy but argued for something more. "Doig seems intent on finding out far he can go before his private wilderness flips over into kitsch": this telling assessment recognizes the major originality of an aesthetic that seems to risk kitsch even as—or really because—it has subjected the private landscape to aesthetic differentiation.[39]

Doig's early success was largely a product of this dialectic. The prettier the picture, the more it involved transmedial complexity; the more transmediation perfected it, the more it risked kitsch. Richard Shiff's account of Doig's practice follows its imagery from distant memory through photographic parallel through the mutations, accidents, and material obstructions that transform it into a composite that is, surprisingly, attractive. As Doig adds further steps of remediation to this process— transferring film to video and video to stills, and subjecting that static result to painterly ambiguity—"layers of translucency accumulate, only to result in obscurity," and ultimately to yield beauty.[40] If an old postcard image of a lake in the Canadian Rockies is revivified on canvas, it is not

to give memory new perceptual life as much as to consign it to this ob-
scurity, to "create the impression of an image fading from view," in Doig's
words, "as if it were pinned to a bedroom wall where the occupant of the
room was viewing it as he faded off to sleep."⁴¹ Here we have the character-
istic surprise that makes Doig's work so compelling—this combination, at
once so contemporary and so sincere, of postaesthetic process and sen-
timental commitment to the affective life of human image making. At its
most extreme, this combination results in pictures that seem little more
than a "washy surface of stains"—the ultimate result of their material-
heavy realization—but also a compelling evocation of visual experience
important to someone real.⁴² Doig's pictures may be about the process
by which paint fades memory and unfixes photography, but they are also
supplemental perceptions, as if paint itself could become a prosthetic sen-
sorium superior to anything the eye or the camera could provide. If the
latter proposition is familiar—a commonplace, almost, in the history of
the aesthetic—that is what makes Doig contemporary: the discovery, after
remediation, of something yet justifiably immediate. Stéphane Aquin sur-
veys the strange array of Doig's medial sources—the "ever-growing image
bank made up of personal photographs, advertising materials, art books
and magazines, postcards from numerous time-periods and places, CD-
covers, newspaper pictures, etc."—and notes that the "mnemonic charge"
they establish as the "prime condition" of the work ultimately develops
into an analogous diversity in the material product: "Blurred shapes, the
colours of a quasi-psychedelic lyricism, the impression of almost stro-
boscopic film stills, the mystifying effects of the thick and runny paint"
all indicate that Doig's image bank and his practice of image production
bedevil each other.⁴³ Ultimately he achieves both a lush immediacy and
a critique of nostalgia for the vivid image. What perpetually fades or dis-
torts into a repeatedly remediated memory is also an available visual ef-
fect that never trades its aesthetic power for its status as a critical moment.

But somehow the product is still aesthetic enough to provoke that
skepticism about the "painterly": Doig's venture through media detritus
and material surrender lucks into beauty, it would seem, and that ren-
ders the process suspicious. If, as Keith Hartley argues, his works end
up enjoying the old *juste milieu*, "a balance, or, better still, a synthesis
between abstraction and figuration," that harmony of aesthetic proper-
ties, there seems to be a troubling collision of contemporary priorities

and familiar consolations.[44] Shiff notes the risk involved: "He leads his banalities toward a sensory and psychological precipice, over which he barely keeps from falling—into kitsch, possibly."[45] Even if the balance is not lost, it seems, Doig might fall into a kitsch aesthetic, because his contemporaneity is so indebted to the throwback effects of sensory experience in synthesis with abstraction—dedicated, in other words, to something impressionistic. The discourse on his work all suggests that Doig has achieved a furtherance of the impression. Even if Monet's pink snow was but a pretext for prodigious remediations, Monet's project has a worthy successor in pictures that react in new ways to the impression's duality. As he proliferates processes by which aesthetic perceptions barely keep from falling into failure, Doig subjects impressions to new contemporary forms of emergence, and he achieves the classic effect whereby perceptual fragmentation somehow becomes pictorial finesse.

Here, the relationship between impressionism and kitsch is importantly misleading. Doig's painterly beauty seems impressionistic in a bad way— in kitsch fashion—because he has yielded to a contemporary furtherance of impressionism's authentic indeterminacy. It is critical rather than decorative, but so critical that it appears decorative after all: this is the paradox that informs much writing about Doig, and if it sounds specious—a matter of art world hype or pandering cleverness—it does have a basis in a vital debate about the status of art today. As art moves beyond its total dedication to criticality as such—entering a postconceptual moment—it is precisely this sort of specious relationship to beauty that characterizes aesthetic engagement. As we turn now to explore that relationship and its implications for Doig's impressionism, we will also wonder about its implications for Kinkade. If kitsch is a sign that Doig has given Monet new contemporary validity, how can it also be a sign that Thomas Kinkade has not? If, in other words, the "sweetie color" beauty, pictorial warmth, and gratifying immediacy of Doig's work signify new life for the impression's antipainterly critique, why and how do similar effects in Kinkade's work signify a bad kind of co-optation of the impression, an exploitation of its aesthetics, its critical collapse? A hasty answer to this question could simply point to Kinkade's mere repetition of Monet, the failure to make his mode of perception contemporary, the nostalgia for it that makes it unreflective—just the thing Doig subjects to critical remediation. But a fuller answer adds a necessary analysis of what constitutes kitsch in these

6.3 Peter Doig, *Concrete Cabin II*, 1992, oil on canvas, 200 x 275 cm.

cases, and how a reversal of these value judgments might map a new contemporary visual-cultural field.

Doig's *Concrete Cabin II* (fig. 6.3) depicts a housing complex in Briey, France—an approximation of the Unité d'Habitation, built by Le Corbusier in 1961 but abandoned since 1973. The work was the result of Doig's intermedial process, and it entails all the sourcing and final pictorial effects that would come to be characteristic of his work. It joins a perceptual critique to the demands we associate with a kitsch aesthetic, reinventing the kitsch travesty of art for a postcritical contemporaneity. Indeed, something kitsch—something even reminiscent of Kinkade—was an important initial motivation for the picture. Seeing the white building through dark forest, Doig recalled another time he had seen domestic light through the trees. He had been walking late at night on a deserted road and was relieved to see a house glowing in the near distance. "I can remember the terror of . . . the pitch black," he says, "with the densest trees around. When you do finally see the light of a house it's incredibly welcoming."[46] Longing for the domestic, figuring it as a light in the darkness, Doig is not unlike Kinkade in his motivation for conjuring pictorial imagery. When he then resorts to an impressionist precursor for help evolving the image

into an aesthetic composition, he actually compounds the potential kitsch of the result. Doig explains that he chose not to paint the building first and then lay the trees over it but rather to represent the design of their interlacing all at once—in the manner of Cézanne: "I purposely painted the man-made buildings through the trees rather than paint them first, then paint a screen of trees [or] nature on top. I had seen Cézanne do this a lot—the light of architecture glimpsed."[47] This effort to render the real impressions of an architectural light source, one that is the object of longing, is enough to give Doig's work here a merely painterly status, and, in that sense, a kitsch association. And the citation of Cézanne compounds the problem, insofar as Doig seems to articulate a sentimental project in terms of a nostalgic art history.

But both the picture's visual longing and its deference to Cézanne are part of a timely project. It may be true that Doig felt drawn to that welcoming domestic light, but his representation of it also involved something far less inviting. The abandoned building did glow white behind the trees, but it was also pocked by areas of darkness—the empty "concrete cabins" that had been the building's individual apartments, which now, as ruins, loomed darker than the forest itself. "Doig's experience of the building shifted from a welcoming feeling to a threatening one," leading to a play of light and dark meant to evoke the problem of perceptual transformation rather than any durable form of perceptual solace. Cézanne also inspires a more searching goal. His way of "superimposing one color over another, regardless of the actual position of the represented objects" invents an ambiguous spatial order, "concerned with representing the process of perception and its feel."[48] And this "pictorial knowledge" underwent further revision in memory: for Doig and Cézanne alike, "functional memory" is abstracted into something more like the "idea of memory," an emergent source of critical imagery. All this is continuous with Doig's more radical concern for the longer process of perception, which takes in other media and conceptual complexity. Concrete Cabin II does not begin and end with glimpses of light and sensory satisfaction. In addition to threats of darkness and the more abstractionist, conceptual Cézanne, it includes all the refractory pausings of Doig's more transmedial aesthetic. Doig spent time working on the building itself; he stayed, too, long after capturing his first sense of the building's visual value. In the process of reimagining it, he made video that was then atomized into stills and, in turn, translated into

a new basis for reckoning with the perceptual motility behind the larger process of perception when mediations of light and dark preempt memory, seeing, and imagination. Doig has published the video stills made as studies for the *Concrete Cabin* works as an artist's book, *Briey* (1993)—a minimal selection of photocopied versions of the images isolated from the videotape version of his own actual experience of approaching the bright building through the darkness. Such measures—micromanagement of visuality, unsparing analytics—carry Doig far from what may be kitsch inspirations and effects. Amid the biographical love of light, the impressionist source, and the sheer beauty of the final work is a whole set of processes and ancillary works that stall easy painterly production.

And yet what keeps Doig's "private wilderness from [flipping over] into kitsch" retains an important relationship to it.[49] Clearly, Doig is happy to take the risks involved, not only the risk of painting sentimentalized perceptions and the beautiful result but that of declaring his attachment to painting itself and its impressionist history. This is not the ironic kitsch of other postmodern or contemporary artists for whom embracing kitsch has been a way to critique the concept of art and the aesthetic. The difference is that between a conceptual art and a post-conceptual aesthetic: if Doig's work sometimes seems kitsch, if his impressionism is to blame, it is because he has made a post-conceptual return to the material of painterly perception, a contemporary return to the grounds of the impressionist aesthetic. He might have achieved a painterly contemporaneity by ironizing impressionist style—exaggerating its sentimentality, putting it to inappropriate uses. That could have been a way to repurpose kitsch, in the spirit of the contemporary art that has done so. He would have utterly failed at painterly contemporaneity by repeating impressionist styles without a difference—the surest way to kitsch, given its perfect overlap with the immediate, intense satisfactions that are the definitive features of the category. But Doig achieves painterly contemporaneity by incorporating pure kitsch into his process, not quite repeating or ironizing it, but acknowledging its valid participation in that longer procedure of perceptual engagement subtextual to his pictorial work. What, then, is the status of that work, and what has it done for the kitsch aesthetics of impressionism today?

Peter Osborne has recently explained why truly contemporary art must be postconceptual. In his account, art has gone beyond the conceptual not

by abandoning the concept but by transforming the ontology of the artwork. This transformation depends upon a new sense of the relationship between art and the aesthetic—a revision of the aesthetic concept of art. Osborne locates a precursor to this revisionist concept in the early Romantics' conception of an art that maintained a certain role for aesthetic feeling. Whereas Kant had developed no viable ontology of the work of art, his successors in Jena Romanticism saw how the work of art must be at once "irreducibly conceptual" and aesthetic in its "mode of appearance."[50] The aesthetic that is "an ineliminable aspect of the early Romantics' ontological conception of art" is a crucial critical legacy for a truly conceptual art—or, rather, a postconceptual art that recognizes the proper relationship between art and its aesthetic component.[51] That relationship is, essentially, arbitrary: Osborne argues for an "anywhere or not at all" status for art's mode of aesthetic presentation, claiming (among his six insights into the definitive qualities of the postconceptual) that contemporary art is still conceptual, but it has an "ineliminable—but radically insufficient—aesthetic dimension"; some materialization is essential to the fulfillment of its conceptual project, but its minimalist insufficiency is part of an anti-aestheticist dedication to limitless formal possibilities.[52] Osborne's argument focuses on the way his ontology of the artwork revises the history of art and enables new appreciation for the spatial and temporal possibilities of projects that transcend medial and geopolitical boundaries. But Osborne also provides a way to think about the contemporary return to aesthetic experience, in Doig's work and also more generally in recent efforts to rethink and revalue aesthetic beauty. It need not betray the criticality of conceptual art. Indeed, it becomes essential to art's conceptual critique, as the material basis without which art has no ontological claim but against which it must define itself. This insufficiency of the aesthetic is an inspired way to redeem the pleasurable objecthood of art today—to restore it without the sort of conservative impulse Osborne rightly sees in other current efforts at aesthetic affirmation.

In other words, Osborne theorizes a contemporary aesthetic that does not simply reactivate the dialectic of avant-garde and kitsch. He does allow for the validity of kitsch—his argument implicitly redeems its insufficiency—but now as but a part of art itself, the simple beauty of a presentation that partakes of a conceptual project. It is as if a fully avant-garde contemporaneity can finally make peace with the kitsch aesthetic that had,

in the classic analysis, seemed to mark its betrayal. Now, that betrayal is simply the incorrigible insufficiency of the aesthetic material avant-garde art needs for its conceptual departures. Contemporary art in its post-conceptual moment has co-opted the kitsch aesthetic. This outcome provides us with a good formula for understanding how and why Doig flirts with painterly beauty. His work corresponds to what Osborne describes as the "ontology of materializations"—the exploration of arbitrary forms of aesthetic presentation with a conceptual disinterest.[53] And this outcome also provides us with a good way to think about the legacy of impressionism in this contemporary project. Impressionism is not just a lush aesthetic that makes the most striking demand for conceptual remediation. It is a kind of model for arbitrary materiality. Its impressions correspond to what Osborne calls the "spatial radicalism" of art's "anywhere or not at all" ontology, its unplaceable emergence into its ontological condition.[54] In other words, the questionable way impressions compose a picture or a thought, seeming to undermine themselves with the very minimality that makes them valid, corresponds to the questionable position of the aesthetic in the postconceptual as Osborne defines it. We need only think back to Doig's use for Monet's pink snow to make this connection. The pinkness of snow was a provocation for Doig to conceive of new relations among media forms, but that postconceptual outcome was prepared by Monet's own inclusion of pinkness among the very many material presentations of light's refraction, his serial proof that it could change in a moment.

Its postconceptual ontology distinguishes Doig's impressionism from what is at work in Kinkade's highlights. The difference between the contemporary and the commercial here is the difference between two ways of minimizing aesthetic perception. It might also be the difference between art and nonart, but the more pertinent opposition distinguishes Doig's way of making the mere impression an opportunity for conceptual play and Kinkade's foreclosure of that opportunity. If both artists participate in impressionism's tendency toward kitsch immediacy and intensity, Doig does so in such a way as to process contrastive versions of it, open to what various media imagine, conceptually engaged with contemporary image production. Kinkade inverts this process, making a singular aesthetic quality bear the full burden of attention. Doig shows how impressionism becomes kitsch but then subsumes it within the process of taking art beyond the aesthetic; he shows how impressionism aids in contemporaneity,

rather than preventing it. Kinkade makes contemporary impressionism seem inevitably kitsch by disallowing its postconceptuality. Comparing the two artists enables us to locate what might seem generally inevitable—kitsch impressionism—in Kinkade's way of refusing to engage with the contemporary process whereby his imagery would lose its merely aesthetic appeal. Ultimately, then, the difference between Doig and Kinkade is the difference between impressionism fully realized as a postconceptual art form and a pseudo-impressionist aesthetic defined, in Osborne's terms, as too fully responsible for the work of art.

<div style="text-align:center">⸻ ✿ ⸻</div>

But Kinkade is not therefore a hopeless case. If his pseudo-impressionism is kitsch because it fails to make his kitsch aesthetic a subordinate part of a postconceptual art project, perhaps it only takes a postconceptual project to redeem his pseudo-impressionism—to make it too a proper form of art. Theories of kitsch after postmodernism see value in the "melancholic" variety, which develops something like a conceptual critique in its retraction of the immediate satisfactions it would seem to provide. Kinkade may or may not be melancholic depending upon his reception, and his reception has lately been shifting. After his death and the collapse of his commercial empire, his whole enterprise of impressionistic utopianism looks more and more mournful or elegiac, and critics tend more often to focus upon the hopeless longing that led Kinkade, who grew up without wealth, to fantasize about domestic bliss. Once melancholy defeats utopian plenitude, something like a postconceptual project does emerge, and impressionism becomes a function of the sort of aesthetic insufficiency necessary to contemporary art as such. Or it may not, if Kinkade continues to seem nostalgic only. To guarantee him postconceptual status, and to demonstrate the potential contemporaneity even of pseudo-impressionism, it takes concerted effort—for example, the 2004 exhibition that presented Kinkade as a contemporary artist.

The exhibition was staged by Jeffrey Vallance, an installation artist associated with the "infiltration" art movement, which sites its work at institutions typically outside the art world. He was the first (and still only) curator to mount a show of Kinkade's work. *Thomas Kinkade: Heaven on Earth* (2004), exhibited at the Main Gallery at California State Univer-

sity, Fullerton and CSUF Grand Central Art Center, Santa Ana, contained Kinkade's original paintings along with one example of every piece of Kinkade's mass-produced tie-in products, all organized into an array of themed installations. A gallery, faux domestic settings, a Kinkade library, a chapel, and a three-dimensional, life-size version of the "bridge of faith" depicted in the Kinkade picture with that title together featured the many aspects of Kinkade's claim upon public attention. The "centerpiece" was a Kinkade Visa credit card; a surprise addition was the burned remains of a Kinkade calendar, found in the wreckage of the World Trade Center after 9/11. Vallance says he designed the exhibition "to work on three levels."[55] It appealed to Kinkade's faithful, who were delighted by its comprehensive celebration of everything Kinkade. For the "jaded contemporary art viewer," the exhibition was equally if differently satisfying, since it sorted Kinkade's cultural productions into the categories and schemas important to contemporary-art installation practice. Finally, the third group "saw it working on both levels at once."[56] Vallance insists that he approached his project without irony: "For me irony is far too simplistic and expected. To do the show seriously was the challenge."[57] What made the show a contemporary event rather than a commercial one was what it performed: Vallance believes that Kinkade is "a kind of repressed trickster" whose work should be understood in terms of its performative effects.[58] Vallance was pleased with the way those effects played out at his own exhibition:

> Most writers pretty much admitted that they loathed Kinkade and came expecting to hate the show—like gawkers at a train wreck. But then something happened. When they came to see the actual show, the kitsch was laid on so thick that something snapped in their brains. They experienced transcendence and ended up liking the show. This was precisely what I had planned.[59]

This kitsch transcendence was a function of what Vallance pursues more generally: "cognitive dissonance," or, more specifically, a "state of dissonance arousal" or condition in which two incompatible possibilities coexist in such a way as to produce a kind of euphoria.[60] Infiltration art depends upon it, Vallance suggests, because an "inconsistency of beliefs" inevitably develops in the association of contemporary art and inappropriate institutional contexts. Tired dialectics of subversion-and-containment

are likely to result unless infiltration art can perform better ones; "dissonance arousal" is the key to infiltration, taking it beyond deadlocked versions of art's cultural status.[61]

Vallance performed a postconceptual Kinkade, and, in the process, a renewed impressionism. His Kinkade is a new Yves Klein; the commercial huckster becomes a trickster artist, and one who engineers the sort of dissonance that originally made impressionism important. Although that dissonance is external to the works Kinkade himself made rather than a part of the process internal to works by artists like Doig, it actually just creates the conceptual context for the reactions Kinkade's work does produce. Vallance frames commercial art in such a way as to disclose the postconceptuality of kitsch. That effect has also been the subject of a perceptive review of Kinkade by Doug Harvey, who similarly stresses the sort of cultural experience Kinkade might enable, in order to argue that he takes up the position of "artist as avatar"—the artist as a cultural figure through whom the public might achieve visionary experience, or, at least, "freedom from self-consciousness" and a "deep animal response" of fulfilling absorption.[62] Harvey notes that Kinkade's work therefore "raises more questions about what constitutes art in contemporary culture" than most contemporary art, but his focus is not this sort of critique. Indeed, Harvey distinguishes the Kinkade effect from the old "formalist polemic awaiting completion" and takes greater interest in the way Kinkade represents a combination very much characteristic of our moment: that of the "high-pitched busyness of contemporary culture" and the "low hum of contemplative interiority."[63] Insofar as the two are currently inflecting each other in new ways, Kinkade registers visual culture today with unprecedented precision, establishing a new art world with different criteria without simply producing some new version of the old antagonism between high and low, elite and popular art. Once it becomes impossible to dismiss him as a kitsch nonartist, and once his imagery has been loosed into the sphere of the postconceptual, Kinkade seems less different to Doig. Perhaps not as deserving of a certain recognition or high prices, not as good at producing objects of conceptual or aesthetic distinction, but as much an example of impressionism's persistent validity.

What might seem to be Monet's opposite posterities—in the commercial kitsch co-optation of Kinkade's highlights and the purposive material practice of Doig's contemporary art—turn out to abet similar forms

of contemporaneity. Monet gave Kinkade the register, at once stylistic, thematic, and historical, to idealize a lost domesticity, but its decorative intensity also communicates a desperate project. The excessive materiality of the nostalgic urge becomes melancholic. What looks like commercial success also conceives of loss. It bespeaks failed consolation and becomes critical of the aesthetic. Monet's historical aesthetic, then, gives Kinkade's impressionism a kitsch status, devolving into pseudo-impressionism, but it also attends the production of that pseudo-impressionism in such a way as to call critical attention to the new meaning of kitsch. Monet persists as a model for the minimal aesthetic perception that now redeems aesthetic failure, converting it into the basis for art after conceptual immateriality. Art that had become too ontologically unaccountable rediscovers its basis in material objecthood with an arbitrary commitment not unlike that of the impression; the impression's kitsch posterity in Kinkade becomes his claim to postconceptual relevance and associates him, surprisingly enough, with Doig's contemporaneity. For Kinkade's project—as played out in Vallance's exhibition but more generally in the public eye—now appears to involve a postconceptual process similar to (although placed differently than) Doig's way of remediating the pictorial image trace and finding something immediately beautiful in the record of its transformations. And Doig looks like Kinkade too, if not visually, then conceptually, since his own form of kitsch aesthetics also retains this risky commitment to aesthetic debasement. Finally, in this shared pseudo-impressionism that turns out, after all, to launch the impressionist impulse into contemporaneity, Kinkade and Doig suggest that impressionism survives its kitsch thematization even in the most commercial art and the most unlikely citations. More than that, it thrives on its kitsch afterlives, once kitsch survives its extravagant roles in modern and postmodern nonart to become something merely aesthetic.

———

There is more to be said, however, about the historic possibility of a postconceptual impressionism. For it is not a new one. It cropped up earlier—at the moment of the Monet revival among the New York School of abstract expressionism. Monet's sudden popularity in the mid-1950s created a very brief vogue for what was known, briefly, as abstract *impressionism*. Monet

not only became an inspiration to artists and theorists trying to explain, justify, and energize radical forms of abstraction and gestural art but also helped to distinguish a new second-generation trend within the New York School and its larger expressionistic style. Michael Leja's explanation of the "Monet Revival" locates its real interest in the way a return to impressionism dialed back the high-art abstractionism of the New York School and reintroduced more conciliatory representational traditions. Whereas the heroic expressionists had stressed forms and concepts, abstract impressionism "preferred color over line, percept over concept, optical art over haptic, contemplative over athletic process, space over surface, reality over unreality, nature over culture."[64] A surprising number of major artists—Philip Guston, Joan Mitchell, Sam Francis, Nell Blaine, Miriam Schapiro, Wolf Kahn, Hyde Solomon, and others—were seen to be part of an effort to "take gesture painting in directions marked by evocation of natural forms, flickering color, patterned brushwork, and/or a calmer, meditative mood."[65] That effort also had telling cultural associations, for it subjected a highbrow, avant-gardist aesthetic to something more like a "mass-market populism" and a possibly healthy "suburbanization."[66] In Louis Finkelstein's 1956 account of it, abstract impressionism entailed a vital restoration of painting's visual sensibility, its immanent sensuous world. Contradicting any implication of autonomy or essential conceptuality, this reenergized impressionism had its "antecedent premises . . . bound up with rather than imposed upon vision" in an aesthetic true to the way "perception always challenges concept."[67] Finkelstein suggests that this challenge is also a challenge to the contemporary tendency to underrate sensuous perception (either out of "Puritanism" or a commitment to the deadened sensibilities of mass culture).[68] And it seems that something like that tendency is what guaranteed abstract impressionism only a brief shot at contemporaneity. The conceptual won the day, along with related trends in pop art and the neo-avant-garde.

That subsequent history, however, suggests that abstract impressionism has an important relationship to conceptual art, and in turn, to the contemporary art of painting. Abstract impressionism was a sort of post-conceptual art *avant la lettre*. It represents a lost possibility recently regained in the history of art and, more specifically, the history of impressionism: the dogged persistence of aesthetic experience, in its proper relationship to the conceptual project that defines art as such. If we con-

sider painters like Peter Doig and Thomas Kinkade throwbacks not to impressionism itself but to the continuation represented by abstract impressionism, their kitsch aesthetics gain worthier associations. Kitsch perhaps emerges as something determined less by unaesthetic failure than by a history in which nonconceptual, noncritical art has been ghettoized into irrelevance and conceptual critique has lost its necessary basis in the aesthetics that kitsch has appeared to travesty. Ultimately, impressionism's apparent kitschiness today might be a function of its unlucky failure to persist in full dialectical reaction against abstract expressionism, in adequate mitigation of the conceptual, and in true assertion of its vision for aesthetic engagement.

7

THE PSEUDO-IMPRESSIONIST NOVEL

Sebald, Tóibín, Cunningham

Walking the streets of Prague in search of his lost past, W. G. Sebald's Austerlitz happens to step on some uneven paving stones. The feeling is momentous. It revives "the scenes of my early childhood, every trace of which had been expunged from my memory for as long as I could recollect."[1] The simple sensation underfoot spurs immediate recall, which becomes a chance to reconstruct the past. It is also a direct citation of Proust's *Recherche*. Marcel too steps on uneven paving stones, just before he enters the party at the house of the Princesse de Guermantes in Proust's final volume. For Marcel, the sensation is a further opportunity (like the taste of the madeleine) to escape temporality. It is an impression, which means that it joins this sensation to one from long ago, treading upon uneven stones at the Baptistry of St. Mark in Venice.[2] The new feeling is not just a reminder of the old. It makes the lost moment present, available to unprecedented recognition. This analogy then confirms a form of joy that defeats death; transcending temporality, Marcel's impression partakes of eternity. Sebald's Austerlitz undergoes a similar set of recognitions. He feels that "memories were revealing themselves to me not by means of any mental effort but through my senses, so long numbed and now coming back to life."[3] Austerlitz finds his efforts to remember overtaken by involuntary impressionism, as an apparently trivial, minor experience does the Proustian work of revelation.

But are the discoveries the same? Has Austerlitz really regained a past lost to the Holocaust in the way Marcel recalls Venice? Could there be the same joy—the same transcendence? Could impressions survive the Holocaust, not only in Austerlitz's own mind but in aesthetic culture? Why does Sebald return to the scene of Proust's impressionism?

And why do so many writers continue to do this sort of thing—to write a genre of perception proper to another time? Contemporary literature is full of novels still citing and also imitating Proust and his contemporaries. And in some high-profile instances, imitation has gone beyond implicit reenactment of critical scenes and styles to return to the very lives of the impressionists themselves. Colm Tóibín's *The Master* (2004) and Michael Cunningham's *The Hours* (1998) are novels about Henry James and Virginia Woolf respectively. But they may as well have been written by them. Realized in the spirit of James and Woolf, *The Master* and *The Hours* pay homage to impressionism. This seems natural enough; there is something essentially appropriate about this form of mimicry. At the same time, however, it raises questions about the validity of literary impressionism today. Just as we must ask about Sebald's motives in adapting Proust to the problem of memory after the Holocaust, we might also wonder what James and Woolf mean to a contemporary culture of fiction that persists in registering such belated impressions. The stakes are different, of course, but Sebald's example frames hard questions about the afterlife of impressionism in contemporary novels—those that claim its legacy so explicitly, and, by association, those that simply presume its living value. If these novels simply prolong the legacy, their impressionism has lost its original value, for then it means something it never did for Proust, James, and Woolf: nostalgia for modernist prestige, refusal of presence, failure at contemporaneity. But if there is new relevance in this furtherance of Proust, James, and Woolf, these novels signal something else: impressionism's role in making fiction contemporary. If it is just nostalgic anachronism, impressionism has become a pseudo-impressionism haplessly co-opting the prestige of an old aesthetic—an embarrassment to contemporary fiction, which loses face among the arts of the moment and gains only traditional authority. But a living impressionism could be the real fulfillment of impressions in a literature made contemporary, their best chance yet at cultural achievement.

Many novelists today write as if the styles, thematics, and objectives of the original impressionists were still current. What the publishing industry calls mid-list literary fiction, the sector of it with elevated status but also fairly widespread appeal and competitive sales, has an impressionist core, which we might characterize in terms of a set of tendencies distinctive to it as a mode. It is not just a matter of subjective consciousness, which determines fiction of many kinds. This impressionist mode of contemporary literary fiction courts momentary insights, fragmentary crises, and suggestive atmospheres, rendering them dramatically significant (rather than randomly meaningless) through focalized psychologies. Epistemological reversals stake fictional meaning on the barest glimpse and the minimal intuition, which, as for the original impressionists, are compelling for the alternative realism of their vivacity. Still central are moments in which an ordinary perception spurs revelations because of its relative nullity, or truth depends upon some insight freed into recognition by the dispersal of attention. Flux is the crucible of discovery. Meaningful experience is what it was for modernist characters and narrators who devolve into rudimentary awareness, from which something substantial emerges. Such emergences occur amid the conviction, established by the impressionist painters, that perceptual immediacy has an innocence required for sophistication, that aesthetic susceptibility is a form of justice to what is real. Free perception is an end in itself, but therefore also the essence of the purposive. Randomness is fateful; contingencies have value; sensibility yields speculation. These dynamics distinguish a project shared among an array of writers whose subjects may be different but whose very idea of the literary is an impressionist invention. But is this a true idea of the literary, or a mode of literariness—an elaborate citation of literature's past relevance? Do these tendencies and tactics help writers today do what they will, or are they a kind of reflexive house style, a fallback vernacular that undermines fiction's contemporaneity?

Sebald's Proustian impressions may indeed seem, in the circumstances, evasive and precious—all-too-familiar escapist responses to traumatic events that merit more solid treatment, or at least something more original. Tóibín's James is hardly adequate to the sexual recuperation *The Master* would accomplish: although the novel promises to take us inside James's homosexuality, we get no further than Jamesian impressions of it. And Cunningham's Woolf can also seem redundant and trivialized—

too much the visionary aesthete, or worse, the highbrow connoisseur of nice sensations, even at the moment of her death by suicide. This pseudo-impressionism makes explicit a problem threatening to so many contemporary novels composed of modernist impressions: mimicry travesties the original impressionists as surely as it destroys any claim to contemporary relevance. Other potential offenders include Julian Barnes and Ian McEwan, to name two prominent examples—Barnes as the author of *The Sense of an Ending* (2011), which reenacts the deluded impressions of Ford Madox Ford's *The Good Soldier* (1915) despite what has changed since the culture of sexual deception essential to Ford's sense of the difference between appearance and reality; and McEwan as another inheritor of Woolf's aesthetic, which, as David James has noted, is an unlikely "phenomenological register" for the hypercontemporary *Saturday* (2005).[4] James identifies more contemporary literary impressionists—writers as diverse as Philip Roth and Milan Kundera—and we might add any number of others, from Karl Ove Knausgaard to Susan Minot, from Michael Chabon to Teju Cole. Pseudo-impressionism entails descriptions, plots, and themes invented for conditions very different from our own—different media environments, habits of communication, social mores, and visual cultures, which needed what impressions could bring of free engagement. If impressionism therefore risks a kind of anachronism of engagement, the problem is magnified in *The Hours* and *The Master*. Its consequences are personified by the James and Woolf of Tóibín and Cunningham, who figure what happens when impressionism is adapted for contemporary uses.

What happens, however, is only as anachronistic as other impressionist reiterations—in advertising, film, painting, and other cultural formations in which this sort of legacy has taken effect. Elsewhere, pseudo-impressionism has turned out to be a renewal not only for impressionism but also for that which it seems to undermine. Turning now to the problem of its contemporaneity in fiction, it will help to recall what we know about these other instances in which co-opted, outdated, or inadequate impressions have asserted new validity. The mere distractions of the advertising impression were new forms of attention, stimulating to cultural critique; *photogénie* made the problem of the impression's emergence a challenge to new filmic mobility; and what looks to be a kitsch recurrence of impressionism in contemporary painting has postconceptual purpose to it. These examples should prepare us to discover new justification for

impressionism in the pseudo-impressionist novel, and indeed they reflect what we will find: not an outworn aesthetic serving only to authenticate literariness or belatedly to co-opt modernism, but a timely one in which the demands now placed upon fiction are discovered by the effort to render impressions.

—————— ∞∞ ——————

When Sebald's Austerlitz trips over uneven paving stones outside his childhood home in Prague, and when, later, he feels his childhood come alive again in the Ladies' Waiting Room at the Liverpool Street Station in London, he does seem to undergo a Proustian transcendence. Lost time is found as it is for Marcel, as experiences "deeply buried and locked away within me" now "came luminously back to my mind."[5] Once involuntary memory has offered the chance to pursue these luminous reminders, Austerlitz can "conjure it all up" through the kind of aesthetic reconstruction Proust undertakes in his own pursuit of impressions.[6] In Proust's impressionism, rudimentary perceptions become the basis for transcendence because of the way they fail, at the original moment of experience, to become thoughts: precisely because they originally fail, they emerge with supreme power at a later moment in which they are provoked again, because the analogy between the two impressions (both obscure and ineffable) defies the passing of time. To taste a tea-soaked madeleine years after doing it in childhood is to feel eternal—and to reconstruct a childhood that originally escaped experience—because the impression remains embedded in the life of the moment, enabling later access to that moment and therefore a timeless mind. As Marcel observes, "the work of oblivion" is such that there is "no connecting link" between the returned memory and the present.[7] But "for this very reason it causes us suddenly to breathe a new air": because it is not conveyed to the present by the passing of time, the lost object of memory can be truly regained, truly new to the mind.[8] "Diverse happy impressions" are experienced "at the present moment and at the same time in the context of the distant moment, so that the past was made to encroach upon the present": in this fashion, true memory is a function of an analogy between rudimentary perceptions, and it takes place "outside time" because the analogy is an "extra-temporal" property.[9] A feeling "common both to the past and to the present" is "much more es-

sential than either of them."[10] Again, this quality depends upon the nature of the impression as Proust defines it. A special variety of perception, it is "real without being actual, ideal without being abstract," and this perfect duality means that it keeps to the "essence of things," awaiting recognition at once sensory and transcendental. Only that combination can enable the "minute freed from the order of time" that frees us as well.[11] That perfect duality and its potential for timelessness are the basis of Proustian memory and Proust's impressionism.

Austerlitz, it would seem, enjoys a similar impressionist access to past perceptions. Because they were deeply buried, they never became a part of his ongoing life history and were never subject to temporality; recovered, they provide access to what was buried along with them, and a sense of power. "It was the very evanescence of those visions that gave me, at the time, something like a sense of eternity": there could be no more canonical impressionism than this dualistic reversal, and its explicitly Proustian cast confirms its use to Sebald's story.[12]

But what do we make of a recovery whose impressions were buried not by bourgeois neurosis—by the relatively minor anxieties of a Proustian upbringing—but by the Holocaust? Austerlitz has returned to Prague to find the parents he lost as a boy when his father was unable to move the family with him to Paris, and his mother put Austerlitz on a children's transport from Prague to London before being sent to Theresienstadt. It has taken years to piece together the facts of an unknown history, which, haunting him, has shaped a melancholy life of empty longing. Even as he finds traces of his parents and reconstructs the life he lived with them, nothing is really regained. And so the Proustian notes ring false. Those moments of perceptual plenitude and timeless transcendence seem out of place in a narrative so highly conscious of irreparable loss and so painstakingly attentive to the negations present in any traces of traumatic history. Sebald's pseudo-impressionism is not just a false note, but a real problem for his project: the vivid illuminations are but part of a narrative discourse given to the kind of impressionist atmospherics and elusive pleasures that only aestheticize historical trauma.

But just when we do hope that Austerlitz has achieved some redemption through an impression that brings the past to life, we face the truth: no such redemption can occur, least of all through the memory of perception. As Ann Pearson and Lauren Walsh have noted in their readings

of Sebald's version of Proustian memory, the sort of recollections that at first come naturally to Marcel are only ever mediated for Austerlitz— through the artificial means of photographs and other material representations that are never actually presentations of past experience.[13] Sebald's text may be impressionistic, but that is because it is littered with recycled imagery. As Walsh argues, his memories are "photo-textual," always concerned with the intervening process whereby artificial image discourse takes the place of true perception in an effort to recover the past.[14] As Austerlitz tries to remember, he often finds that what and how he remembers is photographic, and that the photographs in question have no reliable relationship to what they represent. This problem is a product of historical trauma and a response to it. The Holocaust has dispersed true insight into false documents—the speciously systematic architectural plans of the buildings that housed atrocities, films of labor camps made to look like "a Potemkin village or sham Eldorado."[15] Austerlitz can find no true past in these records; they represent only the traumatic gap between experiential life and any means of reckoning with it. In response, his own narrative record turns upon photographic evidence that only replaces memory with imagery that can fit no life story. If what ought to be direct representation is so faulty, the vagaries of memory are worse, and those epiphanies that seem to restore Austerlitz's past actually throw him back upon nothingness. They are a matter of "substitute or compensatory memory" that confirms only traumatic deception, and they make Austerlitz feel "as if I had no place in reality"; if he also feels "as if time did not exist at all," it is not a Proustian achievement but an annihilation.[16] Whereas the Proustian fragment can become part of a restored whole, Austerlitz finds that "as soon as I tried to hold one of these fragments fast, or get it into better focus, as it were, it disappeared into the emptiness revolving over my head."[17] The art of writing gives fragmentary past experience analogical integrity for Marcel. For Austerlitz, no aesthetic can make up for what history has wrought, and there is only a "terrible anxiety" when the past does seem to emerge.[18]

Rather than a reaction against Proust, however, Austerlitz's terrible anxiety suggests a revision. Sebald seems to mimic the Proustian impression and then to disclaim it, but the larger result adapts Proust to new ends. Once we set the two writers against each other we recall that Proust too was aware of memory's artificial mediations. His impressions were made immediate by their distance from each other—the distance in time

that allows for the analogical relationship that makes impressions out of mere sensations. More than that, they truly emerge only through the labored effort of an aesthetic vocation. For Proust, uneven paving stones are always only the start of a process that has as much to do with cultural refinement as transcendence. And that refinement has a traumatic aspect. Proust is no simple devotee of the aesthetic. There are brutal social contests that intervene between his blind and redeemed impressions, and they do much to undermine any confidence that lost time awaits its later perfect discovery. As Marcel notes with ironic regret, these "drawing-room transformations" are lost histories—the Dreyfus Affair failing to gain proper historical recognition, the status of fashionable young women masking the ignominy of social ascent, the great name taken only at its "current valuation."[19] No personal impression can ensure that historical atrocities get just recognition. Sebald helps us to remember this about Proust, which is to say that his citation of Proustian impressionism is a contribution to it as well—an intertextual fiction, a realization of what Proust implies at a moment prior to the fuller expression of the historical problem with which he prepares to engage.[20] In other words, the historical trauma that would seem to invalidate Sebald's impressionism actually demands its fuller realization, in fiction that builds upon Proust's sense of what impressionist immediacies entail. Sebald seems to build toward something different in kind—the post-traumatic impression rather than the aesthetically redemptive one—but his theory of memory is not such a total departure. If Proust is more like Sebald after all, Sebald is more like Proust, because he does not entirely reject the mediated impression of the unreliable photographic image. Photographs in Sebald do not simply assert epistemological skepticism or a skeptical ontology of the image. They enable observations and memories that are significant and sustaining. Sebald understands that artificial imagery can supplement the mind in useful, enriching ways; his photographs are true prosthetic perceptions as much as they are alienated, mechanical detritus.

Filmic photography comes through for Austerlitz. Searching for some record of his mother's life and death at Theresienstadt, he obtains a copy of a propaganda film made by the Germans to record the result of a "general improvement campaign" undertaken for the 1944 visit of a Red Cross commission to the camp.[21] The campaign made Theresienstadt look like a pretty, happy place of productive work and healthy communal living.

Austerlitz discovers that this "most reassuring spectacle" was filmed by the Germans ("whether for propaganda purposes or in order to justify their actions and conduct to themselves") and succeeds in obtaining a copy of the film through the Imperial War Museum in London.[22] He has high hopes. Although he has been "unable to cast my mind back to the ghetto and picture my mother Agáta there at the time," he believes that in the film he "might perhaps be able to see or gain some inkling of what it was really like."[23] The prospect alone stimulates his imagination to visualize her walking among the propagandized settings of the improvement campaign. But the film only shows a "patchwork of scenes cobbled together" (rather than the complete version), only flickering images that "seemed to dissolve even as they appeared."[24] This disappointment seems to confirm a skepticism about impressions. Whereas Proust's Marcel conjures up past images with immediate plenitude, Sebald's Austerlitz has only a dissolving patchwork of scenes that are themselves false—a paltry register of propagandistic lies about a death camp, degraded in its transfer from grotesque pretense to simulacrum to the museum's video viewing room. Or so it seems, until Sebald discovers a way to make the film yield what he needs to see. "In the end the impossibility of seeing anything more closely in those pictures . . . gave me the idea of having a slow-motion copy of this fragment from Theresienstadt made." Austerlitz subjects the faulty image to further mediation, and that process, which could be expected only to worsen the problem of unreliability, works. It "did reveal previously hidden objects and people, creating, by default as it were, a different sort of film altogether."[25] It not only turns up an image of Austerlitz's mother— "just as I imagined the singer Agáta from my faint memories and the few other clues to her appearance that I now have"—but also converts the lying propaganda film into a record of the truth about Theresienstadt.[26] The film's false cheer and productivity become funereal toil: "the men and women employed in the workshops now looked as if they were toiling in their sleep," and their bodies give way to "frayed outlines" suggestive of the kind of violence actually at work in the camp.[27] Damaged parts of the film are magnified and blot its central images; the musical soundtrack slows from a "merry polka" to a dirge; the words of the commentary become an unintelligible "menacing growl."[28] Somehow the film finally becomes a true memory of Theresienstadt. And this is how the skeptical mediation of the image functions in Sebald: it cannot be distinguished from memory

itself, for better or for worse, and it can achieve the kind of truth available to a post-traumatic historical moment.

Moreover, it results in the aesthetic mode Sebald himself practices: the slow-motion propaganda film is very much like Sebald's own fiction for its layered realities blended into a dissolving patchwork of scenes, its elusive descriptions that, in the most unlikely ways, do yield fictional truth.[29] Sebald is indeed an impressionist, and because his impressionism results from the trenchant post-traumatic skepticism characteristic of his vision, we can confirm that it is, after all, no pseudo-aesthetic. The apparent pseudo-impressionism of *Austerlitz*—which seems to be a throwback to what happens to Proust's Marcel as a result of stepping upon uneven paving stones—extends the Proustian impression to the most vital of contemporary projects. Sebald does not reject the Proustian impression in his suggestion that its form of memory can now give us only "terrible anxiety." Rather, he develops a new form of impressionist representation in which the most insubstantial, elusive, inadequate impression, rendered less significant than ever by historical violence, has real purchase, perhaps more than ever before, upon fictional belief. Austerlitz is no Marcel in his final achievement, but his imagery has strange conviction and surprising validity—appropriate to a moment in which any transcendence would carry impressions too far. And yet Sebald has not stunted the Proustian impression in order to stake out some more authentic middle ground. If anything, he has expanded its reach, making it include the mediations that must intervene between a lost experience and its aesthetic recovery. It is possible to argue, finally, that impressionism gains validity as it develops from the classic Proustian dynamic to the moment in which Sebald demands more from it: what is latent in Proust's implicit history becomes active in Sebald's need to trace the faulty abundance of perceptions lost to the mind, deferred to simulacra, and found again only in impressionistic contingency.

This contemporary impressionism participates in the reiterations we have seen elsewhere. It is no coincidence that Austerlitz's version of the Theresienstadt propaganda film resembles French impressionist cinema. In his effort to make the film's terrible mechanics yield sustaining truth, Austerlitz subjects it to the kind of transformations sought, with lesser but similar urgency, by filmmakers like Abel Gance, who hoped that the cinematic machine might be made to produce emotional magic after

all. Austerlitz has his own version of *photogénie*, which reflects the same sort of anxiety about the possibility of impressionist emergence amid the forces of modernity. There are affinities with Béla Kontuly here too, in the shared project of a modest postwar aesthetic, the reuse of diminished aesthetic material. And although Austerlitz is no James Frey, he does have his own version of the impressionistic effort at self-fashioning that makes *A Million Little Pieces* at once such a fraud and such a powerful enactment of will. In both cases, the subjective truth of the impression becomes a real truth the more it cycles through disgrace; for both Austerlitz and Frey's autobiographical protagonist, a valid self might be pieced together from the remnants left to a culture of inauthenticity. Similarly, a true image might emerge from the society of the spectacle, both for Austerlitz and for the impressionist advertisement, in which the problem of distraction becomes a broken form of attention not unlike that which keeps Austerlitz in search of answers. Both endeavors surprise us with the critical insight available to perceptions subsumed within conditions that would seem to disallow any insight at all, turning the problem of public deception against itself.

These similarities help confirm that Sebald has not regressed to a pseudo-Proustian impressionism but instead drawn Proust into an active, contemporary project. Even so, impressionism might undermine his contemporaneity: is he not a postmodern writer, rather than a modernist one? The ontological extent of his skepticism, the artifice of his style, his relationship to history: these are hallmarks of postmodern fiction, neglected perhaps by any association of Sebald's work with a Proustian project, even a revisionist one. And the problem is not simply a matter of literary-historical categorization, since Sebald's postmodernity might be essential to his theories of memory, history, and representation. What we have described as a neo-Proustian project might be just the kind of reaction against Proustian solace fundamental to the advent of postmodernism's anti-aesthetic.[30] And yet the aesthetic is just what Sebald preserves. He remains attached to the possibility that some heightened version of perceptual experience, transformed in the manner of Proustian impressions, has redemptive power, however weak it may now have become. What does this tell us about his postmodernism? And what do we learn about impressionism, if it seems to moderate a postmodern anti-aesthetic? These questions are important beyond their relevance to literary-historical categorization, because answers to them help say how impressionism

has driven fiction's contemporary development. An aesthetic preserved through the postmodern has become impressionism's claim to contemporaneity: this is what we will discover as we turn now to two other writers who explicitly associate postmodern fiction with the project of modernism. Colm Tóibín and Michael Cunningham may be modern or postmodern in their use for Henry James and Virginia Woolf, but their impressionism suggests a further alternative: impressionism's persistence in contemporary fiction signals renewed commitment to the rudimentary aesthetic of primary perception after what both modernism and postmodernism have made of it. To update a modernist like Proust, as Sebald has done, is to find room in his modernist impressions for a postmodern gap that becomes, in turn, something new—all the more in the work of writers who turn modernists into contemporaries after postmodernity.

———— ✺ ————

Was Henry James gay? No records prove that he had sex of any kind, but Sheldon Novick's recent biography claims that James did have some sort of sex with men—including no one less than Oliver Wendell Holmes. The claim makes an important difference. Unfortunately, the sexless Henry James can interest today's readers only so much. The sexual James would seem to speak to us more powerfully, especially if his art is only sex by other means, sublimated sexual tension. This recognition is central to Tóibín's novel. Inspired in part by Novick's biography, *The Master* imagines what happened when James and Holmes spent the night together and how James thought about sex in general, connecting the dots between his private homosexuality and his public literary persona. The result ought to have been transformative. Here, finally, would be a more human, more contemporary Henry James, and perhaps even a new gay hero.

But consider one representative scene. Early in the novel James visits the Wolseleys in Dublin Castle. Lady Wolseley knows that James likes men, so she assigns him a handsome manservant named Hammond. Late one evening, Hammond effectively offers James sex. But James opts for tea instead. Afterward, alone in his bed, James thinks about what he has missed. These thoughts are vague:

> He put his hands behind his head in the darkness of the bedroom, the firelight having fully dimmed. He was disturbed by the idea that he

longed, now more than ever before, in this strange house in the country, for someone to hold him, not speak or move even, but to embrace him, stay with him. He needed that now, and making himself say it brought the need closer, made it more urgent and more impossible.[31]

For an urgent need, this one is oddly distant. For a scene that might have dramatized the new sexual James, this one is oddly routine—just the old James after all. Tóibín might be right to think that James longed for nothing more than embrace, but surely other thoughts and feelings would have gone through his mind. The problem is less the longing, perhaps, than the language. Why suppose that James's sexual thoughts would have kept to the rhetoric of his own writing? Why must James "say it" for the need to become urgent? This vagueness is that of James's public language—less daring, even, than what he wrote in his letters to the young men he admired.[32] Why has Tóibín chosen the style of the "verbal hedges" James used for his public fictions rather than one that might better explore sexual feeling?[33] Why the all-too-familiar James after all?

Tóibín's version of James's mind is highly impressionistic—or rather, too much a matter of Jamesian impressions, those supersubtle, refined, arch suppositions, the kind of sophisticated intuition James writes, for example, when Isabel Archer senses her husband's adultery by "[gazing] at a remembered vision—that of her husband and Madame Merle unconsciously and familiarly associated."[34] This allusive, inchoate, indirect impression is perfect for Isabel's mind, her story, and her historical moment, but is it right for *The Master*? To do for James what James did for Isabel is to make a kind of category mistake. Tóibín presumes that James felt things privately and immediately in terms of his public, constructed impressionism—that he felt nothing really physical. The impressionism he chooses to inherit from James disallows frank sexuality, so that his effort at rehabilitation fails. Consider the contrast with Sebald's Proust: developing a contemporary version of the Proustian impression, Sebald also gives Proust broader relevance. Tóibín's James is Victorian, and his impressions, because they fail to match their occasion as they would in James, are hardly even that modern.

Cunningham's *The Hours* revisits the life and death of Virginia Woolf. Like Tóibín, Cunningham represents his impressionist impressionistically, and seems to trivialize the writer and her style. *The Hours* begins

with a suicidal Virginia Woolf walking toward the river where she will drown herself, noticing certain sensuous qualities of the scene around her—the colors of the sky and earth, textures of farmers' clothing, and the water, "yellow-brown, dappled stuff, solid-looking as a road."[35] Just before she goes under, she notes "a man fishing in a red jacket and a cloudy sky reflected on opaque water."[36] These are apt Woolfian descriptions, but strange for a woman on her way to her death. Cunningham suggests that "in spite of herself" (the phrase repeats), someone so perceptive as Woolf could not help but see vividly even to the last. She forever perceives the beauty of life itself, which, usually so sustaining, finally fails to keep her alive—hence the special tragedy of her last observations. And yet the impressionistics of these last observations are chilling, because they remain so superficially lush. Would a suicidal impressionist really dapple up her world as lightly as she might describe her fictional landscapes? Cunningham offers nothing of the deeper, wilder mental engagement we might expect from such a mind in crisis. The effect is actually grotesque—literally so in the very last description of Woolf's dead body underwater: "All this enters the bridge, resounds through its wood and stone, and enters Virginia's body. Her face, pressed sideways to the piling, absorbs it all: the truck and the soldiers, the mother and the child."[37] Woolf absorbs it all, utterly impressionable, but she makes nothing of it, not just because she is dead, but because Cunningham has chosen to make her impressions nothing more than superficial sensations. Her impressionism has been neutralized. In Woolf's own work, it rarely kept to the mere look or feel of things. But Cunningham's version of it is merely impressionistic, and the result verges perhaps on something unseemly and tasteless, an unethical aestheticization of human suffering. Like Tóibín, he has applied a form of pseudo-impressionism to a precursor from whom he might have taken something more authentic, and as a result, we might conclude, undermined impressionism's significance both to its historical moment and to ours.

James's impressions were never just dim guesses, vague presumptions, or detached imaginings. They had a vivid, visceral feel to them, in metaphorical language often strangely given to risky concretion, in the intensity with which, for all their sophistication, they might be registered. They only seem to keep to a range restricted by refinement and decorum; they actually fall into complex engagement with styles of thought and feeling

that guarantee them the sort of narrative drive that takes James's stories well beyond mannered restraint and well into the world of melodrama. Woolf's impressions rarely keep to the level of immediate apprehension or simply visual stimulation; rather, they partake of a phenomenological awareness in which immediate visual apprehension is at once the opportunity for and the product of essential recognition. There is in Woolf always that structure of *intentionality* whereby the mind that makes its world is undone by it, only to reformulate new impressions. This kind of changeable synthetic mode of perception was what James and Woolf brought to the scene of fictional consciousness. Very often it was even the subject of their fiction, in stories in which characters stand or fall according to the genius of their feelings, the depth of their glances, or the satisfaction they can take from what they see. But at the start of *The Master* and *The Hours*, impressionism seems to have lost this dramatic power. Tóibín's Jamesian impressionism is only vague and elusive—lacking the immediate intensity of James's incisive intuitions. Cunningham's Woolfian impressionism is only sensuously receptive—lacking the philosophical wonderment Woolf discovers in the appearance of things. Whereas we might hope to find in these contemporary novels an impressionism enriched by its opportunities, since James and Woolf, to apply to situations in which its changeable synthesis has responded to new cultural challenges, instead we have an impressionism that lacks even what James and Woolf gave it. It seems pseudo-impressionist both for its anachronism and for its insufficiency, which, together, bring us once again to the problem of impressionism at its worst.

After Woolf's suicide, *The Hours* shifts to the present moment, to depict a contemporary version of Clarissa Dalloway. This second section of the novel imitates the first part of *Mrs. Dalloway* (1925), following its new Clarissa around the streets of New York City, even repeating key phrases, memories, and encounters from its source text. But not the same impressions: whereas Woolf's Clarissa took her impressions hard, feeling all too keenly the existential implications of her London observations, this new Clarissa takes it all in stride. The difference makes a certain kind of sense historically. The flux of London impressions was new to Woolf's

Clarissa and her culture. By the time Cunningham's Clarissa walks the urban street, flux has become a familiar urban specialty, and someone like her can happily and safely enjoy it. And yet this safer enjoyment, written in the same register used for Woolf's truly perilous perceptions, is once again grotesque. It seems again that Woolf's impressionist style has been neutralized—made nothing more or less than an easy pleasure—with chilling results. *The Hours*, it seems, is at best what Seymour Chatman calls an "homage pastiche."[38]

But then Cunningham comes back to Woolf herself, and things change again. In the third section of *The Hours*, Cunningham tends more toward the uneven, uneasy style of thought and feeling we actually do find in *Mrs. Dalloway*. The superficial limits to the impressions of the novel's first two sections give way to a range in which perceptions encompass more elusive sensations and more supreme longings. Cunningham moves from a pseudo-Woolfian style to a genuine citation in passages like this one:

> She rises from her bed and goes into the bathroom. . . . In the bathroom, she washes her face. She does not look directly into the oval mirror that hangs above the basin. She is aware of her reflected movements in the glass but does not permit herself to look. The mirror is dangerous; it sometimes shows her the dark manifestation of air that matches her body, takes her form, but stands behind, watching her, with porcine eyes and wet, hushed breathing. She washes her face and does not look, certainly not this morning, not when the work is waiting for her and she is anxious to join it the way she might join a party that had already started downstairs, a party full of wit and beauty certainly but full, too, of something finer than wit or beauty; something mysterious and golden; a spark of profound celebration, of life itself, as silks rustle across polished floors and secrets are whispered under the music.[39]

Here Cunningham mimics the perceptual dynamic that gives Woolf's impressionism its critical power. No simple perception remains adequate to the representation of the moment; rather, apperception prompts more inchoate awareness. As Woolf suppresses what she will not see, reflecting upon its dangers, her anxiety charges imagination of what sums up her feeling about—her impression of—the work she wants to do. That feeling is not simply felt but made metaphorical; the impression is an

analogy, so that the evanescent image it generates is not a sensory one but instead a figural juncture of sensory phenomena (rustling, whispers) and things themselves. This aesthetic emotion is epiphanic. But it is not safely won—not the charmed aesthetic of pseudo-impressionism, but something as dangerous as the evil reflection it never really supplants. Woolf is still anxious, and her sense of "life itself" is precarious, still shadowed by the nothingness of dark manifestation. Her impressionist register only gains its keen sense of life itself at the risk of life's destruction. Perpetually primed to find analogical significance in rustles and whispers, to let sparks register profound celebration, Woolf's impressionism is in jeopardy of total losses: the comprehensive nature of these impressions can just as easily "match her body" with monstrous failure. Thus what seems to be a light and momentary intuition carries with it the full weight of existential justice, putting everything in the balance, not just in the moment of this Woolfian act of consciousness but across her fiction: the style of perception enacted here is also a principle of characterization and, in turn, a narrative dynamic, as the drama of consciousness becomes the focus for any further drama that occurs.

Cunningham gets it just right in this passage. But the kind of impressionism that obtains all across Woolf's fiction is not all-pervasive in *The Hours*. Cunningham's Woolf registers these precariously comprehensive impressions, but his novel does so only inconsistently—mainly when Woolf herself is thinking, when she is called upon to feature aesthetic interiority. Selective in his impressionism, Cunningham seems perhaps to use it only to perform a kind of costume-drama interiority, mimicking Woolf's actual impressionism only when he wishes to achieve historical accuracy. And the very fact that he is capable of writing truly Woolfian impressions suggests that his failure to do so more thoroughly is yet another symptom of pseudo-impressionism—a sign of a merely decorative commitment to a style delimited to the function of occasional grace note.

Read another way, however, this inconsistency has different implications. If Cunningham sometimes does write like Woolf but at other times reduces her impressions to something more gracious (by either truncating them to simple sensation or making them serve a nostalgic purpose), he takes up a kind of reflexive relationship to the possibilities at hand. That is, he has his choices, and he is aware that impressionism might have these different versions and uses. Juxtaposing Woolfian impressions with spe-

cious ones, dramatizing impressionist reverie while also, at other times, blocking its insights, Cunningham pieces together a kind of impressionist metafiction. Whereas *Mrs. Dalloway* is consistent in its version of consciousness, *The Hours* takes diverse approaches; whereas Woolf's novel makes perception a critical dynamic, Cunningham's version makes a further turn of the screw by subjecting Woolf's dynamic to further critique. The diversity of Cunningham's impressionisms might seem like inconsistency, but it generates a differential awareness very much in the spirit of impressionism itself. Through it, *The Hours* reflects upon the limitations of pseudo-impressionism, thereby warning against indulgence of only part of the impressionist process; it stresses the link between impressionist sensibilities and high-cultural distinction, also warning against exclusionary associations of wealth, commerce, and artfulness; it involves historical awareness of the ways different perceptual arrangements suit the minds of different historical moments. Cunningham knows that an impressionistic twenty-first-century New York must mean something entirely different from an impressionist 1920s London, and that the best way to register the difference, and therefore to get a critical purchase on the history of perception, is through juxtaposition—more specifically, juxtaposition of the impressionism London enabled and its relative pacification on the streets of contemporary New York. And juxtaposition also of romanticized impressions (those of Woolf's tragic suicide) and realistic ones (those she takes when Cunningham shifts to her everyday life). Cunningham seems to know even more than Woolf herself how impressions might vary.

Thematizing the impression at the level of conceptual form rather than plot or character alone, Cunningham makes that shift through which modernist epistemologies become the object of postmodern reflection. His novel is about the form of impressionist consciousness Woolf helped to innovate and through selective construction, *The Hours* extends Woolf's form of modernist uncertainty to textual deconstruction. Thus Cunningham makes the novel more fully an impressionist medium. He does so, however, in accord with Woolf herself, and his relation to postmodernity is continuous with her modernism. For Woolf herself worked toward it: *Mrs. Dalloway* was followed by novels ever more reflexively aware of the ways impressionist consciousness could become the pattern for textual deconstruction, as Woolf too became more interested in the diversity of possible impressionisms and how they could differentiate

textual practices within a given work. Cunningham continues that project, and if he makes it postmodern, he only elaborates a postmodernism readied in the self-divisions of Woolf's own impressions, which he has at once travestied and transformed.

Like Sebald's postmodern impressionism, Cunningham's is aesthetically constructive. In *The Hours*, it enables intersubjectivity—a consciousness shared among women across history and across cultures, as the dispossession of the impressionistic mind becomes its hope for solidarity.[40] Cunningham's women come together because of their differences. His Virginia Woolf thinks differently from his modern-day Clarissa Dalloway, and she, in turn, has a mind unlike that of Laura Brown. Their different historical moments and different relations to *Mrs. Dalloway* deconstruct impressions that might otherwise follow norms of emergence. But the parts of the novel hang together; Cunningham has differentiated them in order to find essential correspondences, and these suggest that his more radical impressionist dispersal has conferred a freedom to create new meaning for women's lives otherwise so vulnerable to nothingness. This new meaning is based in sexuality—the unifying force is the lesbianism inchoate for Woolf, impossible for Laura, and troubled for Clarissa—and Cunningham's new version of Woolf's impressionism seems to be at once its product and its redeemer. It is because Woolf's sexuality speaks across time to Laura and is realized in Clarissa that Cunningham can construct his new impressionist intersubjectivity. But it is because of this impressionism that he can define sexuality in terms of its emerging historical mentalities and write it back into a history of repression. Finally, it is this constructive purpose that makes impressionism contemporary in *The Hours*. It transforms consciousness, advancing its modernist multiplicity through postmodern mediation to a contemporary sense of what difference really means for the mind.

—⁂—

What Cunningham does for Woolf, Tóibín does for James. *The Master* is not a simple travesty of James's style. Even if passages seem to debase Jamesian impressionism, John Bayley is right to observe that "Tóibín does not make the mistake . . . of using a Jamesian style and manner of writing as if from the Master's mind as well as from his pen. . . . He takes James's

mind and life as a subject, but for a novel that is all his own."[41] Indeed, for the most part Tóibín strikes a balance between Jamesian echoes and new tones more suited to his contemporary subject. And at his best, Tóibín manages to transpose Jamesian impressionism into a new mode—one true to James's mode of sophisticated intuition, a contemporary version of the perceptual mediations special to the Jamesian impression. So, for example, Tóibín describes James half-awake, troubled by nightmares: "He touched the muscles on his neck which had become stiff; to his fingers they seemed unyielding and solid but not painful. As he moved his head, he could hear his muscles creaking. I am like an old door, he said to himself."[42] Here, at the outset, is impressionism's way of denying distinctions between truth and feeling, mind and muscle. Here too is the kind of metaphor—that of the "old door"—that profits from this denial. But precisely because Tóibín proves himself so capable of carrying forward the legacy of this impressionist style, it is disappointing when he does not do so, when sex makes him lapse into pseudo-impressionism, what one critic calls "shorter-winded approximations of Jamesian refinement."[43] For every keen impression, there is a false evasion, as when a young Henry James stands beneath the apartment window of his almost-lover Paul Joukowsky: "As night fell, he knew that he himself on the unlit street could not be seen, and he knew also that he could not move, either to return to his own quarters or—he held his breath at the thought—to attempt to gain access to Paul's rooms."[44] A thought that could hold a breath could surely be an impression; it could have been a powerful complex of mind and body, a transformative mental act. But Tóibín goes for something impressionistic instead—a pseudo-Jamesian approximation of refined thinking in which "gaining access" stands feebly for something the real James might well have imagined more erotically. Again, this evasiveness seems inconsistent with Tóibín's project of reclamation. Why bother to retell James's story as a homosexual one if his sexuality is re-closeted, impressionistically?

One answer to this question might note that Tóibín's pseudo-impressionism functions something like kitsch pictorialism: it tries for an authentic decorative effect while actually trivializing what could be its aesthetic engagement. And Tóibín might have an especially questionable motive for this familiar form of co-optation. In a sense, the prudishly self-evasive James authorizes Tóibín himself by making him the real Master.

However formidable James might have been, here he is an innocent, an apprentice only. Tóibín's modern-day sexual savvy out-masters James by making sex the better part of sophistication; a different sort of reclamation takes place, in which Tóibín becomes the necessary interpreter of an aesthetic that can be explained as a symptom of repression. In this case, pseudo-impressionism becomes a kind of power grab. To delimit James's passions to a degraded version of his own aesthetic style is to subordinate them to our sexual contemporaneity.[45]

But whereas the scenes with Hammond and Joukowsky find James thinking in terms of the subtlest possible impressions, another sexual moment—the scene in which James sleeps naked with Oliver Wendell Holmes—finds him thinking in a different style altogether. Here the subtler sort of impression mingles with intense physical feeling and also removed conceptual interpretation. The result is not much more gratifying to the voyeuristic reader—we won't ever get a really sexual James, it seems—but it does present James's fine mind violated by the kind of perceptual diversity that sexual passion might provoke:

> Every breath, every hint that Holmes might move, or even the idea that Holmes, too, was awake, burned in his mind. There was no possibility of sleeping. . . . Henry longed to know if Holmes were as conscious as he was of their bodies touching, or if he lay there casually, unaware of the mass of coiled heat which lay up against him. The following day they would move to other rooms, so it would not be like this again for them. It had not been planned, and Henry had put no thought into it until he had seen Holmes by the lamplight moving naked at the washstand. Even now, if there was a choice, if another bed became available, he would go there instantly, creep out of here through the darkness. Nonetheless, he felt his powerlessness as a kind of ease. He was content not to move or to speak, and he would feign sleep if he needed to do so. He knew that his remaining still and his silence left Holmes free, and he waited to see what Holmes would do, but Holmes did not move.[46]

Elsewhere, the thought of sex makes James hold his breath. Here, every breath burns in his mind. "Longing to know" reverses epistemological priorities. In other ways too, feeling takes precedence in such a way as to give immediacy to thought. The sight of Holmes's naked body is what

puts thought into James's head; his immobility is at once a matter of intense proprio-perception and forfeiture of the body. As desire undoes his power to separate feeling, wanting, knowing, and touching—indeed, as the circumstance of no other bed prevents the evasion he might otherwise pursue—James's heightened state of awareness does generate impressions. They are true to James himself, rather than short-winded refinements, and they help Tóibín's contemporary project by specifying the crux of repression and its effects. That is, evasive language here does not make intense longing vague, but moves about among perceptual registers in such a way as to reflect the problem of irresolution of another kind. James cannot act upon his desires, and Tóibín captures the sort of impressions that would at once cause and follow from that failure of will. Impressions without visceral incidence are perfect for a sexuality without opportunity: this equation justifies a representational mode that otherwise seems so nebulous. It enables Tóibín to develop a form of impressionism that is at once Jamesian and contemporary, because it has all the perceptual vitality of a Jamesian consciousness with all the critical awareness Tóibín seeks to construct around a sexuality seen from our perspective. If we need to know why James failed to become our sexual contemporary, his impressions have the answer: he could not yield to feelings for which there were no good words. In James's mind, as Tóibín imagines it, thought of sexuality is vague not simply because James is repressed, but because there is no sexuality without the language for it. That problem—at once so Jamesian and so contemporary—is what makes Tóibín's version of the Jamesian impression such a timely reinvention.

John Carlos Rowe has argued that James's impressionism is effectively a deconstructionist mode. James enacts what deconstructionists would later argue: that we are never really "present" to immediate experience, which always comes to us mediated and delayed by structures of language. Rowe describes Jamesian impressionism as "a schematizing of differences (sense and idea, body and mind, picture and sign, conscious and unconscious) in which language discovers its necessity as a system of defenses against a nature that otherwise refuses to 'present' itself."[47] Just as deconstructionist critics would critique "presence" and show language to be a questionable arranger of what we take to be immediate experience, James proves that we are always "re-marking" what our eyes seem to see. And Tóibín follows suit, further reminding us that even our primary sexual

feelings are mediated through stylized forms of mental action, defended against by language. As Daniel Hannah has noted, Tóibín's James occupies "a voyeuristic distance from his own homoerotic inclinations," and *The Master* "refigures James's uncertain sexual identity as a textual gap," in accordance with a poststructuralist version of impressionism.[48] Indeed, that refiguration is itself the story of *The Master,* in a sense, as the young, impressionable James capable of feeling his thoughts becomes a man more likely to put a verbal gap between them.

James's impressions of the body of Oliver Wendell Holmes come early in his life. The pseudo-impressions come later—once James has developed resistance to troubling perceptual forms and his own linguistic style of representation has more fully come to occupy his mind. This James thinks more evasively and more pseudo-impressionistically the older he gets and the more practiced he becomes in modes of reflective denial. It's a problem James himself knew well: many of his novels base their dramatic action upon the difference between impressionable youth and sophisticated age, often even making this difference a decisive ethical aporia. Suggesting that James matures away from a mode of impressionist immersion into this more detached style, Tóibín also suggests that impressionism ultimately cannot help but remove experience from the worlds it would fully register. Just as Cunningham and Sebald foreground the artificiality of the impressions that compose memory and found epiphany, and just as they develop elements of textual construction to match this reflexive sense of the way impressionism works, Tóibín augments an elusive Jamesian style in order to make a new theme of the linguistic impression. And he does so because it is useful to our contemporary sense of the meaning of sexuality. Although Tóibín may seem to lord it over a James who could not share or even conceive of his sexual freedom, Tóibín actually pursues a vital corrective to a problem in the way we imagine sexuality today. James's closeted impressions, so heavily mediated by the way he uses words, give the lie to our contemporary fantasy of the primacy of sexuality—queer sexuality especially, which, in Tóibín's view, could use a more Jamesian consciousness.

What if James had emerged from *The Master* a new queer hero? What if Tóibín did discover in him, and implicit in his writing, powerful sexual desires like our own? What if there had been consummations, rendered with intense perception of their pleasures and consequences? A queered

James could have made up for decades of cultural denial—the elisions that, as Michael Anesko has shown, kept James's sexuality out of the public record. Anesko has documented all the ways James's family, executors, and critics conspired to strike from the record James's expressions of desire for men; Tóibín fills in the gaps they created, and he might have done so in such a way as to undo the historical damage. A James distanced from us by false measures would have become a sexual presence. In turn, that presence could have helped queer people to "feel historical," to use a current phrase for the crucial form of public affect from which they have been excluded.[49] But Tóibín has taken measures to block that feeling. He has chosen to leave the gaps open, not to deny people the comforts of historical feeling but to preserve the historical truth of the only James we can ever really know. It would be a lie, Tóibín suggests, to rediscover the lost James with all his sexuality intact. What made it unavailable was also something essential to it—not just the chicanery of executors, but the lack of presence James himself felt. There never was a true sexuality to reclaim. Nor is there now one simply to feel: this is the striking contemporary implication of Tóibín's James, made through reference to an impressionist consciousness as critically incisive now as it was for James himself. Impressions for James were shifting perceptions whose presences turned out to be what the mind would make of them. Constructions of verbal sophistication, they are sexually disappointing—and apparently lacking in impressionist immediacy—only until we recognize their queerer uses. Jamesian impressions yet have a power to show us how immediacy is made. And that makes him a real queer hero, insofar as it transforms him from a representative type to a proper theorist of representation, a queer theorist whose impressionism is not a matter of sexual feelings we might share but a way to face the truth about them.

This James is like what Cunningham makes of Woolf and what Sebald makes of Proust. In all these cases, what seems to be a false or belated impressionism is its extension into postmodernity and beyond. Pseudo-impressionism may seem to make trivialized precursors the basis for merely nostalgic, noncontemporary writing—a kitsch literary aesthetic. But it actually rediscovers these precursors and makes them part of a project at once authentic to them and important to us. Although a postmodern impressionism might seem to entail a break with its modernist past, it is continuous with it, applying what Proust, Woolf, and James

knew about perceptual experience to the new demands of postmodernity. In doing so, however, this new version of impressionism represents a new development in literary history. It reasserts a modernist aesthetic: despite the new stress upon the mediatory nature of any perceptual act, the failure of presence, the pastiche of what was once more powerfully fragmentary, aesthetic experience makes a kind of comeback. The continuity through which the impression allows for greater postmodern skepticism also maintains a commitment to what is achieved by the impression's fraught form of perceptual emergence. Even if that emergence deconstructs—not beginning in primary experience; not surviving the course of history—it remains valid in Sebald, Cunningham, and Tóibín, for whom some aesthetic dynamic is still, or is yet again, basis for insight. Sebald's Austerlitz may suffer only terrible anxiety, but he finds something sustaining in the paltry images that have survived the traumatic past. Not only do they yield meaningful memory, they are themselves objects of satisfaction, visually compelling even when they testify to something terrible. Likewise for us, Sebald's graphic mode (his image-texts, his way of building discourse around visual imagery) has pleasures beyond those of skepticism. It has real beauty, basing its critical vision in sensory validity. Cunningham subjects sensory validity to multiple variations, showing it to be arbitrarily constructed, but it therefore only becomes a better basis for sensibility. Tóibín may heighten James's sense that impressions come to us only after language, but they come through nevertheless. His impressions are still rudimentary feelings—still very much felt—even if verbalized, since, for Tóibín as for James, language has a life of its own. This is no reaction against modernist aesthetics, but a furtherance of the modernist sense that what undermines representation enhances its critical value. In this continuity, impressionism is decisive, for it sets up the aesthetic structure by which presence fails without losing its purpose: the modernist impression that always had its dual nature can suit contemporary purposes too, and that lasting problem is what these novels by Sebald, Cunningham, and Tóibín embody. But their explicit reference to it also indicates something more. Explicitly focused upon the contemporary relevance of Proust, Woolf, and James, these writers endorse a return to the aesthetic.

This new development is something we have seen before, in the post-conceptual aesthetic at work in Peter Doig and Thomas Kinkade. In their

work, pseudo-impressionist kitsch turns out to be a sign of a recon-structed sense of what aesthetic experience means for the category of art today. Whereas conceptual art had departed from the aesthetic object and any experience it might render autonomous, postconceptual art discovers a new minimal need for it. Now, aesthetic material is a minimal but essen-tial aspect of the conceptual project, an *aesthesis* important precisely for its role as a provisional ground for art's departures. This new role is a kind of concession to what the postmodern arts had denied; it reflects recogni-tion that the modernist aesthetic has not lost its validity, despite its ideo-logical problems and historical waning. Something like this recognition is behind the return to Proust, Woolf, and James in contemporary fiction, which partakes of a larger revival of the modernist aesthetic at work in texts that do not engage in such devoted homage. In the work of Ian Mc-Ewan, for example, David James sees a "reluctant" impressionism, one no longer convinced that "sensory perceptions construct our experience of the world" but still dedicated to "the novel's affecting capacity to simulate perception while probing the ethical ramifications of how characters act toward the social realms they perceive"—in other words, to the way im-pressionist fiction specifies grounds for what become larger ventures into realms well beyond inner life.[50] Here too is a revival of *aesthesis* with new interest in what it might yield of contemporary possibility, and we see it in many writers whose impressionism has new ramifications. Such a revival justifies the persistence of impressionism. Literary fiction that persists in rendering impressions now does so with the backing of a renewed sense of the value of that endeavor—more specifically, the reconstructed com-mitment to a minimal aesthetic that has made modernism contemporary again.

8

THINKING MEDIUM

The Rhetoric of Popular Cognition

Daniel Kahneman's *Thinking, Fast and Slow* (2011) is not a work of fiction, but it does have a hero. Kahneman won the Nobel Prize in Economics in 2002 for helping to prove that human beings are not rational agents. We misunderstand our own interests, Kahneman has shown, by failing at statistical reasoning. Thinking intuitively, we misjudge and miscalibrate true outcomes, for there is a bad difference between "expected utility" (which should guide us) and the "prospects" that skew our actual beliefs and choices.[1] Kahneman's more recent, popular version of his research asserts that this duality also determines fundamental styles of thinking more generally: fast thinking, automatic, intuitive, immediate mental process; and slow thinking, which rationally develops thorough understanding based on hard evidence and careful speculation. Fast thinking, or "System 1," "provides the impressions that often turn into your beliefs, and is the source of the impulses that often become your choices and your actions."[2] Slow thinking, or "System 2," makes decisions on choices on the basis of what System 1 provides, subjecting impressions to fuller thought and to the cognitive corrections often necessary to valid reasoning. But despite the greater rationality of System 2, Kahneman prefers System 1: "Although System 2 believes itself to be where the action is, the automatic System 1 is the hero of the book."[3] Kahneman is an impressionist, despite his better judgment, and his book contributes to a genre that has recently made the problem of the impression a popular triumph.

We might call that genre "popular cognition." Its progenitor is Oliver Sacks, who invented this "romantic science" that, at the intersection of "fact and fable," popularizes medical research.[4] Distinct from that research, popular cognition dramatizes the wonders of cognitive psychology—and puts it to practical use. Popular cognition has an impressionist outlook when the mind's mysteries are a matter of impressionistic intuition— when it focuses, like *Thinking, Fast and Slow*, on the impressions that become our beliefs, thoughts, and decisions. But it becomes more fully an impressionist genre when it makes a "hero" of the impression, building complex fictions around it, developing a dynamic rhetoric around this kind of personification. Ironically, that is largely what accounts for its success as a contribution to another genre: the "business book." Malcolm Gladwell has been the most successful writer to link the romantic science of human creativity to the business of corporate innovation. Mihaly Csikszentmihalyi's *Flow: The Psychology of Optimal Experience* (1990) likewise theorizes creativity as an intersection between an impressionistic state and a proven competitive advantage. Nassim Taleb's *Black Swan* (2007) takes a maverick approach to this linkage, daring corporate innovators to develop better skills of prediction through recognition of the primacy of randomness. Daniel J. Levitin explains how the "organized mind" protects its "rapid perceptual categorization system" and succeeds through "chunking."[5] And Jonah Lehrer has made the most explicit connections between the business of creative cognition and the legacy of impressionism. His *Proust Was a Neuroscientist* (2007) indicates in its title the larger framework that is the subject of this chapter: the history of unlikely association between the destabilizing creativity of the impressionist imagination and the corporatized mind—between impressionism and big business. It is a relationship perhaps most aptly epitomized in a title that hardly has time for words: Bill Gates's *Business @ the Speed of Thought: Succeeding in the Digital Economy* (1999).

Kahneman's contribution compels us to take seriously the idiosyncrasies of actual human economic perception—the impressionism of behavioral economics. By making a hero of the fast thinking of System 1, he gives the impression new credibility as a form of thought. Kahneman argues that our two systems of thinking usually work very well together. Typically, System 1 makes accurate snap judgments, and System 2 can simply elaborate upon them. System 1 "effortlessly [originates] impressions and

feelings that are the main sources of the explicit beliefs and deliberate choices of System 2," and when "all goes smoothly, which is most of the time," System 2 simply proceeds on that basis. But System 1 is bad with numbers; it is susceptible to priming and improbable projections, and it is vulnerable to inaccurate memories, falsely causal explanations, and specious proportional guesswork. Our impressions can mislead us, and then System 2 must "[overrule] the freewheeling impulses and associations of System 1."[6] This dynamic is Kahneman's central concern. *Thinking, Fast and Slow* mainly discusses those instances in which slow thinking must correct our impressions. But "if System 1 is indeed the origin of much of what we do wrong," it is also the origin of "what we do right—most of what we do."[7] Kahneman marvels at the "rich and detailed model of our world" it maintains. This ambivalence has a decisive effect upon his rhetoric and his project: it produces a new kind of person for our economy to cultivate.[8]

"Fast and slow" is explicitly a fiction. If, as Kahneman argues, "you generally believe your impressions and act on your desires, and that is fine—usually," then the real norm of thinking does not admit of any duality.[9] Usually it is a single process, and only breaks apart under the strange circumstances created by an economy in which large numbers, deceptive priming, and far-future projection make arbitrary demands. In other words, impressions as such are a product of an economic system that isolates them; without it, they would simply be thinking itself. Kahneman does not say so, but his epistemological norm is really something more like "thinking medium," and impressions ought to be its mediating force. But impressions lose their mediating status when they are polarized into fastness. And that happens not so much because the polarity is a normal condition of thought, not even because economic contexts create it, but for rhetorical convenience. In a remarkable passage, Kahneman explains why he has chosen to personify his systems despite the fact that they do not actually have this dualistic personal reality:

The psychology of causality was the basis of my decision to describe psychological processes by metaphors of agency, with little concern for consistency. I sometimes refer to System 1 as an agent with certain traits and preferences, and sometimes as an associative machine that represents reality by a complex pattern of links. The system and the machine

are fictions; my reason for using them is that they fit the way we think about causes. . . . I assume that you (like me) find it easier to think about the mind if we describe what happens in terms of traits and intentions (the two systems) and sometimes in terms of mechanical regularities (the associative machine). I do not intend to convince you that the systems are real.[10]

Kahneman isolates System 1 as an agent with traits and preferences—a hero, and, at other times, a villainously lazy, sloppy, or tricky sort of character—because we naturally find it easier to think in terms of human agency. He distinguishes these personal types because characterization makes them easier to understand. But the fiction creates a fascinating circularity. System 1 becomes a recursive construction as it is made amenable to our System 1 habit of thinking fast; it is because we have a penchant for specious causal thinking (a crucial aspect of fastness) that System 1 is a useful contrivance. To what extent is System 1 a product of itself? Toward the end of his book, Kahneman reiterates his choice to "[describe] the workings of the mind as an uneasy interaction between two fictitious characters."[11] He reminds us that "the two systems do not really exist in the brain or anywhere else," and hopes we "have acquired an intuitive sense of how they work without getting confused by the question of whether or not they exist."[12] But this *mise-en-abyme* offers up an impressionistic account of the impression—a System 1 version of these systems, invented despite the systems' unreality.

If Kahneman's goal is to make us aware of the ways our impressions fail us—that we need to abandon them in order to succeed at accurate prediction and good decision making—it might seem that he has done something tricky in structuring his argument according to an impressionist rhetoric. As this rhetoric takes over, it contributes greater intuitive intensity to Kahneman's categories, making the heroic System 1 seem more romantically tragic and System 2 seem more classical in its blank efficiency. Ironically, impressions come to seem more simply impressionistic than Kahneman's argument should allow; strangely, mere impressions are the by-product of his effort to argue that human thinking is normally intuitive. In other words, to argue that our impressions normally include proper judgment but only fail when statistics enter into it, Kahneman has made an impressionist distinction between two systems of thinking; once

distinguished from proper judgment, impressions devolve into the merely automatic, low-level version of themselves, to become part of a new story by which they emerge into rigorous thinking only when knowing about the difference between "fast" and "slow" enables us to take charge of their relationship. A new form of "thinking medium" emerges, one that mediates the two systems after all, and makes the power to do so a function of special acumen.

Kahneman purports to help us all know when to trust our impressions and when to subject them to further thought, but his book may have a more narrow audience: those who stand to gain from the ordinary person's failure to think slow. The more Kahneman personifies System 1, the more it comes to characterize a kind of person susceptible to impressionistic error. To know how to remedy those errors—how to think medium—is also to know how to exploit them, and how to maximize the profit to be made off people who fail to know their own true interests. Were these two systems unpersonified, indistinguishable functions of human thinking, they would simply be a continuum upon which we all operate; as reified types, they lend themselves to identification, encouraging us to embody either creative intuition or the canny control of its naïveté. *Thinking, Fast and Slow* makes the transition from popular psychology to business book on the basis of this identification. Distinguishing a naïvely intuitive general public from a specialized class of experts, it indicates how the latter might imagine their expertise as an ideal partnership between impressionist intuition and rational judgment. Although normal cognition ought to mediate the two—although the impression itself is typically all we need of either—Kahneman's account polarizes them in such a way as to enable the emergence of a new mediator: the economic expert, who masters the duality the impression itself would resolve.

This transition from popular psychology to business book is what defines popular cognition. Implicitly or explicitly, the genre tends in this direction, and no more so than in the work of its most successful practitioner: Malcolm Gladwell. Gladwell's *Blink: The Power of Thinking Without Thinking* (2005) is, like Kahneman's book, a celebration of the power of automatic, immediate, unconscious mental process—"the power of the glance."[13] And Gladwell too is concerned with "those moments when our instincts betray us" and our quick judgments turn out to be wrong.[14] His heroes are those great athletes, seasoned gamblers, and emergency-room

doctors with expert intuition. Aware, however, that even their intuitions can be very wrong, Gladwell searches for ways to "control rapid cognition," to have its benefits without its failures.[15] Ultimately he theorizes a form of judgment that moderates intuition with wisdom. It is something he practices as well, as his own rhetorical strategies simulate the "power of the glance." But even more than Kahneman, he finally makes this rhetoric tell a different story about the power to be had over thinking without thinking—the power of business expertise.

Gladwell's examples begin with stories. The first is about an error at the Getty Museum: the mistaken purchase of a counterfeit statue (a *kouros*) without confirmation by true experts. The people at the Getty thought they saw an authentic artifact; later, experts knew instantly—at a glance—that it was a fake. They could not say how they knew, and any further thinking might have clouded their judgment; they just knew, and they were right. These experts demonstrate the benefits of "fast and frugal thinking" and the special genius of the "adaptive unconscious."[16] Their insight demonstrates that "decisions made very quickly can be every bit as good as decisions made cautiously and deliberately"[17]—indeed, better, since cautious and deliberate decision making had led to the mistaken purchase. But this anecdote also works in another way: it enacts this style of thinking. Gladwell concludes this opening example by noting that "the first few sentences about the *kouros* all generated an impression—a flurry of thoughts and images and preconceptions—that has fundamentally shaped the way you have read this introduction so far."[18] Not only have these sentences explained impression-based judgment, they have provoked it. With what effect depends upon what follows.

At first Gladwell seems to be a populist popularizer. "The power of knowing, in that first two seconds," he writes, "is not a gift given magically to a fortunate few. It is an ability that we can all cultivate for ourselves."[19] We all possess an adaptive unconscious, where we make judgments automatically; we all have a tendency toward "thin-slicing," by which we generalize on the basis of narrow portions of experience.[20] The difference between those whose snap judgments fail them and those who get things right is education. There is "as much value in the blink of an eye as in months of rational analysis," as long as our "first impressions" are practiced ones; often we must improve upon them by "changing the experiences that comprise those impressions."[21] Gladwell's real discovery is

that instinct must be cultivated—not only that "truly effective decision-making relies on a balance between deliberate and instinctive thinking" but also that this balance is achieved only insofar as instinctive thinking becomes an abbreviated form of trained judgment.[22] We make a start by reading Gladwell's book. Then, however, the experts take over. When, for example, a doctor responds to what might be a heart attack, his or her intuitive judgment now depends upon a highly cultivated supplement. Gladwell tells the story of a historic change at Cook County Hospital, which was underfunded and overtaxed, not affording the time necessary for lengthy diagnosis or doctors capable of making quick judgments with any accuracy or reliability. Enter Lee Goldman, a cardiologist who developed an algorithm with which doctors could quickly assess risk factors and develop diagnoses far more accurately than by instinctive observation alone. The algorithm transfers experiential wisdom to quick thinking, giving impressions the benefit of fuller evaluation, condensing full judgment into a more impressionistic form.[23] It cultivates a better impressionism. But is this really the kind of thing "we can all cultivate for ourselves"? Does it not require forms of expertise that contradict what "blink" implies? Ideally impressions allow for just this kind of conjunction of intuitive immediacy and good judgment. In Gladwell's account, however, they devolve into first impressions and learned wisdom, only to be patched back together, rhetorically at first, and then by the special power of a fortunate few.

"It's the kind of wisdom that someone acquires after a life-time of learning and watching and doing"; "being able to act intelligently and instinctively in the moment is possible only after a long and rigorous course of education and experience": no longer a matter of blink-style insouciance, "thinking without thinking" has become a hard achievement.[24] Worse, it cannot be trusted even then, for there is no way to know when our impressions have the benefit of long and rigorous wisdom, and "the best we can do . . . is puzzle out the right mix of conscious and unconscious analysis on a case-by-case basis."[25] Or trust the experts. For Gladwell, certain people have a proven record of acting intelligently and instinctively in the moment, and they are the ones we should trust to make the snap judgments that govern our most important choices. If *Blink* has any overarching epistemological agenda, it is not so much to convince us that our snap judgments can be educated and controlled, but to accustom us im-

mediately to trust those whose snap judgments have been educated and controlled. His portrait of a class of experts—so potentially appealing to the narrower business-book readership—is actually a product of his theory of the adaptive unconscious, much the way Kahneman's two systems are a product of his theory about our tendency toward fast thinking. "The first impressions of experts are *different*," and Gladwell himself enacts the difference by presenting anecdotally his own expert first impressions of the experts he celebrates.[26] The stories he tells about his examples may seem to be the routine approach of this sort of journalistic enterprise; to popularize cognitive psychology, it would seem, it is necessary to pursue a kind of narratorial domestication of it. But Gladwell's anecdotes are impressionistic in a more important way. They fashion his own voice into the necessary mode of snap wisdom, insofar as they demonstrate how to perceive what's essential with immediate insight. To recognize this circularity is to discover the secondary story told by Gladwell's book: how popular cognition has shaped itself into a dominant cultural mode of information, transferring its theory of elusive human creativity to a practice of storytelling. To call this storytelling "impressionistic," however, would be to misidentify its relationship to the impression. Gladwell's anecdotes are not just quick sketches meant to lend experiential vivacity to the information he reports. They cycle his theory of experiential vivacity back into the form of a book that claims authority by enacting the juncture of instinct and wisdom it advocates.

Gladwell's reviewers have been quick to question his motives. They often take the most skeptical view of the way his version of popular cognition links the mysteries of the mind to corporate interests. Rachel Donadio, writing in the *New York Times*, observes that *Blink* is a step on the ladder by which "Gladwell has risen to the top of the A-list in the vast subculture of gurus brought in to penetrate the isolation chamber of the boardroom."[27] Noting that Gladwell has coined terms that have become "a working vocabulary for marketers desperate to reach consumers" and that "Gladwell has had the most pronounced impact in corporate culture," Donadio says it is "small wonder" that he has "spoken at Google, Microsoft and Hewlett-Packard, among many other companies," and that he was one of a handful of people invited to address the World Business Forum the year *Blink* was published. She suggests that he is "a contemporary incarnation of a recurring figure in the American experience,"[28]

represented by the likes of Dale Carnegie and Norman Vincent Peale—trickster figures whose inspirational advice on how to game human behavior has bridged popular psychology and big business. Donadio represents a resistance that seems to motivate much of the negative press on Gladwell's work, provoked by his impressionistic way with the research he popularizes but really galvanized by a sense that his impressionistic mode panders to an audience for whom something like "thin-slicing" is an opportunity to take advantage of the public mind. David Brooks's admission that "that thick-slicing part of my brain wasn't as happy with 'Blink'" reflects a sense that Gladwell has actually diminished mental life.[29] But this diminishment is but part of an enterprise that diminishes our impressions precisely in order to subject them to the boardroom and its culture of expertise.

Gladwell's theory of expertise also threatens to contradict his theory of thinking without thinking. Much the way Kahneman's two systems polarize impressions into a state of insufficiency, the "long and rigorous course of education and experience" necessary to enable us to register accurate impressions might actually make us insensitive to them. The educated, experienced mind might be too sophisticated to be impressionable. This problem is not original to Gladwell, of course; the impressionists had always worried over the innocence and sensitivity necessary to an art that might be spoiled as much as enhanced by knowledge.[30] In Gladwell's case, however, a commitment to expertise requires much compensatory work—in his rhetoric, which attempts to enact an impressionistic education for the impression, and in his allowance for exceptions. One such allowance is particularly telling. Explaining why our snap judgments are sometimes wrong, Gladwell offers the example of racial profiling—perhaps the worst way impressions are misleading. But police who attribute unlawful motives to people based on race suffer from what Gladwell calls "momentary autism."[31] A problem that afflicts us all, momentary autism is a temporary loss of the power to infer the content of other minds, and it serves as a limit case for *Blink*. It is also tellingly opposite to expertise: a failure at immediate perception due to excessive commitment to inadequate wisdom already known. *Blink* is based around the fantasy of the expert as ideal impressionist, but it is haunted by the nightmare of the mind-blind autist, who has neither wisdom nor impressionability.

Ambivalent about the idealized impression—blink-style fast think-ing—Gladwell stabilizes its relationship to judgment in rhetorical strate-gies that yield both the business book and the autist, the virtues of eco-nomic expertise and the problem of unwise obliviousness. For another form of popular cognition, however, the autist plays a very different role, in a story with very different cultural uses. Whereas Gladwell's autist is a failed expert, the autist has become a new paradigm for impressionist cre-ativity in new approaches to understanding and documenting the lives of autistic people. Here too impressions are idealized, but ambivalence about them drives a very different rhetoric of cognitive achievement.

For many years the popular theory of autism was what Gladwell invokes. People with autism were locked in their own minds and unable to under-stand the minds of others. Symptoms of this mind-blind autism were all a matter of nonimpressionability: flat affect, repetitive body movements, and excessive logicality were viewed as functions of the self-enclosure of autistic solipsism. People with autism could be hyperintelligent or men-tally retarded, but they were seen to share in common a failure to receive external stimuli, a blindness to other minds and to perceptual experience as such. More recently, a different diagnosis has transformed this charac-terization. Now it is hypersensitivity that produces the autist's classic non-communicative detachment. All too sensitive to overtures from others and from the perceptual world, the autistic mind is overwhelmed, and that is why it seems to retreat from engagement—engaging in repetitive movements, for example, in an effort to gain time for response or to miti-gate the intensity of the perceptual exchange.[32] Stella Waterhouse's *Positive Approach to Autism* (2001) and Karen Zelan's *Between Their World and Ours: Breakthroughs with Autistic Children* (2003) suggest that the "social withdrawal of autists" is not a function of mind-blindness but rather a "hypersensitivity to human and other stimuli" that "invites them to with-draw and pressures them to ignore the mind's social workings."[33] Donna Williams argues that "autism is an extreme example of a mechanism that acts to protect sanity" when the sensitive mind is unable to integrate sen-sory input.[34] This disability, however, can also be an advantage. This re-visionist account has helped to inspire an alternative understanding of human creativity, and, more generally, new progress in the recognition of neurodiversity.[35]

It is not that people with autism fail to receive stimuli to which they are insensitive. Rather, autism involves a different form of sensory coherence, local rather than central. Local coherence, which involves a focus upon parts rather than wholes, may be a disadvantage (since it is what makes sensory input overwhelming), but it has important advantages of its own. Coherence theory as developed by Uta Frith (in her 1989 *Autism: Explaining the Enigma*) and explained further by Francesca Happé and others distinguishes "the tendency to draw together diverse information to construct higher-level meaning in context" from the autistic tendency to engage in "relatively piecemeal processing."[36] Piecemeal processing may be highly vulnerable to error and breakdown, especially as a function of autistic hypersensitivity, but it can also aid in special perceptivity. Oliver Sacks notes that a tendency to compose the world entirely of specifics yields a "multiverse" of "innumerable, exact, and passionately intense particulars."[37] As Bruce Mills argues in his work on "Autism and the Imagination," the autist's invulnerability to the organic, whole designs comprehensible according to shared public expectations clears the way for "the discrete shape, the distinct color, and the individual pattern."[38] Local coherence produces "an imaginative faculty defined by close attention to mechanical or physical patterns not psychological or social rules, by private not public symbol structure, and by an internal integrity or unity evolving in part from idiosyncratic sensory preferences."[39] It mounts a challenge to conventional aesthetics, producing "striking artistic works" and enabling what Mark Osteen and others call "autistry."[40] Different from the kind of savant-genius conventionally associated with autism, this local coherence artistry partakes of a new way of thinking about autism. It has inspired a new version of popular cognition in which the genre's rhetoric supports empowering forms of autistic personhood.

The rhetoric of autistry began to emerge in the work of Oliver Sacks, whose pioneering essay on "The Autist Artist" and profiles of Temple Grandin and other autistic people in *An Anthropologist on Mars* (1995) helped make the shift from mind-blindness to local coherence. Sacks's main example in "The Autist Artist," José, is a man incapable of hearing or speaking but very much capable of exquisitely detailed, imaginatively inventive drawings of natural objects. "I think José, an autist, a simpleton too, has such a gift for the concrete, for *form*, that he is, in his way, a naturalist and natural artist"; being a simpleton might clarify aesthetic

forms.[41] Of course, Sacks maintains a negative view of this gift, as he does in his profile of the artist Stephen Wiltshire. He greatly admires Wiltshire but then also notes that he is less an artist than a "perceptual missile," a "sort of transmitter" of the bits of information that "rush past."[42] Rather than generating true imaginative unities, Wiltshire only filters unassimilated fragments, because he lives amid an array of "innumerable, unconnected though intensely vivid particulars," experiencing the world only as a Proustian "collection of moments."[43] He may never be capable of "creativity," defined here as "the power to originate, to break away from the existing ways of looking at things, to move freely in the realm of the imagination, to create and recreate worlds fully in one's mind—while supervising all this with a critical inner eye."[44] Even if "the catching of this-ness, perceptual genius, is no small gift,"[45] Stephen Wiltshire's autism does not amount to what art requires. The need for supervision is decisive, and Sacks's work persists in the kind of dualistic rhetoric that structures popular cognition for Gladwell and Kahneman.

Popular cognition makes a departure toward something else in the pursuit of neurodiversity. Dualistic rhetoric gives way to something more plural. Whereas this rhetoric has a tendency to translate ambivalence about impressions into oppositional characterizations, allegories of expertise, and a difference between perception and "supervision," the pursuit of neurodiversity has a different rhetorical structure. It develops accounts that are also ambivalent about what it means to be impressionable, but subjects this ambivalence to the rhetoric of the *memoir*—the autism memoir, in which popular cognition takes a different relationship to the typical self.

Neurodiversity names the view of atypical neurological development that respects its normal human difference. It dispenses with distinctions between disability and viability in favor of a distinction between what is merely neurotypical and alternative conditions of the mind. As part of a neurodiverse world, autism not only loses much of its stigmatized pathology but also becomes a valuable means to understand mental diversity itself: much the way local coherence allows for departures from centralized norms, autism is a kind of form for diversity—most obviously in the way its associated conditions array themselves along a spectrum, but also in the questions it raises about the psychological rhetorics that help determine what is typical and what is not. One leading advocate for

the neurodiversity of autism is Ralph James Savarese, who has written a groundbreaking memoir on the subject: *Reasonable People: A Memoir of Autism & Adoption* (2007). Savarese's memoir balances an advocate's empathy with reports from the field, developing a dynamic account of how two forms of information have advanced his insight into autism. That balance is, to some degree, what makes the book a work of popular cognition, but it fits the genre because of the way it engages with the problem of how to tell the human story of perception. Discovering both psychological and physical bases for his son's condition, Savarese comes to realize the necessity of multiple and dynamic responses to it. Consequently, he both regrets the difficulties of autism and appreciates the resourceful complexity of its mechanisms for coping and advancement. In general his goals are to stress the "radically polygenic character of life itself" and to recognize a "dynamic and human" interior to people too often thought to be blank and static.[46] In his account of his own son's development, Savarese delights in the appreciation made possible by this recognition of neurodiversity, as he moves from unsparing horror at DJ's occasional violence to admiration of the strengths that make him "abnormally *gifted*" as well.[47] DJ's gifts include a form of autistry: his poetry, through which he takes part in the more general tendency of many autists to express themselves in compellingly metaphoric or metonymic language. Savarese implies that the autist's perceptual availability results in a circumvention of the conventional symbolic capacity and an "analogical capacity" that better links language to perceptual truth.[48] But Savarese also recognizes that if "DJ was a poet 60–70% of the time," he really "needed to be a poet no more than, say, 10–20% of the time."[49] Not only is it impractical to indulge this form of autistry, but also there is a danger in what he calls "the romance of pure perception"—the view that people with autism might have a privileged capacity for the genre of perception linked to special powers of creativity, empathy, and authenticity.[50]

Savarese is also compelled by science to wish for something less poetic; while theorizing his son's "analogical capacity," he is led by personal experience to question its practicality. In this complex interchange, Savarese discovers the diverse implications of impressionability, and his ambivalence remains plural. He indulges neither romance nor realism: the rhetorical form of his book maintains a dialectical relationship between them. This is often the rhetorical dynamic set up by the problem

of impressionability in the autism memoir. It differs from that set up by Gladwell and Kahneman, for whom this kind of ambivalence ironically goes from realism to romance—from hard science to fictionality and, in turn, to business-book co-optation. Neurodiversity resists that kind of co-optation in the autism memoir. Indeed, that resistance may be its essential project.

Temple Grandin's *Thinking in Pictures and Other Reports from My Life with Autism* (1995) is half dedicated to the story of her life—her early childhood diagnosis; moments of hope and discouragement in her personal, intellectual, and professional development; and celebration of her successful struggle to become a leading figure in the fields of animal science and animal rights. But the book is also half dedicated to a scientific treatment of autism, its variants, its drawbacks and advantages, and the forms of education and therapy helpful to those who have it. To the degree that the two halves fit, Grandin makes a major contribution to popular cognition, but the book's status as a model of the genre is also enabled by the same rhetorical strategy and structure important to the genre's other major texts: for Grandin, autism is a matter of an analogous unity of seeing and thinking, of primary and ultimate judgment. Her unity of autobiographical and scientific modes in *Thinking in Pictures* matches the object of her inquiry with her approach to it. And if in Grandin's case this unity also provokes a reaction that, in turn, defers "thinking in pictures" to expertise defined in terms of economic specialization, the consequent expert is Grandin herself.

The first pages of *Thinking in Pictures* assert the relationship, often important to popular cognition, between primary perception and business advantage: "I think in pictures. . . . Language-based thinkers often find this phenomenon difficult to understand, but in my job as an equipment designer for the livestock industry, visual thinking is a tremendous advantage."[51] The rare frankness with which Grandin makes this connection indicates a difference: here, the tremendous advantage will be shared between experts in the livestock industry and the autistic community. Grandin's account makes familiar associations between disadvantageous, low-functioning habits of attention and cognition and their use to higher pursuits. She explains how a failure to "assimilate information" in a way that "most people take for granted" means she has informational specifics stored in her head for later retrieval.[52] She notes that the problem of

"sensory overload," often so damaging to her efforts and prospects, also allows her to develop a "concrete visual corollary" that enables mastery of abstract problems others are unable to solve.[53] Both abilities have proven vital to her work developing better machines and equipment for the management of livestock. When, for example, Grandin explains that "I am good at designing this equipment" because "I can visualize what the device will feel like," she converts disability into the basis for special cognitive and professional advantage. But that conversion—and popular cognition expertise—only came about because of her dogged persistence. Insistent that "nothing was going to stop me," Grandin worked very hard to ensure that her potential use to livestock management resulted in actual advances for herself and for the business.[54] That persistence, in turn, was also a product of autistic ways of seeing and thinking. Gladwell's popular cognition defers to a class of experts defined in terms of their professional specialization, rather than any natural gift for turning primary perception into valid judgment. Grandin is an expert because of cognitive capacities very much based in the primary perceptivity to be used for professional gain.

Both Gladwell and Grandin face the problem of local coherence. If the validity of immediate intuition threatens to subsume the judgment into which it ought to emerge—if blink-style thinking can mislead, and sensory overload can overwhelm—how do you ensure that emergence occurs? Gladwell's answer, as we have seen, is expertise, and that informs his rhetorical strategies and determines his book's ultimate generic destination. He offers anecdotal impressions and subjects them to educative framing in his signature version of expert popularization. Thus he models how impressions might be open to exploitation by corporate strategies comparable to his rhetorical ones. Grandin develops the "concrete visual corollary," which becomes a sustaining allegorical focus: a door could be at once a visual form and an event and thereby open up new possibilities beyond the local. Her book follows suit, modeling the development of autistic expertise, which inverts Gladwell's business-book trajectory. We might best understand it in terms of its integrity. Whereas Gladwell actually abandons blink-style intuition in his deference to expertise, resorting to educated habit in order to shore up deficient impressions, Grandin first theorizes a coherent impression, and develops a larger rhetorical integrity

on the basis of it. This same rhetorical integrity characterizes popular cognition as it is practiced in other autist autobiographies—for example, Tito Mukhopadhyay's *How Can I Talk If My Lips Don't Move?* (2011).

Mukhopadhyay was diagnosed with severe, low-functioning autism at an early age, and yet he went on to publish a memoir before the age of ten. He won the attention of specialists with his writing, which offers some of the most illuminating, exciting first-person accounts of autistic experience available, all the more striking for the contrast between their eloquence and Mukhopadhyay's limited spoken expression. Mukhopadhyay confirms from the inside what new theories have proposed. His condition, he reports, is essentially one of sensory overstimulation. He sees or hears too much in everything, and his mind and body produce responses to limit or reject excessive sensation. These responses are what typically look like meaningless behavior: whereas flapping hands and intense vocalization have been seen as evidence of severe mental deficiency, Mukhopadhyay describes them as efforts to ameliorate overstimulation. When something like a tree becomes an excessive stimulus, Mukhopadhyay might begin to scream, but because "screaming would stop me from looking at the tree . . . for I can do only one thing at a time. I can either use my eyes or use my ears."[55] When overstimulation occasions a "total shutdown of the senses," he flaps his hands, because that activity is a therapeutic form of proprio-perception: "I usually flap my hands to distract my senses to a kinesthetic feel, so that my senses may be recharged."[56] In these and other ways, "low-functioning" behavior actually reflects great proficiency, Mukhopadhyay's "extreme sensory activities," his extraordinary ability to focus on certain perceptions at the expense of others.

He confirms the mixed value of local coherence—symptomatically, in great detail. One example describes how fragmentary perception of parts of a door emerge precariously into a sense of the door as such:

When I enter a new room, which I am entering for the first time, and look at a door, I recognize it as a door, only after a few stages. The first thing I see is its color. If I do not get into a deeper cogitation of its color by defining it as "yellow," and mentally lining up all the yellow things I know of, including one of my yellow tennis balls when I was seven years old, I move to the shape of the door. And if at all I lay my eyes on the door

hinge, I might get distracted by the functions of levers. However, I pull my attention from there and wonder about the function of that yellow, large rectangular object, with levers of the first order, called a hinge.[57]

If he is to "[sum] up the components into one conclusion," he must either be familiar with the object in question or make extensive efforts to conjoin the vividly, locally distinct parts of the object into a whole.[58] But he has reason to prefer the more difficult process, because it enables a powerful recollective imagination. Having articulated the parts of the door with such singular attention to detail, Mukhopadhyay is able to conjure it up with perfect vivacity after the fact. He is able "to actually 'see' the room coming back alive in front of my eyes," he claims.[59] There is a virtue, then, in the failure at central coherence—in the Proustian nonemergence that keeps impressions close to their original immediate specificity. It is a state of mind in which perception cleaves to its own form of validity, and although Mukhopadhyay recognizes the disability that entails, he also recognizes its artistry. It is what makes him at once a nonverbal autist and a perceptive writer. In another striking example of this dynamic, Mukhopadhyay implicitly likens himself to Proust. He is at school and unable to focus on the day's work. He fails to do anything productive because he focuses all of his attention on the details of the schoolroom's ceiling, imagining how he might link them with diagonals anchored by an endless number of tiny nails. Having missed the lesson and utterly exhausted his powers of visual perception on his epic work on the theater ceiling, Mukhopadhyay finds that he has serendipitously primed himself for an alternative experience. He can now listen more attentively to Proust. That evening, his mother reads to him from *Swann's Way*, and "after a whole day of visual work my ears were ready to hear Proust's work."[60] Of course, Mukhopadhyay does not directly liken his ceiling diagonals to Proust's *Recherche*, for he knows it to be a massive waste of effort. But there is a shared epic project in play here, at least in terms of the perceptual capacity involved. Mukhopadhyay's visual work on the ceiling theater has been so monumental that it sets up an auditory magnitude akin to Proust's book. For both writers, the mere impression, on its own terms, contains its own magnitudes, as its local coherence becomes a focus for aesthetic transcendence.

Such triumphs could easily build a strong narrative, emotional arc. At first, Tito is a diagnosed low-functioning autistic child unable to speak,

whose mother cannot control his outbursts, tantrums, and disturbing physicality. Ultimately, he is a published author, subject of an acclaimed documentary film, and the basis for transformative redefinitions of autism itself. His story could well have been one of salvific conversion from a lost state of mental and social nothingness to triumphant achievement glorifying to himself, his family, and his fellow autists. But the way he tells it, the story remains focused on particular achievements, described not in sequences that show how failure has given way to success, but in their nonnarrative specificity. In a monadic, modular structure, each part of his narrative is its own story, put together in accordance with his special sense of the way meaning develops out of locally coherent perceptions. That structure is explained in terms of figures through which Mukhopadhyay lays bare the mechanisms of his autobiographical genre. Mirrors and escalators obsess him, principally because of the way they convert the focus of his local coherence into larger meaning. In mirrors, Mukhopadhyay sees stories forming; escalators seem to ease singular focus toward a more dynamic development of ongoing information and explanation. In both cases, models for representation provide coherence without falsifying or mitigating the locality that, for better or for worse, defines his autistic phenomenology. What that locality produces in the larger scheme of the book is a set of stories that never suggest that Mukhopadhyay needs to be cured. Even if his earlier life involved frustrations, discomforts, and limitations he is happy to leave behind as he becomes a more high-functioning writer, student, and son, he stresses the isolated singularity of both stages in order to fragment what a disability narrative might otherwise provide of progress, transcendence, or recovery. His narrative has a special integrity—an essential form, actually, since it harmonizes the perceptual life of its protagonist, the structure of its parts, and an overall vision of autist autobiography reconceived as something other than a story of illness and recovery, low-functioning to high, autism to neurotypicality.

Or impressionism to expertise. Mukhopadhyay is like Grandin in innovating an alternative form of popular cognition in which the power of immediate intuition is not explained away but fully inhabited—not undone by its rhetorical transformation but reinforced in the telling. These autist memoirs are the mirror image of the business book in which popular cognition dissects impressionist consciousness. To turn from Kahneman and Gladwell to Grandin and Mukhopadhyay is to survey a field

of contemporary impressionisms, from that which would discipline a perceptual vivacity at once idealized and excluded to that which includes this vivacity on a continuum of diverse but normal forms of perception. This is the field defined by the contemporary version of impressionist cognition—today's popular impression. Once its rhetorics have been exposed, they link historical impressionism to many of the ways we talk about perception today, which very often put these different rhetorics into telling combinations. This chapter will end with two examples—high-profile texts that owe their significance to the ways they draw upon the impression's cognitive popularity.

Mark Haddon's *The Curious Incident of the Dog in the Night-Time* (2003) is narrated from the point of view of a boy with an autism-spectrum disorder. It has shared best-seller shelf space with Gladwell and Kahneman, but more importantly, it shares their sense of what must happen for problematic primary perception to emerge into accurate judgment. *The Curious Incident* may tell its story from the point of view of a boy with autism, and it thrives upon local coherence, but it also implies a business book's sense of the relationship between the romance of pure perception and the form of judgment necessary to exploit it. Christopher Boone shares with Tito Mukhopadhyay a powerful susceptibility to sensory stimuli. *The Curious Incident* makes this susceptibility a source of great creativity—the basis for the novel, in fact, which Christopher himself writes. At the same time, however, the novel stresses Christopher's powers of rational, systematic, statistical reckoning—savant capacities that are equally important to the structure of his text. As much as the novel is rich in sensory information, it is made up of numerical parts and projects, and the productive tension between the cognitive rhetorics that result is largely what has made it such a likeable account of not just one autistic boy's achievements but the human mind. Christopher embodies a neurodiversity that is also the height of neurotypicality. The tension between cognitive rhetorics poses the novel's dramatic question. Will Christopher become an ideally human combination of felt experience and rationality, thinking medium and transforming autism into an exemplary form of consciousness? Or will he remain oversensitive and hyper-rational—all too human in another way?

Statistical rationality first characterizes Christopher as he begins to narrate his story in numbered sections, starting with number two. He will proceed according to prime numbers, indicating the mathematical habit

that will govern his thinking, but indicating immediately how it might entail its own form of creativity. *The Curious Incident* is full of mathematical charts and graphs, puzzles and conundra, many of which demonstrate the sort of counterintuitive statistical truths that popular cognition often sets against bad habits of intuitive presumption. The first-person, autobiographical mode might seem to entail a subjectively idiosyncratic narration, but the novel initially asserts the higher objectivity that should, according to business-book popular cognition, supplement immediate thinking with practiced judgment. And if the result is an idiosyncratically creative mode after all, the effect is similar to that which popular cognition would cultivate. Mathematical subjectivity enables efficient, effective ingenuity, as in the world of business innovation; to the extent that Christopher seems to embody it, he exemplifies what Kahneman and Gladwell suggest about the virtue of algorithmic thought. Then again, Christopher is autistic, and a novelistic protagonist: he will have to change, and the cognitive rhetoric he initially represents is but the first part of a more diverse scheme.

If Christopher's autism makes him the ideal slow thinker, he is also—more truly—open to immediate perception. He receives and reports his perceptions with great primacy; locally coherent in his attention to the world around him, he represents experiences that enter his text all the more directly for his inability to subject them to central interpretation. He is the classic impressionist center of consciousness—a function of pure innocence through which the narrative world transmits directly to its audience.[61] Here also the novel introduces a cognitive rhetoric in need of change. Too immediately sensitive and candid, Christopher will have to find some way to mediate his impressions, to make himself and his novel less subject to merely local coherence.

Thus is born the novel's signature invention. "This is a murder mystery novel": Christopher's story takes the form of detective fiction because it allows him to practice both hyper-rational procedure and empirical hypersensitivity.[62] He "[does] not like proper novels," he says, because of their tendency toward metaphorical language and implausible fictionality. But he wishes to write some kind of fiction, at once to mediate and to organize the facts, and the murder mystery is perfect: it compels both objective factuality and special perceptivity. As Christopher notes in quoting his hero Sherlock Holmes, "The world is full of obvious things which

nobody by any chance ever observes"; "But he notices them, like I do."[63] Both requirements correspond very well to Christopher's own autistic capabilities. He is systematically rational and keenly aware, but, more than that, he is gifted with a set of habits and tendencies that magnify these essential advantages. He does not subject his immediate perceptions to the centrally coherent distortions of presupposition or theory, never jumping to conclusions based on conventional expectations about guilt or innocence. His credo is Occam's razor, which maintains that "no more things should be presumed to exist than are absolutely necessary."[64] Inversely, his rationality is unswayed by the personal feelings and biases so notoriously important to the human interest of mystery novels in which detectives find themselves fooled by vagaries of the personal relationships that inevitably develop over the course of the plot. Christopher's murder mystery novel perfects the genre. Strangely enough, this autist variation reconciles the rhetorics of popular cognition, and in so doing, it perfects the perceptual logic of the impression. *The Curious Incident* is a peculiar avatar of impressionism's contemporary relevance, inventing a comprehensive mode of engagement with contemporary forms of thought.

But it is too peculiar, of course, and irony destroys it. Hyper-rationality and hypersensitivity might make for good detection, but they make Christopher's life impossible, too often becoming obtuseness and distraction, over-reading and underestimation. His task is to figure out who has killed his neighbor's dog, discovered stabbed to death with a garden pitchfork. His method is relentless questioning and purely systematic deduction, neither of which really works: Christopher is soon forbidden by his father from pursuing the investigation, and it turns out that his father is hiding evidence not only essential to the case but also important to Christopher's own life story. The situation conspires to mislead him, and his gifts, so perfectly suited to detective scrutiny, are useless in the face of complex emotional deception. He does nevertheless solve the case and, in the process, the complex human problems undermining his own story, but by accident. More importantly, his narrative develops its interest and appeal through the ironic gap between what he thinks and what we know: Christopher only reports but does not understand the information delivered through his hypersensitive perceptions and hyper-rational deductions, leaving his readers in the aesthetically entertaining but ethically problematic position of knowing what he does not. The result is a narrative structure very different from that developed by Tito Mukhopadhyay, who

is always careful to claim authority over what he knows and always un-sentimental in his account of autistic liability and advantage. Christopher has no authority over what he knows, even as he authors the text within a text that is *The Curious Incident*, and he ends up producing a highly senti-mental, romantic account of autistic disability. The gap between his detec-tive ideal (which maximizes the advantage of polarized cognition) and his narrative product (which entails only accidental achievement) is pathetic, a source of readerly pity, a factor in disability advocacy only insofar as it provokes a wish to occupy the position of ironic meaning-making that complements autistic innocence.

This is to say that *The Curious Incident* is sometimes a powerfully effec-tive fictional popularization of what Tito Mukhopadhyay achieves in his autobiography—and sometimes a telling parody of what Kahneman and Gladwell produce in their ambivalence about impressionist cognition. Christopher's account of himself often matches what Mukhopadhyay de-scribes when he explains why he engages in apparently meaningless phys-ical behavior. When Christopher travels the Underground alone to Lon-don to seek evidence and is overwhelmed by sensory input, he presents his mental experience as an excessively detailed enumeration of available information. Signs run together "because there were too many and my brain wasn't working properly," prompting him to "make my hand into a little tube so that I was looking at one sign at a time."[65] What appears to passersby as inappropriate behavior is in fact a valid effort to delimit stimuli and narrow focus—a result of not perceptual deficiency but ex-cess. Christopher recognizes this excess himself, in a more positive man-ner, when he notes, "I see everything."[66] His example is "standing in a field in the countryside" and noticing everything about it—the total number of cows and houses, hedgerows and items of trash—often to the point of ex-haustion. "And it means that it is very tiring if I am in a new place because I see all of these things," which neurotypical people would probably not notice.[67] This account ends with Christopher affirming an advantage over "most people" who "are almost blind and they don't see most things and there is lots of spare capacity in their heads."[68] Here Christopher becomes an advocate for neurodiversity and an exemplar of the special impression-ability that constitutes the autist's claim to perceptual plenitude.

Elsewhere, he becomes an avatar of popular cognition as it has been dramatized in business books designed to make an advantage out of cog-nitive polarization. As Christopher haplessly churns out equations and

graphs meant to aid in his pursuit of the truth, he becomes a parody—a sympathetic, charming caricature—of statistical expertise. As he over-reacts to simple stimuli—taking too much at face value, engaging in compulsive resistance to objects simply because he dislikes their color or focuses too much symbolic significance upon them—he becomes a parody of blink-style, impulsive judgment and feeling. If the genre of popular cognition inadvertently produces (and becomes) a parodic impressionism in its effort to recognize the centrality of the impression to human understanding, *The Curious Incident* shows what happens when that genre literally becomes a cognitive fiction. What was implicit and apparently incidental in the rhetorical structure of popular cognition becomes explicit and essential to a story about human understanding, apparently because the form of human understanding in question is autistically disabled, but actually because popular cognition has popularized a polarized version of the way we think and feel. In other words, *The Curious Incident* is only explicitly a product of the reconstructed autist imagination. Implicitly, it follows from business-book thinking about the options available to thinking that is either fast or slow.

By turns true to neurodiversity and to popular cognition, *The Curious Incident* has earned a mixed reputation. Readers and critics have praised it as a surprisingly authentic account of autism-spectrum experience and blamed it for dangerous travesty. They have celebrated the novel's inventive ironies and attacked its sentimentality.[69] This ambivalence extends to the book's conception and reception. It was originally intended for a young adult audience and, as Haddon admits, not intended to represent the autistic mind. (Haddon began with a compelling voice that only later developed into that of an autistic boy.) It ultimately became a West End stage production notable for an inventive set design elaborately dedicated to the dramatization of autist mind effects. Such differences follow from the novel's own uncertainty about its protagonist's form of perceptual experience and the rhetorical positions it takes in relation to it. All this is suggestive of a familiar problem that has often put such impressionism in compromising positions. *The Curious Incident* is an impressionist text for the susceptible innocence of its protagonist, its dedication to subjective interpretation, its fragmentary structure, and its felt immediacies. But the novel's contemporary impressionism goes beyond this simple legacy and inheritance of basic tendencies. *The Curious Incident* draws upon new

ambivalence about what impressions entail and organizes it into a new, contemporary impressionist rhetoric. Impressionism's familiar problems, updated in popular cognition, are given new aesthetic form and become the object of renewed controversy. As an impressionist genre, the popular cognition of *The Curious Incident* has both a contemporary and a more timeless relevance. It is something we understand only if we recognize at once its contemporaneity (in relation to the latest best-seller) and its old habits of mind.

Jonah Lehrer has made a similar argument in *Proust Was a Neuroscientist*. Indeed, he makes the argument more directly, attributing today's popular concept of neuroscience to its more impressionist history. *Proust Was a Neuroscientist* is a collection of essays explaining how great modern writers and artists developed theories of perception, memory, creativity, and other objects of neuroscientific study before—and, it is implied, more authentically than—neuroscience itself. Lehrer authenticates neuroscience by finding it at work in more impressionistic creativity, achieving something like Haddon's reconciliation as well as his controversy.

Lehrer begins with a claim that Walt Whitman's practical theory of embodied experience corresponds to what neuroscientists now know about the relationship between mind and body—but that Whitman derived his theory from a resourceful and fortunate mix of Emerson, wartime observation, and personal experience, which together resulted in something very much like Antonio Damasio's theory of embodied reason. Whitman is Lehrer's first example of the way "artistic investigation of our experience" affords a necessary correlative and corrective to "the reductionist methods of science."[70] Science alone is inadequate to full or true reckoning with the life of the mind, and descriptions provided in and through the work of artists supplement the scientific account with enriching alternative interpretations. And when "science is seen through the optic of art, and art is interpreted in the light of science," the two "complete each other," and "the mind is made whole": not only does the collaboration perfect methods imperfect on their own, it actually solves a problem in the object of its study. A bold version of the recursive tendency in popular cognition makes the mind whole by demonstrating the need for a holistic method of study; Lehrer's own way of conjoining art and science is a match for what he discovers, for example, in Whitman, making Lehrer himself a successor to the creative tradition he celebrates.

In the case of Whitman, there is a process by which the artist amounts to a neuroscientist. Public experiences and theoretical inspiration usher Whitman toward his proto-neuroscientific insight into the nature of embodied reason. But as Lehrer's chapters proceed, this process becomes more mysterious. It vanishes into the recesses of the artistic mind, so that Lehrer's argument becomes recursive in another way: these artists become inspiring neuroscientists precisely because their own minds are unavailable to neuroscientific explanation. Proust, for example, came by his prescient theory of memory not through any researches or experiences we might document or explicate, but because he was a solipsist: "Deprived of a real life—his asthma confined him to his bedroom—Proust made art out of the only thing he had: his memory."[71] Although he was influenced by Bergson, his genius was unaccountable, since "somehow, by sheer force of adjectives and loneliness, he intuited some of modern neuroscience's most basic tenets."[72] The mystery of the process creates a problem for Lehrer's project. If his goal is to reconcile art and science and thereby "make whole" their explanatory powers, he develops an unreliable partnership that depends upon capricious intuition. Like other practitioners of popular cognition, he will have to shore up the process, find some way to stabilize excessively subjective creativity.

These recursive performances reach a climax—in Lehrer's work and in the longer history of impressionism—with Lehrer's chapter on Cézanne. The subject is Cézanne's postimpressionism, defined as a reaction against the limitations of the impression. In Lehrer's account, Cézanne "found the impressionist project too insubstantial" because it rested content with merely sensory impressions.[73] Impressions needed interpretation in order to correspond accurately with true mental experience, because in fact "everything we see is an abstraction" rather than an immediate object of visual observation.[74] "Seeing is imagining," perception is abstraction, and "Cézanne discovered that visual forms . . . are mental inventions that we unconsciously impose upon our sensations."[75] His genius was to discover "the beginning and the end of our sight," and the result was postimpressionism: "It is because Cézanne knew that the impression was not enough—that the mind must *complete* the impression—that he created a style both more abstract and more truthful than the impressionists," and in the process developed a mode of inquiry that recursively corresponds to the larger project of Lehrer's book.[76] What emerges is the most

essential correspondence between impressionism and popular cognition. Just as the impression's deficit allegedly provoked postimpressionism, an incomplete neuroscience has provoked Lehrer to a kind of utopian re-mediation, accomplished by creativity. If Cézanne wanted "to make us aware of the particular way the mind creates reality," prompted by a lesser theory of perceptual emergence, Lehrer wants to re-create this role for the creative mind. And once again, creative genius claims credit: "No matter how hard he tried, Cézanne could not escape the sly interpretations of his brain": what prompted him to recognize the centrality of the mind's creative abstractions was something compulsively, recursively essential to his own mind.[77]

But what does Lehrer then make of the infinite regress that follows? How does he develop a valid project on the basis of interpretations that defer to such creative subjectivity? He concludes by noting appreciatively that "the post-impressionist movement begun by Cézanne was the first style to make our dishonest subjectivity its subject."[78] But Lehrer's rhetoric here also indicates a problem with the movement and his latter-day advancement of it. What becomes of this dishonesty?

The project in question is that of advancing the effort to innovate a "third culture" to bridge the gap between the two cultures so influentially distinguished by C. P. Snow. Bringing the recursive dynamics of popular cognition to the highest level, Lehrer notes that our effort to reconcile art and science in the spirit of Snow's call for a third culture has "serious limitations": "it has failed to bridge the divide between our two existing cultures. There is still no dialogue of equals. Scientists and artists continue to describe the world in incommensurate languages."[79] Lehrer calls for the development of a "fourth culture" that would foster true reconciliation:

This fourth culture . . . will ignore arbitrary intellectual boundaries, seeking instead to blur the lines that separate. It will freely transplant knowledge between the sciences and the humanities, and will focus on connecting the reductionist fact to our actual experience. It will take a pragmatic view of the truth, and it will judge truth not by its origins but in terms of its usefulness.[80]

To model this better reconciliation, Lehrer offers a reading of Ian McEwan's *Saturday*, which tells the story of a physician whose scientific

outlook is moderated by a creatively impressionistic consciousness of mitigating factors, making the novel "a potent demonstration that even in this age of dizzying scientific detail, the artist remains a necessary voice."[81] The novel "symbolizes, perhaps, the birth of a fourth culture," which Lehrer's own book models even more fully.[82] And yet this fourth culture also symbolizes something else. Because it actually concedes ground to creative subjectivity, accomplishing its reconciliation in the ambiguity of the mysterious mind rather than any truly above-board collaboration of art and science, it leaves room for error. Lehrer says he wants to "keep *our* reality, with all its frailties and question marks, on the agenda," but it becomes clear that his stress on blurred boundaries and useful truths licenses a kind of willfully "dishonest subjectivity"—something more deceptively impressionistic.[83]

With this arrival at the impressionistic, we come to a principal legacy of the impressions of Proust and Cézanne, at least as Lehrer and popular cognition have inherited it. Here is a proper science of the impressionistic, actually, with its neuroscience associations and its ironically rigorous derivation. In Lehrer's case, it has led in two directions—to two very telling developments in the contemporary history of impressionism. One is similar to the direction in which other instances of popular cognition have pointed. Lehrer's subsequent books have linked his fourth culture to business culture, suggesting that the mind's essentially subjective creativity is an opportunity for expert specialization and commercial exploitation. *How We Decide* (2009) and *Imagine: How Creativity Works* (2012) outdo Gladwell in their reconciliations of impressionist creativity and business opportunity, demonstrating even more emphatically that the mind's vagaries might encourage development of a "fourth culture" of a very different kind. That culture is perhaps best represented by the titles of lectures Lehrer has given as his status as a practitioner of popular cognition has increased: "The Secret to Investing: Outwit Your Brain" and "The Benefits of Daydreaming." But the second direction toward which the "dishonest subjectivity" of contemporary impressionistics has led has undermined Lehrer's chance of becoming a Gladwell kind of guru. It has led him to "take a pragmatic view of the truth" and to judge it by its "usefulness" to such an extent that he has actually falsified information.

In July 2012, Lehrer resigned his position at *The New Yorker* after it was reported that he had fabricated some of the information in *Imagine: How*

Creativity Works. It was also discovered that Lehrer had rehashed much of his own writing, self-plagiarizing articles out of former blog posts. In a subsequent apology delivered in a speech sponsored by the Knight Foundation on February 12, 2013, Lehrer discussed the problem of accidental bias, error, and the cognitive flaws that lead even the best forensic scientists to falsify information. Admitting to such flaws himself, Lehrer concludes that he will only redeem himself if he can successfully adopt the sort of rules and standard operating procedures through which forensic professionals minimize error and bias. Only rules and standard procedures will make him "less tempted by shortcuts"—less prone, we might add, to indulge dishonest subjectivity and its cognitive impressionistics, and less likely to pursue the sort of reconciliations that would subject science to the biases inherent to the creative process.[84] No longer able to dream of that fourth culture, Lehrer came to embody the legacy he once wanted to claim. He is a contemporary Proust or Cézanne after all, not because he creatively anticipated what is next in the field of neuroscience, but because he trusted his intuitions—indulged his impressions. But whereas Proust and Cézanne were therefore leading innovators, Lehrer found himself at a crisis in his career that ironically began with such a brilliant exposition of the relevance of the impression to not only the contemporary mind but also our dreams of a better culture.

CONCLUSION

*T*he *Curious Incident of the Dog in the Night-time* takes us a long way from Monet or Conrad—a long way from the styles and sensibilities that originally characterized impressionism. What a stretch, really, to attribute impressionism to the very different subjectivity of this kind of contemporary novel, in which flat and comically mathematical observations, so much of our moment, seem to entail the opposite of the vivid, sophisticated perceptiveness so important to impressionism historically. Of course, the argument about *The Curious Incident* has not been that it is a stylistic or temperamental match for Conrad or Monet, but rather that it advances the same rhetoric that made impressions visually or verbally important to their work. In popular cognition, that rhetoric takes on a new contemporary relevance, which Haddon's novel registers in its characterization of the special perceptual advantages available to the autistic mind. Haddon does have a connection back to historical impressionism, of the sort that indicates impressionism's continuing relevance, since it helps to identify what is shared in common by successive variants of this mode. But he has even more in common with Monet and Conrad: not just the rhetoric but the whole character of impressionism, which yet exerts a strong influence over our fictions more generally.

Haddon's Christopher Boone is like so many impressionist protagonists—characters in fiction, the *tache* in history, trickster practitioners, baffled spectators—for whom some decisive event must turn upon the unlikely and therefore striking emergence of great from small. In his

life's story, a feeling of love finally becomes possible for him only once his powers of perception have been assessed, destroyed, and remade. The initial assessment shows that his judgment of bare appearances is faulty; it is then subjected to harrowing disarray, only to be redeemed, finally, by a different presentation of the initial bare appearance. In the initial moment, it is a dead dog that Christopher misunderstands: this simple, almost schematic information eludes him. Information then becomes entirely elusive, impressionistic in form, until the novel's last moments present him with a living, loving dog whose minimal impulses yield great and abiding feeling.

This is not just to say that Christopher becomes more perceptive and more normal. His powers of perception finally conform to that impressionist logic whereby the least perception has most authentic power, amid a narrative structure in which narratability itself depends upon the force that drives the passing glance. All this makes *The Curious Incident* a paradigmatic example of the ambitions, at once thematic and discursive, that make so much fiction today still impressionist, despite the great difference between a novel by Mark Haddon and one by Joseph Conrad. Here too we have an example of the persistent tendency, even in 2005, to build a certain kind of novelistic fictionality around dynamics registered most visibly by the dual-nature brushstrokes of the 1870s.

So what, finally, should we make of that persistence? The introduction to this book showed that the kind of impressionism still at work in novels by David Mitchell and Zadie Smith can seem at once to represent an anachronistic, kitschy, even ideologically suspect vestige and a valid, timely recurrence. Subsequent chapters have suggested that impressionism could survive co-optation, social realism, and conceptual aesthetics to become a postcolonial and postconceptual mode—to develop into new forms that are perhaps even more fully true to its generic destiny. Does that mean that the kind of mainstream literary fiction written by Haddon, Mitchell, and Smith offers evidence of a living impressionism—one more alive today than ever—or must something qualify this aesthetic optimism, or at least moderate the language we might use to recognize an impressionist ascendancy? Even if these writers are proof that impressionism keeps coming into its own, should that provoke affirmative conclusions?

This last question is really two questions, since it asks about both impressionism today and what is to be gained by affirming it. These two questions, however, might be reunited within the category of kitsch. We

have discovered that impressionism's persistence as kitsch is no disqualification: just because it has been co-opted by decorative, commercial, or noncritical uses does not mean it has been destroyed, because such uses are at once true to it and, more than that, reasons to revise our sense of what kitsch entails. Such co-optation had been readied by the impression itself, which has promiscuous relations to perceptual debasement and thrives on the dependency of aesthetic value on its minimal sources. And in its later moments, the impression's minimality comes into an association with a necessary kind of aesthetic weakness in art needing to renegotiate its relationship to totalitarian politics, capitalism, information, and conceptual art. Decorative impressionism only perfected a preemptive vision of nature already determined by Monet himself and his relationship to Japanese design. The belated Hungarian impressionism of Béla Kontuly has an apologetic relationship to fascist objectivity, and the impressionist advertisement, similarly, weakens the attentional logic of consumer culture. In contemporary work by Peter Doig and Colm Tóibín, we have found a return to a modest aesthetic that acknowledges art's ontological basis in minimal materiality. In all these cases, we have discovered a justification for kitsch, a reason it debases art, and in this justification we have a reason to affirm impressionism today. That is, affirmative conclusions are not just empty advocacy for impressionism but the climactic part of a theory about its long-term historical significance. We should favor what impressionism has become because it plays a vital part in maintaining a sort of aesthetic experience critical to a world in which art and politics have not ceased to conspire against us.

Matei Calinescu ends his discussion of kitsch in a surprising spirit of détente. Having rehearsed the classic conflict between authentic avant-gardism and kitsch debasement, he relents. He has been declaring that kitsch is "a crowd-pleasing art, often devised for mass consumption . . . meant to offer instant satisfaction of the most superficial aesthetic needs or whims of a wide public," and has confirmed that "the world of kitsch is a world of aesthetic make-believe and self-deception."[1] But then he wonders if it is not a mistake to exaggerate its dangers. After all, it "suggests the way toward the originals," and if "in today's world no one is safe from kitsch," that means that it "appears as a necessary step on the path toward an ever elusive goal of fully authentic aesthetic experience."[2] Calinescu does not devote much time to this argument—it reads like an after-

thought—but it is nevertheless a remarkable challenge to the classic views on this subject, which either vilify kitsch or celebrate its anti-aesthetic potential. Calinescu identifies the possibility that kitsch is a first step toward art, even if its history is one of aesthetic debasement. And in this strange position, we have a place for impressionism today. Its affinities with kitsch itself (its predisposition to this sort of co-optation, its minimality, its felt intensity and scandalous prettiness) position impressionism right at this provisional, halting progress back toward the aesthetic. Even (or especially) when impressionism seems to have devolved into mere highlights and distractions, it offers points of access to aesthetic experience, redefined as open attention to the free play that is the sensible emergent, that sense of something purposive in hardly seeing. This opportunity should provoke us to affirm what has become of impressionism—for two reasons. It suggests that impressionism has not lost its critical power even when it has been co-opted, since the critical dynamic embedded in the original impression has only reconciled itself to the simpler pleasure of aesthetic experience. And it suggests that the kitsch impression is always poised gamely for something more—a simple pleasure or problem awaiting its return to aesthetic value reconceived.

More than anything else, this aesthetic opportunity is what explains the peculiar value of the moments in which impressionist recurrences seem at once anachronistic and contemporary. The introduction to this book raised questions about such moments in the work of Mitchell and Smith. Impressionist techniques and effects in Mitchell's *The Thousand Autumns of Jacob de Zoet* and Smith's *NW* might be seen as perfunctory citations of a prestigious modernist style or as valid new uses for it. But now we might note that these novels succeed precisely insofar as we see them in both ways, as perfunctory performances that take the necessary step on the path toward something elusively authentic. Of course, this is not to say that they are elementary texts, but rather that they embody that marvelous reversal whereby kitsch returns us to a history of aesthetic achievement.

Mitchell's felt subjectivism and rapid traces of sensibility sometimes seem like empty stylization. Agitated consciousness and vibrantly compressed descriptions can seem adventitious—not consistent with his novel's project, and just formulaic capitulation to styles readers expect, having grown accustomed to their impressionist conventionality. But now

that we can place these styles in the longer history of impressionism, we might reconsider their decorative effects. They do take part in Mitchell's project, understood as a global one and a contemporary reflection upon cross-cultural desire. His quick and apparently perfunctory impressionist descriptions do have a decorative character, but that perfectly suits his subject: *The Thousand Autumns* is all about the ways Japanese formal custom might mislead a Western consciousness, and all about the ways a certain preemption of natural behavior enables something that is at once lovely and sinister. Mitchell cleverly makes us expect a transformation of this decorative dynamic, in which a more authentic emergence will create a venue for natural feeling. But instead, macabre fantasies develop, in a novel that is fully aware of the history of the relationship between Japanese aesthetics and Western taste. That relationship is undone here, as both participants are shown to base their imperialist cultures in the most primary brutality. As a framework for this discovery, impressionism becomes a register of global awareness, a contemporary critique of world systems. Its contemporary novelistic modes (focalized minimality yielding publicly durable concepts, quick vivacity signifying authentic recognition) are linked to stylized, decorative impressions in such a way as to make critical use of impressionism's cross-cultural history—very much a contemporary advantage. And it shows how a kitsch impressionism reenters aesthetic history: the pretty grace notes Mitchell seems to use only for atmospheric decoration cannot help but engage with cultural determinations. In turn, they go toward the sort of aesthetic narratability at work in the original impression, and the histories it took in.

Smith repurposes an impressionist mode of fragmentary compression: the central section of *NW* multiplies information-age impressions, quick recognitions that have only the limited rationality of new media presentations. As impressions, however, they have their own thematic story to tell; they complement the history that is their content with formal questions about collective memory. These impressions recall a shared past in a certain community of London, but only to the extent that they survive the format made available to them by the fragmentary flow of information today. There is no doubt, then, that Smith has given impressionism contemporary validity, perhaps in the form of what she herself has called the "constructive deconstruction" that is one path forward for fiction.[3] Nevertheless, we might ask about her wish to repurpose a modernist aes-

thetic. Here and elsewhere, Smith declares her solidarity with the modernist project; why does she take that risk? To some degree, she recalls Peter Doig: both are so obviously contemporary that they can afford to risk concessions to modernism. And both are motivated by beauty—Doig in his painterly richness, and Smith in not only her fiction's fineness but also its explicit engagement with aesthetic theory. *On Beauty* (2005) is a novel that takes on Elaine Scarry's theory linking sheer aesthetic delight to powers of justice. It bespeaks Smith's tendency to participate in a high-modernist ideal that goes back to impressionist *intransigeance*: it was the impressionists who popularized the idea that fidelity to the visible world could equate to social justice, and that was indeed the source of their original radicalism. For Smith, however, this ideal has become a more modest sense of the relationship between the fine impression and the social order. In her fiction, beauty is but a small start toward justice. But it is a start nonetheless, and further evidence of the way the debased impression today stands in wait for its chance at aesthetic achievement.

If this is no real defense of its achievement—nothing like the reclamation of the aesthetic urged by Scarry or, in different ways, Isobel Armstrong and Wendy Steiner—it does argue for a form of aesthetic experience more integrated into everyday life.[4] It gives us another way to say how impressionism has come to dominate culture since its glory days: as a routine genre of perception, but one that retains impressionism's original power to glamorize perceptual emergence. Poised at aesthetic beginnings, this contemporary impressionism is a hardy generic crux for small perceptual achievements that might amount to something. Thanks to impressionism, we can hope to trust what is compressed into our momentary insights, and we know implicitly what sort of stories might extrapolate upon them. We have the rare benefit conferred by a form of perception with a cultural history—a style of seeing that comes to us laden with its legacy of uses, so that we enter into a cultural practice when we might seem only to fail to think clearly. As a mode of perception, impressionism has a long history of reversals that redefine aesthetic experience in this fashion. We can make of it no viable defense of the aesthetic, since it is complicit with so much that would seem to destroy the aesthetic as such, but we can at least confirm that impressionism keeps generating new chances for the aesthetic regime of art.

NOTES

INTRODUCTION

1. Robert Herbert, *Impressionism: Art, Leisure, and Parisian Society* (New Haven: Yale University Press, 1988), 195–264; Fredric Jameson, "Romance and Reification: Plot Construction and Ideological Closure in Joseph Conrad," *The Political Unconscious: Narrative as a Socially Symbolic Act* (Ithaca: Cornell University Press, 1981), 225–242.

2. István Bizzer, "Summary," *Kontuly Béla, 1904–1983* (Budapest: Mikes Kiadó, 2003), 122.

3. ZsuZsa D. Fehér and Gábor Ö. Pogány, *Twentieth Century Hungarian Painting*, trans. Caroline and István Bodóczky (Budapest: Corvina Press, 1975), 17–18.

4. The 2003 exhibition catalog notes that "from the end of the 1950s, he created innumerable figure compositions for the art exporter company ARTEX. . . . His works were in demand mostly in the USA and Japan, especially his still lives" (István Bizzer, *Kontuly Béla, 1904–1983*, unpublished translation by Réka Mihalka, 74). Pictures that never left Hungary show even greater commitment to pseudo-impressionist technique—for example, Kontuly's still lifes from subsequent decades held by the Ernst Museum in Budapest. See Bizzer, *Kontuly Béla*, 95.

5. Ivan T. Berend, *Decades of Crisis: Central and Eastern Europe Before World War II* (Berkeley: University of California Press, 1998), 394.

6. Ibid., 368.

7. Bizzer, *Kontuly Béla*, unpublished translation by Réka Mihalka, 74.

8. Ibid.

9. Ibid.

10. Fehér and Pogány, *Twentieth Century Hungarian Painting*, 6.

11. Ilona Sármány-Parsons argues that the term has been misapplied to the development of modern art in Central Europe: see her "Ambivalent Attractions: On the Influence of impressionism in Vienna and Budapest Around 1900," *Centropa* 8, no. 1 (January 2008):

86–104. See also Ernő Kállai, *The New Painting in Hungary* (1925): "Impressionism was an extraordinarily mobile, intellectually superior vantage point from which to obtain the most undisturbed enjoyment of world and life. . . . The only artists who could ever keep a foothold among all these rarefied and volatile sense impressions were the French. . . . The Hungarian temperament lacks the ability to subject its instincts to this degree of rational control and intellectual sublimation" (*Between Worlds: A Sourcebook of Central European Avant-Gardes, 1910–1930*, ed. Timothy Benson and Éva Forgács [Cambridge, MA: MIT Press, 2002], 620).

12.	Éva Forgács, "The Safe Haven of a New Classicism: The Quest for a New Aesthetics in Hungary, 1904–1912," *Studies in East European Thought* 60 (2008): 93.

13.	György Lukács, "The Ways Have Parted" (1910), trans. George Cushing, in Benson and Forgács, *Between Worlds*, 128–129.

14.	Sármány-Parsons, "Ambivalent Attractions," 100–101.

15.	Ibid., 100.

16.	Forgács, "The Safe Haven of a New Classicism," 94

17.	See Karen Fiss, *Grand Illusion: The Third Reich, the Paris Exposition, and the Cultural Seduction of France* (Chicago: University of Chicago Press, 2009), 45–98.

18.	Mark Stevens, "Critics Pick," *New York Magazine* (September 12, 1994), 54, qtd. in Gary Tinterow, "The Blockbuster, Art History, and the Public," in *The Two Art Histories: The Museum and the University*, ed. Charles W. Haxthausen (Williamstown, MA: Sterling and Francine Clark Art Institute, 2002), 145.

19.	"Impressionist Art Gallery," website, http://www.impressionist-art-gallery.com/, accessed June 10, 2013.

20.	See chapter 6 for a fuller explanation.

21.	See James Wood's account of the novel's "vitality" and the "vividly human" effect of its style ("The Floating Library," *The New Yorker* [July 5, 2010], www.newyorker.com, accessed May 15, 2013); and Ron Charles's description of the novel as "an apothecary cabinet of vibrant set pieces" (review of *The Thousand Autumns of Jacob de Zoet*, *The Washington Post* [June 30, 2010], www.thewashingtonpost.com, accessed December 2, 2014).

22.	David Mitchell, *The Thousand Autumns of Jacob de Zoet* (New York: Random House, 2010), 99.

23.	Ibid., 188.

24.	See K. Thomas Kahn, "Lamenting the Modern: On Zadie Smith's *NW*," for a discussion of the critical tendency to associate Smith with the subjectivism of writers like Woolf (*The Millions*, September 26, 2012, www.themillions.com, accessed May 15, 2015).

1. FIRST AND LASTING: HISTORIES FOR THE *TACHE*

1.	Louis Leroy, "L'Exposition des Impressionnistes," *Le Charivari* (April 25, 1874), in *Éloges et Critiques de L'Impressionnisme*, ed. Dominique Lobstein (Paris: Artlys, 2012), 34.

2.	Chesneau in *Paris-Journal* (May 7, 1874), qtd. in Jacques Letheve, *Impressionnistes et Symbolistes devant la presse* (Paris: Armand Colin, 1959), 70, qtd. in Charles S. Moffett, ed.,

The New Painting: Impressionism 1874–1886 (San Francisco: The Fine Arts Museums of San Francisco, 1986), 130.

3. John House, *Impressionism: Paint and Politics* (New Haven: Yale University Press, 2004), 46–48.

4. Gustave Geffroy, preface, *Exposition de tableaux pastels et dessins par Berthe Morisot*, exhibition catalog (Paris: Boussod Valadon, 1892), qtd. in Anne Higonnet, *Berthe Morisot's Images of Women* (Cambridge, MA: Harvard University Press, 1992), 33.

5. Stephane Mallarmé, qtd. in Moffett, *The New Painting*, 34.

6. Higonnet, *Berthe Morisot's Images of Women*, 146.

7. Stephen Eisenman, "The Intransigent Artist *or* How the Impressionists Got Their Name," in *Critical Readings in Impressionism and Post-Impressionism*, ed. Mary Tompkins Lewis (Berkeley: University of California Press, 2007), 150.

8. Duret qtd. in Richard Shiff, *Cézanne and the End of Impressionism: A Study of the Theory, Technique, and Critical Evaluation of Modern Art* (Chicago: University of Chicago Press, 1986), 22.

9. Mallarmé, qtd. in Moffett, *The New Painting*, 34, 29.

10. Duranty, qtd. in Moffett, *The New Painting*, 46.

11. Walter Pater, "Conclusion," *The Renaissance: Studies in Art and Poetry* (1873; 1893), ed. Donald L. Hill (Berkeley and Los Angeles: University of California Press, 1980), 187–188.

12. Ford Madox Ford, "On Impressionism," *Poetry and Drama* II (June, December 1914): 169.

13. Joseph Conrad, preface to *The Nigger of the "Narcissus"* (New York: Doubleday, 1914), 13.

14. Edwin Evans, "Une opinion anglaise pur *Pelléas et Mélisande*," qtd. in Ronald L. Byrnside, "Musical Impressionism: The Early History of a Term," *The Musical Quarterly* 66, no. 4 (October 1980): 536; Edward Burlingame Hill, "Claude Debussy's Piano Music," qtd. in Byrnside, 533.

15. Virginia Woolf, *To the Lighthouse* (1927; reprint, San Diego, New York, and London: HBJ, 1981), 23.

16. Richard Shiff, "The End of Impressionism," in Moffett, *The New Painting*, 74.

17. Richard Brettell writes of Cézanne's *House of Père Lacroix*, "The 'impression' of the scene on the mind and sensibility of the artist is the subject of [the] painting. The work is at once objective and subjective, as if it is an impression not of the eye, but on the mind of the artist" (*Impression: Painting Quickly in France, 1860–1890* [New Haven: Yale University Press, 2001], 26); James Henry Rubin, *Impressionism and the Modern Landscape: Productivity, Technology, and Urbanization from Manet to Van Gogh* (Berkeley: University of California Press, 2008), 12. Elsewhere Brettell distinguishes between two kinds of realism—photographic and psychological—and he also recognizes a dual split between impressionisms that are "transparent" and "mediated" (*Modern Art 1851–1929: Capitalism and Representation* [Oxford University Press, 1999], 18).

18. H. Peter Stowell, *Literary Impressionism: James and Chekhov* (Athens: University of Georgia Press, 1980), 18. For the comparison to the phenomenological synthesis see also Maria Elisabeth Kronegger, *Literary Impressionism* (New Haven: College and University Press, 1973), 25, 41. For another account of subjective objectivity, see Wolfgang Iser, *Walter Pater: The Aesthetic Moment*, trans. David Henry Wilson (Cambridge: Cambridge

University Press, 1987), 36. See also Mary Tompkins Lewis on the "twofold" nature of this aesthetic ("The Critical History of Impressionism: An Overview," in Lewis, ed., *Critical Readings in Impressionism and Post-Impressionism*, 1).

19. Anthea Callen, *The Art of Impressionism: Painting Technique and the Making of Modernity* (New Haven and London: Yale University Press, 2000), 1, 3, 156.

20. Georg Lukács, "The Ideology of Modernism," in *Realism for Our Time: Literature and the Class Struggle*, trans. John and Necke Mander (New York: Harper & Row, 1964), 43; Fredric Jameson, *The Political Unconscious: Narrative as a Socially Symbolic Act* (Ithaca, NY: Cornell University Press, 1981).

21. T. J. Clark, *The Painting of Modern Life: Paris in the Art of Manet and His Followers* (New York: Knopf, 1985), 166. Clark discusses the ironist's view of the relationship between country and city in the impressionists' images of lower-middle-class suburban leisure, noting that while one view might be that "paint would *perform* the consistency of the landscape," at best it would "give form" to the dialectic interplay between "nature and artifice, fashion and recreation," and it might simply become, as in Manet's *Les Bords de la Seine à Argenteuil* (1874), "a kind of joke about false equivalence" (180, 201, 166).

22. Daniel Hannah, *Henry James, Impressionism, and the Public* (Surrey, UK: Ashgate, 2013), 51.

23. John Carlos Rowe, *The Theoretical Dimensions of Henry James* (Madison: University of Wisconsin Press, 1984), 194.

24. Eisenman, "The Intransigent Artist," 150–152.

25. Ibid., 154.

26. Richard Brettell, *Impression: Painting Quickly in France, 1860–1890* (New Haven and London: Yale University Press, 2000), 26.

27. James Henry Rubin, *Impressionism and the Modern Landscape: Productivity, Technology, and Urbanization from Manet to Van Gogh* (Berkeley: University of California Press, 2008), 14, 12.

28. Here I refer mainly to House, *Impressionism*; Brettell, *Impression*; and Callen, *The Art of Impressionism*.

29. Brettell, *Impression*, 22.

30. House, *Impressionism*, 146.

31. Ibid., 69.

32. E. H. Gombrich, *Art and Illusion: A Study in the Psychology of Pictorial Representation* (Princeton: Princeton University Press, 1956), 210. My account of the debate is indebted to Cécile Guédon (private correspondence) and to Edward Winters, "Pictures and Their Surfaces: Wollheim on 'Twofoldness,'" http://www.um.es/logica/Winters.htm#_ftn3, accessed July 18, 2013. See also Dominic McIver Lopes, "Painting," in *The Routledge Companion to Aesthetics*, ed. Berys Gaut and Dominick McIver Lopes (London: Routledge, 2001), 497. Also relevant here is Gombrich's account of the way "impressionism demanded more than a reading of brushstrokes. It demanded . . . a reading across brushstrokes" as well as his account of the "visual shock" of its incomplete representation (202, 217).

33. Richard Wollheim, *Painting as an Art* (Princeton: Princeton University Press, 1987), 21, 46.

34. Ibid., 46.

35. Werner Wolf writes of the "intrapictorial elements triggering a narrative script" in visual art, though his account explains the ways a picture's representational contents "frame" a story ("Framings of Narrative in Literature and the Pictorial Arts," in *Storyworlds Across Media: Toward a Media-Conscious Narratology*, ed. Marie-Laure Ryan and Jan-Noël Thon [Lincoln: University of Nebraska Press, 2014], 142).

36. Gerald Prince, "Narrativehood, Narrativeness, Narrativity, Narratability," in *Theorizing Narrativity*, ed. John Pier and José Angel García Landa (Berlin and New York: Walter de Gruyter, 2008), 19.

37. David Herman, "Scripts, Sequences, and Stories: Elements of a Postclassical Narratology," *PMLA* 112, no. 5 (October 1997): 1048.

38. D. A. Miller, *Narrative and Its Discontents: Problems of Closure in the Traditional Novel* (Princeton: Princeton University Press, 1981), ix–x.

39. House, *Impressionism,* 181.

40. Ibid.

41. Ibid., 173.

42. Ross King, *The Judgment of Paris: The Revolutionary Decade That Gave the World Impressionism* (New York: Walker, 2006), 349.

43. Albert Boime, *Art and the French Commune: Imagining Paris After War and Revolution* (Princeton: Princeton University Press, 1995), 7–8.

44. Ibid., 27.

45. Ibid., 7.

46. Paul Tucker, "The First Exhibition 1874: The First Exhibition in Context," in Moffett, *The New Painting,* 106.

47. Nicholas Green, "Dealing in Temperaments: Economic Transformation of the Artistic Field in France During the Second Half of the Twentieth Century," in Lewis, ed., *Critical Readings in Impressionism and Post-Impressionism,* 41.

48. Tucker, "The First Exhibition 1874," 110.

49. See Walter Besant, *The Art of Fiction* (London: Chatto and Windus, 1902), 5; Henry James, "The Art of Fiction," in *The Art of Criticism: Henry James on the Theory and Practice of Fiction*, ed. William Veeder and Susan Griffin (Chicago: University of Chicago Press, 1986), 170.

50. Ford Madox Ford, *Joseph Conrad: A Personal Remembrance* (London: Duckworth, 1924), 182.

51. Virginia Woolf, "Modern Novels," in *The Essays of Virginia Woolf,* Vol. 3: 1919–1924, ed. Andrew McNeillie (New York: Harcourt Brace Jovanovich, 1991), 33.

52. See Ian Watt, *Conrad in the Nineteenth Century* (Berkeley: University of California Press, 1981), 168–180; Michael Levenson, *A Genealogy of Modernism: A Study of English Literary Doctrine 1908–1922* (Cambridge: Cambridge University Press, 1986), 30–36, 105–119; Paul Armstrong, *The Challenges of Bewilderment: Understanding and Representation in James,*

Conrad, and Ford (New York: Cornell University Press, 1987); Tamar Katz, *Impressionist Subjects: Gender, Interiority, and Modernist Fiction in England* (Urbana: University of Illinois Press, 2000); John Peters, *Conrad and Impressionism* (Cambridge: Cambridge University Press, 2001); Adam Parkes, *A Sense of Shock: The Impact of Impressionism on Modern British and Irish Writing* (Oxford: Oxford University Press, 2011); Max Saunders, *Self-Impression: Life-Writing, Autobiografiction, and the Forms of Modern Literature* (Oxford: Oxford University Press, 2010).

53. For a discussion of impressionism in the work of Rimbaud and other French poets see Aimee Israel-Pelletier, *Rimbaud's Impressionist Poetics: Vision and Visuality* (Cardiff: University of Wales Press, 2012), which expressly disagrees with my way of defining literary impressionism in terms of the practice and the thematics of perceptual emergence and rightly suggests that it might be "more varied in its outcomes" (2).

54. Watt, *Conrad in the Nineteenth Century*, 177.

55. Parkes, *A Sense of Shock*, 99–145.

56. Joseph Conrad, *Heart of Darkness* (London: J. M. Dent & Sons, 1946), 109.

57. Roger Fry, "The Post-Impressionists," in *The Roger Fry Reader*, ed. Christopher Reed (Chicago and London: University of Chicago Press, 1996), 81, 82.

58. Ibid., 82.

59. Arnold Hauser, *The Social History of Art*, Vol. 4: Naturalism, Impressionism, the Film Age (New York: Vintage, n.d.), 229–230.

60. José Ortega y Gasset, "On Point of View in the Arts," in *The Dehumanization of Art and Other Essays on Art, Literature, and Culture* (Princeton: Princeton University Press, 1968), 124–125. For one of the first observations of the transition see also Guillaume Apollinaire, "Cubism Differs" (1913), in *Manifesto: A Century of Isms*, ed. Mary Ann Caws (Lincoln: University of Nebraska Press, 2001), 124.

61. Yves-Alain Bois and Rosalind Kraus, *Formless: A User's Guide* (Cambridge: MIT Press, 1997), 28.

62. Clement Greenberg, "Cézanne" (1951), in *Art and Culture* (New York: Beacon, 1961), 52.

63. Ibid., 53.

64. D. H. Lawrence, qtd. in Joseph J. Rishel, "A Century of Cézanne Criticism II: From 1907 to the Present," in *Cézanne*, ed. Françoise Cachin, Isabelle Cahn, Walter Feilchenfeldt, Henri Loyrette, and Joseph J. Rishel (Philadelphia: Philadelphia Museum of Art, 1996), 57.

65. Qtd. in William H. Gerdts, *Monet's Giverny: An Impressionist Colony* (New York: Abbeville Press, 1993), 193.

66. Bruce Weber, *The Giverny Luminists: Frieseke, Miller and Their Circle* (New York: Berry-Hill Galleries, 1995), 10.

67. Gerdts, *Monet's Giverny*, 165.

68. Sarah Vure, ed., *Circles of Influence: Impressionism to Modernism in Southern Californian Art* (Newport Beach, CA: Orange County Museum of Art, 2000), 39.

69. Gerdts, *Monet's Giverny*, 40.

70. Aileen O'Bryan, qtd. in Nicholas Kilmer, "Frederick Carl Frieseke: A Biography," in *Frederick Carl Frieseke: The Evolution of an American Impressionist*, Guest Curator Nicholas

Kilmer, Catalogue and Exhibition Coordinator Linda McWhorter (Savannah: Telfair Museum of Art and Princeton University Press, 2001), 33.

71. David Sellin, "Frieseke in Le Pouldu and Giverny: The Black Gang and the Giverny Group," in *Frederick Carl Friesecke: The Evolution of an American Impressionist*, Guest Curator Nicholas Kilmer, Catalogue and Exhibition Coordinator Linda McWhorter (Savannah: Telfair Museum of Art and Princeton University Press, 2001), 83; William Low, "In an Old French Garden," *Scribner's Magazine* 32, no. 1 (July 1902): 13.

72. David Sellin, *Americans in Brittany and Normandy 1860–1910* (Phoenix, AZ: Phoenix Art Museum, 1982), 80.

73. Clara MacChesney, "Frieseke Tells Some of the Secrets of His Art," *The New York Times* (June 7, 1914), SM7.

74. Ibid.

75. Jacques Rancière, *Aisthesis: Scenes from the Aesthetic Regime of Art*, trans. Zakir Paul (London: Verso, 2013), 139.

76. Ibid.

77. One good index of "contemporary impressionism" as a public practice is the set of works and texts posted to *Art Index*, at https://www.artfinder.com/story/contemporary-impressionism/, where an array of images for sale promises to "bring tranquility and warmth to your home." One advertisement for a corporate-art business suggests that impressionist pictures convert love of art into business success: "Impressionist oil painting reproductions will create a powerful and memorable message to your customers and help you stand out from the competition. The richness and vibrancy of Impressionist oil paintings creates a feeling of timeless elegance. With the unique wide appeal and non-offensive nature of Impressionism, our museum quality reproductions make an ideal choice for the hospitality and corporate industry" ("Impressionist Art Gallery," http://www.impressionist-art-gallery.com/, accessed June 10, 2013).

78. Clement Greenberg, "Avant-Garde and Kitsch" (1939), in *Art Theory and Criticism: An Anthology of Formalist, Avant-Garde, Contextualist, and Post-Modernist Thought*, ed. Sally Everett (Jefferson, NC: McFarland and Company, 1991), 35. See chapters 2 and 6 for fuller accounts of kitsch.

79. Steven Fox, *The Mirror Makers: A History of American Advertising and Its Creators* (New York: William Morrow, 1984), 25.

80. Herbert Adams Gibbons, *John Wanamaker*, Vol. 2 (New York: Harper and Brothers, 1926), 72; Kilmer, "Frederick Carl Frieseke," 26.

81. Gibbons, *John Wanamaker*, 73–74. Kilmer also cites this passage, to suggest that Wanamaker's patronage may have been a "mixed blessing" ("Frederick Carl Frieseke," 26).

82. Ibid., 74.

83. Weber, *The Giverny Luminists*, 8.

84. Ibid., 10.

85. Charles H. Caffin, "Some New American Painters in Paris," *Harper's Monthly Magazine* 118, no. 704 (January 1909): 291.

86. H. Barbara Weinberg, "Frieseke's Art Before 1910," in Kilmer and McWhorter, *Frederick Carl Friesecke*, 53–54.

87. Robert Herbert, *Impressionism: Art and Leisure in Parisian Society* (New Haven: Yale University Press, 1988); Ruth Iskin, *Modern Women and Parisian Consumer Culture in Impressionist Painting* (Cambridge: Cambridge University Press, 2007), 115.

88. John House, "Monet: The Last Impressionist?," in *Monet in the Twentieth Century*, ed. Paul Hayes Tucker with George T. M. Shackleford and MaryAnne Stevens (New Haven: Yale University Press, 1998), 10. See also House on the way Monet protected his haystacks from the wrong natural effects (6), and Paul Hayes Tucker for an extensive account of Monet's elaborate efforts to construct nature at Giverny ("The Revolution in the Garden: Monet in the Twentieth Century," in Tucker et al., 37–50).

89. Christopher Palmer, *Impressionism in Music* (New York: Charles Scribner's Sons, 1973), 19.

90. Ronald Byrnside, "Musical Impressionism: The Early History of the Term," *The Musical Quarterly* 66, no. 4 (October 1980): 524–525.

91. Louis Laloy, "Claude Debussy and Debussyism," in *Louis Laloy (1874–1944) on Debussy, Ravel and Stravinsky*, ed. and trans. Deborah Priest (Aldershot, England and Brookfield, VT: Ashgate, 1999), 85–98.

92. Byrnside, "Musical Impressionism," 537.

93. Ibid., 523.

94. Palmer, *Impressionism in Music*, 20.

95. Arnold Schoenberg, "From Composition with Twelve Tones," in *Source Readings in Music History*, rev. ed., ed. Robert P. Morgan (New York: Norton, 1998), 86–87.

96. Palmer, *Impressionism in Music*, 28.

97. Leon Botstein, "Beyond the Illusion of Realism: Painting and Debussy's Break with Tradition," in *Debussy and His World*, ed. Jane F. Fulcher (Princeton: Princeton University Press, 2001), 157.

98. Ibid., 160.

99. Ibid., 161.

2. THE IMPRESSIONIST ADVERTISEMENT

1. Linda Nochlin, *The Politics of Vision: Essays on Nineteenth-Century Art and Culture* (London: Thames and Hudson, 1989), 64. Nochlin here reports on Pissarro's worries, and, in her description of Pissarro's relationship to impressionism gone bad, sketches a tendency contrary to the one described here.

2. Castagnary qtd. in John Rewald, *The History of Impressionism*, Vol. 1 (New York: The Museum of Modern Art, 1961), 330.

3. Raymond Williams, "The Magic System," *New Left Review* 1, no. 4 (July–August 1960): 27, 29.

4. Michelle H. Bogart, *Advertising, Artists, and the Borders of Art* (Chicago: University of Chicago Press, 1995), 143.

5. Marchand qtd. in Bogart, *Advertising, Artists, and the Borders of Art*, 139.

6. Len Lye, dir., *The Birth of the Robot* (1935), *The British Avant-Garde in the Thirties*, DVD, British Film Institute, 2000.

7. John Hewitt, "The 'Nature' and 'Art' of Shell Advertising in the Early 1930s," *Journal of Design History* 5, no. 2 (1992): 133.

8. Ibid.

9. "Surrealism Pays," *Newsweek* (January 3, 1944): 57–58.

10. Irving Howe, "The Idea of the Modern," qtd. in Matei Calinescu, *The Five Faces of Modernity: Modernism, Avant-Garde, Decadence, Kitsch, Postmodernism* (Durham: Duke University Press, 1987), 121; Clement Greenberg, "Avant-Garde and Kitsch," (1939), in *Art Theory and Criticism: An Anthology of Formalist, Avant-Garde, Contextualist, and Post-Modernist Thought*, ed. Sally Everett (Jefferson, NC: McFarland and Company, 1991), 10.

11. Leslie Fiedler, "Death of Avant-Garde Literature," qtd. in Calinescu, *The Five Faces of Modernity*, 121; Terry Eagleton, "Capitalism, Modernism, and Postmodernism," *New Left Review* 152 (July/August 1985): 67; Bruce Robbins, "Modernism in History, Modernism in Power," in *Modernism Reconsidered*, ed. Robert Kiely, Harvard English Studies 11 (Cambridge, MA: Harvard University Press, 1983), 237.

12. Robbins, "Modernism in History," 238; Benjamin H. D. Buchloh, "Figures of Authority, Ciphers of Regression: Notes on the Return of Representation in European Painting," *October* 16 (Spring 1981): 55.

13. Stephen R. Fox, *The Mirror Makers: A History of American Advertising and Its Creators* (Urbana and Champaign: University of Illinois Press, 1984), 113.

14. "Does 'Atmosphere' Advertising Make Good?" *Printers' Ink* 77, no. 4 (October 26, 1911): 48.

15. Commercial Art Director, "Making the Pictorial Contrast Sharp," *Printers' Ink* 111, no. 8 (May 20, 1920): 113.

16. Pamela Miles Homer, qtd. in Shintaro Okazaki, Barbara Mueller, and Charles R. Taylor, "Measuring Soft-Sell Versus Hard-Sell Advertising Appeals," *Journal of Advertising* 39, no. 2 (Summer 2010): 6.

17. Okazaki et al., "Measuring Soft-Sell Versus Hard-Sell Advertising Appeals," 13, 17.

18. Greenberg, "Avant-Garde and Kitsch," 32.

19. Thibebauly-Sisson, "Claude Monet: An Interview," *Le Temps* (November 27, 1900), qtd. in Rewald, *The History of Impressionism*, 50.

20. Henry James, "Preface to *The Princess Casamassima*," in *The Art of the Novel: Critical Prefaces by Henry James* (New York: Charles Scribner's Sons, 1946), 59.

21. James, "The Art of Fiction," in *Henry James and Robert Louis Stevenson: A Record of Friendship*, ed. Janet Adam Smith (London: Rupert Hart-Davis, 1948), 62.

22. T. J. Clark, *The Painting of Modern Life: Paris in the Art of Manet and His Followers* (New York: Knopf, 1985), 268.

23. James H. Rubin, *Impressionism* (London: Phaidon, 1999), 376.

24. Ibid.

25. Clark, *The Painting of Modern Life*, 267–268.

26. See Georg Lukács, "The Ideology of Modernism," in *Realism in Our Time: Literature and the Class Struggle* (New York: Harper & Row, 1962), 17–46; Fredric Jameson, *The Political*

Unconscious: Narrative as a Socially Symbolic Act (Ithaca, NY: Cornell University Press, 1981), 210–215.

27. Walter Benjamin, "The Work of Art in the Age of Mechanical Reproduction," in *Illuminations*, ed. Hannah Arendt (New York: Harcourt Brace Jovanovich, 1968), 222.

28. Theodor Adorno, "On the Fetish Character in Music and the Regression of Listening," in *The Culture Industry: Selected Essays on Mass Culture*, ed. J. M. Bernstein (London and New York: Routledge, 1991), 32.

29. Williams, "The Politics of the Avant-Garde," in *The Politics of Modernism* (London: Verso, 1989), 62; Andreas Huyssen, *After the Great Divide: Modernism, Mass Culture, Postmodernism* (Bloomington: Indiana University Press, 1986), 161.

30. Thomas Frank, *The Conquest of Cool: Business Culture, Counterculture, and the Rise of Hip Consumerism* (Chicago: University of Chicago Press, 1997), 39, 47, 53, 47.

31. Jackson Lears, *Fables of Abundance: A Cultural History of Advertising in America* (New York: Basic Books, 1994), 342–343.

32. David Bordwell, *The Cinema of Eisenstein* (Cambridge, MA: Harvard University Press, 1993), 121; Arthur McCullough, "Eisenstein's Regenerative Aesthetics: From Montage to Mimesis," *The Montage Principle: Eisenstein in New Cultural and Critical Context*, ed. Jean Antoine-Dunne with Paula Quigley (Amsterdam and New York: Rodopi, 2004), 51.

33. Ibid. See also Tristan Donovan, *Fizz: How Soda Shook Up the World* (Chicago: Chicago Review Press, 2013), for an account of this campaign: "Pepsi set out to align itself with the hopes and dreams of baby boomers. . . . Pepsi gave director Ed Vorkapich free rein. . . . On seeing the result one outraged Pepsi executive moaned that Vorkapich had delivered an art film when he was supposed to be making an ad. . . . Coca-Cola's warm and gentle scenes of suburban life and things going better with Coke seemed tame and conservative by comparison" (183). Donovan notes, however, that Vorkapich had been influenced by Leni Riefenstahl, though Vorkapich's own father, the Serbian American cinematographer Slavko Vorkapich, was such a noted innovator in cinematic montage that film scripts of the 1930s and 1940s often used the simple notation "Vorkapich" to indicate a montage sequence. Ed Vorkapich claimed that the advertising ought to "create an emotional response with a visual language" (Michael Dawson, *The Consumer Trap: Big Business Marketing and American Life* [Urbana and Champaign: University of Illinois Press, 2003], 100).

34. Pepsico, "You've Got a Lot to Live, and Pepsi's Got a Lot to Give," Pepsi Cola advertisement, 1969, Pepsi Generation Oral History & Documentation Collection, Archives Center, National Museum of American History, Smithsonian Institution. Pepsi Co. could not give permission to reprint stills of this advertisement, but it can be seen at https://www.youtube.com/watch?v=X7l3FxHiqyQ.

35. Jean Baudrillard, *Simulacra and Simulation*, trans. Sheila Faria Glaser (Ann Arbor: University of Michigan Press, 1994), 87.

36. Jonathan Crary, *Suspensions of Perception: Attention, Spectacle, and Modern Culture* (Minneapolis: University of Minnesota Press, 1999), 49.

37. Ibid., 30. Here I follow Howard Eiland, whose "Reception in Distraction" (*boundary 2* 30, no. 1 [2003]: 51–66) explores the "famous Benjaminian ambivalence" about the "new

kinetic apperception" Benjamin saw "coming into being in all areas of contemporary art," and looks for ways to resolve that ambivalence into a rigorous theory of "productive distraction" (60). See below for my account of the way the dialectic of attention and distraction amounts to something productive—to what Eiland calls a "spur to new ways of perceiving."

38. Ibid., 150.

39. Ibid.

40. Ibid., 152, 328.

41. Ibid., 344.

42. Ibid., 152.

43. James, "Art of Fiction," 51.

44. Howard Eiland, "Reception in Distraction," *boundary 2* 30, no. 1 (2003): 56.

45. Ibid., 53, 61.

46. Crary, *Suspensions of Perception*, 148.

47. Eagleton, "Capitalism, Modernism, and Postmodernism," 67.

48. Jackson Lears, *Fables of Abundance: A Cultural History of Advertising in America* (New York: Basic Books, 1995), 88, 55, 139.

49. Ibid., 169.

50. Ronald Berman, "Origins of the Art of Advertising," *Journal of Aesthetic Education* 17, no. 3 (Autumn 1983): 62.

51. Ibid., 63.

52. Ibid., 64.

53. Ibid.

54. Lears, *Fables of Abundance*, 169, 329. The exceptions, ironically, occur in the totalitarian cultures of this moment, as Karen Pinkus proves in her extensive survey of the modernist forms of fascist advertising in Italy (*Bodily Regimes: Italian Advertising Under Fascism* [Minneapolis: University of Minnesota Press, 1995]).

55. Roland Marchand, *Advertising the American Dream: Making Way for Modernity, 1920–1940* (Berkeley: University of California Press, 1985), 142, 148.

56. Lears, *Fables of Abundance*, 380.

57. Paul Parker, "The Modern Style in American Advertising Art," *Parnassus* 9, no. 4 (April 1937): 20–21.

58. Ibid.

59. Ibid.

60. Lye sought got commercial sponsorship through John Grierson, a producer who "agreed to promote the film if lively music and a few advertising slogans were added." Thereafter Lye made a number of films for the General Post Office (see Roger Horrocks, "Len Lye's Films," in *Len Lye: A Personal Mythology*, ed. Ron Brownson [Auckland: Auckland City Art Gallery, 1980], 28). For the history of the collaboration between the General Post Office and its film unit, see Paul Swann, *The British Documentary Film Movement, 1926–1946* (Cambridge: Cambridge University Press, 1989).

61. Len Lye, dir., *A Colour Box* (1935), *The British Avant-Garde in the Thirties*, British Film Institute, 2000.

62. Daniel O'Hara and Alan Singer, "Thinking Through Art: Reimagining the Aesthetic Within Global Modernity," *boundary 2* 25, no. 1 (Spring 1998): 2.

63. Ibid., 4.

64. Jacques Rancière, *Aisthesis: Scenes from the Aesthetic Regime of Art*, trans. Zakir Paul (London: Verso, 2013), x.

65. Ibid.

66. Max Horkheimer and Theodor W. Adorno, *Dialectic of Enlightenment* (New York: Continuum, 1972), 125.

67. Andreas Huyssen, *After the Great Divide: Modernism, Mass Culture, Postmodernism* (Bloomington: Indiana University Press, 1987), 15.

68. G. F. Hartlaub, "Art as Advertising" (1928), reprinted in *Design Issues* 9, no. 2 (Autumn 1993): 73.

69. Ibid., 76.

70. Ibid.

71. Ibid.

72. Ibid.

73. See Anthony Vagnoni, "Creative Differences," *Advertising Age* (November 17, 1997), www.adage.com, accessed April 3, 2014; "The Swimmer," Levi Straus & Co., 1991, https://www.youtube.com/watch?v=-c8NSljbw8M, accessed September 21, 2013. The advertisement may have been adapted not directly from Cheever's short story but from the 1968 Frank Perry film based upon it.

74. John Cheever, "The Swimmer," *The Stories of John Cheever* (New York: Knopf, 1978), 607.

75. James Hurman, "First Impressions," *AdMedia* (December 2005): 32–36.

76. Ibid.

77. Greenberg, "Avant-Garde and Kitsch," 35.

78. Ibid.

3. *PHOTOGÉNIE* FROM RENOIR TO GANCE TO RENOIR

1. André Bazin, *Jean Renoir*, ed. François Truffaut, trans. W. W. Halsey II and William H. Simon (New York: Simon and Schuster, 1973), 84.

2. Ibid.

3. Ibid., 64, 85.

4. Ibid., 85.

5. Ibid., 87.

6. Ibid.

7. Ibid.

8. Ibid., 108.

9. See William Henry Fox Talbot in Alan Trachtenberg, ed., *Classic Essays on Photography* (New Haven, CT: Leete's Island Books, 1980), 29. See also Aaron Scharf's explanation of this link and his claim that "a derogatory association with the images of the camera"

helped give impressionist painting its name (*Art and Photography* [New York: Penguin, 1979], 350).

10. Poe in Trachtenberg, *Classic Essays on Photography*, 38.

11. Kracauer in Trachtenberg, *Classic Essays on Photography*, 249; McNamara, "The Aesthetic of the Instant: Painting and Photography in Normandy," in *The Lens of Impressionism: Photography and Painting Along the Normandy Coast, 1850–1874* (Ann Arbor: University of Michigan Museum of Art, 2009), 29; and on the impressionists' response to photography see Scharf, *Art and Photography*, 161–179, Françoise Heilbrun, "Impressionism and Photography," *History of Photography* 33, no. 1 (February 2009): 18–25.

12. William J. Ivins, Jr., *Prints and Visual Communication* (New York: Da Capo Press, 1969), 144, 155.

13. See Baudelaire on the "photographic industry" as "the refuge of every would-be painter, every painter too ill-endowed or too lazy to complete his studies" and its "impoverishment of the French artistic genius" ("The Modern Public and Photography," in "The Salons of 1859," in *Art in Paris, 1845–1862: Salons and Other Exhibitions, Reviewed by Charles Baudelaire*, trans. and ed. Jonathan Mayne [London: Phaidon Publishers, 1965], 153).

14. Weston in Trachtenberg, *Classic Essays on Photography*, 170.

15. Henry Peach Robinson in Trachtenberg, *Classic Essays on Photography*, 92.

16. Ibid., 94.

17. Ibid., 96.

18. Bazin in Trachtenberg, *Classic Essays on Photography*, 240; Bazin notes that photography "freed Western painting, once and for all, from its obsession with realism and allowed it to recover its aesthetic autonomy. Impressionist realism, offering science as an alibi, is at the opposite extreme from eye-deceiving trickery" (243).

19. Kracauer in Trachtenberg, *Classic Essays on Photography*, 258.

20. Kaja Silverman, *The Miracle of Analogy, or The History of Photography, Part I* (Stanford, CA: Stanford University Press, 2015), 118.

21. Dudley Andrew, *Mists of Regret: Culture and Sensibility in French Film* (Princeton: Princeton University Press, 1995), 34.

22. David Bordwell, "French Impressionist Cinema: Film Culture, Film Theory, and Film Style," Ph.D. diss., University of Iowa, 1974, 16.

23. Louis Delluc, "Beauty in the Cinema" (1917), qtd. in Laura Marcus, *The Tenth Muse: Writing About Cinema in the Modernist Period* (Oxford: Oxford University Press, 2007), 182.

24. Germaine Dulac, "Aesthetics, Obstacles, Integral *Cinégraphie*," in *French Film Theory and Criticism: A History/Anthology, 1907–1939*, Vol. 1: 1907–1929, ed. Richard Abel, 389–390 (Princeton, NJ: Princeton University Press, 1988).

25. Ibid., 390.

26. Ibid., 391.

27. Ibid., 393–394.

28. Ibid., 394.

29. Ibid.

30. Ibid., 397.

31. Louis Delluc, "Beauty in the Cinema" (1917), in Abel, *French Film Theory and Criticism*, 137.

32. Marcel Gromaire, "A Painter's Ideas About the Cinema," in Abel, *French Film Theory and Criticism*, 176.

33. Elie Faure, "The Art of Cineplastics" (1922), trans. Walter Pach, in Abel, *French Film Theory and Criticism*, 261; Ricciotto Canudo, "Reflections on the Seventh Art," trans. Claudia Gorbman, in Abel, *French Film Theory and Criticism*, 296; Dulac, "Expressive Techniques," 305.

34. Ezra Pound, *Gaudier-Brzeska: A Memoir* (New York: New Directions, 1974), 89. The observation continues: "The state of mind of the impressionist tends to become cinematographical. Or, to put it another way, the cinematograph does away with the need of a lot of impressionist art."

35. Bordwell, "French Impressionist Cinema," 273.

36. Ibid.

37. Ibid., 285.

38. Ibid., 279.

39. Louis Delluc, *Photogénie* (Paris: Maurice de Brunoff, 1920), 13.

40. Ibid., 9.

41. Jean Epstein, "On Certain Characteristics of *Photogénie*," trans. Tom Milne, in *Film Theory: Critical Concepts in Media and Cultural Studies*, Vol. 1, ed. Philip Simpson, Andrew Utterson, and K. J. Shepherdson (Oxford: Routledge, 2004), 52–53.

42. Ibid., 52.

43. Ibid., 53.

44. Ibid., 55.

45. Ibid., 55–56.

46. Jean Epstein, "The Senses 1(b)," in Abel, *French Film Theory and Criticism*, 243.

47. Mary Ann Doane, "The Close-Up: Scale and Detail in the Cinema," *differences* 14, no. 3 (2003): 89.

48. Sarah Cooper, *The Soul of Film Theory* (Houndmills: Palgrave Macmillan, 2013), 39; Ian Aitken, *European Film Theory and Cinema: A Critical Introduction* (Bloomington: Indiana University Press, 2001), 82; Marcus, *The Tenth Muse*, 182.

49. Bordwell, "French Impressionist Cinema," 126.

50. Christian Metz, *The Imaginary Signifier: Psychoanalysis and the Cinema*, trans. Celia Briton et al. (Bloomington: Indiana University Press), 76.

51. Paul Willemen, *Looks and Frictions: Essays in Cultural Studies and Film Theory* (Bloomington: Indiana University Press, 1994), 128, 126.

52. Ibid., 129.

53. Ibid., 131.

54. Ibid., 132.

55. Ibid., 124.

56. Gilles Deleuze, *Cinema 1: The Movement-Image*, trans. Hugh Tomlinson and Barbara Habberjam (Minneapolis: University of Minnesota Press, 1986), 41.

57. Bordwell, "French Impressionist Cinema," 257.

58. Fernand Léger, "*La Roue:* Its Plastic Quality" (1922), in Abel, *French Film Theory and Criticism*, 272.

59. Lucy Fischer, "*La Roue:* Movies, Modernity, Machine, Mind," *Modernism/modernity* 20, no. 2 (2013): 194.

60. Deleuze, *Cinema 1*, 42.

61. *La Roue,* dir. Abel Gance (1922), DVD (Flicker Valley, LLC, 2008), I, 3:06.

62. Ibid., I, 10:22.

63. Ibid., I, 37:24.

64. Ibid.

65. Georges Sadoul, "L'École *Impressionniste* (1920–1927)," in *Le Cinéma Français* (Paris: Flammarion, 1962), 32. Norma's mobility might be compared to that of Charlie Chaplin, who has been seen to embody filmic movement in such a way as to justify and to parody it. See Jacques Rancière, *Aisthesis: Scenes from the Aesthetic Regime of the Art* (London: Verso, 2013), 196.

66. Gance, *La Roue,* I, 1:54:34.

67. Mulvey's "Visual Pleasure in Narrative Cinema" sharpens the point of the psychoanalytic reaction against the mystifications of *photogénie* by explaining how and why "fetishistic scopophilia . . . builds up the physical beauty of the object, transforming it into something satisfying in itself," how "the beauty of woman as object and the screen space coalesce" (*Visual and Other Pleasures* [Bloomington: Indiana University Press, 1989], 21, 22). Willemen draws upon Mulvey and subsequent expansions of the critique of fetishistic scopophilia when he makes the denials of *photogénie* cause to reject impressionism as a coherent, viable movement.

68. Alan Williams, *Republic of Images: A History of French Filmmaking* (Cambridge: Harvard University Press, 1992), 90.

69. Gance, *La Roue,* II, 1:35:57.

70. Ibid., 1:36:37.

71. Deleuze, *Cinema 1*, 46, emphasis added.

72. Ibid., 48.

73. Ibid.

74. Ibid.

75. Ibid., 42.

76. Ibid., 46.

77. Ibid., 43.

78. Ibid., 16.

79. Tamar Garb, "Renoir and the Natural Woman," *The Oxford Art Journal* 8, no. 2 (1985): 3. For more on the gender ideology of impressionism, see Norma Broude, *Impressionism: A Feminist Reading: The Gendering of Art, Science, and Nature in the Nineteenth Century* (Boulder, CO: Westview Press, 1997), which explains how impressionism, following romanticism, "appropriated feminine subjectivity for the arts" (15); and Tamar Katz's explanation of the ways "feminine subjectivity centers . . . impressionist fiction" (*Impressionist Subjects: Gender, Interiority, and Modernist Fiction in England* [Urbana: University of Illinois Press, 2000], 199).

80. Kelly Basílio argues that the story shares with impressionist painting "une tentative simi-
 laire de rendre [la] vibration lumineuse," and William J. Berg explores not only Maupas-
 sant's impressionism but also his story's debt to *La balançoire* specifically, as well as "the
 theme of the gaze" shared in common among these artists. Basílio, "Trilles et frétille-
 ments: L'écriture 'impressionist' du désir dans 'Une partie de campagne' de Maupassant,"
 in *Guy de Maupassant: Études réunies par Noëlle Benhamou* (Amsterdam: Rodopi, 2007),
 33; Berg, *Imagery and Ideology: Fiction and Painting in Nineteenth-Century France* (New-
 ark: University of Delaware Press, 2007), 208–209, 212, 213.
81. Seymour Chatman, "What Novels Can Do That Films Can't (and Vice Versa)," *Critical
 Inquiry* 8 (180): 133–139.
82. Bazin, *Jean Renoir*, 131.
83. Ibid.
84. Peter Marks, "From 'Moulin Rouge!' to Puccini; Next for Baz Luhrmann, Bringing 'La
 Bohème' to Broadway," *New York Times* (March 14, 2002), nytimes.com, accessed Oc-
 tober 12, 2013; David Denby, "The Film File: Moulin Rouge!," *The New Yorker*, www
 .newyorker.com, accessed October 12, 2013.
85. *Moulin Rouge!*, dir. Baz Lurhmann, DVD (20th Century Fox, 2003), 1:11:57.
86. Baz Luhrmann, *Moulin Rouge!*, DVD Information.
87. *Moulin Rouge!* 1:59:10.

4. THE "IMAGE OF AFRICA" FROM CONRAD
TO ACHEBE TO ADICHIE

1. Chinua Achebe, "An Image of Africa: Racism in Conrad's *Heart of Darkness*," *Massa-
 chusetts Review* 18, no. 4 (Winter 1977); Stephen Ross, *Conrad and Empire* (Columbia:
 University of Missouri Press, 2004), 4.
2. Achebe, "An Image of Africa: Racism in Conrad's *Heart of Darkness*," in *Hopes and Im-
 pediments* (New York: Anchor Books, 1988), 12.
3. Ibid., 10.
4. Stephen Ross and Christopher GoGwilt have explained the frames of reference Conrad
 might have brought to bear: see *Conrad and Empire* and Christopher GoGwilt, *The In-
 vention of the West: Joseph Conrad and the Double-Mapping of Europe and Empire* (Stan-
 ford, CA: Stanford University Press, 1995).
5. Achebe, "An Image of Africa," 4–5.
6. Joseph Conrad, *Heart of Darkness* (London: J. M. Dent and Sons, 1946), 96.
7. Chinua Achebe, "African Literature as Restoration of Celebration," in *The Education of a
 British Protected Child* (New York: Penguin, 2009), 118.
8. Achebe, "An Image of Africa," 118.
9. Nicholas Brown, *Utopian Generations: The Political Horizon of Twentieth-Century Lit-
 erature* (Princeton, NJ: Princeton University Press, 2005), 32; Abdul JanMohamed, *Man-
 ichean Aesthetics: The Politics of Literature in Colonial Africa* (Amherst: University of
 Massachusetts Press, 1983), 160, 161.

10. Kwaku Larbi Korang, "Making a Post-Eurocentric Humanity: Tragedy, Realism, and *Things Fall Apart*," *Research in African Literatures* 42, no. 2 (Summer 2011): 7.

11. Ibid., 6.

12. Ibid., 8.

13. See C. L. Innes and Bernth Lindfors, "Introduction," *Critical Perspectives on Chinua Achebe* (London: Heinemann, 1978), for the "emergence of a 'School of Achebe' in Nigerian fiction" (6).

14. Edward Said's "Two Visions in *Heart of Darkness*" stresses the way Conrad's narrative forms "draw attention to themselves as narrative constructions" and foreground a "discrepancy between the orthodox and [Conrad's] own view of empire" in such a way as to deconstruct the sort of mystifying romance Achebe deplores (*Culture and Imperialism* [New York: Knopf, 1993], 28–29).

15. Georg Lúkacs, "The Ideology of Modernism," in *Realism in Our Time: Literature and the Class Struggle*, trans. John and Necke Mander (New York: Harper & Row, 1964), 24; *Studies in European Realism* (1950), trans. Edith Bone (New York: Grosset and Dunlap, 1964), 6.

16. Lukács, *Studies in European Realism*, 6.

17. Ibid., 8.

18. Eric Ashby, *Universities: British, Indian, African: A Study in the Ecology of Higher Education* (London: Weidenfeld and Nicholson, 1966), 215.

19. Apollos O. Nwauwa, *Imperialism, Academe, and Nationalism: Britain and University Education for Africans, 1860–1960* (London: Frank Cass, 1997), 173.

20. Robert W. July, *An African Voice: The Role of the Humanities in African Independence* (Durham: Duke University Press, 1987), 164; Ashby, *Universities*, 241.

21. Nwauwa, *Imperialism, Academe, and Nationalism*, 208.

22. See Chinweizu Ibekwe, who notes that the Asquith Schools were designed "to meet Britain's needs for bureaucrats and for the protection of Britain's economic interests against African competition" and therefore "did not dare provide facilities for training Africans in entrepreneurial skills," instead emphasizing the liberal arts (*The West and the Rest of Us: White Predators, Black Slavers, and the African Elite* [London and Lagos: NOK Publishers, 1978], 324).

23. Gauri Viswanathan, *Masks of Conquest: Literary Study and British Rule in India* (New York: Columbia University Press, 1989), 10.

24. Chinua Achebe, "The Education of a British-Protected Child," in *The Education of a British-Protected Child*, 4.

25. Ngũgĩ wa Thiongo, *Decolonising the Mind: The Politics of Language in African Literature* (London: Heinemann, 1986), 70.

26. Brown, *Utopian Generations*, 1.

27. Simon Gikandi, "Globalization and the Claims of Postcoloniality," *The South Atlantic Quarterly* 100, no. 3 (Summer 2001), 652: See also Peter J. Kalliney's alternative argument that Leavis gave postcolonial writers like Ngũgĩ a model for the "articulation of . . . oppositional cultural imperatives" (*Commonwealth of Letters: British Literary Culture and the Emergence of Postcolonial Aesthetics* [Oxford and New York: Oxford University Press, 2013], 78).

28. Achebe, "The Education of a British-Protected Child," 21.

29. Achebe, "An Image of Africa," 3.

30. Lionel Trilling, "The Modern Element in Modern Literature," in *Varieties of Literary Experience*, ed. Stanley Burnshaw (New York: NYU Press, 1962), 415.

31. Bruce Robbins, "Modernism in History, Modernism in Power," in *Modernism Reconsidered*, ed. Robert Kiely, Harvard English Studies 11 (Cambridge, MA: Harvard University Press, 1983), 232; Fredric Jameson, "Postmodernism and Consumer Society," *The Anti-Aesthetic: Essays on Postmodern Culture*, ed. Hal Foster (Seattle: Bay Press, 1983), 124.

32. In a sense, Achebe responds against the aesthetic ideal articulated in the tradition represented by Freidrich Schiller, who, as David Lloyd has argued, defined a form of "aesthetic experience in which the individual becomes representative of the species" and, in turn, fit for the rational State ("Arnold, Ferguson, Schiller: Aesthetic Culture and the Politics of Aesthetics," *Cultural Critique* 2 [Winter 1985–1986]: 165). In other words, the idea that impressions become worthy of aesthetic experience only in relation to the larger prerogative of political institutions that naturalize them has a longer history.

33. Ngũgĩ wa Thiong'o, "Literature and Society: The Politics of the Canon," in *Writers in Politics*, rev. ed. (Oxford: James Currey, 1997), 11.

34. Ngũgĩ wa Thiong'o, *Decolonising the Mind* (London: Heinemann, 1986), 90.

35. Ngũgĩ, "Literature and Society," 11.

36. Carol Sicherman, "Ngũgĩ's Colonial Education: 'The Subversion . . . of the African Mind,'" *African Studies Review* 38, no. 3 (December 1995): 15, 24.

37. Sicherman, "Ngũgĩ's Colonial Education," 31.

38. Carol Sicherman, "Revolutionizing the Literature Curriculum at the University of East Africa: Literature and the Soul of a Nation," *Research in African Literatures* 29, no. 3 (Autumn 1998): 137.

39. Ngũgĩ, *Decolonising*, 87.

40. Ngũgĩ, "Literature and Society," 12–13.

41. Ibid., 18.

42. Ngũgĩ wa Thiong'o, "Writers in Politics: The Power of Words and Words of Power," in *Writers in Politics*, 72.

43. Ibid., 73.

44. Ibid., 76.

45. Simon Gikandi, *Ngũgĩ wa Thiong'o* (Cambridge: Cambridge University Press, 2000), 106.

46. Ezenwa-Ohaeto, *Chinua Achebe: A Biography* (Oxford: James Currey, 1998), 171.

47. Kalliney, *Commonwealth of Letters*, 212.

48. Gareth Griffiths, *African Literatures in English: East and West* (New York: Longman, 2000), 173.

49. Chinweizu, *The West and the Rest of Us*, 320.

50. Griffiths 173.

51. Jahan Ramazani, "Modernist Bricolage, Postcolonial Hybridity," *Modernism/modernity* 13, no. 3 (September 2006): 450. Ramazani's phrase refers to Okigbo and to A. K. Ramanujan.

52. Ezekiel Mphalele, "Voices in the Whirlwind: Poetry and Conflict in the Black World," *Voices in the Whirlwind and Other Essays* (London: Macmillan, 1973), 76–77.

53. Ibid., 2, 7.

54. Chinweizu, *The West and the Rest of Us*, 308.

55. See David James (and the discussion of his work in chapter 7) for a similar account of the way impressionism becomes responsible in contemporary fiction (*Modernist Futures: Innovation and Inheritance in the Contemporary Novel* [Cambridge: Cambridge University Press, 2012], 135–160).

56. Henry Louis Gates, *The Signifying Monkey: A Theory of African-American Literary Criticism* (Oxford: Oxford University Press, 1989), 118; Edward Said, *Culture and Imperialism* (New York: Knopf, 1993), xxv.

57. Byron Caminero-Santangelo, *African Fiction and Joseph Conrad: Reading Postcolonial Intertextuality* (Albany: SUNY Press, 2005), 4.

58. Buchi Emecheta, *Head Above Water* (1986; London: Heinemann, 1994), 19.

59. Ibid., 64.

60. Ibid.

61. Ibid., 66.

62. Ibid., 58.

63. Ibid.

64. Buchi Emecheta, *In the Ditch* (1972; London: Heinemann, 1994), 7.

65. Emecheta, *Head Above Water*, 67.

66. Emecheta, "Just an Igbo Woman," www.emeagwali.com, accessed May 19, 2013.

67. Here I refer to Kalliney's account of the ways "white and black, metropolitan and late colonial variants of modernism shared cultural institutions, collaborating on a project to rework the doctrine of aesthetic autonomy in the middle decades of the century," but the example of Emecheta and *The New Statesman* suggests that this sort of collaboration could also foster development of a colonial variant of a political aesthetic (*Commonwealth of Letters*, 9).

68. B. Kojo Laing, *Search Sweet Country* (San Francisco: McSweeney's Books, 2011), 326.

69. Ibid., 305.

70. Ibid., 309.

71. Ibid., 310.

72. Ibid., 309.

73. Ibid., 310.

74. Ibid., 311.

75. Barbara Kingsolver, *The Poisonwood Bible* (New York: HarperFlamingo, 1998), 36.

76. Lynda Prescott qtd. in Jennifer Wenzel, "Intertextual Africa: Chinua Achebe on the Congo, Patrice Lumumba on the Niger," in *African Writers and Their Readers: Essays in Honor of Bernth Lindfors*, Vol. 2, ed. Toyin Falola and Barbara Harlow (Trenton and Asmara: Africa World Press, 2002), 224; Héloïse Meire, "Women, A Dark Continent? *The Poisonwood Bible* as a Feminist Response to Conrad's *Heart of Darkness*," in *Seeds of Change: Critical Essays on Barbara Kingsolver*, ed. Priscilla Leder, 72 (Knoxville: University of Tennessee Press, 2010). See also Kingsolver's own account of her sources and goals ("Author's Note," *The Poisonwood Bible*, 9–10).

77. Here I quote Meire's summary of Pamela Demory's argument ("Women" 82). See Demoary, "Into the Heart of Light: Barbara Kingsolver Rereads *Heart of Darkness*," *Conradiana* 34, no. 3 (2002): 181–193.

78. Jed Esty might note that Kingsolver's impressionism is a symptom of colonial underdevelopment. See *Unseasonable Youth: Modernism, Colonialism, and the Fiction of Development* (Oxford: Oxford University Press, 2011), 22.

79. Barbara Kingsolver, "Barbara Kingsolver on the Long Gestation of *The Poisonwood Bible*," *The Guardian Review* (May 11, 2013): 6.

80. Ibid.

81. Ibid.

82. See Maya Jaggi, "A Life in Writing: Barbara Kingsolver," *The Guardian* (June 11, 2010), http://www.theguardian.com/books/2010/jun/12/life-in-writing-barbara-kingsolver, accessed June 18, 2015.

83. W. G. Sebald, *The Rings of Saturn* (1995), trans. Michael Hulse (New York: New Directions, 1998), 103–104.

84. Rebecca Walkowitz, *Cosmopolitan Style: Modernism Beyond the Nation* (New York: Columbia University Press, 2006), 163–164. Walkowitz's reading of Sebald's revision of *Heart of Darkness* (165–170) gives the full context for Sebald's cosmopolitan revision of Conrad's impressionism.

85. Sebald, *Rings of Saturn*, 122.

86. Ibid., 122–123.

87. Ibid., 125.

88. Ibid.

89. Even Sebald, who would have felt the difference between his early education at the Oberrealschule in Oberstdorf, premised upon a "highly idealistic Christian/humanist ethos," and the late 1960s University of Fribourg context that nurtured his dissertation on Carl Sternheim (Richard Sheppard, "Speech Day at Sebald's School, 1962 and 1963," *Journal of European Studies* 41, no. 3–4 [2011]: 203). See also Sheppard, "Sebald's Dissertation, University of Fribourg," *Journal of European Studies* 41, no. 3–4 (2011): 209–210.

90. Chimamanda Ngozi Adichie, "Strangely Personal: Growing Up in Chinua Achebe's House," *Pen America*, www.pen.org, accessed April 28, 2013.

91. This is to agree with Ian Baucom that Adichie pursues the "realism of the everyday," but to argue also that she advances that pursuit beyond the tradition of nineteenth-century realism through its impressionist intensification to a postrealist impressionism ("A Study in African Realism," *Public Books* [November 1, 2013], http://www.publicbooks.org/fiction/a-study-in-african-realism, accessed May 6, 2014).

92. Chimamanda Ngozi Adichie, *Half of a Yellow Sun* (London: Fourth Estate, 2009), 3.

93. Ibid., 56.

94. Ibid., 62.

95. Ibid., 72.

96. Ibid., 111.

97. Ibid., 167–168.

98. Ibid., 307.

99. Ibid., 425.

100. John Marx makes a similar argument about *Half of a Yellow Sun* in his account of the way the novel "reimagines the hierarchy of global administration" ("Failed-State Fiction," *Contemporary Literature* 49, no. 4 [2008]: 399).

101. Adichie, *Half of a Yellow Sun*, 32.

102. Ibid., 274.

103. Ibid., 274–275.

104. Ibid., 279.

105. Achebe, "The Education of a British-Protected Child," 116.

106. Chimamanda Ngozi Adichie, *Americanah* (London: Fourth Estate, 2013), 3.

107. Princeton is also a telling alternative to the University of London as a host for postcolonial fiction, since one important source of the reaction against the Asquith Schools in the early 1960s was the alternative American educational example. See Ashby, *Universities*, 242.

108. Adichie, *Americanah*, 155.

109. Ibid., 131.

110. Ibid., 296.

111. Ibid., 335–336.

112. Ibid., 256.

113. Ibid.

114. Ibid., 422.

5. THE IMPRESSIONIST FRAUD

1. John Ruskin, *The Works of John Ruskin*, ed. E. T. Cook and Alexander Wedderburn, 39 vols. (London: George Allen, 1903–1912), 29: 160.

2. Adam Parkes, *A Sense of Shock: The Impact of Impressionism on Modern British and Irish Writing* (Oxford: Oxford University Press, 2011), 23.

3. Qtd. in Paul Tucker, "The First Impressionist Exhibition in Context," in *The New Painting: Impressionism 1874–1886*, ed. Charles S. Moffett (San Francisco: The Fine Arts Museums of San Francisco, 1986), 109. Cardon actually wrote positively that "the scribblings of a child have a naivety, a sincerity which makes one smile, but the excesses of this school sicken and disgust."

4. Lévi-Strauss, "The Structural Study of Myth," *Structural Anthropology*, Vol. 1, trans. Claire Jacobson and Brooke Grundfest Schoepf (New York: Basic Books, 1963), 226.

5. Ibid.

6. Lewis Hyde, *Trickster Makes This World: Mischief, Myth, Art* (New York: Farrar, Straus and Giroux, 1998), 268, 53.

7. Yves Klein, "Truth Becomes Reality" (1960), qtd. in *Yves Klein: With the Void, Full Powers* (Minneapolis: Walker Art Center, 2010), 11.

8. Klaus Ottmann, ed., *Yves Klein: Works, Writings, Interviews* (Barcelona: Poligrafa, 2010), 57.

9. Thomas McEvilley, "Yves Klein: Messenger of the Age of Space," *Artforum* 20, no. 5 (January 1982): 38.

10. Ibid., 40, 38.

11. Sidra Stich, *Yves Klein* (Ostfildern: Hatje Cantz Publishers, 1995), 104.

12. Yves Klein, "The Monochrome Adventure: The Monochrome Epic," in Ottmann, *Yves Klein*, 136.

13. Yves Klein, *Dimanche* (*Le journal d'un seul jeur*, November 27, 1960, reprinted in conjunction with the exhibition *Yves Klein: With the Void, Full Powers*, Walker Arts Center, Minneapolis, MN, October 23, 2010–February 13, 2011, produced by the Hirshorn Museum and Sculpture Garden, Smithsonian Institution, Washington, DC), 4.

14. Stich, *Yves Klein*, 80.

15. Klein, "The Monochrome Adventure," 144; Stich, *Yves Klein*, 75.

16. Stich, *Yves Klein*, 53.

17. Ibid., 67.

18. McEvilley, "Yves Klein," 43, 61.

19. Nuit Banai, "From the Myth of Objecthood to the Order of Space: Yves Klein's Adventures in the Void," in *Yves Klein*, ed. Olivier Berggruen et al. (Ostfildern: Hatje Cantz Publishers, 2004), 19.

20. Klein, "The Monochrome Adventure," 143.

21. McEvilley, "Yves Klein," 45.

22. Jean-Michel Ribittes, "Yves Klein and the War of the Jealous Gods," in Berggruen et al., eds., *Yves Klein*, 156.

23. Klein, "Truth Becomes Reality," 1960, qtd. in Dante Hon Carlos and Eric Crosby, ed., *Gallery Guide: Yves Klein: With the Void, Full Powers*, Exhibition curated by Philippe Vergne and Kerry Brougher, Walker Arts Center, Minneapolis, MN, October 23, 2010–February 13, 2011, 11.

24. Klein, "Chelsea Hotel Manifesto," qtd. in Ottmann, ed., *Yves Klein*, 24; Ottmann, ed., *Yves Klein*, 24.

25. McEvilley, "Yves Klein," 51.

26. Claire Bishop, *Artificial Hells: Participatory Art and the Politics of Spectatorship* (London: Verso, 2012), 88, 89.

27. Fred Hiatt, "Japan's Highest Bidder; Tycoon Bought 2 Priciest Artworks Ever," *The Washington Post* (May 19, 1990), A1, www.washingtonpost.com, accessed June 3, 2013.

28. Terry McCarthy, "The Last of the Big Spenders," *The Independent* (November 16, 1993), www.independent.co.uk, accessed July 15, 2013.

29. Doug Struck, "Van Gogh's Portrait in Intrigue; World's Priciest Artwork is Missing Without a Trace," *Washington Post* (July 29, 1999), C1, www.washingtonpost.com, accessed July 15, 2013.

30. "Japanese Buying Spree," *Newsweek*, May 28, 1990.

31. "One Man, Two Masterpieces, and Many Questions in Japan," *The New York Times* (May 19, 1990), www.nytimes.com, accessed June 22, 2013.

32. McCarthy, "The Last of the Big Spenders."

33. Ibid.

34. Struck, "Van Gogh's Portrait in Intrigue."

35. Philip Hook, *The Ultimate Trophy: How the Impressionist Painting Conquered the World* (Munich and London: Prestel, 2009), 200.

36. A similar process abetted simple bribes: as the *South China Morning Post* reported, "Art sales could be used to conceal bribes. For example, a construction company might lend a politician money to buy one of van Gogh's early and poorly rated paintings. The politician would then sell the painting to the construction company for perhaps 10 times the price he paid for it and pocket the profit" ("Japan's Art Collections Pay for Excesses of Bubble-Economy," *South China Morning Post* [Hong Kong] [January 25, 1998], www .scmp.com, accessed June 22, 2013).

37. See K. Wieland, J. Donaldson, and S. Quintero, "Are Real Assets Priced Internationally? Evidence from the Art Market," *Multinational Finance Journal* 2, no. 3 (1998): 167–187.

38. As an article in the Canadian *Globe and Mail* reported, Japanese business moguls wanted art treasures recent enough to be subject to revaluation, and contemporary work was "too cheap to satisfy their ambitions" ("Japanese Business Moguls Hungry for Western Art Treasures," *The Globe and Mail* [January 13, 1990], www.theglobeandmail.com, accessed July 15, 2013).

39. Philip Hook argues by contrast that "French impressionist pictures, in what was already a dramatically rising market, were perfect for the purpose, because they had no fixed and provable value. They were worth what you wanted them to be worth" (*The Ultimate Trophy*, 200). Hook's own account suggests that impressionist pictures could not have served such a purpose if they didn't have some provable base value upon which increases would be plausible.

40. Struck, "Van Gogh's Portrait in Intrigue."

41. Art Buchwald, "The $82 Million Question," *Los Angeles Times* (May 29, 1990), C1, www .latimes.com, accessed July 15, 2013.

42. Fabian Bocart, Ken Bastiaensen, and Peter Cauwels, "The 1980s Price Bubble on (Post) Impressionism," ACEI Working Paper Series (November 2011), 3.

43. Ibid., 19.

44. The show's exhibition catalog emphasizes Japan's decisive effect on impressionism by noting that "Eprouvant le besoin de rénover la peinture issue de la tradition illusionniste qui s'est établie depuis la Renaissance, ces artistes voient dans l'exemple japonais une solution possible à leur problème" (19). *Le japonisme*'s decisive impact on impressionism made it "une esthétique qui va transformer totalement l'art de la peinture en Occident" (*Le Japonisme*, catalog for exhibitions at Galeries nationales du Grand Palais, Paris [17 mai–15 aout 1988] and Musée national d'art occidental Tokyo [23 septembre–11 décembre 1988] (Paris: Editions de la Réunion des musées nationaux, 1988), 19).

45. Wieland et al., "Are Real Assets Priced Internationally?" 19.

46. Klaus Berger, *Japonisme in Western Painting from Whistler to Matisse* (1980), trans. David Britt (Cambridge: Cambridge University Press 1992), 67.

47. Ibid. 36. The exhibition catalog for the 1988 show also stresses this reason for the significance of *le japonisme* to the advent of impressionism: "dans la tradition culturelle du Japon, l'art ne constitue pas un monde séparé de la vie quotidienne dont il fait tout

naturellement partie intégrante. . . . Au Japon, un objet utilitaire tend toujours à devenir une œuvre d'art, tandis qu'une œuvre d'art a toujours une fonction bien déterminée dans la vie qui elle-même est toute imprégnée d'art" (19). See Ernst Scheyer, "Far Eastern Art and French Impressionism," *The Art Quarterly* 6, no. 2 (spring 1943): 116–143 for an early account of this relationship stressing the significance of *le japonisme* to the emergence of impressionism out of realism.

48. Berger, *Japonisme in Western Painting from Whistler to Matisse*, 333.

49. See Horoko Yokomizo, "The Presentation and Reception of Japanese Art in Europe During the Meiji Period," in *Japonisme and the Rise of the Modern Art Movement: The Arts of the Meiji Period*, ed. Gregory Irvine, 54–89 (London: Thames and Hudson, 2013).

50. Hook, *The Ultimate Trophy*, 202.

51. Ibid., 213.

52. Takashi Murakami, "Theory of Superflat Japanese Art" (2000), in *Superflat* (Tokyo: Madra Publishing Co., 2000), 17.

53. Ibid., 17.

54. "A Million Little Lies: Exposing James Frey's Fiction Addiction," *The Smoking Gun*, January 6, 2006, www.thesmokinggun.com, accessed July 15, 2013.

55. "Oprah's Questions for James," *Oprah*, www.oprah.com, January 26, 2006, accessed July 17, 2013.

56. Stephen Colbert, "The Wørd," *The Colbert Report*, October 17, 2005, www.colbertnation.com, accessed November 22, 2013.

57. "A Million Little Lies," 4.

58. James Frey, "Frey's Note to the Reader," *The New York Times* (February 1, 2006), www.nytimes.com, accessed July 17, 2013.

59. Ibid.

60. Ibid.

61. Ibid.

62. Ibid.

63. James Frey, *A Million Little Pieces* (London: John Murray, 2003), 37.

64. Ibid., 189.

65. Daniel Mendelsohn, "But Enough About Me," *The New Yorker* (January 25, 2010), www.newyorker.com, accessed July 17, 2013.

66. Max Saunders, *Self-Impression: Life-Writing, Autobiografiction, and the Forms of Modern Literature* (Oxford: Oxford University Press, 2010), 10–11.

67. Ibid., 51.

68. Ibid., 47.

69. Ibid., 280.

70. Ibid., 42.

71. Ibid., 551.

72. Ibid., 552.

73. Andrew Hudgins, "An Autobiographer's Lies," *The American Scholar* 65, no. 4 (Autumn 1996), 552.

74. T. S. Eliot, "Hamlet," in *Selected Prose of T. S. Eliot*, ed. Frank Kermode (London: Faber and Faber, 1975), 48.

75. See Saunders, *Self-Impression*, 57–62, as well as Saunders's more general account of "the use of fiction as a resource for autobiography" as it focuses upon the transformation of personality (14).
76. Hudgins, "An Autobiographer's Lies," 552.
77. Frey, *A Million Little Pieces*, 111.
78. Ibid.
79. Ibid., 285.
80. Ibid., 123.
81. Ibid., 231.
82. Ibid., 169.
83. Ibid., 348–349.
84. Ibid., 280.
85. Frey, "Frey's Note to the Reader."
86. "A Million Little Lies," 4.
87. Janet Maslin, "Cry and You Cry Alone? Not if You Write About It," *The New York Times* (April 21, 2003), www.newyorktimes.com, accessed July 19, 2013.
88. Frey, *A Million Little Pieces*, 273, 365.
89. Ibid., 387.
90. "A Million Little Lies," 4.
91. Frey, *A Million Little Pieces*, 505.

6. CONTEMPORARY IMPRESSIONS, KITSCH AESTHETICS: KINKADE/DOIG

1. Stéphane Aquin, "No Land Foreign to Painting," in *Peter Doig: No Foreign Lands*, contributions by Hilton Als, Stéphane Aquin, Keith Hartley, Angus Cook, and Peter Doig (Montreal Museum of Arts, National Galleries of Scotland; Ostfildern: Hatje Cantz, 2013), 13.
2. M. Stephen Doherty, *The Artist in Nature: Thomas Kinkade and the Plein Air Tradition* (New York: Watson Guptill, 2002), 9.
3. Kinkade, "A Winter's Cottage," *Thomas Kinkade: Painter of Light*, www.thomaskinkade.com, accessed September 25, 2013; Christina Waters, "Selling the Painter of Light," *AlterNet* (October 15, 2001), www.alternet.org, accessed September 25, 2013.
4. Aquin, "No Land Foreign to Painting," 14.
5. Wendy Katz, "Introduction," in *Thomas Kinkade: Masterworks of Light* (Boston, New York, London: Little Brown, 2000), 19.
6. Thomas Kinkade and Rick Barnett, *The Thomas Kinkade Story: A 20-Year Chronology of the Artist* (Boston, New York, and London: Bulfinch Press, 2003), 189.
7. Katz, "Introduction," 17.
8. Monica Kjellman-Chapin, "Manufacturing 'Masterpieces' for the Market: Thomas Kinkade and the Rhetoric of High Art," in *Thomas Kinkade: The Artist in the Mall*, ed. Alexis Boylan (Durham: Duke University Press, 2011), 213.
9. Susan Orlean, "Art for Everybody," *The New Yorker* (October 15, 2001), 124.

10. Ibid.

11. Ibid., 125.

12. See "Media Arts Group Reports Fourth Quarter and Twelve Months 2002 Result," *Business Wire* (March 13, 2003), www.businesswire.com, accessed September 23, 2013; the estimate of Kinkade's wealth was his own, qtd. in Orlean, "Art for Everybody," 125.

13. Alexis L. Boylan, "Introduction," in *Thomas Kinkade: The Artist in the Mall,* ed. Alexis Boylan (Durham: Duke University Press, 2011), 2–3.

14. Ibid., 3.

15. Ibid.

16. Ibid., 13.

17. Katz, "Introduction," 21.

18. Kjellman-Chapin, "Manufacturing 'Masterpieces' for the Market," 224.

19. Katz, "Introduction," 29.

20. Clement Greenberg, "Avant-Garde and Kitsch" (1939), in *Art Theory and Criticism: An Anthology of Formalist, Avant-Garde, Contextualist, and Post-Modernist Thought,* ed. Sally Everett (Jefferson, NC: McFarland and Company, 1991), 32, 34.

21. Ibid., 35.

22. Ibid.

23. Matei Calinescu, *The Five Faces of Modernity: Modernism, Avant-Garde, Decadence, Kitsch, Postmodernism* (Durham: Duke University Press, 1987), 251, 229, 248.

24. Ibid., 239.

25. Katz, "Introduction," 21, 24.

26. Ibid., 17, 32.

27. Boylan, "Introduction," 13.

28. Greenberg, "Avant-Garde and Kitsch," 35.

29. Celeste Olalquiaga, *The Artificial Kingdom: A Treasury of Kitsch Experience* (New York: Pantheon, 1998), 292.

30. Ibid., 291.

31. Ibid., 297.

32. Judith Nesbitt, "A Suitable Distance," in *Peter Doig,* ed. Judith Nesbitt (London: Tate Britain, 2008), 11.

33. *Time Out*; Keith Hartley, "Visual Intelligence," in *Peter Doig,* ed. Nikki Columbus (New York: Rizzoli, 2011), 54.

34. Peter Doig and Angus Cook, "In Conversation," in *Peter Doig: No Foreign Lands,* 167; Richard Shiff, "Drift," in *Peter Doig,* ed. Nikki Columbus (New York: Rizzoli, 2011), 326.

35. Doig and Cook, "In Conversation," 170.

36. Gareth Jones, "Weird Places, Strange Folk," *frieze* (May 9, 1992), www.frieze.com, accessed September 23, 2013.

37. Ibid.

38. Ibid.

39. Ibid.

40. Shiff, "Drift," 303.

41. Ibid., 302.

42. Ibid., 338.

43. Aquin, "No Land Foreign to Painting," 14.

44. Keith Hartley, "Visual Intelligence," in *Peter Doig: No Foreign Lands*, 152.

45. Shiff, "Drift," 328.

46. Ibid., 339.

47. Ibid., 342.

48. Ibid.

49. Jones, "Weird Places, Strange Folk."

50. Peter Osborne, *Anywhere or Not at All: Philosophy of Contemporary Art* (London and New York: Verso, 2013), 41.

51. Ibid.

52. Ibid., 48.

53. Ibid., 28.

54. Ibid., 149.

55. Jeffrey Valance, "Thomas Kinkade's Heaven on Earth," in Boylan, ed., *Thomas Kinkade: The Artist in the Mall*, 197.

56. Ibid.

57. Ibid.

58. Ibid., 203.

59. Ibid., 199.

60. Ibid., 198.

61. For Vallance's full account of what infiltration art entails see "Interview with Jeffrey Vallance," *Whitehot Magazine of Contemporary Art* (March 2011), whitehotmagazine.com

62. Doug Harvey, "Skipping Formalities: Thomas Kinkade, Painter of Light," *Art Issues* 59 (1999): 16–19.

63. Ibid., 19, 17, 19.

64. Michael Leja, "The Monet Revival and New York School Abstraction," *Monet in the 20th Century*, ed. Paul Hayes Tucker with George T. M. Shackleford and Mary Anne Stevens (New Haven: Yale University Press, 1998), 106.

65. Ibid., 105.

66. Ibid., 107.

67. Louis Finkelstein, "New Look: Abstract-impressionism," *ArtNews* 55 (March 1956): 38.

68. Ibid., 68.

7. THE PSEUDO-IMPRESSIONIST NOVEL: SEBALD, TÓIBÍN, CUNNINGHAM

1. W. G. Sebald, *Austerlitz*, trans. Anthea Bell (New York: Random House, 2001), 150.

2. Marcel Proust, *In Search of Lost Time*, Vol. VI: *Time Regained*, trans. Andreas Mayor and Terence Kilmartin, rev. by D. J. Enright (New York: Modern Library, 1993), 255.

3. Ibid., 150.

4. David James, *Modernist Futures: Innovation and Inheritance in the Contemporary Novel* (Cambridge: Cambridge University Press, 2012), 156.

5. Sebald, *Austerlitz*, 156.

6. Ibid., 157.

7. Proust, *Time Regained*, 261.

8. Ibid., 262.

9. Ibid.

10. Ibid., 263.

11. Ibid., 264–265.

12. Ibid., 95.

13. Ann Pearson, "'Remembrance . . . is nothing other than a quotation': The Intertextual Fictions of W. G. Sebald," *Comparative Literature* 60, no. 3 (Summer 2008): 261–278; Lauren Walsh, "The *Madeleine* Revisualized: Proustian Memory and Sebaldian Visuality," in *The Future of Text and Image: Collected Essays on Literary and Visual Conjunctures*, ed. Ofra Amihay and Lauren Walsh, 93–130 (Newcastle, UK: Cambridge Scholars, 2012).

14. Walsh, "The *Madeleine* Revisualized," 105.

15. Sebald, *Austerlitz*, 243.

16. Ibid., 140, 185.

17. Ibid., 219.

18. Ibid., 228.

19. Proust, *Time Regained*, 446–447.

20. Pearson reads intertextuality across Sebald's fiction, but the intertextual relationship between Proust and *Austerlitz* is for her one that confirms that "the modernist vision of salvation" is "completely absent" from Sebald's novel (273).

21. Sebald, *Austerlitz*, 242.

22. Ibid., 244–245.

23. Ibid., 245.

24. Ibid., 246.

25. Ibid., 246–247.

26. Contrast the interpretation offered by Marianne Hirsch, for whom this film is symptomatic of "postmemory," or the post-Holocaust failure of anything like the form of memory available to Proust and his contemporaries (*The Generation of Postmemory: Writing and Visual Culture After the Holocaust* [New York: Columbia University Press, 2012], 40–49); Sebald, *Austerlitz*, 247.

27. Sebald, *Austerlitz*, 247.

28. Ibid., 249–250.

29. Rebecca Walkowitz's account of Sebald's "vertigo" and its combination of panoramic and microscopic views is a fuller account of this impressionistic mode (*Cosmopolitan Style: Modernism Beyond the Nation* [New York: Columbia University Press, 2006], 155, 159). See also Massimo Leone for a reading of this vertigo as a product of "the patchwork nature of Sebald's style and the labyrinthine topology of his semantics" ("Textual Wanderings: A Vertiginous Reading of W. G. Sebald," in *W. G. Sebald: A Critical Companion*, ed. J. J. Long and Anne Whitehead [Seattle: University of Washington Press, 2004], 90).

30. Here I have in mind Jean-François Lyotard's sense that postmodernism "denies itself the solace of good forms" in the representation of experience (*The Postmodern Condition: A*

Report on Knowledge, trans. Brian Massumi [Manchester: Manchester University Press, 1984], 81).

31. Colm Tóibín, *The Master* (New York: Scribner, 2004), 37–38.

32. See Michael Anesko, *Monopolizing the Master: Henry James and the Politics of Modern Literary Scholarship* (Stanford, CA: Stanford University Press, 2012), 75.

33. Eric Haralson, *Henry James and Queer Modernity* (Cambridge: Cambridge University Press, 2003), 102.

34. Henry James, *The Portrait of a Lady* (1881), Vol. 2, *The Novels and Tales of Henry James: New York Edition*, Vol. IV (New York: Charles Scribner's Sons, 1922), 204.

35. Michael Cunningham, *The Hours* (New York: Farrar, Straus and Giroux, 1998), 4.

36. Ibid., 5.

37. Ibid., 8.

38. Seymour Chatman, "*Mrs. Dalloway*'s Progeny: *The Hours* as Second-Degree Narrative," in *A Companion to Narrative Theory*, ed. James Phelan and Peter J. Rabinowitz (New York: Blackwell, 2005), 274. Chatman also calls the novel a "complementary transposition" to account for its relationship to Woolf's novel, and in his comprehensive stylistic comparison he notes that *The Hours* lacks the "psychic fluidity" Woolf achieves (272, 278–279).

39. Ibid., 31.

40. Here I revise Carol Iannone's observation that Cunningham's story presents a "triptych describing the modern Progress of Woman" ("Woolf, Women, and *The Hours*," *Commentary* [April 1, 2003]: 52).

41. John Bayley, "What Henry Knew," rev. of *The Master*, by Colm Tóibín, *New York Review of Books* 51, no. 12 (July 15, 2004), http://www.nybooks.com/articles/archives/2004/jul/15/what-henry-knew/, accessed July 14, 2010.

42. Tóibín, *The Master*, 1.

43. Janet Maslin, "The Hours of a Master at an Awkward Age," rev. of *The Master*, by Colm Tóibín, *New York Times* (May 31, 2004), http://www.nytimes.com/2004/05/31/books/books-of-the-times-the-hours-of-a-master-at-an-awkward-age.html, accessed July 14, 2010.

44. Tóibín, *The Master*, 9.

45. I make this complaint more fully in my review of Eric Haralson's *Henry James and Queer Modernity* (*Modernism/modernity* 12, no. 1 [January 2005]: 192).

46. Tóibín, *The Master*, 92–93.

47. John Carlos Rowe, *The Theoretical Dimensions of Henry James* (Madison: University of Wisconsin Press, 1984), 194.

48. Daniel Hannah, "The Private Life, the Public Stage: Henry James in Recent Fiction," *Journal of Modern Literature* 30, no. 3 (Spring 2007): 73, 74.

49. Here I have in mind Christopher Nealon's *Foundlings: Lesbian and Gay Historical Emotion Before Stonewall* (Durham: Duke University Press, 2001) and Heather Love, *Feeling Backward: Loss and the Politics of Queer History* (Cambridge: Harvard University Press, 2007).

50. James, *Modernist Futures*, 156, 158.

8. THINKING MEDIUM: THE RHETORIC OF POPULAR COGNITION

1. Daniel Kahneman, *Thinking, Fast and Slow* (London: Penguin, 2011), 270–271.
2. Ibid., 58.
3. Ibid., 21.
4. Oliver Sacks, "Preface," *The Man Who Mistook His Wife for a Hat* (1970; New York: Touchstone, 1998), ix.
5. Daniel J. Levitin, *The Organized Mind: Thinking Straight in the Age of Information Overload* (New York: Dutton, 2014), 100, 179.
6. Kahneman, *Thinking, Fast and Slow*, 21.
7. Ibid., 16.
8. Ibid., 416.
9. Ibid., 24.
10. Ibid., 77.
11. Ibid., 415.
12. Ibid., 415.
13. Malcolm Gladwell, *Blink: The Power of Thinking Without Thinking* (2005; London: Penguin, 2006), 14.
14. Ibid., 14.
15. Ibid., 253.
16. Ibid., 11.
17. Ibid., 14.
18. Ibid., 13.
19. Ibid., 16.
20. Ibid., 23.
21. Ibid., 97.
22. Ibid., 141.
23. Ibid., 133–135.
24. Ibid., 259–260.
25. Ibid., 269.
26. Ibid., 179.
27. Rachel Donadio, "The Gladwell Effect," *New York Times Book Review* (February 5, 2006), www.newyorktimes.com, accessed September 8, 2013.
28. Ibid.
29. David Brooks, "'Blink': Hunch Power," *New York Times Book Review* (January 16, 2005), www.newyorktimes.com, accessed September 8, 2013.
30. See my article, "Walter Pater's Literary Impression," for a discussion of the relevant problem of impressionability, which is also at work in fiction by James, Proust, and others (*Modern Language Quarterly* 56, no. 4 [December 1995]: 433–456).
31. Gladwell, *Blink*, 235.
32. See Laurent Mottron et al., "Enhanced Perceptual Functioning in Autism: An Update, and Eight Principles of Autistic Perception," *Journal of Autism and Developmental Disorders* 36, no. 1 (2006): 27–43; H. Markram, T. Rinaldi, and K. Markram, "The Intense

World Syndrome—An Alternative Hypothesis for Autism," *Frontiers in Neuroscience* 1, no. 1 (2007): 77–96; and M. Dawson and I. Soulières, "The Level and Nature of Autistic Intelligence," *Psychological Science* 18 (2007). This chapter focuses on the popular versions of this research rather than the information it provides.

33. Karen Zelan qtd. in Ralph James Savarese, *Reasonable People: A Memoir of Autism and Adoption* (New York: Other Press, 2007), 201.

34. Donna Williams, *Nobody Nowhere: The Extraordinary Autobiography of an Autistic* (New York: Times Books, 1992), 204.

35. A source for "neurodiversity" is Harvey Blume, "Neurodiversity: The Neurological Underpinnings of Geekdom," *Atlantic* (September 30, 1998), www.theatlantic.com, accessed October 21, 2013. See also www.neurodiversity.com and Amy Harmon, "Neurodiversity Forever: The Disability Movement Turns to Brains," *The New York Times* (May 9, 2004), www.nytimes.com, and Andrew Solomon, "The Autism Rights Movement," *New York Magazine* (May 5, 2008), www.nymag.com.

36. Francesca Happé, *Autism: An Introduction to Psychological Theory* (Cambridge, MA: Harvard University Press, 1995), 116, 117.

37. Oliver Sacks, "The Autist Artist," in *The Man Who Mistook His Wife for a Hat* (1970; New York: Touchstone, 1998), 229.

38. Bruce Mills, "Autism and the Imagination," in *Autism and Representation*, ed. Mark Osteen (New York: Routledge, 2008), 127.

39. Ibid., 116.

40. Ibid., 128; Mark Osteen, "Autistry," in Osteen, ed., *Autism and Representation*, 97.

41. Sacks, "The Autist Artist," 230.

42. Oliver Sacks, *An Anthropologist on Mars* (New York: Vintage, 1995), 218.

43. Ibid., 242.

44. Ibid., 241–242.

45. Ibid.

46. Ralph Savarese, *Reasonable People: A Memoir of Autism & Adoption* (New York: Other Press, 2007), xiv.

47. Ibid., 395.

48. Ibid., 258.

49. Ibid.

50. Ralph Savarese, "The Body's Narrative: Classical Autism and Synesthetic Response," unpublished paper.

51. Temple Grandin, *Thinking in Pictures: And Other Reports from My Life with Autism* (New York: Doubleday, 1995), 19.

52. Ibid., 24–25.

53. Ibid., 54, 36.

54. Ibid., 110.

55. Tito Rajarshi Mukhopadhyay, *How Can I Talk If My Lips Don't Move?: Inside My Autistic Mind* (New York: Arcade Publishing, 2011), 7.

56. Ibid., 140.

57. Ibid., 94–95.

58. Ibid., 96.
59. Ibid., 99.
60. Ibid., 124.
61. In this he is comparable to the classic example: the protagonist of *What Maisie Knew*, as described by Henry James in his preface to that novel. See *The Art of the Novel: Critical Prefaces by Henry James*, ed. R. P. Blackmur (Chicago: University of Chicago Press, 2011), 143.
62. Mark Haddon, *The Curious Incident of the Dog in the Night-Time* (New York: Random House, 2003), 4.
63. Ibid., 73.
64. Ibid., 90.
65. Ibid., 170.
66. Ibid., 140.
67. Ibid.
68. Ibid., 144.
69. See James Berger, "Alterity and Autism: Mark Haddon's *Curious Incident* in the Neurological Spectrum," in Osteen, ed., *Autism and Representation*, 271–288, and Gyasi Burks-Abbott, "Mark Haddon's Popularity and Other Curious Incidents in My Life as an Autistic," in Osteen, ed., *Autism and Representation*, 289–296.
70. Jonah Lehrer, *Proust Was a Neuroscientist* (Boston: Houghton Mifflin, 2008), x.
71. Ibid., 76.
72. Ibid.
73. Ibid., 97.
74. Ibid., 109.
75. Ibid., 104.
76. Ibid., 109. "It is because Cézanne knew that the impression was not enough—that the mind must complete the impression—that he created a style both more abstract and more truthful than the impressionists," and in the process developed a mode of inquiry that recursively corresponds to the larger project of Lehrer's book.
77. Ibid.
78. Ibid., 119.
79. Ibid., 191.
80. Ibid., 196.
81. Ibid., 195.
82. Ibid., 196.
83. Ibid., 197, 119.
84. Lehrer, "My Apology," http://www.jonahlehrer.com, accessed September 14, 2013.

CONCLUSION

1. Matei Calinescu, *The Five Faces of Modernity: Modernism, Avant-Garde, Decadence, Kitsch, Postmodernism* (Durham: Duke University Press, 1987), 262.

2. Ibid., 262.

3. Zadie Smith, "Two Paths for the Novel," *New York Review of Books* (November 20, 2008), http://www.nybooks.com/articles/2008/11/20/two-paths-for-the-novel/, accessed June 2, 2016.

4. Here I refer to the very different theories of aesthetic experience discussed by Scarry, who argues for homologies between aesthetic and ethical judgments and claims that "something beautiful fills the mind yet invites the search for something beyond itself" (*On Beauty and Being Just* [Princeton: Princeton University Press, 1999], 32); Steiner, for whom "the experience of beauty involves a challenge to achieve the value or beauty of the Other" and therefore "a pleasure different in kind from normal experience" (*Venus in Exile: The Rejection of Beauty in Twentieth-Century Art* [New York: The Free Press, 2001], xxiv), and Armstrong, in her effort to "[broaden] the scope of what we think of as art" to include the "ceaseless mediation" at work in "playing and dreaming, thinking and feeling," and other endeavors "embedded in the processes and practices of consciousness" (*The Radical Aesthetic* [Oxford: Blackwell, 2000], 2).

INDEX